Re-Enchantment

University College Cork
Coláiste na hOllscoile Corcaigh

The near-absence of religion from contemporary discourse on art is one of the most fundamental issues in postmodernism. Artists critical of religion can find voices in the art world, but religion itself, including spirituality, is taken to be excluded by the very project of modernism. The sublime, "re-enchantment" (as in Weber), and the aura (as in Benjamin) have been used to smuggle religious concepts back into academic writing, but there is still no direct communication between "religionists" and scholars. *Re-Enchantment*, volume 7 in The Art Seminar series, will be the first book to bridge that gap.

The volume includes an introduction and two final, synoptic essays, as well as contributions from some of the most prominent thinkers on religion and art, including Boris Groys, James Elkins, Thierry de Duve, David Morgan, Norman Girardot, Sally Promey, S. Brent Plate, and Christopher Pinney.

James Elkins is E.C. Chadbourne Chair in the Department of Art History, Theory, and Criticism at the School of the Art Institute of Chicago, and Head of History of Art at the University College Cork, Ireland. He is the author of *Pictures and Tears, How to Use Your Eyes, What Painting Is, The Strange Place of Religion in Contemporary Art* and *Master Narratives and Their Discontents*, all published by Routledge; and *Six Stories from the End of Representation*, published by Stanford University Press.

David Morgan is Professor of Religion at Duke University, and author of several books, including *Visual Piety, The Sacred Gaze*, and *The Lure of Images* (Routledge). He is co-founder and co-editor of the journal *Material Religion*.

The Art Seminar

VOLUME 1
ART HISTORY VERSUS AESTHETICS

VOLUME 2
PHOTOGRAPHY THEORY

VOLUME 3
IS ART HISTORY GLOBAL?

VOLUME 4
THE STATE OF ART CRITICISM

VOLUME 5
RENAISSANCE THEORY

VOLUME 6
LANDSCAPE THEORY

VOLUME 7
RE-ENCHANTMENT

Sponsored by the University College Cork, Ireland; the Burren College of Art, Ballyvaughan, Ireland; and the School of the Art Institute, Chicago.

Re-Enchantment

EDITED BY

JAMES ELKINS AND DAVID MORGAN

University College Cork
Coláiste na hOllscoile Corcaigh

Routledge
Taylor & Francis Group

NEW YORK AND LONDON

First published 2009
by Routledge
270 Madison Ave, New York, NY 10016

Simultaneously published in the UK
by Routledge
2 Park Square, Milton Park, Abingdon, Oxon OX14 4RN

Routledge is an imprint of the Taylor & Francis Group, an informa business

Typeset in ACaslon-Regular by Swales & Willis Ltd, Exeter, Devon
Printed and bound in the United States of America on acid-free paper by
Edwards Brothers, Inc

Library of Congress Cataloging-in-Publication Data
Re-enchantment / edited by James Elkins and David Morgan. – 1st ed.
p. cm. – (The art seminar ; vol. 7)
Includes bibliographical references and index.
1. Art and religion–Congresses. 2. Art criticism–Congresses. I. Elkins, James,
1955– II. Morgan, David, 1957–
N72.R4R44 2008
704.9'48–dc22
2008009226

ISBN10: 0–415–96051–7 (hbk)
ISBN10: 0–415–96052–5 (pbk)
ISBN10: 0–203–89166–X (ebk)

ISBN13: 978–0–415–96051–9 (hbk)
ISBN13: 978–0–415–96052–6 (pbk)
ISBN13: 978–0–203–89166–7 (ebk)

TABLE OF CONTENTS

Series Preface vii
James Elkins

SECTION 1 INTRODUCTION 1

Enchantment, Disenchantment,
Re-Enchantment 3
David Morgan

SECTION 2 STARTING POINTS 23

Art and Religion in the Modern Age 25
David Morgan
From the Form of Spirit to the Spirit of Form 47
Randall K. Van Schepen
How Some Scholars Deal with the Question 69
James Elkins
Religion as Medium 79
Boris Groys
Mary Warhol/Joseph Duchamp 87
Thierry de Duve

SECTION 3 THE ART SEMINAR 107

Participants: Gregg Bordowitz, Thierry de
Duve, Wendy Doniger, James Elkins, Boris
Groys, Kajri Jain, Tomoko Masuzawa, David
Morgan, and Taylor Worley 109

SECTION 4 ASSESSMENTS 185

Jeremy Biles 187
Ann Pellegrini 192
Chris Parr 195

Norman Girardot 200
S. Brent Plate 209
Stephen Pattison 211
Lisa DeBoer 217
Kevin Hamilton 219
Sally M. Promey 222
James Panero 225
William Dyrness 228
Ena Giurescu Heller 229
Daniel A. Siedell 232
Robin M. Jensen 235
Diane Apostolos-Cappadona 237
Theodore Prescott 239
Amy Sillman 241
Graham Howes 243
Samantha Baskind 244
Jens Baumgarten 249
David Brown 255
Insoo Cho 258
Cordula Grewe 261
Deborah J. Haynes 266
Pepe Karmel 269
Anna Niedźwiedź 270
Kristin Schwain 273
Jorgelina Orfila 275
Christopher Pinney 277

SECTION 5 AFTERWORDS

SECTION 5 AFTERWORDS 285

Missing Religion, Overlooking the Body 287
Jojada Verrips
The Next Step? 297
Erika Doss

SECTION 6 ENVOI TO THE *ART SEMINAR* SERIES

SECTION 6 ENVOI TO THE *ART*
 SEMINAR SERIES 303
Envoi 305
James Elkins

Notes on Contributors 311

Index 315

SERIES PREFACE

James Elkins

It has been said and said that there is too much theorizing in the visual arts. Contemporary writing seems like a trackless thicket, tangled with with unanswered questions. Yet it is not a wilderness; in fact it is well-posted with signs and directions. Want to find Lacan? Read him through Macey, Silverman, Borch-Jakobsen, Žižek, Nancy, Leclaire, Derrida, Laplanche, Lecercle, or even Klossowski, but not— so it might be said—through Abraham, Miller, Pontalis, Rosaloto, Safouan, Roudinesco, Schneiderman, or Mounin, and of course never through Dalí.

People who would rather avoid problems of interpretation, at least in their more difficult forms, have sometimes hoped that "theory" would prove to be a passing fad. A simple test shows that is not the case. Figure 1, below, shows the number of art historical essays that have terms like "psychoanalysis" as keywords, according to the *Bibliography of the History of Art.* The increase is steep after 1980, and in three cases—the gaze, psychoanalysis, and feminism—the rise is exponential.

Another sampling (Figure 2) shows that citations of some of the more influential art historians of the mid-twentieth century, writers who came before the current proliferation of theories, are waning. In this second graph there is a slight rise in the number of references to Warburg and Riegl, reflecting the interest they have had for the

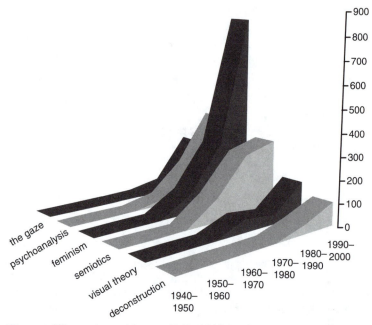

Figure 1 Theory in art history, 1940–2000

current generation of art historians: but the graph's surprise is the precipitous decline in citations of Panofsky and Gombrich.

Most of art history is not driven by named theories or individual historians, and these graphs are also limited by the terms that can be meaningfully searched in the *Bibliography of the History of Art*. Even so, the graphs suggest that the landscape of interpretive strategies is changing rapidly. Many subjects crucial to the interpretation of art are too new, ill-theorized, or unfocused to be addressed in monographs or textbooks. The purpose of *The Art Seminar* is to address some of the most challenging subjects in current writing on art: those that are not unencompassably large (such as the state of painting), or not yet adequately posed (such as the space between the aesthetic and the anti-aesthetic), or so well known that they can be written up in critical dictionaries (the theory of deconstruction). The subjects chosen for *The Art Seminar* are poised, ready to be articulated and argued.

Each volume in the series began as a roundtable conversation,

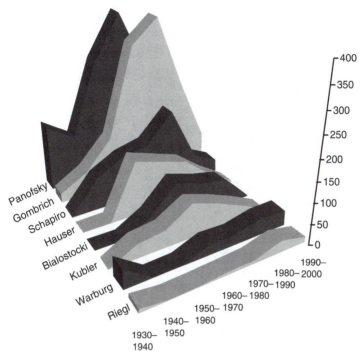

Figure 2 Rise and fall of an older art history, 1930–2000: Citations of selected writers

held in front of an audience at one of the three sponsoring institutions—the University College Cork, the Burren College of Art (both in Ireland), and the School of the Art Institute of Chicago. The conversations were then transcribed, and edited by the participants. The idea was to edit in such a way as to minimize the correctable faults of grammar, repetitions, and lapses that mark any conversation, while preserving the momentary disagreements, confusions, and dead-ends that could be attributed to the articulation of the subject itself.

In each volume of *The Art Seminar*, the conversation itself is preceded by a general introduction to the subject and several "Starting Points," essays that were read by the participants before the roundtable. Together the Introductions and "Starting Points" are meant to provide the essential background for the conversation. A number of scholars who did not attend the events were then asked to

write "Assessments"; their brief was to consider the conversation from a distance, noting its strengths and its blind spots. The "Assessments" vary widely in style and length: some are highly structured, and others are impressionistic; some are under a page, and others the length of a commissioned essay. Contributors were just asked to let their form fit their content, with no limitations. Each volume then concludes with one or more "Afterwords," longer critical essays written by scholars who had access to all the material including the "Assessments."

In that way *The Art Seminar* attempts to cast as wide, as fine, and as strong a net as possible, to capture the limit of theorizing on each subject at the particular moment represented by each book. Perhaps in the future the subjects treated here will be colonized, and become part of the standard pedagogy of art: but by that time they may be on the downward slide, away from the centers of conversation and into the history of disciplines.

1
INTRODUCTION

ENCHANTMENT, DISENCHANTMENT, RE-ENCHANTMENT

David Morgan

The process of modern Western secularization, according to Max Weber, began with ancient Jewish monotheism and took a decisive step in capitalism's debt to Calvinism. "Die Entzauberung der Welt," the elimination of magic from the world, is a religious impulse whose genesis resides in "the old Hebrew prophets and, in conjunction with Hellenistic scientific thought."[1] It was Isaiah, Jeremiah, and a Psalmist who denounced "idols" as no more than blocks of wood and stone: "Those who make them are like them; so are all who trust them" (Psalm 115: 8). The figures were not inhabited by spirits or gods, but consisted only of dead matter. The emptiness of idols was a way of pointing to the real architect of the universe and human affairs—the one, true God in heaven whose people was Israel. For the prophets, the magic did not leak from carved figures like some vital fluid; it was never there to begin with. Idols were nothing but the product of human folly.

Although there were no gods in water or trees or the moon, the world of the prophets was not bereft of spiritual power. The mountains still leapt and declared the glory of the Lord. This glory was a form of speech, a material speech or praise bearing witness to the maker. Jewish iconoclasm did not invent the idea of handiwork proclaiming the glory of the creator, but it concentrated on glory as an aesthetic category. In tandem with this aesthetic, Judaism developed

an alternative conception of the natural world that allowed it to stand as an aesthetic object. "The sun knows its time for setting" and "Thou didst set the earth on its foundations," Psalm 104 states, which is a poetic way of saying that the law-like will of the creator held the sun and the earth in place, that it governed the operations of all the heavenly bodies, which were wrongly worshipped by Israel's neighbors and by many within the nation itself. Was that world disenchanted? To Canaanites and Babylonians it must have seemed like an empty place, precipitously drained of its divine substance. But not to the new advocates of radical monotheism. For them, the divine was related to the world not through the mechanics of libation or the rituals of divination, not as infused in sacred spaces or invoked through magical incantations. The prophetic understanding of the divine did not see God acting like that except in extraordinary instances, and those were locked up in the authority of sacred writ, in the holy narratives of God's word, the inspired texts that *remembered* theophany. This form of dispensation placed history between divine action and the present, structured time as issuing from the holy and conveying its consequences into the present, which were delivered and maintained as the covenant God established and expected his people to honor. The Jewish deity did not poke holes in time at the beck and call of earthbound magi, but relied on time as the medium of revelation, mapped out in the words that performed his will. Among other things, this meant that good stories and good story-telling came at a premium. In the aesthetic logic of time and narrative, timing mattered.

The difference between magic and radical monotheism is the "de-divinizing of the world," to borrow the phrase from Friedrich Schiller that Weber found inspiring. This difference, established in the prophetic phase of ancient Israel, might be said to have birthed the idea of nature as a domain governed by laws that inhered in nature rather than gods, and that what violated these laws was now "supernatural." Secularization commenced a long and meandering biography in monotheism. It reached a new phase of life when the "inalienable rights of man" could render kingship "unnatural." Along with monarchy went its sacred apparatus, resulting in the separation of church and state, in theory if not entirely in practice. The rise of science and technology, hymned by the Enlightenment and exploited by the Industrial Revolution and the rational administration of

economy, resulted in the disenchantment of the world, as it was explained by Weber and has been echoed by many others. Ernest Gellner succinctly summarized the term's widely accepted meaning: "the Faustian purchase of cognitive, technological, and administrative power, by the surrender of our previous meaningful, humanly suffused, humanly responsive, if often also menacing or capricious world."[2]

Gellner captured the plaintive note of Weber's account. Weber did not applaud the disenchanted world, but saw in it the prospect of "mechanized petrifaction," an inescapable cage that traps moderns in a regime of spiritless production and consumption. If consumption had once been moderated by Calvinism's curbing of acquisition for its own sake and its prioritization of calling or vocation as the organizing moral structure of human life, capitalism had since acquired "mechanical foundations" that no longer required the assistance of Calvinist theology, which had allowed the Puritans to regard wealth as a sign of divine blessing.[3] Consumption reigned autonomously, fully purged of the religion that helped create the social ethic of capitalism. Others have celebrated the shift and elaborated the Weberian thesis, even hailing disenchantment as the great contribution of Christianity to Western civilization. In a fascinating and sweeping book, *The Disenchantment of the World*, Marcel Gauchet has argued that Christianity was the juncture at which the West undertook "a departure from religion," completing a long process of secularization that began with the axial age of religious evolution.[4]

For Weber, however, the trade came at a price that he felt unsure was justified. The modern world was haunted: "the idea of duty in one's calling prowls about in our lives like the ghost of dead religious beliefs."[5] Duty to what? At the end of the day, what does a pile of money buy one? In the cultural economy of Protestant belief, the life-long investment in one's calling had paid off in the coin of eternal life and divine satisfaction. Though freed from the asceticism, intolerance, and dogmatism of Puritan belief, modern life had become like the idols of old—empty and disenchanted. Haunting seems to happen where enchantment has been banned or suppressed. The gods are replaced by ghosts and they disturb us with hollow sounds. Ghosts are not the things they once were, but nagging forms of memory that refuse to let the past go away. They are unfinished business, terrifying proof that the past is not yet over.

Weber rued the present condition of humanity. One finds Friedrich Schiller doing the same in the poem of 1788 from which Weber took the idea of "die Entzauberung der Welt." "The Gods of Greece" is an elegy that regrets the passing of the ancient gods and their world of enchanted nature and enchanting art. The haunting that drives Schiller's poem is the loss of the gods who ceased to exist when a different world and deity arose and had no use for them. Now the gods are only legends, "beautiful beings from the land of fables."[6] Weber must have been drawn to the poem because of Schiller's contrast of monotheism and polytheism: "All those blooms have fallen/ from the North's winter blowing./ That *one* might be enriched among all others,/ this world of gods had to pass away." Schiller was taken to task for this by another poet, Friedrich Leopold, Count of Stolberg, for whom the poem's wistful celebration of paganism was an affront to the Christian conception of God.[7] But Stolberg's deeper objection seems to have been his suspicion that Schiller was embracing the heretical view of the freethinker or infidel. When the poet proclaimed that the Greeks felt the pleasure of the creator more closely as it pulsed through their chests, and lamented the modern creator who reveals himself to the intellect and hides himself in the clouds, but is nowhere to be found, Stolberg saw Schiller articulating "the naturalist's relation to divinity."[8] And Stolberg denounced as "more audacious" (*vermeßner*) Schiller's "complaint" of the enrichment of "the one" God at the expense of the others.[9] He missed in the poem what he called "the ideas about God which our religion puts to us": the loving Father, the incarnate Son, the doctrine of immortality and resurrection. "These ideas," Stolberg insisted, the true basis of human happiness, "even if he [Schiller] should have the misfortune not to believe them, appear much more noble and benevolent than the games of Greek fantasy, whose view of the gods joins the most vulgar superstition to the most wretched atheism."[10]

Though several writers leapt quickly to Schiller's defense, Stolberg's offense is not hard to understand.[11] The poem unquestionably regarded monotheism as a fundamental aspect of modernity's difference from Greek culture and regretted the consequence. But it was not monotheism that Schiller blamed as much as an uninspired and dogmatic Protestantism. In a shortened second version of the

poem published a few years later, he referred to "gloomy earnest and sad renunciation" (*Finstrer Ernst und trauriges Entsagen*), which may be taken as a less than flattering portrayal of what Weber called Protestantism's other-worldly asceticism, perhaps as it appeared personified to Schiller in Stolberg himself. Schiller's Protestant tags stand in withering contrast to the pair of well-known descriptors of Winckelmann's representation of ancient Greek art: "noble simplicity and quiet grandeur" (*edle Einfalt and stille Größe*).[12] Schiller also bemoaned the empty, mechanistic world of modern materialism that Stolberg accused him of celebrating as an infidel's naturalism. But Stolberg was not far wrong: Schiller had for several years been engaged in philosophical reflection about religion and nature that took him beyond the bounds of orthodox Christian teaching. Although he did not abandon Christianity, neither was he a conventional believer. As his *Philosophical Letters*, published in 1786, show, he was compelled by monistic thinking about the relationship of the divinity to nature: "The universe is a divine thought," Julius, the persona of Schiller, wrote. And "God and nature are two dimensions that are completely alike. . . . Nature is a god infinitely articulated."[13] The force that seeks to return this articulation to divine unity is love. Julius quotes Jesus and refers to him as the "founder of our faith." Founder, but not redeemer.[14] Schiller considered the religious imagination of conventional thinking quite unconvincing. In a contemporary letter to a friend he pointed out that "the God which I push aside in 'The Gods of Greece' is not the God of philosophers, nor the benevolent dream-image of the great multitude, but a monstrosity wrought from many feeble, wrong-headed ways of thinking. The gods of Greece, which I bring to the fore, are simply the endearing qualities of Greek mythology united in *one* way of thinking."[15]

The hostile response to the original version of the poem suggests that Schiller did not need to say more for his contemporaries to contextualize his verse, for the poem spends most of its time dwelling on the difference between then and now, the lost world and the present one:

> At that time by the art of poetry/ a picturesque garment clothed truth!/ Life flowed fully through creation/ and what will never feel again, felt then./ To press her to the loving breast,/ one gave to

nature a higher nobility./ Everything displayed to consecrated gazes,/ Everything revealed the trace of a god.

Where only now, as our sages claim,/ a soul-less fire ball turns,/ in that time Helios steered his golden chariot/ in calm majesty./ . . .

Beautiful world, where are you? Come back,/ Charming age of nature's bloom!/ Only in the fairy land of songs/ does your golden trace live on./ The fields mourn what has died out,/ no deity shows itself to my eye,/ Of that life-warm image/ only the skeleton remains to me.

All those blooms have fallen/ from the North's winter blowing./ That *one* might be enriched among all others,/ this world of gods had to pass away. Sadly I search the starry arc,/ I find you there, Selene, no more;/ through the forests I call, through the waves,/ Alas! their echo is empty.

Unconscious of the joys she gives,/ never enrapt by her excellence,/ never aware of the arm that directs her,/ never enriched by my gratitude,/ unfeeling even for her artist's honor,/like the dead thud of a clock's pendulum,/ disenchanted nature serves slavishly the law of gravity![16]

Schiller implies the gods were abandoned because they were no longer required: "Idly the gods returned home to the land of poets,/ unneeded by a world that outgrew their harness, which steadies itself in its own wavering." But what must have bothered orthodox Christian readers of his day is why the gods' celebration of life was set aside: in order to be emancipated tomorrow, he wrote, this disenchanted or, literally, "de-divinized" nature (*die entgötterte Natur*) digs its own grave today. Christians deferred their bliss until the afterlife, missing the joy of the present world, and re-creating nature after their own leaden image. Schiller mourned the disenchantment of nature as the Christian deferral of joy, whose accomplice was the mechanistic science of the day.

Though "The Gods of Greece" might suggest a nostalgic yearning to escape to a lost world of fabulous nature worship, in fact

Schiller entertained nothing of the sort. In his *Letters on the Aesthetic Education of Humanity* (1795), he defined the ideal in art in terms of abstracting form from the body of a thing. Modern artists were not ancient Greeks, but they ought to learn from them to recognize the ideal. Neither should the moderns defer their quest for joy to the afterlife. The proper aim was to seek the ideal, which was to be pursued in the imagination: "Nothing need here [in the mind] be sacred to [the artist] except his own law, if he but observes the demarcation separating his territory from the actual existence of things. . . . [I]t is in the world of semblance alone that [humanity] possesses this sovereign right, in the insubstantial realm of the imagination."[17] The artist was the lord of an aesthetic realm. A consequence of Schiller's strong affirmation of the imagination as a constructive faculty and of the artist's creative autonomy was that art became a world of its own, characterized by its own laws. It was the realm of fantasy, of play, evoked by the artist and therefore as intricate as the artist's imagination. Yet this sovereignty was purchased at the price of strict demarcation. The "sovereign right" of the artist's creation ended abruptly whenever the artist transgressed the limits of the imagination and sought to make the ideal work real. Semblance or fiction must remain what they are lest the ideal be taken for the merely real. Art should never seek merely to imitate reality, for the result will be a slavish lack of imagination and an inevitable failure. Rather than craving for the material world, the artist must develop a disinterested way of seeing, an aesthetic view, what Schiller called "a disinterested and unconditional appreciation of pure semblance."[18] Art was a re-enchantment of the world, not with gods, but with the play of imagination.

Modes of enchantment

By purging nature of gods, Christianity had postponed bliss to the next world. And by championing artistic imagination, Schiller's version of the ideal circumscribed art within the realm of play, thereby limiting art's political power. Each of these compromises banned or repressed powers that refused to die. The result was the condition for haunting. Ghosts arise where suppressed needs and impulses voice objection to their mistreatment. Folklore evinces different kinds of

ghosts—apparitions, vengeful spirits, poltergeists. Likewise, there are different forms of enchantment. There is the malevolent animation of objects or demonic possession of people with spiritual powers that must be driven out—by greater powers. These may be stronger spirits, more effective spells—in effect, forms of counter-enchantment. Or the powers may be trumped by disenchantment, that is, by a religion that denies them existence or by reason, which explains them singularly in terms of the operation of psychology or physics or economics. Examples will make the point better.

A familiar version of enchantment is the menacing animation of objects. It is not a happy enchantment, not a successful re-enchantment, not a resolution of conflict, but rather the agonizing, uncanny repetition of a violence, a dark ritual that won't go away.[19] Things are haunted, such as the painted portrait of the Puritan patriarch Colonel Pyncheon in Hawthorne's *House of the Seven Gables*. The portrait remembers its sitter's guilt in acquiring the land on which the haunted house was built. The Colonel had denounced a rival, the rightful owner of the land, and had then sanctioned his prosecution for witchcraft. The condemned man was executed, but not before he issued a fatal curse on the Colonel, which came true and was transmitted to his heirs. The spell was not broken until the patriarch's final incarnation, the latter-day Judge Pyncheon, died in the seat of avarice and hypocrisy. Hawthorne devoted a remarkable chapter to observing the Judge's fresh corpse, as if it were an embodied version of the portrait of the patriarch, which hung in the mansion's parlor. The Judge was the product of what Schiller had castigated in "The Gods of Greece": a self-satisfied, punctilious Christianity, whose dogmatism had gutted compassion and rendered it a white-washed avarice. Hawthorne vented his contempt as narrator by speaking to the corpse of the Judge frozen in his parlor chair, taunting it, cursing it, and thereby exorcising the ghost of the Colonel, who watches from the filmy veil of his portrait. It bears remembering that Hawthorne himself was the descendent of a judge at the Salem witch trials. He ends the chapter with a note of deliverance or rebirth: "We breathe more freely, emerging from Judge Pyncheon's presence into the street before the Seven Gables."[20] Art has disenchanted the haunted portrait, dispelled the ghost born of crime, whose legacy had been passed from generation to generation of the Pyncheon family.

Enchantment in literature and fairy tales is folklore transformed into art, a formalization of the pleasure of ghost stories around the campfire. But enchantment also remains a living part of the fabric of modern life, beyond the artifice of art. It happens to everyone, university professors no less than religious believers and naïve princesses. A case in point is Joan Didion's intelligent account of her own "year of magical thinking," spent struggling to come to terms with the death of her husband and the chronic illness of her daughter. Subtly, unconsciously, she resisted the fact of his death. "I was thinking as small children think," she wrote, "as if my thoughts or wishes had the power to reverse the narrative, change the outcome." She was unable to give away all of her husband's shoes since "he would need shoes if he was to return."[21] But magical thinking was not an acceptable way of being. It was an uneasy transitional state, a form of denial, even "derangement," according to Didion, a haunting that needed to be driven out. Magical thinking was the dark world of grief and mourning through which she had to pass in order to regain a grip, to return to the world of facts and rationality that was suddenly taken from her in the violence of loss. Enchantment, in Joan Didion's case, is nothing to pine for, but something to survive.

Sociologist Mark Schneider has argued that enchantment happens even in the social sciences whenever people lack competence to explain an event in naturalistic terms.[22] Smitten by the beloved and lacking a soberly neurological way to account for the power of the attraction, the lover will rely on characterizing the power of love as a "magnetic," "mysterious," "electric," or otherwise irresistible "magical" force. But this implies that as soon as I acquire competence in naturalistic explanation, the enchantment will end. In fact, that's not always the case. People prefer the enchantment—in matters of love, fear, hatred, or enjoyment derived from suspending disbelief in the experience of things as varied as religious miracles, theater, art, rumors, humor, or the sensation of a scandal or a mystery. We often favor the incredulous. When there is a compelling emotional or ideological reason to do so, we may prefer to believe even against solid evidence to the contrary. For example, walking home at night, I may pick up a rock or stick to act against the fear that someone or something is lurking in the shadows, threatening me. Each sound, shadow, or movement is easily amplified into a predator. The fear's animation

of objects is the first aspect of enchantment; the countervailing use of a talisman is a second or complementary form intended to answer to and defuse the threat. Disenchantment is another possibility, of course, but not always a desirable one. I might pause to scrutinize the blurry shape in the bushes in order to determine that it is nothing more than a configuration of branches. But the need to be afraid or the feeling of security or deliverance or the rush of confidence provided by the talismanic weapon may be more appealing than a rational explanation of things that go bump in the night. Enchantment has its uses.

Disenchantment takes place as a breaking of a spell, but only when it can offer something better than what one gains by enchantment. "For disenchantment to occur," Schneider asserts, "a cognitive boundary must be formed that isolates certain ways of interpreting the world and sets them in opposition to others."[23] And, we might add, offers a reward that trumps enchanting belief. Disenchantment occurs when the way of seeing that accounted for a menace or joy no longer commands our loyalty. The human mind is very capable of entertaining diametrically opposed propositions. One can believe in providence and evolution, God and chance, destiny and fortune at the same time. Why not, if it helps me get what I need? It is important to distinguish this phenomenon of enchantment from the psychopathology of magical thinking described by Didion as well as by grief counselors and psychologists as a common form of dealing with loss. The grieving need to accept the death of their loved ones in order to recover an engagement with their lives, but must otherwise rational adults surrender their belief in UFOs or God or national destiny? Belief in God has often been used to justify imperialism and racism, but also to endorse democracy and social justice. Enchantment is far too valuable to be rejected out of hand.

The larger point here, which encompasses both Didion's and Schneider's accounts of magical thinking, is that enchantment, no less than disenchantment, appears inherent to human consciousness. In an early work, the philosopher Lesek Kolakowski argued that myth, the very substance of enchantment, results from the situation in which human beings find themselves: "Demanding from itself an understanding of itself, consciousness also demands that understanding be possible in relation to acts in which it comes to know nature.

It therefore produces a mythological value of truth and endows with this value the results of its own labors."[24] In other words, since human beings are self-aware, they cannot explain their self-consciousness—and therefore themselves—merely as another part of nature. They are compelled, Kolakowski argues, to interpret their presence in the natural world, to look behind nature for their raison d'être since consciousness itself appears to transcend nature as a realm of objects of knowledge. Humans cannot know themselves knowing, cannot be the object and the subject of knowing in the same instant. Myth arises in that moment. Humanity is the creation of Allah, Yahweh, Brahma, or the Great Spirit. A myth is a story or an image that bestows meaning on the world, which is otherwise incapable of meaning, is indifferent to the human need for it. Myth sees things coming from an origin and progressing toward an end. Myth shows that the things that happen do so for an underlying reason. Myth is about purpose and the power and hope and social cohesion and transcendence that such purpose offers human consciousness.

But if that purpose can be liberating and empowering, it can also saddle human beings with the burden of duties they may find onerous, even enslaving, especially when myth works to encode social castes, inequality, and exploitation. Then disenchantments of various kinds lend themselves to the utility of enlightenment and emancipation. Therefore, operating with both in hand, enchantment and disenchantment, broadens the capacity for explaining events and provides a powerful means of social control when wielded by authorities or institutions, but also strategies for overturning the grip of authority. As rational and technologically progressive as the project of Enlightenment and modernity has wished to regard itself, many scholars since the late twentieth century have pointed to growing signs that enchantment is a fundamental part of the disenchanting program of modernity. The flourishing of religion is only one of them. The fervent belief in the power of technology, the millennial power of literacy and democracy, and the notion that capitalism exerts a moralizing influence are others.[25] Churches, militaries, corporations, governments, initiation societies, and universities exercise both powers. And so does the art world.

The interpretation of art is rife with enchantment. The things people say about paintings, photographs, or installations are

remarkable, even preposterous, and often the product of an imaginative riff or projection, a freewheeling dance with suggestion, an indulgence of the play instinct described so provocatively by Schiller as the experience of aesthetic freedom.[26] Works of art often serve as scaffolding on which viewers hang their penchants or desires, a loose framework for free association or intuitive flights of fancy. Even if the connection a viewer makes is not intended as intuitive, it may look that way to the baffled person standing next to him. This happens to me regularly when I visit museums or galleries with friends. But that is one way to play the game, the pleasurable fellowship of art. From the banter and contention emerges a felt-substance, a bracing array of intuitions that leads to larger questions and insights. One's interpretation of a work may have nothing whatsoever to do with the artist's intention; may indeed contradict what the artist had in mind. The enchantment of art commonly consists of the ways it speaks to you, mysteriously, directly, out of the blue, addressing matters you'd only dimly glimpsed, but which now suddenly rush forward into the uncanny light cast by the work of art. The history of the reception of a work of art, especially widely admired ones such as Leonardo's *Last Supper* or the Laocoön group, demonstrates the vitality and variety of response.[27] In these instances, enchantment is about the strange fit between a work of art and the worlds that viewers bring to it. As such, we might think of the experience of art as a form of enchantment that is useful in rendering a valuable way of knowing the world. It operates at an intuitive level, possibly in tandem with other ways of knowing. Artistic experience is a metaphorical way of thinking that may parallel rational or empirical or biological processes but is not reducible to them.[28]

We can also think of enchantment in art in a more familiar way. The art world is full of hype and iconoclasm, that is, enchantment and disenchantment. Artists are sometimes invested in fizz and aura and their work in a hail of critical attention and promotion that boosts its price and the artist's reputation to stratospheric levels. Such artists, darlings and celebrities, can do no wrong as art makers, it would seem, until a new star outshines them and their halo quickly dims. But this species of enchantment has to do with a sort of secularized charisma and its commodification in the relentless cycles of the art-luxury market.

Art and varieties of re-enchantment

The sacralization of art took shape from the late eighteenth century to the end of the nineteenth century. Romantic writers and artists believed that art and nature could produce a bracing experience of what was variously called the infinite, the sublime, the timeless, or the divine. Artists were geniuses who had access to such domains and needed to be championed against the incursions of bourgeois sensibility, orthodox religion, false taste, and the state. Like many artists and theorists before him, Wassily Kandinsky added "prophet" to the artist's office, claiming that artists were geniuses who propelled an upwardly arcing movement of spiritual enlightenment that gradually pulled their societies into the progressive development.[29] Like Schiller, he endorsed art as a kind of play, seeing in the imagery made by children and non-industrialized peoples forms of creative production inspired by what he called "inner necessity" rather than enslavement to the external forces of conventional taste or the apish compulsion to imitate natural appearances. Deeply neo-Romantic, Kandinsky's art pursued a fascination with mood and emotional resonance by dissolving objects into increasingly non-representational forms and colors that he felt were akin to musical effects for their more direct access to the human soul. If Schiller urged the artist to play in the fields of the ideal, Kandinsky moved even beyond semblance to non-objective elements directed entirely by free play. Fairy tales, medievalizing fantasy, folk art, children's art, the soulful language of form and color— all were forms of artistic enchantment that occupied Kandinsky and like-minded artists in pre-war Munich, in part because painting these subjects in abstract styles quietly transcended a grisly world of rampant industrialization and militarization.

Kandinsky's work can appear quaint in light of what followed. But others have taken up the quest of an art that is spiritualizing in its effects. An exhibition in the mid-1980s hailed the cause, focusing on the spiritual implications of non-hard edge abstraction since the turn of the century.[30] In 1991, Suzi Gablik published her book *The Re-Enchantment of Art*, announcing her disenchantment with "the compulsive and oppressive consumeristic framework in which we do our work"; complaining that "we live in a culture that has little capacity or appreciation for meaningful ritual."[31] Like Weber, she

accepted that the disenchantment of the world is the fundamental character of modern life. The many millions of Muslims, Jews, Hindus, and Christians in Europe and North America who faithfully observe religious rites would object to the assertion that they've lost the capacity for meaningful ritual, but Gablik was not interested in traditional forms of religion. The modern world of the West had lost its soul and conventional religion does not appear to have been a part of the solution. "Re-enchantment, as I understand it, means stepping beyond the modern traditions of mechanism, positivism, empiricism, rationalism, materialism, secularism, and scientism—the whole objectifying consciousness of the Enlightenment—in a way that allows for a return of soul."[32] Instead of traditional forms of religion, Gablik associated the work of many contemporary artists with New Age thought, invoking the words of Don Juan as reported by Carlos Castaneda when discussing the ritualistic performances of a Chicago artist: "Human beings have a very deep sense of magic. We are part of the mysterious. . . . Some of us, however, have great difficulty getting underneath the surface level; others do it with total ease." Artist Fern Shaffer was one who did it with ease, according to Gablik, dancing in a shamanistic manner, dressed in raffia, beside frozen Lake Michigan with the purpose of healing the earth. "An ancient rhythm takes over," Shaffer commented. "Time does not exist anymore. We perform the rituals to keep the idea alive."[33] Art, in the view of Gablik and many of the artists she discussed, was a way of exercising the primordial power of dreaming, imagining or envisioning that re-establishes a connection with a non-rational, mythical domain shut out by modern science and consumerism. Art can save us; it can re-humanize us. It can re-enchant us by taking us back to the mysterious origins that our modernity has occluded. This notion of enchantment urges the sacralization of art. Even among viewers who do not share Gablik's New Age perspective, art is widely believed capable of saving a nation's or a people's soul, purifying taste, uplifting a vulgar public, transforming civic culture, provoking moral enlightenment, celebrating what is best in a civilization, providing access to timeless and universal goods, revealing truths of transcendent value, enabling communion with great minds. Art is intrinsically, undeniably good. Art bears the sacred and keeps it for the ages. In this way of thinking, merely to see art, to be in its presence, is an

indefatigably wholesome thing. So school buses disgorge hordes of children at museums for a liturgy of art appreciation.

Suzi Gablik's project of re-enchantment points to a more broadly shared belief that art is a spiritual good, that it contributes importantly to the life of a society, to the enduring realm of values that ought to matter to everyone, even though most people won't be able to agree on many of what those values are. Whatever else it may be, if we grant that enchantment is a human way of knowing, we should not be surprised at the desire among artists and large numbers of the public to make and appreciate art that involves spiritual meaning. What is perhaps more surprising is that many art critics, art school professors, and art historians should express contempt for art that intends to do so and viewers that welcome it. In the quest to control the profession, they exert a disenchanting influence, limiting art and its interpretation to their expertise. It is, after all, what professional guilds do. Medical doctors limn and patrol strict boundaries that separate their profession from all others, especially those that fail to meet their rigidly enforced standards of scientific competence.[34] It is much easier to ignore or to dismiss with a roll of one's eyes what Kandinsky and many since have embraced as "the spiritual in art." When art takes on spiritual meanings, it requires of the professional interpreter an expertise that far exceeds the narrower and more defensible boundaries of formalist criticism, art-world journalism, knowledge of artists and their works, and skill at making art and cultivating one's career at it. What institution will endorse judgments about the spiritual valence of art if not the church or theosophical society or some comparable guild of mystics? Moreover, the gate-keeping and reward systems of the art world are founded on the myth of the avant-garde, that is, a historical narrative rooted in the secular vision of artists as critical opponents of bourgeois respectability and such reactionary institutions of middle-class authority as church and state. How could the art world embrace art that was at peace with the enemy? That may seem like a strange question to ask since the avant-garde is no longer a compelling reality. But the symbolic capital of the idea has not deflated. Young artists still dream of overturning the applecart, fomenting aesthetic revolution, scandalizing respectability, challenging the political establishment, tweaking the noses of their elders.

Even if there is a large market in art about spirituality, the professional discourse on art will resist recognizing it because it does not fit the grain of the discourse, which does not run in the direction of personal or institutional affirmation of metaphysical commitments. Those make art into therapy, which of course it is and always has been, but they preclude the distance of disinterestedness at which the play of art ideally occurs according to the privileged tradition of modern aesthetic thought. When art serves a spiritual purpose, it must leave the sacrosanct precinct of its own autonomy, pulling its professionals along with it to places they may not wish to go. There are scholars and writers who will make the journey as scholars, not believers, but they study something not strictly defined as "art"—the history of images, visual culture, religious artifacts, the ethnography of visual practice. Some try to study both—art and the felt-life of religious imagery—finding the study of art and visual enchantment a rich intersection for inquiry. Yet, speaking as one of them, it seems to me such scholars are sometimes caught betwixt and between, neither fish nor foul.

The book

In the following pages, readers may note the rather little attention paid to lived religion and its many everyday visual practices. This book is about theory in the criticism and historical understanding of contemporary art and the indifference it has often shown for religion. It would seem that even the contents of this book testify to the exclusiveness of the art world that James Elkins identifies in his essay and that precipitated this very project. The bridge-work necessary to connect the two disparate domains—critical theory of art and the world of religious institutions, on the one hand, and the popular culture of religious visual practice, on the other—is not highly developed. According to many of the essays and remarks recorded in parts of this book, modern religious visual practice as well as the presence of religion in modern art would sustain considerable investigation. But the critical and historical work necessary to make this case is only just beginning.

A profoundly suggestive beginning may occur in the "Starting Points" essay by Boris Groys, where he draws our attention to the

way in which religion has become a mass-medium that both impoverishes it by reducing it to the status of mere opinion, but also offers the possibility of becoming a "site of revelation," an "avant-garde" that might render the ordinary extraordinary. Yet the issue of the relationship of art and religion remains deeply conflicted. The transcripts published here suggest that there is no consensus among art world professionals. Artist Gregg Bordowitz rejects the claim that artists are not interested in spirituality. Critic Thierry de Duve wishes they were not, indeed, asserts they should not be. Kajri Jain faults prevailing European philosophical traditions for skewing reflection on the relation between art and religion, especially the way in which they manacle the idea of "art." For her part, Tomoko Masuzawa wants everyone involved in the discussion to think in fundamentally different ways about the definition of "religion." Wendy Doniger widens the register to non-Western religion and art. Taylor Worley urges broad reflection on religion and the arts among theologians as well as artists and art critics. David Morgan wonders why there is not more interest in the visual culture of lived religion among art theorists, and James Elkins urges colleagues in the art world to examine a taboo that many of them would much rather quietly ignore. It is a noisy, meandering, unintegrated conversation that does not easily admit of resolution.

The editors have not aimed to provide a comprehensive, seamlessly resolved, or normative model for how to think about art theory and religion. None is available and, for all of its inconsistencies and blind spots, that's not what the current discourse needs. There are serious disagreements to flesh out and some radical differences to identify. We think these deserve a straightforward presentation, along with a frank indication of the disarray, even cacophony, which sometimes makes conversation all but impossible. We are confident that the transcript registers this state of affairs. In the end, the editors will consider their efforts amply rewarded if the various parts of the volume are able to combine to indicate the complexity of the issue of art and religion in the contemporary world and to invite fresh critical thinking that might improve the conceptualization of how to write and talk productively about contemporary art and belief. Accordingly, we've organized the book in a way that will offer some insight into the modern history of art theory and religion while also registering

the considerable dissonance over their relation to one another. Following this Introduction, five "Starting Points" essays seek to provide a historical and thematic setting for the transcripts that follow. These historical and theoretical essays focus exclusively on European and American materials—not because the writers are oblivious to other perspectives, but because the very framing of "art and religion" is a fundamentally Euro-American affair that must begin to sort out its own history if it is to begin to recognize how it must move beyond itself. The transcript is an edited version of a day-long conversation at the School of the Art Institute, convened and moderated by James Elkins. Since no conversation is ever without its limits and myopias, the editors invited sixty-eight artists, scholars, and writers from around the world to peruse the transcript and a few additional materials and to provide their assessments of the conversation. Writers were encouraged to be as critical or as visionary as they liked. Twenty-nine responded with constructive but unflinching criticisms that readers will surely find correspond to their various sentiments. Finally, two Afterwords present a complete overview of the project, and a concluding note by James Elkins brings the book to a close.

Notes

1. Max Weber, *The Protestant Ethic and the Spirit of Capitalism*, tr. Talcott Parsons (London: Routledge, 2001), p. 61.
2. Ernest Gellner, "The Rubber Cage: Disenchantment with Disenchantment," in Gellner, *Culture, Identity, and Politics* (Cambridge: Cambridge University Press, 1987), p. 153.
3. Weber, *The Protestant Ethic*, p. 124.
4. Marcel Gauchet, *The Disenchantment of the World: A Political History of Religion*, tr. Oscar Burge (Princeton: Princeton University Press, 1997), p. 9.
5. Weber, *The Protestant Ethic*, p. 124.
6. There are two versions of the poem—the first, of twenty-five stanzas, appeared in 1788; the second, sixteen stanzas in length, was published in 1800. Both are reproduced in Friedrich Schiller, "Die Götter Griechenlandes," *Sämmtliche Werke*, 3rd ed., 5 vols (Munich: Carl Hanser, 1962), 1: 163–69 and 169–73. The prose translation here, taken from the first edition of the poem, is my own, and is presented without attempting the meter or rhyme of the original.
7. Friedrich Leopold Graf zu Stolberg, "Gedanken über Herrn Schillers Gedicht: Die Götter Griechenlandes," *Deutsches Museum* 8 (August 1788): 97–105.
8. Ibid., p. 101. Schiller, "Die Götter Griechenlandes," p. 165: "Näher war der Schöpfer dem Vergnügen,/Das im Busen des Geschöpfes floß./ Nennt

der Meinige sich dem Verstande?/ Birgt ihn etwa der Gewölke Zelt?/ Mühsam späh" ich im Ideenlande,/ Fruchtlos in der Sinnenwelt."

9. Stolberg, "Gedanken," p. 102.
10. Ibid., pp. 104–5.
11. For a catalogue of his defenders and a sampling of what they wrote, see *Schillers Werke*, 42 vols, ed. Georg Kurscheidt and Norbert Oellers (Weimar: Hermann Böhlaus Nachfolger, 1991), vol. 2, pt. 2, pp. 162–68.
12. Johann Joachim Wickelmann, *Reflections on the Imitation of Greek Works in Painting and Sculpture*, tr. Elfriede Heyer and Roger C. Norton (La Salle: Open Court, 1987), pp. 32–3.
13. Schiller, "Philosophische Briefe," in *Sämmtliche Werke*, vol. 5, 344; 352.
14. Ibid., p. 355.
15. Letter to Christian Gottfried Körner, 25 December 1788, excerpted in *Schillers Werke*, vol. 2, pt. 2, p. 165. Emphasis in original.
16. Schiller, "Die Götter Griechenlands," 1788 version, in *Sämmtliche Werke*, vol. 1, pp. 163 and 167–68:

> Da der Dichtkunst malerische Hülle
> Sich noch lieblich um die Wahrheit wand!
> Durch die Schöpfung floß da Lebensfülle,
> Und, was nie empfinden wird, empfand.
> An der Liebe Busen sie zu drücken,
> Gab man höhern Adel der Natur.
> Alles wies den eingeweihten Blicken,
> Alles eines Gottes Spur.
>
> Wo jetzt nur, wie unsre Weisen sagen,
> Seelenlos ein Feuerball sich dreht,
> Lenkte damals seinen goldnen Wagen
> Helios in stiller Majestät . . .
>
> Schöne Welt, wo bist du? Kehre wieder,
> Holdes Blütenalter der Natur!
> Ach! Nur in dem Feenland der Lieder
> Lebt noch deine goldne Spur.
> Ausgestorben trauert das Gefilde,
> Keine Gottheit zeigt sich meinem Blick,
> Ach! von jenem lebenswarmen Bilde
> Blieb nur das Gerippe mit zurück.
>
> Alle jenen Blüten sind gefallen
> Von des Nordes winterlichem Wehn.
> *Einen* zu bereichern, unter allen,
> Mußte diese Götterwelt vergehn.
> Traurig such ich an dem Sternenbogen,
> Dich, Selene, find ich dort nicht mehr;
> Durch die Wälder ruf ich, durch die Wogen,
> Ach! sie widerhallen leer!
>
> Unbewußte der Freuden, die sie schenket,

Nie entzückt von ihrer Trefflichkeit,
Nie gewahr des Armes, der sie lenket,
Reicher nie durch meine Dankbarkeit,

Fühllos selbst für ihres Künstlers Ehre,
Gleich dem toten Schlag der Pendeluhr,
Dient sie knechtisch dem Gesetz der Schwere,
Die entgötterte Natur!

17. Friedrich Schiller, *Letters on the Aesthetic Education of Man*, tr. Elizabeth M. Wilkinson and L. A. Willoughby, in Friedrich Schiller, *Essays*, ed. Walter Hinderer and Daniel O. Dahlstrom (New York: Continuum, 1993), p. 168.
18. Ibid., p. 171.
19. I have found especially suggestive and thoughtful on this matter of ghosts a book by Avery F. Gordon, *Ghostly Matters: Haunting and the Sociological Imagination* (Minneapolis: University of Minnesota Press, 1997).
20. Nathaniel Hawthorne, *The House of the Seven Gables: A Romance* (New York: Signet, 2001), p. 247.
21. Joan Didion, *The Year of Magical Thinking* (New York: Vintage Books, 2007), pp. 35, 37.
22. Mark A. Schneider, *Culture and Enchantment* (Chicago: University of Chicago Press, 1993).
23. Ibid., p. 123.
24. Leszek Kolakowski, *The Presence of Myth*, tr. Adam Czerniawski (Chicago: University of Chicago Press, 1994), p. 116.
25. A fascinating discussion is Graham Murdock, "The Re-Enchantment of the World: Religion and the Transformations of Modernity," in Stewart M. Hoover and Knut Lundby, eds, *Rethinking Media, Religion, and Culture* (Thousand Oaks, CA: Sage, 1997), pp. 85–101.
26. Schiller, *Letters on the Aesthetic Education of Man*, pp. 172–74.
27. See Leo Steinberg, *Leonardo's Incessant Last Supper* (New York: Zone; Cambridge: MIT, 2001); Richard Brilliant, *My Laocoön: Alternative Claims in the Interpretation of Artworks* (Berkeley: University of California Press, 2000).
28. A classic study of the cognitive theory of art is Rudolf Arnheim, *Visual Thinking* (Berkeley: University of California Press, 1969).
29. Wassily Kandinsky, *The Spiritual in Art*, in *Complete Writings on Art*, ed. Kenneth C. Lindsay and Peter Vergo (New York: Da Capo Press, 1994), pp. 153–55.
30. Maurice Tuchman, ed., *The Spiritual in Art: Abstract Painting 1890–1985*, exhibition catalogue (Los Angeles County Museum of Art, 1986).
31. Suzi Gablik, *The Re-Enchantment of Art* (New York: Thames and Hudson, 1991), p. 3.
32. Ibid., p. 11.
33. Ibid., p. 42.
34. Schneider, *Culture and Enchantment*, has explored this aspect in the history of science and social sciences.

2
STARTING POINTS

ART AND RELIGION IN THE
MODERN AGE[1]

David Morgan

Any history of "art and religion" does well to acknowledge the deeply modern and Western character of the subject. Although all cultures have fashioned artifacts for use in ritualistic practice, it remains problematic to call the artifacts "art" and the rituals "religion" without critical reflection on the modern character of the categories. "Art" only began to emerge as a rubric in the modern sense during the sixteenth and seventeenth centuries with the rise of collecting, art criticism and theory, and the hagiography of the artistic genius, most importantly in Giorgio Vasari's *Lives of Eminent Artists.*[2] In the course of the seventeenth and eighteenth centuries religion came increasingly to be considered a voluntary concern, suffered as a matter of individual conscience. While it was widely seen as a necessary social utility, persecution as a policy dramatically subsided. One's religion became increasingly a private matter. But if the privatization of religion appeared to secularize political culture and social institutions, religion entered the marketplace to find its way back to public life, especially in the United States. It also persisted in the civil religion of republicanism.

But I am already ahead of myself. There may be many reasons for the connection, but two of the most important are the tendency in the nation-state to look to art for a powerful moral effect on the public and citizenry; and the tendency since to spiritualize art and its

experience. Understanding this cultural history is crucial for situating the rubric of "art and religion" within its proper historical context. Failing to do so leads inevitably to misrepresenting the connection by essentializing and universalizing it.

Art and the republic

We are strongly disposed today to speak of "art" and of "religion" as if they were discrete cultural forms, rather like timeless categories of human "nature," each with its own history, each identifiable as such at any time and in any place. That is the enchantment of nationhood, which thoroughly colors the modern imagination. Nationhood is the fundamental unit of cultural measurement, the medium in which societies organize themselves such that when moderns look back in time they see nations, speaking of, say, what the French or Germans did long before there was a France or a German in the modern sense. Exhibitions, college courses, textbooks, and scholarship since the nineteenth century have used nationhood as a primary measure for parsing the history of art and religion.[3] Before the modern era the world consisted largely of kingdoms and heaven-sent realms whose sovereignty rested in the person of the monarch or emperor. In such a world there were often only two kinds of religion: ours (usually the ruler's) and theirs. After the eighteenth century, however, the world came increasingly to be composed of sovereign nations, that is, organic units of peoples separated by land, language, history, and culture. Empires, monarchies, kingdoms, and dynasties gave way to peoples, parliaments, democracies, and sovereign nations. The ruling family was replaced by the national family as the touchstone of collective identity and sovereignty. Artifacts were gathered up and placed in museums, public institutions formed—as in the most famous case of the Louvre—from former palaces. The wealth, luxuries, antiquities, and collected curios of the royal family became patrimony of the nation. The state museum became the repository of national memory and achievement—the people's record of its descent through the ages.[4] Religion, like art, was an expression of the national soul.

The passage from dynasty to demos was effected by rounds of imaginative remembering in which art and religion came to stand as

vital, constitutive agencies of the national ethos. Herder, for instance, and later Romantic writers inspired by his example, took German, Czech, or British art and poetry from the status of minor folk or provincial craft or artisanship to the much grander stature of national art and style, regarding it as the treasure house as well as in some cases the patriotic engine of national identity. In his *Observations on the Feeling of the Sublime and Beautiful* (1764), Immanuel Kant had included a discussion of the aesthetic disposition of various European nations and extended his remarks to include Arabs, American Indians, Greeks, and Romans.[5] Each "people" exhibited certain feelings for the sublime or the beautiful as an aspect of their "national characteristics." The premier theorist of German Romanticism, Friedrich Schlegel, in a series of essays on the history of European painting published in 1803, assumed that nationality and artistic individuality were the two enduring frameworks of all painting. Just as each nation possessed "its determinate physiognomy in manners and lifestyle, feelings and shape, so also its own music, architecture, and sculpture; and how could it be any other way?"[6] In the spirit of his historicism of *Geist*, or mind (though often translated as "spirit") evolving over time, Hegel claimed that every work of art "belongs to its age, to its nation, and to its environment."[7]

Benedict Anderson famously defined nationalism as a form of imagined community.[8] To this compelling thesis may be added the way in which art and religion, conceived in the nationalizing imagination as discrete forms of cultural activity, become the sovereign means of expressing the essence of the nation, the people, and therewith come to play a principal role in bearing nationhood. But the bind forged between nationhood, art, and religion does not end there. Modern Western nationhood is deeply tied to modern democracy. And modern democracies have universally fostered the need for art—that is, art as a non-sectarian treasury of moral and ultimately theological capital. Taste—the eighteenth-century notion of a refined sensibility able to recognize moral and aesthetic worth, to judge rightly and to act accordingly—was esteemed a public source of goodness or virtue that needed to be cultivated in the modern republic in order to benefit a public that was increasingly understood as an aristocracy of the middle-class. Self-rule, it was widely believed, relied upon a tasteful body politic. Republican ideology grounded

civic virtue in a literate, morally upright, tastefully refined citizenry, and often looked to the visual rhetoric of neoclassicism as the fitting style for promoting the national ideal of republican taste.[9] It is no mistake that this style was used by ideologues like Thomas Jefferson and city planners such as Pierre L'Enfant. The style eventually fossilized in banks, post offices, and public schools, which stood as the imprimatur of national authority and continuity, the visual register of security and reliability.

The search for a collective style to represent national unity in the sacred spaces of a civil religion had its secular counterpart in the longing to establish a singular diction and orthography in American English. Noah Webster tirelessly pursued the publication of an American dictionary and American common school books to this end: teaching his new countrymen how to speak and write promised to deliver the new republic from corruption and tyranny and the divisive forces of an uneven and locally determined literacy. Liah Greenfeld has gone so far as to define the modern conception of the nation as "the idea of a homogeneously elite people." Nationality, she claims, "elevated every member of the community which made it sovereign."[10] To be a national means to enjoy the privilege of native status. Democracy heightens the status by undermining class distinctions (at least, in theory), making equality a primary value. But this comes at the risk of exploitation: a society without class is a society without taste, without distinction, and therefore in threat of vulgarity and the influence of the lower domain of humanity. Early national moralists repeatedly expressed this anxiety and looked to the arts, to public education, and to civil religion as necessary antidotes. This is perhaps most desperately evident in Revolutionary France, where one of the great artists of the age, Jacques-Louis David, turned pageant master during the Revolution, when government ideologues struggled to transform the state religion of Catholicism into a secular religion of the new state by baptizing public rituals, dedicating the state to the "Eternal Being," nurturing a cult of secular martyrs, and establishing a secular clergy in service to the Civil Constitution.[11] Even though these initiatives failed miserably in their own regard, they clearly signal the modern project of art and civil religion in the service of promoting the cause of the nation-state.

The elevation of public taste was constantly on the minds of the

writers, moralists, and artists of the early republic in the United States. The promotion of poetry, literature, and the visual arts was considered vital in this enterprise. A moral theory of art charged the work of art with a solemn task of uplift and moral education, a task that was not unreligious, and became a fundamental part of American civil religion in the countless monuments, public buildings, and eventual public collections of art in the nation's capital.[12] In contrast to Romanticism's celebration of folk culture as the repository of soul, the republican or moral theory of art identified art as a refiner of the popular soul. Art and letters were necessary for the formation of a citizenry capable of upholding the ideals of the new American republic. The modern state has invested handsomely in art in order to sacralize its rituals, to construct and hallow the memories of its origins and deeds, to honor the cult of patriots. Civil religion, clothed and formed in the arts, is an integral operation of the modern nation.[13]

The civic function of art regarded it as a moral force that was decoupled from institutional religion. One of the most widely read advocates of the aesthetic education of modern humanity for citizenship in a state grounded in the Enlightenment's ideal of human freedom was the German poet Friedrich Schiller. In the context of the de-railed French Revolution, a tragic foiling of the European longing for a democratic state grounded in reason and liberal sentiment, as Schiller interpreted it, he argued in a famous set of letters published in 1795 that humanity could learn to live as free in the modern world only by undergoing an aesthetic tutelage. "If man is ever to solve that problem of politics in practice," Schiller claimed, "he will have to approach it through the problem of the aesthetic, because it is only through Beauty that man makes his way to Freedom."[14] In a series of sweeping mediations of opposites typical of German Idealist thought at the time, Schiller reasoned that beauty combines the two natures of humankind—the sensuous and the rational—into a higher unity: "By means of beauty the sensuous man is led to form and to thought; by means of beauty the spiritual man is brought back to matter and restored to the world of sense."[15] Class warfare was mediated by the poet and artist. Freed from the brute state of mere physicality and force, humanity is enabled to recognize moral freedom; likewise, beauty reconciles an alienated class of

bourgeois and aristocratic leaders and owners to the world of the body and senses. The state or kingdom (he used the political terms *Staat* and *Reich* interchangeably) of force and the state of laws or governance, naturally at war with one another, are reconciled in what Schiller called the "aesthetic state," which constitutes a higher state of freedom, or play, the domain of appearance or representation. In this aesthetic state, according to Schiller, humans are "relieved of the shackles of circumstance, and released from all that might be called constraint, alike in the physical and in the moral sphere."[16] Art could teach people how to be free by inwardly reconciling the opposite aspects of human nature that Schiller felt were the source of enmity and strife in social life. The liberated soul would, he believed, live a liberated social existence. Schiller's hope was that art would elevate humanity to a true state of freedom one person at a time. If freedom could not be legislated (and no political setting in the German territories of his day suggested it could be; matters in France were hardly more encouraging), it could be realized aesthetically, inwardly, in the grip of the beautiful.

The spiritualization of art

To do justice to the topic of the modern spirituality of art, one would have to examine a vast sum of material from eighteenth- and nineteenth-century France, Britain, the United States, Switzerland, the Netherlands, Spain, Russia, and Germany. I have neither the space nor the expertise to do so. Therefore I will select a national tradition in Europe that has contributed greatly to this discourse, assuming that it is in many respects representative of the larger development. German philosophers, theologians, poets, art critics, and art historians from the mid-eighteenth century to the mid-twentieth century generated a dense and enormous literature that accorded to the conjunction of art and religion a privileged status and lead toward the spiritualization of art. Indeed, it could be argued that for many of them the "spiritual in art" replaced "religion" to create a new nexus that has deeply colored most subsequent attempts to think about art and religion.

Friedrich Schiller held up as the model for artistic inspiration the classical ideal of ancient Greek art, regarding it as "the source of all

beauty." In this he followed the example set for Europeans in the eighteenth century by Johann Joachim Winckelmann, who helped inaugurate a cult or revival of classical antiquity—appropriately religious terms—that swept across Northern Europe and the New World in the second half of the century. The writings of Johann Winckelmann were perhaps the most widely read and highly regarded medium in this new art enthusiasm, which is what it must be called, since Winckelmann and many of his admirers sought to elevate Greco-Roman art to an unparalleled stature as the model for renewal of taste and as the object of a way of seeing that plunged the viewer into an almost ecstatic regard for the works of ancient genius. Consider Winckelmann's description of the Laocoon in his manifesto of feeling, *Reflections on the Imitation of Greek Works in Painting and Sculpture* (1755). Winckelmann beheld the sculpture as a model for antique achievement and modern emulation. He picked out the face and body of the dying Trojan priest for special admiration, describing the figure in terms that recall the attitude and visual piety of a devout viewer beholding the Passion of Christ, focusing on the pain and suffering of Jesus, but identifying with his resignation and sweetness in the face of anguish. His term for the mode of feeling achieved in the Laocoon and all Greek masterpieces was "noble simplicity and quiet grandeur." This "soul" (*Seele*) was, he claimed,

> reflected in the face of Laocoon—and not in the face alone—despite his violent suffering. The pain is revealed in all the muscles and sinews of his body, and we ourselves can almost feel it as we observe the painful contraction of the abdomen alone without regarding the face and other parts of the body. This pain, however, expresses itself with no sign of rage in his face or in his entire bearing. . . . [H]is pain touches our very souls, but we wish that we could bear misery like this great man.[17]

Winckelmann went on to praise Raphael's Sistine Madonna in like manner: "Behold this Madonna, her face filled with innocence and extraordinary greatness, in a posture of blissful serenity! It is the same serenity with which the ancients imbued the depictions of their deities." In the case of Raphael as with ancient artists, Winckelmann believed that "the artist had to feel the strength of this spirit in

himself and then impart it to his marble." "Inner feeling," he insisted, "forms the character of truth" and must be placed by the artist in the work of art.[18] It has been pointed out that this idea of an inner feeling and a subdued grandeur or sublimity in Winckelmann's aesthetic of "noble simplicity and quiet grandeur" was informed by Pietism's cultivation of an inner state of quiet, keyed to the contemplation of sublime subjects such as the passion and death of Jesus.[19] (Winckelmann attended the University of Halle, a vibrant center of Pietist thought and practice in eighteenth-century Germany.) Pietist contemplations of Christ's passion, traceable to Luther and to late medieval spirituality before him, cultivated an intense inner life, a private devotionalism, and empathy keyed to visuality.[20]

Implicit in Winckelmann's cult of antiquity was a spiritualized response to art, an enrapt visual piety in which the work of art emerged as an expression of genius. The act of viewing became the epiphany of genius experienced empathetically by whomever had cultivated the taste or aesthetic capacity for such rapture. Winckelmann inaugurated a strong disposition in European cultural history to spiritualize art, to recognize in it a powerful cultivation of inner life and taste. He regarded the art and artists of his day as degenerate and in desperate need of refinement, for which he offered his rhapsodic responses to antique art. Belief in the power of art to redeem a culture or society attended his sacralization of art and aesthetic experience and paved the way for the Romantic cult of art.

The impact of Pietism on the spirituality of art was not limited to Winckelmann. Broadly speaking, Pietism contributed importantly to German thought in the eighteenth century by stressing feeling as an intuitive discernment and an autonomous judgment. The philosopher Alexander Baumgarten, who coined the term "aesthetic" in 1739, had been educated in a Pietist orphanage and university (Halle). And one of the most important aesthetic theorists of the century, Karl Philipp Moritz, was raised in a devout Pietist home. Moritz developed the concept of disinterested contemplation in a series of brilliant essays in the 1780s, in which he defined the work of art as something that is complete in itself. Useful things have their purpose outside of themselves, namely, in the person who uses them. "But in the contemplation of the beautiful," Moritz wrote in 1785, "I return the purpose from myself to the object itself: I behold

it as something *perfected in itself,* not in me. [This perfectedness] constitutes a whole in itself, and grants enjoyment to me of its own will, inasmuch as I extend to the beautiful object not so much a relation to me as much as my relation to it."[21] This perception of what Moritz called "inner purposiveness" (several years before Kant borrowed the idea) lead the viewer to a "forgetting" of the self in the contemplation of the work of art. It was this loss of the self, according to Moritz, that was "the highest degree of the pure and selfless enjoyment that the beautiful provides us. In that moment we offer up our individual, circumscribed existence for a kind of higher existence."[22] Engrained in this understanding of aesthetic experience is an ethics of encounter that seems mystical. Aesthetic contemplation is a form of transcendence and revelation, a communion with a higher being.

The spirituality of art became one of the primary concerns of philosophers, theorists, and artists around 1800 in Europe and North America. In a celebrated series of lectures delivered in 1801 in Berlin, August Wilhelm Schlegel affirmed the view taken by Moritz and others regarding the uselessness of art. Its reason for being is not practical. Schlegel then developed a definition of beauty indebted to his friend, the Idealist philosopher Friedrich Schelling: beauty is the infinite depicted in the finite. How can this happen? "Only symbolically," Schlegel replied, "in images and signs." His notion of beauty hinged on a concept of revelation that rendered the human passive and disinterested before an experience of the world as unfinished, restless, and dynamic. "The unpoetic view of things is that which holds everything with the observations of the senses and the determinations of the understanding as settled; the poetic view is that which forever interprets and sees in all things a figural inexhaustibility."[23] Art is how human beings participate in the divine life at work in nature. Art is the visualization of the invisible inwardness of all things.

This idea of a material expression of a spiritual force was taken up by Hegel and formed the basis of his reflections on aesthetics. The idea of a *Zeitgeist* informing a work of art appealed very much to the Romantic imagination as well as the subsequent historicism that Hegel did so much to inspire. In the later eighteenth century and first decades of the nineteenth, art and religion came to be seen as

powerful and historically distinctive activities of souls and cultures. An organic theory of art emerged among Romantic thinkers, which stated that works of art were expressions of the soul; they drew their unity from the genius of the artist and generated their structure from within rather than drawing it from without.[24] The implications for the history of the arts and critical thought about the arts were portentous because Romanticism established as a critical norm for taste the notion that the work of art was sacrosanct. It did not owe its formal structure to the superficial appearances of the natural world or to the dictates of taste or criticism or artistic convention, but to the inner governance of the artistic imagination. This empowered the work of art as a privileged revelation of genius. As such, the idea developed that art was a distillation of a culture, a microcosm that contained the spiritual depth and yearnings of a nation, a society, an epoch, an entire civilization.

The Romantic theory of art as a self-contained, self-normed organic structure could lead toward very private self-communion, where artistic experience was akin to a kind of mysticism, a transcendentalism that sacralized art, resulting in what the art critic and connoisseur Bernard Berenson called the "aesthetic moment":

> In visual art the aesthetic moment is that flitting instant, so brief as to be almost timeless, when the spectator is at one with the work of art he is looking at, or with actuality of any kind that the spectator himself sees in terms of art, as form and colour. He ceases to be his ordinary self, and the picture or building, statue, landscape, or aesthetic actuality is no longer outside himself. The two become one entity; time and space are abolished and the spectator is possessed by one awareness. When he recovers workaday consciousness it is as if he had been initiated into illuminating, exalting, formative mysteries. In short, the aesthetic moment is a moment of mystic vision.[25]

Such passages are not hard to find in Romantic art theory extending through the nineteenth century. Arthur Schopenhauer, for instance, had developed a theory of art that was grounded entirely in the momentary transcendence of the here-and-now in the contemplation of works of art. Schopenhauer's revival in late nineteenth-century France contributed to Symbolist thought and the cult of art

and informed Expressionist art and aesthetics in early twentieth-century Germany.[26]

In his epochal discussion of the "spiritual" (*das Geistige*) aspect of art, Wassily Kandinsky spoke of the "language of form and color" and their immediate effect on the viewer, operating like music rather than text or representations.[27] The result was a musical dissolution of subject matter—the material world was transfigured into a dance of forms and colors, even when features of a landscape or figure in Kandinsky's prints and paintings remain discernible. Not confined to appearances, Kandinsky claimed, the artist works from a sense of "inner necessity." Accordingly, Kandinsky believed that the artist was a kind of prophet who leads the larger society upward into greater cultural refinement by virtue of his work, beyond the material vulgarities of the day. The British art critic Clive Bell echoed both Kandinsky's and Schopenhauer's belief in the redemptive power of art: "Art and religion are . . . two roads by which men escape from circumstances to ecstasy. Between aesthetic and religious rapture there is a family alliance. Art and Religion are means to similar states of mind."[28]

Religion need not be understood in the institutional sense of an organized creed and cult, but in terms of the mystical or hermetic knowledge and ritual practices that occupied many artists in the late nineteenth and early twentieth centuries. Occultism and theosophy enjoyed a remarkable vogue and an artistic influence that has been clearly traced.[29] Many artists believed that abstract art was charting a path toward the progress and liberation of humanity. Kandinsky is today the best remembered among them, but art historians have identified dozens and dozens of figures at work on each side of the Atlantic. Abstract works by American and European artists were avidly collected and exhibited by Katherine Dreier during the 1920s to form the Société Anonyme, which she co-founded in 1920 with Marcel Duchamp and Man Ray. Dreier, an abstract painter in her own right, in sympathetic response to Kandinsky's art, believed that abstraction was a spiritualization of vision and that, in Emersonian fashion, seeing aright was the key to spiritual transformation.[30]

Romanticism spawned several traditions of thought and art that became part of the genealogy of art and religion. I count at least five—art's relation to the spiritual progress or impoverishment of

civilization; the beauty of nature as the signature of an underlying spiritual reality; the spiritual in art; the revival of religious art; and the quest to use art to plumb the national soul.

Hegel's *Aesthetics* is perhaps the most well known and systematic presentation of the notion that the arts are indices of the linear stages of civilization's advance, arguing, as he did, that they move from the symbolic mode of architecture to the classical form of sculpture to the romantic sphere, which begins with painting and is followed by music and culminates in poetry. The three stages mark discrete moments in the progressive incarnation of *Geist*.[31] In the United States the belief in the progress of the arts informed the thought of art critic James Jackson Jarves, who cast a wide eye on the world's ancient civilizations and broadly summed up the role of sacred art as either oppressive or liberating:

> The art of a nation is at once its creed and catechism. We need no other literature to reveal its mental condition than the objects of its religious belief or sensuous delight. With this key to the soul in hand, the comparative intelligence and progress of races are easily interlocked. Without the aid of a false and immovable art, as the easily understood substitute of printing, it is scarcely conceivable that the popular mind should have remained as immovable as it has in the East. Wherever art is thus circumscribed we find a similar result. The object itself takes precedence of the idea, and becomes an idol.[32]

If the Greeks advanced over the Asian by creating a refined and beautiful art informed by philosophical reflection, it was "inferior by far to the Christ-love which descended later upon men."[33] And Protestantism, in Jarves' view, "the offspring of freedom of thought," had reached its maturity in the nineteenth century when it was able to inform the truth achieved in the art of Turner and the poetic sublimity of Blake and the sincerity of the Pre-Raphaelites in England and the Nazarenes in Germany (though he conveniently ignored the fact that many of the last were Catholic or Protestant-converts to Catholicism).[34]

Ralph Waldo Emerson is the most important American advocate of the idea of beauty as a revelation of hidden correspondences. Gazing at the morning sky over his home in Concord, Massachusetts,

Emerson was enrapt by the vision of the "silent sea" that drew him into its expansive mystery:

> I seem to partake of its rapid transformations: the active enchantment reaches my dust, and I dilate and conspire with the morning wind. How does Nature deify us with a few and cheap elements? Give me health and a day, and I will make the pomp of emperors ridiculous. The dawn is my Assyria; the sun-set and moon-rise my Paphos, and unimaginable realms of faerie.[35]

Emerson's enchanted experience of nature meant slipping the bonds of a finite self in the beauty-born medium of empathy, an imaginative projection into the landscape in pursuit of what he called the "Universal Being," whose currents circulated through him and which he experienced as a "nothing," a disembodied eye whose limpid vision refines the self to nothing but "part or particle of God."[36]

In visual practice, the most influential aesthetic ideal in the spiritualization of art has been the sublime. Robert Rosenblum traced the visual trajectory of an important aspect of the visual aesthetic of the sublime over the course of the nineteenth century in what he called the "Northern Romantic Tradition," running from the dark and brooding landscapes of Caspar David Friedrich through the paintings of Van Gogh, Kandinsky, and Mondrian to Mark Rothko and Barnett Newman.[37] This plots the development of abstraction as a spiritually-charged visual strategy that culminates in painterly gestures toward transcendence and sublimity, which dematerialize representation and infuse it with a heroic, mythical stature that readily recalls the theological discourse of the "sublime" by theologian Friedrich Schleiermacher, the "numinous" by Rudolf Otto, and the "ultimate" by Paul Tillich.[38] A number of artists including Anselm Kiefer and Bill Viola in the late twentieth century explored similar ground. Informed by a Romantic concept of the sublime, which defined self-transcendence as the nature of spirituality, a practice and theory of painting that stressed self-effacement in various forms of aesthetic experience—grandeur, darkness, emptiness, solitude—remains a compelling aim for many artists today.[39]

If one aspect of Romanticism acclaimed the autonomy of art as a mode of spirituality, another did not. The appeal of the sublime for some lay in its ability to create spiritual sensations that were more

commanding than the constraints and warrants of institutional belief. The sublime made individual experience the measure of spirituality. But for others, art that operated beyond the pale of the community of belief and the tradition that historically informed it, art that indulged the imagination for its own sake, was not Christian. Art could not be elevated to an autonomously religious stature, but must work with institutional religion for the renewal and refinement of the broader public. For Christian artists such as the German Nazarenes or the Pre-Raphaelite Brotherhood in England, art and religion were not equals. Art was the handmaiden of religion, charged with the task of serving faith, of seeking out and celebrating pure religious spirit. For other groups, such as Ruskin and William Morris in England or the artists in France who gathered at the Abbey of Créteuil, art had a Socialist duty to uplift and revolutionize.[40]

A fifth legacy of Romanticism was also readily applied to the modern project of the nation. This model of art was not simply about artistic genius but rather the power of art to recognize and exploit national genius. National character became a guideline for art, which was understood as an expression of national uniqueness. So Caspar David Friedrich refused to go to Italy to study the native art and landscape there, but proclaimed his loyalty to the German landscape. "I have to surrender to what surrounds me," he wrote, "unite with my clouds and rocks, in order to be what I am."[41] About the same time, on the opposite side of the Atlantic, landscape painter Thomas Cole issued a manifesto on behalf of painting American scenery:

> There are those who through ignorance or prejudice strive to main-
> tain that American scenery possesses little that is interesting or
> truly beautiful—that it is rude without picturesqueness, and mono-
> tonous without sublimity—that being destitute of those vestiges
> of antiquity, whose associations so strongly affect the mind, it may
> not be compared with European scenery. But from whom do these
> opinions come? From those who have read of European scenery, of
> Grecian mountains, and Italian skies, and never troubled them-
> selves to look at their own.[42]

The sublime grandeur of the national landscape that Cole and others lauded in their canvases remains a broadly admired body of work.[43] A recent examination of the Hudson River School is nothing less than a

call for national renewal through art. In *Knights of the Brush*, James Cooper diagnoses a national illness and prescribes the regimen for recovery: "We lost the American paradise not through invasion by some foreign army, but through our own blindness. The spiritual beauty of the American landscape resides within the 'enlightened eye,' the seeing eye, the spiritual optics of the beholder. . . . The American nation is an ideal, an idea. We need only a better cultural lens to bring it into focus."[44] That lens is an art that responds to beauty, which Cooper finds admirably displayed in the canvases of Cole, Cropsey, Durand, Church, and their colleagues. It is not a faith in art he commends, but passionate belief in the medicine of beauty to heal the national soul. Cooper's spiritual therapy of art for the nation returns to the sublime eye of Emerson, who likewise believed that the rapturous experience of beauty should inform artistic taste and elevate America.

The subordination of art to religion or nation went against the grain of art for art's sake and the spiritualization of art that earlier Romanticism had fostered. But apparently the greater obstacle to the moral theory of art was the emergence of the avant-garde in Paris in the early twentieth century. The problem was not endowing art with a moral purpose. Careful studies of artists from Courbet to Picasso have shown that the most advanced art of the age could be deeply motivated by the quest for liberation, using artistic media to challenge regnant ideas, to battle against the limits of thought, feeling, and sensibility imposed by social mores as well as dominant economic interests.[45] The issue was that religious establishments were commonly associated with the forces of reaction—oppressive governments, constraining customs, reactionary ideologies against which some artists pitted themselves. Avant-gardism inherited from Henri de Saint-Simon and the Enlightenment harbors a suspicion of religion, a belief that it is vestigial, and a corresponding conviction that modernity is secular at heart.[46] The task of the artist is not to take the place of the priests, which would mean making art a substitute for religion, but to champion the role of the prophet, namely, to speak truth to power. That is surely one reason why many artists today feel compelled to keep at a distance from institutional religion and why artists since the 1890s have looked to the images and objects of "primitive" cultures to renew their art. Whereas the

modern discourse from Hegel to Jarves purported to measure aesthetic progress from the ancient to the modern, Modernism turned to the primitive in order to stress the break or disruption that would allow both purge and rebirth.

I would like to close by drawing attention to the fact that "art" and "religion" are modern constructs that aesthetic Modernism defined by relying on the artifacts of modernity's others—the ritual objects crafted by colonized peoples and collected in ethnographic museums.[47] Moving throughout the discourse of Modernism in art was a dominant conception of the sacred, one which distanced art from institutional religion, most importantly Christianity, in order to secure the freedom of art as an autonomous cultural force that was sacralized in its own right—in Hegelian terms, the manifestation of *Geist*, Mind or Spirit or Genius, the essence of an age or nation (*Zeitgeist*). To this end, the discourse appropriated a variety of histories and cultures, transforming artifacts into "art" and sacred ritual and story into "religion," especially from such primal cultures as those of Africa, Native America, and Oceania, but also "folk art," Asian arts, and ancient ritual and ceremonial objects and architecture, particularly Egyptian. Shamanic ritual and ritual objects as well as mortuary imagery, carvings, and iconographies joined children's art as influential appropriations in the quest for identifying cultural resources that might be transposed into artistic styles. These were to be deployed as ways of transcending the moral, historical, and aesthetic limits of a defunct naturalistic representation. "Primitivism," generally speaking, became the collective nomenclature that signified a variety of alternatives to naturalism, which came to be associated by avant-gardists as different as Kandinsky and Picasso with bourgeois conventionality, whose foundation was the disenchanted regimen of capitalism, industrialism, and rationalism. Institutional religion, that is, Christianity, was nothing more than the moral conditioning and increasingly decrepit authoritarianism necessary to regiment the mass-populations of modernity.

A capacious history of modern art and religion would robustly excavate these resources of Modernism, demonstrating the powerful cultural work of "Primitivism" no less than the degree to which European and American Modernism have rested on a surprising diversity of non-Western cultures. To be sure, these were subjugated

in an ambitious cultural imperialism that turned on a universalizing Modernist aesthetic and a corresponding museology of collection and appreciation. Yet they remain an occluded foundation without which Modernism would not have occurred in the way it did. The relevance of "religion" to understanding "art," two products of the Modernist project, could not be more pressing.

Notes

1. This essay draws in part from an earlier publication, "Toward a Modern Historiography of Art and Religion," in Ena Heller, ed., *Reluctant Partners: Art and Religion in Dialogue* (New York: Mobia, 2004), pp. 16–47.

2. It is quite true that most of these elements have congealed at other moments in history, such as ancient Rome and medieval China, in which case culturally grounded concepts of "art" are properly understood to have emerged, though their relationship to religion in each case will differ widely from the case of Euro-American modernity.

3. Thomas M. Lekan, *Imagining the Nation in Nature: Landscape Preservation and German Identity, 1885–1945* (Cambridge, MA: Harvard University Press, 2003); Brian Keith Axel, *The Nation's Tortured Body: Violence, Representation, and the Formation of a Sikh "Diaspora"* (Durham: Duke University Press, 2000); Harry Harootunian, "Memory, Mourning, and National Morality: Yasukuni Shrine and the Reunion of State and Religion in Postwar Japan," in Peter van der Veer and Hartmut Lehmann, eds., *Nation and Religion: Perspectives on Europe and Asia* (Princeton: Princeton University Press, 1999), pp. 144–60; George L. Mosse, *The Nationalization of the Masses: Political Symbolism and Mass Movements in Germany from the Napoleonic Wars through the Third Reich* (Ithaca: Cornell University Press, 1975), pp. 47–99; Fernand Benoît, *Art et Dieux de la Gaule* (Paris: Artaud, 1969); Josef Strzygowski, *Spuren indogermanischen Glaubens in der Bildenden Kunst* (Heidelberg: C. Winter, 1936).

4. See, for instance, Andrew McClellan, *Inventing the Louvre: Art, Politics, and the Origins of the Modern Museum in Eighteenth-Century Paris* (Berkeley: University of California Press, 1999); and Christophe Loir, *La sécularisation des oeuvres d'art dans le Brabant (1773–1842): la création du musée de Bruxelles* (Bruxelles: Éditions de l'Université de Bruxelles, 1998).

5. Immanuel Kant, *Observations on the Feeling of the Beautiful and Sublime*, tr. John T. Goldthwait (Berkeley: University of California Press, 1960), pp. 97–116.

6. Friedrich Schlegel, "Dritter Nachtrag alter Gemählde," *Europa*, vol. 2 (1803), p. 117.

7. G. W. F. Hegel, *On Art, Religion, Philosophy: Introductory Lectures to the Realm of Absolute Spirit*, ed. and tr. J. Glenn Gray (New York: Harper Torchbooks, 1970), p. 38.

8. Benedict Anderson, *Imagined Communities: Reflections on the Origin and Spread of Nationalism*, rev. ed. (London: Verso, [1983] 1991).

9. John Barrell, *The Political Theory of Painting from Reynolds to Hazlitt: "The*

Body of the Public" (New Haven: Yale University Press, 1986), see especially pp. 1–69.

10. Liah Greenfeld, *Nationalism: Five Roads to Modernity* (Cambridge, MA: Harvard University Press, 1992), p. 487.

11. For a fascinating discussion, see Albert Soboul, "Religious Feeling and Popular Cults during the French Revolution: 'Patriot Saints' and Martyrs for Liberty," in Stephen Wilson, ed., *Saints and their Cults: Studies in Religious Sociology, Folklore and History* (Cambridge, UK: University of Cambridge Press, 1983), pp. 217–32.

12. For a study of the range of traditional arguments for the benefit of art on the American public, see Joli Jensen, *Is Art Good for Us? Beliefs about High Culture in American Life* (Oxford: Rowman & Littlefield, 2002). An important, still unsurpassed discussion is Neil Harris, *The Artist in American Society: The Formative Years 1790–1860* (Chicago: University of Chicago Press, 1966). A recent study of the material culture of American civil religion is Jeffrey F. Meyer, *Myths in Stone: Religious Dimensions of Washington, D.C.* (Berkeley: University of California Press, 2001). Classic, modern statements of the moral theory of art include John Ruskin, *The True and the Beautiful in Nature, Art, Morals, and Religion*, ed., Mrs. L. C. Tuthill (New York: John Wiley & Sons, 1870), and Leo Tolstoy, *What is Art?*, tr. Charles Johnston (Philadelphia, PA: H. Altemus, 1898 [1896]).

13. For a sustained critique of public art in the service of civil religion, see Albert Boime, *The Unveiling of the National Icons: A Plea for Patriotic Iconoclasm in a Nationalist Era* (Cambridge, UK: University of Cambridge Press, 1998).

14. Friedrich Schiller, *On the Aesthetic Education of Man in a Series of Letters*, ed. and tr. Elizabeth M. Wilkinson and L. A. Willoughby (Oxford: Clarendon Press, 1967), p. 9.

15. Ibid., p. 123.

16. Ibid., p. 215.

17. Johann Joachim Winckelmann, *Reflections on the Imitation of Greek Works in Painting and Sculpture*, trs. Elfriede Heyer and Roger C. Norton (La Salle, Ill.: Open Court, 1987), pp. 33, 35.

18. Ibid., pp. 41, 35, 13.

19. A development of Lutheranism that stressed the cultivation and discernment of subjective states of feeling as the primary datum of religious commitment, Pietism reacted against the scholastic emphasis placed on doctrine by Lutheran orthodoxy in Northern European countries during the seventeenth and eighteenth centuries. For a discussion of the significance of Pietism for modern aesthetics, see David Morgan, "Aesthetics," *Encyclopedia of Protestantism*, 4 vols, ed. Hans Hillerbrand (New York: Routledge, 2003), 1: 7–8. Moshe Barasch has discussed Winckelmann and the discernment of Pietist influence; see *Modern Theories of Art, 1: From Winckelmann to Baudelaire* (New York: New York University Press, 1990), pp. 115–16.

20. A superb study of late medieval visual piety is Henk van Os et al., *The Art of Devotion in the Late Middle Ages in Europe, 1300–1500* (Princeton: Princeton University Press, 1994).

21. Karl Philipp Moritz, "Versuch einer Vereinigung aller schönen Künste und

Wissenschaften unter dem Begriff des in sich selbst Vollendeten," 1785, reprinted in Moritz, *Schriften zur Aesthetik und Poetik*, ed. Hans Joachim Schrimpf (Tübingen: Max Niemeyer, 1962), p. 3, emphasis in original: "Bei der Betrachtung des Schönen aber wälze ich den Zweck aus mir in den Gegenstand selbst zurück: ich betrachte ihn, als etwas, nicht in mir, sondern *in sich selbst Vollendetes*, das also in sich ein Ganzes ausmacht, und mir *um sein selbst willen* Vergnügen gewährt; indem ich dem schönen Gegenstande nicht sowohl eine Beziehung auf mich, als mir vielmehr eine Beziehung auf ihn gebe. Da mir nun das Schöne mehr um sein selbst willen, das Nützliche aber blo um meinetwillen, lieb ist; so gewähret mir das Schöne ein höheres und uneigennützlicheres Vergnügen, also das blo Nützliche."

22. Ibid., p. 5.

23. A. W. Schlegel, *Vorlesungen über schöne Literatur und Kunst*, ed. Bernhard Seuffert (Stuttgart: G. J. Göschen, 1884), p. 91.

24. M. H. Abrams remains the great explicator of this Romantic aesthetic, *The Mirror and the Lamp: Romantic Theory and the Critical Tradition* (Oxford: Oxford University Press, 1953). For an extended discussion of the organic theory of art applied to the visual arts more than the literary, as in the case of Abrams, see August Wiedmann, *Romantic Roots in Modern Art: Romanticism and Expressionism: A Study in Comparative Aesthetics* (Surrey, UK: Gresham Books, 1979), pp. 147–93.

25. Bernard Berenson, *Aesthetics and History* (Garden City, NY: Doubleday, [1948] 1954), p. 93.

26. Arthur Schopenhauer, *The World as Will and Representation*, tr. E. F. J. Payne, 2 vols (New York: Dover, 1969 [1818]), 1: 195–200; on Symbolist thought, see Naomi E. Maurer, *The Pursuit of Spiritual Wisdom: The Thought and Art of Vincent van Gogh and Paul Gauguin* (Madison: Fairleigh Dickinson University Press; London: Associated University Presses, 1998) and Patricia Townley Mathews, *Aurier's Symbolist Art Criticism and Theory* (Ann Arbor: UMI Research Press, 1986).

27. Wassily Kandinsky, *Concerning the Spiritual in Art*, tr. M. T. H. Sadler (New York: Dover, 1977); original: *Ueber das Geistige in der Kunst*, 1912.

28. Bell, "Art and Religion," in *Art*, p. 68.

29. See Maurice Tuchman, et al., *The Spiritual in Art: Abstract Painting 1890–1985* (Los Angeles: Los Angeles County Museum of Art, 1986); Kathleen J. Regier, ed., *The Spiritual Image in Modern Art* (Wheaton, IL: Theosophical Publishing House, 1987); Andreas C. Papadakis, ed., *Abstract Art and the Rediscovery of the Spiritual* (London: Art and Design, Academy Group Ltd., 1987); Dickran Tashjian, " 'A Big Cosmic Force': Katherine S. Dreier and the Russian/Soviet Avant-Garde," in Jennifer R. Gross, ed., *The Société Anonyme: Modernism for America* (New Haven: Yale University Press, 2006), pp. 45–73.

30. Tashjian, " 'A Big Cosmic Force'," pp. 48–49.

31. Hegel, *On Art, Religion, Philosophy*, see pp. 120–27.

32. James Jackson Jarves, *The Art-Idea*, ed. Benjamin Rowland, Jr. (Cambridge, MA: Belknap Press of Harvard University Press, [1864] 1960), p. 47.

33. Ibid., p. 49.

34. Ibid., pp. 137–44.

35. Ralph Waldo Emerson, "Nature," in *Essays and Poems*, ed. George Stade (New York: Barnes & Noble Classics, 2004), p. 17.

36. Ibid., p. 12.

37. Robert Rosenblum, *Modern Painting and the Northern Romantic Tradition: Friedrich to Rothko* (New York: Harper & Row, 1975).

38. Friedrich Schleiermacher, *On Religion: Speeches to its Cultured Despisers*, tr. Richard Crouter (Cambridge: Cambridge University Press, 1988); Rudolf Otto, *The Idea of the Holy: An Inquiry into the Non-Rational Factor in the Idea of the Divine and its Relation to the Rational*, tr. John W. Harvey (London: Oxford University Press, 1950); Paul Tillich, *On Art and Architecture*, tr. Robert P. Scharlemann, ed., John Dillenberger with Jane Dillenberger (New York: Crossroad, 1987).

39. For a discussion of this, see David Morgan, "Secret Knowledge and Self-Effacement: The Spiritual in Art in the Modern Age," in Richard Francis, ed., *Negotiating Rapture*, exhibition catalogue (Chicago: Museum of Contemporary Art, 1996), pp. 34–47.

40. Cordula Grewe, *Painting Religion: Art and the Sacred Imaginary in German Romanticism* (Burlington, VT: Ashgate, forthcoming); Keith Andrews, *The Nazarenes: A Brotherhood of German Painters in Rome* (Oxford: Clarendon Press, 1964); for studies of French religious imagery, see Bruno Foucart, *Le Renouveau de la peinture religieuse en France (1800–1860)* (Paris: Arthena, 1987) and Joyce C. Polistena, "The Religious Paintings of Eugène Delacroix: Romantic Religion and Art," work in progress. Christopher Wood, *The Pre-Raphaelites* (New York: Viking, 1981); Daniel Robbins, "From Symbolism to Cubism: The Abbaye of Créteuil," *Art Journal* 23, no. 2 (Winter 1963): 112–16. George Mauner, "The Nature of Nabi Symbolism," *Art Journal* 23, no. 2 (Winter 1963): 96–103. It is difficult to over-emphasize the impact of Ruskin's work in nineteenth-century America. For a good discussion, see Roger B. Stein, *John Ruskin and Aesthetic Thought in America, 1840–1900* (Cambridge: Harvard University Press, 1967). E. P. Thompson, *William Morris: Romantic to Revolutionary* (New York: Pantheon, 1977).

41. Quoted in Jens Christian Jensen, *Caspar David Friedrich*, tr. Joachim Neugroshel (Woodbury, NY: Barron's, 1981), p. 136. See also David Morgan, "German Character and Artistic Form: The Cultural Politics of German Art Theory, 1773–1814," *European Romantic Review* 6, no. 2 (Winter 1996): 183–212.

42. Thomas Cole, "Essay on American Scenery," in *The Collected Essays and Prose Sketches*, ed. Marshall B. Tymn (St. Paul, MN: John Colet Press, 1980), pp. 6–7.

43. See for example the enthusiastically received exhibition and its catalogue by Andrew Wilton and Tim Barringer, *American Sublime: Landscape Painting in the United States 1820–1880* (London: Tate, 2002).

44. James F. Cooper, *Knights of the Brush: The Hudson River School and the Moral Landscape* (New York: Hudson Hills Press, 1999), p. 19.

45. Patricia Leighton, *Re-Ordering the Universe: Picasso and Anarchism, 1897–1914* (Princeton: Princeton University Press, 1989); T. J. Clark, *The Absolute Bourgeois: Artists and Politics in France, 1848–1851* (Princeton: Princeton University Press, 1982).

46. See Donald D. Egbert, "The Idea of the 'Avant-Garde' in Art and Politics," *American Historical Review* 73 (1967): 339–66.

47. A helpful consideration of this in the broad historical context of modernity is Michel-Rolph Trouillot, "North Atlantic Universals: Analytical Fictions, 1492–1945," *South Atlantic Quarterly* 101, no. 4 (Fall 2002): 839–58. My thanks to Keith McNeal for bringing this essay to my attention.

FROM THE FORM OF SPIRIT TO THE SPIRIT OF FORM

Randall K. Van Schepen

[Art] opens ... the holy of holies. ... When a great painting comes into being it is as though the invisible curtain that separates the real from the ideal world is raised. [1]

I'm afraid I'm an agnostic in art, I just don't believe in it with all the mystical trimmings. As a drug it's probably very useful for a number of people, very sedative, but as religion it's not even as good as God. [2]

Beginning at the end: Fried's invocation

When the American critic Michael Fried wrote "Art and Object-hood" in 1967, he forcefully defended the continued relevance of modernist abstraction against the heretical threat of its evil twin, Minimalism, by employing language that was clear, strikingly passionate, and tinged with the fervor of a "true believer." Fried argued that modernist art, by which he meant particular forms of abstraction, provides an aesthetic experience of "grace," an exalted feeling of release from the mundane exigencies of daily living that takes place on an abstract plane of pure experience. The literal relationship to the viewer established by Minimalism, says Fried, denies the possibility of this transcendence with a merely material experience that is

indistinguishable from that of everyday life. Fried's essay included these fecund but notorious last phrases: "We are all literalists most or all of our lives. Presentness is grace."[3] Literalist art offers nothing that we do not already have; modernist art offers a rare gift of the exalted feeling of being fully present.

Through much of its history, modernist art criticism denied its connection to the explicitly spiritual themes found in Fried's essay. Formalist criticism in particular argued that its approach was the most appropriate for a materialist modern age. But Fried's essay acutely demonstrates the fittingness between modernist ideals and metaphysical notions of the work of art and of the perceiving subject. Rather than limiting this essay to an analysis of Fried's "Art and Objecthood," however, I will explore a few of its significant aesthetic assumptions in order to trace its roots and, by extension, those of modernist criticism in general, to the theo-aesthetical thought of the eighteenth century. This essay sees Fried's impassioned defense of modernism as the possible endpoint of a long and fertile thread of theological, philosophical, and critical precedents that provided formal aesthetic experience with transcendent significance. More than mere defensive posturing at the time of formalism's waning influence, Fried's theo-aesthetic language in "Art and Objecthood" thereby indicates deeper continuities between his late modern aesthetic religiosity and historical currents in modern aesthetic theory and philosophical thought.[4]

Johanna Drucker, in *Theorizing Modernism*, critiques Fried's criticism on the very grounds of its explicit championing of a modern, autonomous subjecthood in the face of what Fried later called a "new, more 'contemporary' (e.g., nontranscendental, embodied, 'externalized,' entropic, divided, decentered) model of the subject or self."[5] Drucker also takes Fried to task for the manner in which this form of modern subject relies on an autonomous art object to animate it.[6] What she has to say about the theological implications of Fried's criticism, however, is only that he "transformed Greenberg's formalist prescriptions into an explicit theology of presence, thus directly articulating an implied connection between metaphysics and representation."[7] In other words, Fried finally flushes out the metaphysical implications of the formalist method that have been clandestinely operative all along.

But this "theology of presence" (or, more accurately, "theology of presentness") is not as merely "implicit" as Drucker makes it out to be. While there is some indication that the quasi-religious language that Fried used to describe modernist aesthetic experience in "Art and Objecthood" disturbed his critical colleagues, perhaps it should not have.[8] After all, critics consistently employ religious language to describe aesthetic experience back to the Enlightenment roots of the aesthetic. As Andre Malraux notes about the sometimes uneasy pairing of secularist art theory and religious terminology, "the religious vocabulary may jar on us; but unhappily we have no other."[9] Fried himself recovered one narrative of such pre-histories of his aesthetic concerns in his later art historical research into the phenomenological issues of beholding works of art in the eighteenth and nineteenth centuries.[10] Another, more spiritual, archaeology, however, remains only partially recovered.

An archaeology of the spirit of form

The relationship between spirituality and art is, of course, ancient. But it is not until the eighteenth century, when an independent discipline of art theory develops, that aesthetics must grapple with translating these formerly spiritual experiences into aesthetic ones. I am interested in this process of translation, both in its initial manifestations and in its critical iterations since then. Three themes in Fried's "Art and Objecthood" will function as touchstones to demonstrate the connection that this late-flowering formalist prose maintains with the spiritualized rhetorical tradition from which it flows: disinterestedness, transcendence, and instantaneousness. Each of these essentially formalist aesthetic concerns has, following Elliot's notion of an "objective correlative," a spiritual correlative. The spiritual roots and implications of these themes are transmuted in multifarious forms according to the role that the aesthetic plays in each theorist's overall philosophy. For most, it replaces religion as that realm of ineffable experience that remains indefinable in practical material terms. The present goal is to demonstrate that Fried's vague and explicit spiritual themes are reoccurrences of concerns evident in formal-oriented aesthetic philosophy and criticism from the last two centuries.

To clarify, my pointing to the theological valences of aesthetic theory is in no way meant to disparage either aesthetics or theology because of such similarities. Unlike some, who might display a gleeful satisfaction at having "found out" the hidden spiritual agenda of formalist methodologies, I am rather more interested in discovering how modernist aesthetics reformulates spiritual themes for its own use. I find nothing inherently threatening or backward about such connections, even if I might find them misguided. No less a materialist than T. J. Clark is similarly interested in how the "religious commitments" of critics such as Elliot and Coleridge, commitments that came with "full fledged histories" that put the course of human activities "in question," became a "theology of critical intuition" when translated into modern formalism. "There is an essay to be written," Clark suggests, "on when and how the religious attitude in criticism declines from [the] complex building and questioning of the past [found in critics like Elliot and Coleridge] into a set of metaphysical episodes in an earth-bound, present-bound discussion of cases."[11]

Disinterestedness: believers and beholders. One of the most disturbing aspects of the new abstract but Minimalist sculpture for Fried in 1967 was its "interestedness." Though Fried never uses this term explicitly, it is inherent in his criticism of the Minimalist sculpture's (or "literalist" sculpture to use Fried's term) dependence on the viewer to co-create its experiential situation. In contrast to the disinterested viewer's ability to forget himself, the interested viewer is constantly aware of his bodily presence as a part of the endlessly configurable environment and as an active agent in the work's effect. The object and its relationship to the surroundings are the center "but the situation itself *belongs to* the beholder—it is *his* situation" and it depends on him for its completion: ". . . that the beholder is confronted by literalist work within a situation that he experiences as his means that there is an important sense in which the work in question exists for him alone. . . ."[12] Thus, the effect of literalist work is not reliant on *artistic* conventions but on *phenomenological*, physiological, and spatial experience, which are all determined by a self-conscious process of interestedness. In contradiction to this, Fried proposes that the aesthetic character of modernist art encourages the viewer to have a disinterested relationship to the aesthetic

object. The viewer of the modernist work is absorbed by the experience of the work's artistic configuration, momentarily becoming a point of pure unselfconscious attention. This un-alienated sense of "presentness" is Fried's state of "grace."

Fried's use of the theological concept of grace (that is, the unmerited favor of God) points us back to a time when the conjunction of theology and aesthetics into what I would like to call "theo-aesthetics" was an expected matter of course rather than being so exceptional as to cause notice.[13] In what follows, I would like to discuss a few significant historical instances of such theo-aesthetic thinking. The spiritual roots of the concept of disinterestedness are found in the late seventeenth and early eighteenth century. Kant's *Kritik der Urteilskraft* of 1790 comes as a rigorous summation and anchoring of many of these concepts of the disinterested developed by Locke, Addison, Moritz, Baumgarten, and Lessing. Because Kantian disinterestedness has been so thoroughly analyzed in relation to modernism by theorists such as Thierry de Duve, I will limit my comments here to a few of Kant's predecessors.[14]

The heaviest philosophical precedent for Kant was Locke, who cannot be said to have founded anything close to a system of aesthetics. If pre-Lockean philosophers generally demonstrated a distrust of sensation, Locke made it the task of his epistemology "to establish the integrity and saving power of the simple sensation," says Ernest Lee Tuveson in *The Imagination as a Means of Grace: Locke and the Aesthetics of Romanticism*.[15] Locke opens the door to the Kantian aesthetic subject by separating the individual's sensual experience of beauty from the logical apprehension of the moral or the true: "Beauty does not exist as an objective quality in a universe of atomic motions."[16] Even Jonathan Edwards, an early follower of Locke's who had little difficulty tying morality and reason to any aspect of life, believed, "It is out of reason's province to perceive the beauty or loveliness of any thing: such a perception does not belong to that faculty. Reason's work is to perceive truth and not excellency."[17] For these pre-Kantian philosophers and theologians, then, beauty is experienced in a state of grace outside of self-determined rational control. As Edwards wrote, "God works upon man through the daily shock of sensation."[18] In these first steps toward disinterestedness, Locke and Edwards loose the aesthetic from conscious

logical control, allowing it to range freely in the subject's sensual apprehension.

But perhaps the most striking example of theo-aesthetic theory comes from Karl Phillip Moritz. In 1785, preceding Kant's publication of *The Critique of Pure Judgment*, Moritz publishes "Versuch einer Vereinigung aller schönen Künste und Wissenschaften unter dem Begriff des in sich selbst Vollendeten" ("Toward a Unification of the Arts and Letters under the Concept of Self Sufficiency"). In both his analytic and fictional writing, Moritz draws on the language and experiences of his German Pietistic upbringing to develop a language capable of conveying the transformative power of aesthetic experience. The beholder of an artwork or of beauty has what he calls a "disinterested" (*uneigennützigen*) relationship to the work. A disinterested beholder loses sight of his or her personal needs or desires because the "object completely captivates our attention," diverting "attention momentarily from ourselves," allowing us to "lose ourselves in the beautiful object." This "forgetfulness of ourselves," however, is a pleasurable release and is the "highest degree of pure and disinterested [*uneigennützigen*] pleasure which beauty grants us."[19]

A fascinating comparison can be made between Moritz's theo-aesthetic critical writing and his autobiographic novel *Anton Reiser*. Martha Woodmansee maintains that the characteristics that Moritz assigns art and the beholder are virtually identical to those he assigns to God and the believer (drawn from his German Pietistic upbringing) in *Anton Reiser*. Separately, but using the same terms, Moritz describes art's self-sufficiency and God's self-sufficiency; similarly, he describes the beholder as selflessly disinterested in the practicality of art and the true believer as selflessly disinterested in God for who he is rather than for His practical effect on his life. The theo-aesthetic conflation is clear when comparing Moritz's description of aesthetic experience to this one of the Quietist spiritual teachings of Moritz's youth in *Anton Reiser*:

> [The faithful] are concerned for the most part with that . . . total abandonment of the self and entry upon a blissful state of nothingness, with that complete extermination of all so-called *self-ness* [*Eigenheit*] or self-love [*Eigenliebe*] and a totally disinterested [*uninteressierte*] love of God, in which not the merest spark of

self-love may mingle, if it is to be pure; and out of this there arises
in the end a perfect, blissful *tranquillity* which is the highest goal of
all these strivings.[20]

Moritz's writing on the aesthetic presents a number of concepts that
become central for Kant's aesthetic formulation and for Western aes-
thetics following him: the rejection of easy pleasure (*ergötzt*), the
dependence of the beautiful object on the perceiving human subject,
and the uselessness of the object permitting disinterested contempla-
tion, the tranquility of resolution, and the purity of aesthetic atten-
tion. Each of these central Kantian aesthetic concepts is rooted in
theological principles: rejection of the easy pleasures of the world for
the higher pleasures of the spirit, the experience of God being depen-
dent on his being internalized, the (disinterested) peaceful selflessness
of the believer who humbly receives grace instead of grasping in self-
interest, and the purity of worship/admiration. Moritz proposes that
the greatest aesthetic experience is one of losing one's self in the
appreciation of beauty—even as the greatest spiritual pleasure is one
of losing one's self in the worship of God's beauty.[21] But if the basis
of disinterestedness is indebted to eighteenth-century religious atti-
tudes toward God and spiritual experience in the work of Moritz and
others, Kant, reacting against the religious impulse, uses a concept of
disinterestedness to assert the autonomy of the aesthetic from any
interestedness—including that of religion and morality.[22]

Transcending material. Fried uses "literalist art" as a term of oppro-
brium to refer to the sculpture of Donald Judd, Tony Smith, Robert
Morris, and other Minimalists. In each of these quite distinct artists'
work, Fried perceives a consistent aesthetic of literalism emphasizing
the material and physical character of the work and its phenomeno-
logical relationship to the spectator in the space of the gallery.[23] This
literal attention to the immediate situation is created by an infinitely
changeable self-conscious relationship between subject and object
that Fried calls theatrical. Theatrical works, he says, distance the
beholder, "not just physically but psychically. It is, one might say,
precisely this distancing that *makes* the beholder a subject and the
piece in question . . . an object."[24] More to the point, the self-conscious
awareness of one's bodily presence in such a situation becomes

disconcertingly alienating, making one increasingly aware of being on display as much as the sculpture is.

An abstract relationship between viewer and art object, based on the work's form rather than materiality, is literalism opposite. Fried accounts for the epiphanic experience of abstract modernist works by employing theo-aesthetic ideas such as manifestness, selflessness, and timelessness. Fried later discovered that Diderot also proposed that the artwork should "act" under the "supreme fiction that the beholder does not exist." The autonomy of the aesthetic object permits the viewer to lose himself in his experience of it.[25] For Fried, the modernist work's internal syntax, compositional relationships, and perceptual richness, facilitate (but do not require) a concentrated exercise of freedom where the viewer's immediate literal situation is overcome by an intense selfless attention. With modernist art, Fried says, aesthetic experience is manifest, complete, and convincing in its depth and fullness.[26] This achievement is all the more impressive for its hard won triumph over materiality.

Schopenhauer suggested that this separation of form from matter is "essential" to the work of art, that every work of art *is* just such a separation.[27] But long before Schopenhauer required form to transcend matter, Locke and Jonathan Edwards secured the autonomy of aesthetic sensation. Edwards and Locke proposed that because beauty was not an objective quality of things but a quality perceived through an individual's sensibility, senses and not reason were pre-eminent in its appreciation. Edwards wrote that God used sensation, "such an impression or motion made in some part of the body, as produces some perception in the understanding," as a means of demonstrating His unmerited favor.[28] Aesthetic judgment thereby takes on divine purposes, a further justification for its autonomy.[29]

The aesthetic's transcendence of mundane experience, giving the viewer an exalted feeling, depends on how the work can embody what Schopenhauer called the separation of matter from form. Neither Kant nor Lessing locate the aesthetic in the object. As Michael Podro writes, Kant's judgment relates, "to ourselves, our own mental functioning. The judgment, in Kant's phrase, does not include the object, that is, does not describe the object."[30] The judgment of beauty is not materially determined and transcends the work's particular physical nature in form. As David Wellbery suggests, Lessing also does not

locate the aesthetic in the object itself but in the subjectively apprehended object: "art is located between presence and absence; it is the imaginative presence-to-mind of an existentially absent object. . . ." This "non-presence-to-mind" of an "imaginary object" draws on similar spiritual practices that make the existentially absent divinity present-to-mind. The sensuous is negated to a realm of thought; in poetry, "language negates worldliness."[31]

Jettisoning traditional religion and left with meaningless material explanations of casual relationships by the late eighteenth century, modern German philosophy took as "one of its major tasks" the replacement of "dogmatic theology" and positivist materialism with the transcendent possibilities of the aesthetic, says Andrew Bowie.[32] Thus, the degree to which a work of art could transcend its base materiality was an indication of its greatness. Schiller, for example, suggests that those works that are "able to remove the specific limitations of the art in question without thereby destroying its specific qualities" achieve the greatest.[33] Clement Greenberg's medium specific modernism is a later day version of Schiller's notion. The Schillerian aesthetic experience provides a "sacred moment," where, released from serving our material needs, we are free to contemplate rather than act, says Israel Knox.[34] Further emphasizing the immaterial character of his aesthetic, Schiller writes that the true test of a master artist is that "he can make his form consume his material." If the material is "seductive" and imposes its own effects on the viewer, the relationship becomes "direct" and literal rather than formal and abstract.[35] Only by wresting an aesthetic experience out of materiality, overcoming it with a subjective response or artistic configuration, is the freedom of the subject and the greatness of the artist proved.

Hegel too proposes that art should provide the modern viewer with an experience transcending mere materiality. Because Hegel requires art should be a spiritual rather than literal apprehension of form, painting stands in closer relationship to the beholder than sculpture because it is "only a pure *appearance* of the *spiritual inner* life" where its physicality is "dissolved" in apprehension. Sculpture is more independent (and here the parallels to Fried's literalism should be obvious) because it is "unconcerned about the spectator who can place himself wherever he likes: where he stands, how he moves, how he walks around it, all this is a matter of indifference. . . ."[36]

Painting's content is subjective apprehension: it exists *for* the subject. Sculpture's content is materially independent; it exists *despite* the subject. Clearly Hegel's scheme is none too subtle in its distinctions between the visual arts (all sculpture . . . all painting?). Nevertheless, the stridency of his position clarifies the bias in the Idealist tradition for immateriality in aesthetic experience.

One of the more striking passages on the unartistic effect of literalism or hyper-realism comes in Schopenhauer's "Metaphysics of Fine Art," where he discusses the disconcerting impression that a wax figure makes on the viewer. The absolute literal realism of these figures prevents them from transcending their material condition or the moment they depict. Because the wax figure is so realistic it seems to carry the matter of the person along with their form, as well as a literal moment in time, creating a sense of "repulsion":

> This [lack of separation of form from matter] is really the reason why wax figures produce no aesthetic impression, and therefore are not, in the aesthetic sense, works of art at all. . . . For a wax figure of a man appears to give not only the mere form but with it the matter as well, so that it produces the illusion that the man himself is standing there before you . . . and yet, at the same time, it fails to represent the life which gives such fleeting existence its value. This is why a wax figure is repulsive; it is stiff and stark and reminds us of a corpse.[37]

The wax man's literalism ("the man himself . . . standing there before you") prevents it from being experienced aesthetically—even as it prevents us from currently experiencing the siliconized corpses in traveling exhibits of *Bodyworlds* (*Körperwelten*) as aesthetic objects. The lifelikeness of the waxwork makes it incapable of being enlivened by aesthetic subjectivity. It's nightmarish use of a singular moment over and over accounts for its macabre effect.

The true work of art, says Schopenhauer, should lead us *from* our situation, *from* that particular experience of time and space, *to* "that which exists an infinite number of times in an infinite number of ways." Schopenhauer reserves his strongest language, the wax figure's "repulsiveness," for the fact that it only gives the body's material aspect, turning the body into its most horrifying condition, a mere object. Transcendence requires a separation from matter.

Instantaneous wholeness and healing. The various concepts that make up the matrix of formalist concerns are often difficult to disentangle from each other: the aesthetic's transcendent effect is facilitated by a disinterested state of reception, the autonomy of the work of art is facilitated by an abstract relation to the viewer, and so on. The concept of instantaneousness is similarly intertwined with manifestness, presentness, unity, and epiphany. When Michael Fried objects to Minimalism's use of "duration," he is arguing that it lacks the modernist work's ability to be immediately and intuitively apprehended in an instantaneous experience of manifestness. The physical expansiveness of literalism extends our temporal experience of it. The result is an experience "of endlessness, or inexhaustibility" because the work "is always of further interest; one never feels that one has come to the end of it; it is inexhaustible."[38] Its inexhaustibility, however, is not a result of fullness but because it is empty at its core, pulling the endlessly changing situation around it into our experience of it, like a black hole: "It is endless the way a road might be, if it were circular, for example. Endlessness, being able to go on and on, even having to go on and on, is central both to the concept of interest and to that of objecthood."[39]

Contrast this with Fried's experience of modernist works:

> at every moment the work itself is wholly manifest. . . . It is this continuous and entire *presentness*, amounting, as it were, to the perpetual creation of itself, that one experiences as a kind of *instantaneousness*, as though if only one were infinitely more acute, a single infinitely brief instant would be long enough to see everything, to experience the work in all its depth and fullness, to be forever convinced by it.[40]

The modernist experience of perpetual instantaneousness results from the internal configuration of the work, which can be perceived every moment we apprehend it and which can be recreated every moment. In a brief, instantaneous flash of perception the beholder of the modernist work sees the work's configuration as a convincing unified field, compelling in its immediate, unmediated directness.

Fried's manifest artwork, its creation of a "continual and perpetual *present*," has a long trajectory in the history of the formal aesthetic. Clement Greenberg's interest in this instantaneous feature of painting

in his late criticism is Fried's most immediate forebear. Greenberg's "The Case for Abstract Art" (1959) contains passages such as this one, which is an obvious precedent for Fried's manifestness:

> [A picture] is there all at once, like a sudden revelation. This "at-onceness" an abstract picture usually drives home to us with greater singleness and clarity than a representational painting does. [. . .] You become all attention, which means you become, for the moment, selfless and in a sense entirely identified with the object of your attention. The "at-onceness" which a picture or a piece of sculpture enforces on you is not, however, single or isolated. It can be repeated in a succession of instants, in each one remaining an "at-onceness," an instant all by itself. For the cultivated eye, the picture repeats its instantaneous unity like a mouth repeating a single word.[41]

Thierry de Duve has already traced an art theoretical archaeology of the idea of manifestness that reaches from Lessing to Greenberg through Wölfflin—all theorists who "sought in the instantaneous-ness spatiality of painting the specific essence of plastic art."[42] This notion of manifestness, the singularity of the moment of aesthetic apprehension, more clearly applies to the two-dimensional painting than to three-dimensional arts. Rather than rehearsing de Duve's history here, I would like to extend his remarks. Where de Duve focuses on painting's dominant position for embodying manifestness, Fried also applies "manifestness" to the sculpture. In fact, the primary example of an authentic work of modernist art in "Art and Objecthood" is the sculpture of Anthony Caro. Caro's work is pre-eminently modernist because his achievement of overcoming the lit-eral materiality of his three-dimensional works of art is inherently more difficult, and therefore more triumphant, than similar achieve-ments in paint. Also, arguing along the same lines as Lessing for sculpture's temporal unity, Fried suggests that the timeframe in which the perception of the modernist three-dimensional work of art occurs is so rapid, so seemingly in one rather than many moments, that the beholder is "left with the illusion of timelessness, of instant and simultaneous vision."[43] The effective instantaneousness of Caro's sculpture is achieved most clearly by its formal arrangement, but also by its uniform color and by a singular preferred viewing point.

Exalted by the feeling of this instantaneous apprehension, drawn
into the orbit of the work's internal composition, he viewer's sense
of freedom and autonomy is affirmed even as his self-consciousness
fades away. As early as 1712, Joseph Addison theorized that beauty
was immediately apprehended in a flash of experience that bypasses
reason and ordinary cognition. The "pleasures of the imagination"
happen immediately when a "scene enters" an "opening eye." Colors
impress on the subject's "fancy," we are struck with "symmetry," and
"immediately assent to the beauty of an object. . . ."[44] Interestingly,
Addison asserts that the "mere" pleasure of this transcendent atten-
tion has the higher purpose of improving the spirit and perfecting the
earthly body in preparation for heaven, where our senses will "enjoy
their highest gratification."[45] Specifically, Addison identifies imagina-
tive sensual experience as a "means of grace," says Tuveson, providing
spiritual uplift, "reconciling man, with his spiritual needs and his
desire to belong to a living universe of purpose and values, with a
cosmos that begins to appear alien, impersonal, remote and men-
acing."[46] Moritz's identification of theology with aesthetic experience
brought the epiphanic language of ardent religious fervor to the
experience of the materially present object. In the reverie of this
moment, so easily shattered, seemingly eternity condensed in time,
we forget ourselves and in the process gain much more, the "pure and
disinterested [*uneigennützigen*] pleasure which beauty grants us."[47]
Of course Kant takes this notion of epiphanic selflessness and turns it
inward to the functioning of the faculties, rather than outward toward
the divine.[48]

Addison's early notion of the redemptive function of the aes-
thetic, as a spiritual training ground for the heavenly use of our
senses, develops into a redemptive hope for social or psychological
deficiencies by the eighteenth and nineteenth centuries. But even
though the justifications from the aesthetic are increasingly secular-
ized, aesthetic theory rarely loses all of its spiritual valences. Knox
characterizes Schiller's redemptive aesthetic as, "an interval, a sweet
and lucid interlude, a free contemplation . . . released from the servi-
tude of the senses . . . not yet determined by reason and duty."[49]
Schiller suggests that the aesthetic is at work building its own spirit-
ual kingdom, not unlike that of the church, which is cumulative
throughout the ages. The aesthetic kingdom is also "unnoticed" by

much of culture. Instead of the kingdom of God throughout history, the aesthetic is building a "joyous kingdom of play and of semblance."[50] Never before, and perhaps never since, has the aesthetic had so much hope laid at its feet.[51] As a result, one must constantly acquire new experiences of the beautiful in order to maintain the harmonious state within. The free and harmonious balance of impulses that sets the individual free is only possible with a continuous experience of the beautiful—resulting in an aestheticization of life.[52] Schiller substitutes continuous aesthetic experience for Moritz's continuous experience of the divine.

Many aesthetic theories after Kant borrow, in one form or another, this "healing" and redemptive notion of the aesthetic. Preceded by Moritz's disinterested love of God as a basis for a disinterested aesthetic response, Addison's aesthetic training-ground for heaven, Locke's saving power of physical sensation, and Jonathan Edwards's belief that God speaks through sensation, Kant's aesthetic judgment develops its salvific character as a redemption of subjective faculties. Kant makes central the role of the aesthetic in healing, bridging, and spanning the chasms opened up in the modern subject.[53] Out of this, the early Schiller develops a theory of the socially revolutionary aesthetic that participates in the resolution of class conflict; the late Schiller then proposes that the redemption of life is only possible through a constant exposure to beauty.

Even materialists such as Adorno and Horkheimer maintain a transcendent role for the aesthetic. They also recognize the necessity of employing religious language to account for the aesthetic's unique ability to avoid the "mere imitation of what already is." In their critique of Enlightenment thinking, *The Dialectic of Enlightenment*, they argue that the aura of artworks still has something in common with the "sacred powers" of "enchantment," "withdrawn" as it is from "profane existence" and abiding by "special laws" in the arena marked out by a "magician." Even though the Frankfurt School employed the modern aesthetic as a renunciation of the influence of the cultic, it dialectically "retains the magic heritage all the more surely." Adorno and Horkheimer circle the reader back to the eighteenth-century roots of the aesthetic, where they used theo-aesthetic language to describe both the unwarranted experiences of the grace of God and the free gifts of the aesthetic. Adorno and Horkheimer similarly find

the ability of the aura of "aesthetic semblance" to give an "appearance of the whole in the particular" to be like "*manna*" from heaven.[54] While the metaphor employed here is quite distinct from Moritz's Pietistic ecstasies, the striking commonality between ecstatic fervor and manna is in their similar notion of grace. Grace in each case is God's interruption of the laws of the world as we know it, either in the form of subjective experience or of material nature. For Adorno and Horkheimer, the Old Testament manna metaphor spoke powerfully to their contemporary political concerns. By invoking this story of a people wandering without a home, waiting to find ultimate fulfillment and being sustained by surprising and unwarranted favor, they could bring along with it metaphorical associations to modern hopelessness in the desert of capitalist cultures or of their own post-World War Two ethnic identity. Even in the middle years of the twentieth century, the aesthetic maintained its redemptive role. It was still being asked to provide a hopeful glimpse of a life of wholeness, freed from determination, in the here and now.

Conclusion

This essay opened with a quote from the end of Fried's "Art and Objecthood": "We are all literalists most or all of our lives. Presentness is grace." Much of the intervening discussion focused on how such a notion of "grace," in the form of disinterestedness, transcendence, and instantaneousness, was operable from the beginnings of aesthetic theory to its late manifestation in Fried's justification for modernist art in 1967. I will conclude with a discussion of the quote at the very beginning of Fried's essay. Before Fried sets forth the terms of his argument for high modernist art against the new literalist sensibility that we now recognize as demonstrating many features of the postmodern, he opens with an epitaph from Perry Miller's 1949 intellectual biography of Jonathan Edwards:

> [Jonathan] Edward's journals frequently explored and tested a meditation he seldom allowed to reach print; if all the world were annihilated, he wrote . . . and a new world were freshly created, though it were to exist in every particular in the same manner as this world, it would not be the same. Therefore, because there is

continuity, which is time, "it is certain with me that the world exists anew every moment; that the existence of things every moment ceases and is every moment renewed." The abiding assurance is that "we every moment see the same proof of a God as we should have seen if we had seen Him create the world at first."[55]

Thus it was that the words of a colonial New England Puritan preacher, most known for his fire-brand sermon "Sinners in the Hands of an Angry God," who likely never saw a proper work of art in his life, came face to face with the stark forms of late modern art in the pages of *Artforum* magazine in 1967.

Fried's opening quotation of Perry Miller's study of Jonathan Edwards aligns our expectations along a venerable line of theo-aesthetical thought. It should also bring to mind Fried's description of the modernist artwork as, "every moment . . . wholly manifest" in its "continuous and entire presentness," and in a state of "perpetual creation of itself."[56] The recuperative, revelatory, and ecstatic nature of Edward's encounter with creation becomes Fried's model for the continual renewal of the modern self through aesthetic encounters. The experience of instantaneous presentness (spiritually for Edwards and aesthetically for Fried) is a moment of pure perception, of singular revelation, of imbuing the present moment with the infinite and with continual creation. Edwards' abiding assurance of God's existence becomes Fried's modernist conviction. The bookends of Fried's essay, its literal framing phrases, but also its intellectual framing concepts, invoke the lofty purposes to which the aesthetic has been put for the past two centuries. If Fried's high-minded rhetorical flourishes sound quaint to cynical twenty-first century ears, they nevertheless indicate a self-awareness of the deeper problem to which the tradition of the exalted modern aesthetic was put. The spiritual heritage of Western aesthetics enters in through the side door of formalist criticism as form, autonomy, manifestness, and other pseudo-religious notions in order to claim the only realm of experience that has (perhaps) not yet been subsumed by positivist materiality. Modernist criticism, backed into a corner of its own making, reverted to the language of its foundational moments to justify its redemptive possibilities, but without reverting to the religious beliefs that were the source of many of these principles. But Fried undertook his invocation of the modern

aesthetic's potential at a time when such a hope in the power of form was being seriously challenged. Fried's prescient analysis points beyond itself in its careful articulation of the strength of what it demonizes and in the increasingly fraught hope it places in the spirit of form.

Notes

1. Friedrich Wilhelm Joseph von Schelling, *System of Transcendental Idealism* in Albert Hofstadter and Richard Kuhns, "Philosophies of Art and Beauty" (1964; reprint ed., Chicago: University of Chicago Press, Phoenix Books, 1976), p. 445.
2. Duchamp in Calvin Tomkins *Bride and Bachelors* (New York: Penguin, 1976), pp. 18–19.
3. Michael Fried, *Art and Objecthood: Essays and Reviews* (University of Chicago Press: Chicago, 1998), p. 168. All of the subsequent citations of essays by Fried derived from this self-anthologized volume are cited by the essay's title and anthology page number.
4. Fried himself has denied that any such defensiveness characterized the nature of his criticism. Much later Fried suggests that, "When Rosalind [Krauss] and I entered the field of art criticism just a short time apart, the most interesting critical work by far was Greenberg's. Now you want to say, in retrospect, that that discourse ought to have appeared discredited to us—but it just didn't seem discredited to the most serious people involved in art criticism at the time. Just as an historical fact that has a certain force." [Fried in "Discussion" in "Theories of Art after Minimalism and Pop" in *Discussions in Contemporary Culture: Number One*, ed., Hal Foster (Bay Press: Seattle, WA, 1987), p. 79; see also Krauss's responses, which are supportive of Fried's account (ibid., pp. 77–80). Fried also described the mood of 1967–68 as "distinctly upbeat" (Fried, "An Introduction to My Criticism," p. 13)].
5. Ibid., p. 46.
6. Johanna Drucker, *Theorizing Modernism: Visual Art and the Critical Tradition* (New York: Columbia University Press, 1996), p. 90.
7. Ibid.
8. Krauss says that Fried's invocation of grace "seemed to shake everything I thought I'd understood. The healthy, Enlightenment-like contempt for piety, the faith instead in the intellect's coming into an ever purer self-possession . . . it didn't seem to me that anything about this could be squared with most of Michael's earlier talk about modernism" [Krauss, *The Optical Unconscious* (Cambridge, MA: MIT Press, 1993), 7)].
9. Andrea Malraux, *The Voices of Silence*, quoted in Nicholas Wolterstorff, "Art, Religion, and the Elite: Reflections on a Passage from Andre Malraux," in *Art, Creativity, and the Sacred: An Anthology in Religion and Art*, ed. Diane Apostolos-Cappadona (New York: Crossroads Pub. Co., 1989), p. 262.
10. Fried's three historical studies of the relationship between painter, audience

and painting in eighteenth- and nineteenth-century France are: *Absorption and Theatricality: Painting and Beholder in the Age of Diderot* (Berkeley: University of California Press, 1980); *Courbet's Realism* (Chicago: University of Chicago Press, 1990); and *Manet's Modernism or the Face of Painting in the 1860s* (Chicago: University of Chicago Press, 1996). Fried has addressed the relationship between his criticism and art history in a thorough and convincing fashion in, "An Introduction to My Criticism," pp. 47–54.

11. T. J. Clark, "Arguments about Modernism: A Reply to Michael Fried," in *Pollock and After: The Critical Debate*, ed. Francis Frascina (New York: Harper & Row, 1985), p. 88.

12. "Art and Objecthood," pp. 163–64.

13. One might also note a deeper history that ties theory to theology, such the Greek roots that John Ruskin invokes in his use of the word *theoria* as opposed to *aesthesis* to describe an aesthetic experience that conflates the moral, theological, and beautiful. According to *The Compact Edition of the Oxford English Dictionary*, theoria means "looking at, contemplation" and "the perception of beauty regarded as a moral faculty." Ruskin writes the following in his *Modern Painters*: "The impressions of beauty . . . are neither sensual nor intellectual, but moral; and for the faculty receiving them . . . no term can be more accurate . . . than that employed by the Greeks, 'Theoretic,' which I pray permission . . . to use, and to call the operation of the faculty itself, Theoria . . . the mere animal consciousness of the pleasantness I call Aesthesis; but the exulting, reverent, and grateful perception of it, I call 'Theoria' " (New York: Oxford University Press, 1971), p. 3283.

14. See Thierry de Duve, *Kant After Duchamp* (Cambridge: MIT Press, 1998).

15. Ernest Lee Tuveson, *The Imagination as a Means of Grace: Locke and the Aesthetics of Romanticism* (Berkeley: University of California Press, 1960), p. 24.

16. Ibid., p. 85.

17. Jonathan Edwards from *A Divine and Supernatural Light*, cited in ibid.

18. Edwards cited in Perry Miller, *Jonathan Edwards* (New York: William Sloane Assoc., 1949), pp. 55–56.

19. Moritz, "Versuch einer Vereinigung aller schonen Kunste und Wissenschaften unter dem Begriff des in sich selbst Vollendeten" (heretofore, "Versuch einer Vereinigung"), p. 5; trans. by and cited in Martha Woodmansee, *The Author, Art, and the Market* (New York: Columbia University Press, 1994), p. 20. Subsequent Moritz quotes are from Woodmansee's text and are her translations. My discussion of Moritz draws heavily on Woodmansee's argument for Moritz's importance for the justification of the modern writing. For further exploration of two conflicting attitudes about the continued relevance of aesthetic disinterestedness, see my dissertation, "American-Type Formalism: The Art Criticism of Alfred Barr, Clement Greenberg and Michael Fried," PhD dissertation, University of Minnesota, 1999, p. 42, n. 91. In it, I discuss Andrew Bowie's argument for the continued importance of disinterestedness as a moment of release from instrumental logic [in his *Aesthetics and Subjectivity: From Kant to Nietzsche* (New York: Manchester

University Press, 1990)] and Robin May Schott's argument that Kantian disinterestedness is a universally exchangeable critical aesthetic judgment that parallels the development of universal economic exchange value [in her *Cognition and Eros: A Critique of the Kantian Paradigm* (University Park: Pennsylvania State University Press, first published by Beacon Press 1988, paperback 1993)].

20. Moritz, *Anton Reiser* in his *Werke I*, p. 38; cited in Woodmansee, p. 19. Interestingly, Moritz does not limit the importance of disinterestedness to the reception of works of art, but also admonishes the artist to be selflessly disinterested in how the work might bring him fame or fortune. The danger of the artist's attention falling "outside the work" results in the work not being "whole and self-sufficient," but instead in its seeking approval by pandering to its audience through crowd-pleasing effects. Placing the work of art above such easy pleasures leads to the concept of disinterestedness being associated with an elitist form of culture.

21. Moritz, "Versuch einer Vereinigung," p. 4; in Woodmansee, p. 32: "We do not need the beautiful object in order to be entertained [*ergötzt*] as much as the beautiful object needs to be recognized. We can easily exist without contemplating beautiful works of art, but they cannot exist as such without our contemplation. The more we can do without them, therefore, the more we contemplate them for their own sake so as to impart to them through our very contemplation, as it were, their true, complete existence."

22. Where Moritz's Pietism permitted a theorization of disinterestedness on theological grounds, Kant's emphasis on reason is at odds with his own Pietistic religious upbringing. German Pietism tended to personalize the individual act of faith and to make it more amenable to ecstatic visions and emotional experiences than to reasonable assertions. Kant and his followers disparaged the *Schwärmerei*, the fantasy or irrational enthusiasms, of the Pietists—unless such experiences were "disciplined by reference to Understanding" [Simpson, *German Aesthetic and Literary Criticism: Kant, Fichte, Schelling, Schopenhauer, Hegel*, ed. and intro. David Simpson (New York: Cambridge University Press, 1984), p. 11].

23. In retrospect, what is striking about the list of heretical modernists that Fried felt were leading modern art astray are their quite varied aesthetic positions: the pristine serialism of Judd, the brutish architectural forms of Smith, the postminimalist concerns of Morris. Each artist spent a great deal of intellectual energy articulating the terms of their artistic discourse, employing terms as distinct as "specific objects," "unitary forms," or "anti-form." The best analysis of Minimalist rhetoric and critical discourse available is James Meyer's *Minimalism: Art and Polemics in the Sixties* (New Haven: Yale University Press, 2001).

24. Fried, "Art and Objecthood," p. 154.

25. Fried, *Absorption and Theatricality: Painting and Beholder in the Age of Diderot*, p. 83.

26. Fried, "Art and Objecthood," p. 167. A very significant critical term for Fried, not discussed in this essay, but also important in relation to "belief," is "conviction."

27. Schopenhauer, "The Metaphysics of Fine Art," in *Essays of Arthur Schopenhauer*, ed. and trans. T. Bailey Saunders (New York: M. A. Willey

Book Co., n.d.), p. 283: "The picture, therefore leads us at once from the individual to the mere form; and this separation of the form from the matter brings the form very much nearer the idea. Now every artistic representation, whether painting or statue, is just such a separation. . . . It is, therefore, essential to a work of art that it should give the form alone without the matter; and, further, that it should do so without any possibility of mistake on the part of the spectator."

28. Edwards, in Miller, pp. 55–56.

29. This is where Tuveson leads, to the roots of the Romantic genius, divine inspiration and an artistic autonomy, which is visionary rather than practical. My interest here is in the manner in which these essentially spiritual ideas come to inform the materialist/idealist critical method of formalism. This developing sense of the autonomy of aesthetic sensation is also what permitted Kant to take the further step in proposing that aesthetic beauty is not a literal quality of an object (definable in a categorical manner) but a subjective judgment that is employed as if it were an objective observation.

30. Michael Podro, *The Manifold in Perception: Theories of Art from Kant to Hildebrand* (Oxford: Oxford University Press, 1972), p. 11; Podro's references to Kant in this passage are listed as "*K. U.*, Intro., VII, p. 190,∫ 9, 218; *First Introd.*,∫ 8, 223" and "*K. U.*∫ 8, 215."

31. David E. Wellbery, *Lessing's Laocoön: Semiotics and Aesthetics in the Age of Reason* (New York: Cambridge University Press, 1984), p. 134. Wellbery suggests that to Lessing, "the advantage of poetry is that the task of rendering the object existentially absent has already been accomplished by language. The plastic arts, however, are necessarily troubled by the brute, existential presence that characterizes their material plane of expression." This is at odds with Baumgarten and Meier for whom the paradigm of presence was "the sensate presence of the object in direct perception . . ." (ibid.). A parallel can be made here too with Addison's understanding of the imaginative experience as a "means of grace" providing spiritual sustenance, or to Johan Gottfried Herder's distinction between painting as based on sight and sculpture, which is based on touch; therefore sight, painting, and vision are "the most artificial, the most philosophical sense"; see Moshe Barasch, *Modern Theories of Art, 1: From Winckelmann to Baudelaire* (New York: New York University Press, 1990), p. 167.

32. Bowie, p. 44.

33. Schiller, *On the Aesthetic Education of Man in a Series of Letters*, cited in Simpson, p. 144.

34. Israel Knox, *The Aesthetics of Kant, Hegel, and Schopenhauer* (New York: Humanities Press, 1958; first published in 1936), p. 73.

35. Schiller, *On the Aesthetic Education of Man in a Series of Letters*, cited in Simpson, p. 144.

36. Hegel, cited in Margaret Iverson, *Alois Riegl: Art History and Theory* (Cambridge: MIT Press, 1993), p. 126.

37. Schopenhauer, pp. 283–84.

38. Fried, "Art and Objecthood," p. 166.

39. Ibid., pp. 165–66. Fried here introduces the (Kantian) concept of "interest" and equates it with objecthood.

40. Ibid., p. 167.
41. Clement Greenberg, "The Case for Abstract Art" in *The Collected Essays and Criticism: Vol. IV*, ed. John O'Brian (Chicago; University of Chicago Press, 1986), p. 81. There are notorious anecdotes about Greenberg's studio visits, whereupon he would turn his back to the work of the artist, ask them to set it up, then spin around to take the work in all at once.
42. Thierry De Duve, "Performance Here and Now: Minimal Art, a Plea for a New Genre of Theatre," *Open Letter*, N5–6 (Summer–Fall: 1983), p. 249. Fried disagrees with de Duve's characterization of his pursuing a painterly "essence" but does not refute the lineage; see Fried, "An Introduction to My Criticism," p. 45.
43. Barasch, p. 158. But Fried never uses these categories from Lessing in an absolute fashion. His essays on Jules Olitski, for example, discuss how his veils of stained colors are, apparently,

> falling slowly from approximately the upper left portion of the canvas toward the lower right. The ponderable rate of fall is important. These are not paintings that can be seen all at once—as last year's paintings cried out to be seen—or that rely on the instantaneous impact they make on the viewer. . . . [They] demand to [be] (sic) apprehended in terms of an appreciation of the visual momentum gathered by the colored flood as it moves down the canvas; and I found myself seeing the paintings slowly, as if they were making themselves by a process of flooding and staining down from the top of the canvas as I looked at them (Fried, "New York Letter: Olitski, Jenkins, Thiebaud, Twombly," p. 318).

Other examples come from *Three American Painters* (reprinted in *Art and Objecthood*, pp. 247–48). Fried makes no hard and fast "essential" distinction between the manifestness of painting and Olitski's "visual time"; neither does he make a value judgment by saying that the sense of time in Olitski is obtrusive or inappropriate. Nevertheless, Fried does so when it comes to the kind of endlessness that he perceives at work in theatrical work; quantity has changed to quality. Only art, art that remains true to its pictorial nature, can provide grace from the tyranny of successive time.

44. Addison, "The Pleasures of the Imagination," first published in *Spectator*, V411, in 1712; cited in Tuveson, p. 94.
45. Ibid.
46. Ibid., p. 97.
47. Moritz, "Versuch einer Vereinigung," p. 5; in Woodmansee, p. 19.
48. In Kant's formulation, the aesthetic permits the modern subject to transcend the disharmony of the internal struggle of his faculties. Through the judgment of the beautiful, one feels the harmonious "free play" of the subjective faculties of Imagination (sense) and Understanding (reason). Only in this state of freedom from limited personal perspectives are we capable of producing a (universally) valid (aesthetic) judgment. When the subject's faculties are held in suspension, harmonized between each other and not actively seeking knowledge, they enjoy a state of balance, harmony, and free play at knowledge; the greater the perception of beauty, the more the subject delights in his inner harmony. Kantian philosophy, then, cuts to

the core of every aesthetic response and every respondent's working out of his subjectivity. The aesthetic in the hands of Kant becomes a great restorer of the divided human subject, playing a grand role in creating harmony out of the dichotomous battle of our faculties (see Beardsley, pp. 214–15, for a summary). One might note a remarkable similarity between the Kantian subject and the Freudian one in this regard. The parallels might run something like this: Kantian Imagination/Freudian Id, Kantian Understanding/Freudian Ego, Kantian Judgment/Freudian Super ego. Later, Schopenhauer makes similar claims for the aesthetic as a healer, a realm of peace from ceaseless willing.

49. Knox, p. 73. Knox provocatively suggests that Schiller's aesthetic of "play," founded on "the Kantian free-play of faculties," was really, "in the final analysis . . . an art theory perfectly suited to the bourgeoisie of the time" (pp. 74–75).

50. Schiller originally formulates the aesthetic as the way *to* the higher unified state of the individual and of society, to the rational through the sensuous. But he gradually reveals that the aesthetic is a "constituent" of this higher state (Schiller, *On the Aesthetic Education of Man in a Series of Letters*, cited in Simpson, p. 146).

51. Monroe C. Beardsley, *Aesthetics from Classical Greece to the Present: A Short History* (New York: Macmillan, 1966), p. 229.

52. This road leads to the late-nineteenth century aestheticism of Pater, Whistler, Wilde, and the aestheticist movements lead by William Morris (Arts and Crafts), John Ruskin, Roger Fry (the Omega Workshops), and even the Bauhaus.

53. Kant's aesthetic is full of inherent contradictions. Kant balances his desire for comprehensiveness and universality with his attempt to take account of individual sensibility; his ego-centric subject, appreciating art for how it stimulates his own faculties is, however, required to be selfless and disinterested. For these and other reasons, Israel Knox calls Kant's aesthetics an "aesthetics of paradox." Knox lists Kant's paradoxes as follows: judgment that is universal yet subjective, art that is purposive without purpose, the necessity of judgment that is exemplary but not apodictic, pleasure that is abstract, beauty without content, and the sublime in nature that violates natural form (Knox, p. 32). These core paradoxes indicate not only the complexity of Kant's thinking and the late-eighteenth century aesthetic theories following him, but also the significant tasks to which he and others put beauty and the aesthetic.

54. Max Horkheimer and Theodor W. Adorno, *Dialectic of Enlightenment*, tr. John Cumming (New York: Continuum Publishing Company, 1989); original edition *Dialektik der Aufklärung* (New York: Social Studies Association, 1944), pp. 18–19.

55. Perry Miller, quoting Edwards's journals in *Jonathan Edwards*; cited in Fried, "Art and Objecthood," p. 148. Miller goes on to make a statement at the end of his book on Edwards that Fried must have found compelling: "Truth is in the seeing, not in the thing" (Miller, p. 330).

56. Fried, "Art and Objecthood," p. 167.

HOW SOME SCHOLARS DEAL
WITH THE QUESTION

James Elkins

The following essay is excerpted from the book The Strange
Place of Religion in Contemporary Art (2004), *which precedes
the event that is recorded in this book, and goes in different
directions.* The Strange Place of Religion in Contemporary
Art *is more about contemporary art practices that don't reveal
their religion, or don't admit it.*

In 1999 Sister Wendy Beckett judged an international competition
called *Jesus 2000*, in order to find the best image of Jesus for the
millennium.[1] There were over a thousand entries from nineteen
different countries. Sister Wendy's pick for the winner was Janet
McKenzie's *Jesus of the People*, a painting of Christ as a Black man.
Christ's body had been modeled from a woman's body, and McKenzie
painted three symbols in the background: a halo, a yin-yang, and a
feather. (Sister Wendy thought the feather was a sheaf of wheat or a
lance, but McKenzie intended it as a feather, symbolizing either
"transcendent knowledge" or "the Native American and the Great
Spirit."[2]) The contest was written up in newspapers across the coun-
try. One report I saw appeared in the Corpus Christi, Texas *Caller-
Times:* it describes a local woman's entry, which was a depiction of
Jesus as a middle-aged man wearing a baseball cap, standing on a
country road with a dead-end sign in the background.[3] The artist

explains that she first modeled her figure of Jesus on a homeless man, then gave him her father's body, her own hair, and her daughter's nose. In the newspaper, the painting is presented as a touching act of devotion, but it is out of the question as art.[4]

I think the conclusion of this history has to be that fine art and religious art have gone their separate ways. The distinction can be made visible in many ways. In Berkeley, for example, the Graduate Theological Union sits beside the University of California. The Faculty of the GTU and the Art History Department have amicable relations, but the purposes of the two institutions, and their understandings of art, are radically different. Students in the Theological Union study for religious vocations, and they tend to be interested in art as a spiritual vehicle. Students in the Art History Department are preparing for careers as college professors and curators, and when artworks happen to be religious they take note of the fact just as they would if the art were politically oriented, or concerned with gender, or of interest for its recondite allusions—the religious content is just one more thing to study.

Outside the university, the difference between fine art and religious art can be seen by visiting people's homes. An observant Christian family in suburban America is likely to have religious paintings, posters, and statuettes around the house, mixed in with paintings and sculptures that are displayed as artworks. The two kinds of images are thought of differently, and bought in different places. The artworks in the house are likely to be reproductions of images studied in university and college courses on art history. A house might have a poster of Jean François Millet's *Angelus* in one place, and a print of the Sacred Heart in another. A few images cross over, and work as both art and religion—especially the popular painting by Rosso Fiorentino called *Musician Angel*, and for an earlier generation, Raphael's *Sistine Madonna*. Those exceptions aside, the religious images are unlikely to be found in college curricula, because they are not considered part of the world of art.

As a rule: ambitious, successful contemporary fine art is thoroughly non-religious. Most religious art—I'm saying this bluntly here, because it needs to be said—is just bad art. Virtually all religious art made for homes and churches is poor and out of touch. That is not just because the artists happen to be less talented than Jasper

Johns or Andy Warhol: it is because art that sets out to convey spiritual values goes against the grain of the history of modernism. People in my profession consider such things as *Jesus 2000* untouchable. Some scholars who study visual culture might be interested in the *Jesus 2000* contest because it is part of a widespread phenomenon in popular culture. That sociological approach avoids the problem of the art's quality and importance in order to consider it, dispassionately, as a fact of contemporary life. I can imagine some art critics becoming interested in McKenzie's painting because it is "so bad it's good"—that is, it conforms to Susan Sontag's original definition of camp.[5] For the most part *Jesus 2000* has no place in contemporary academic thinking on art.

There are a few art critics and art historians who write about religion and spirituality. Suzi Gablik, Donald Kuspit, Joseph Masheck, and Robert Rosenblum approach the subject from different perspectives, but they have each affirmed importance of spirituality in art, and the necessity of distinguishing spiritual from religious art.[6] Masheck, in particular, is vexed by the artworld's secularism and by Catholicism's conservatism.[7] It is far more common to find scholars writing as neutral observers of past religious practices. For a mainstream art historian studying Titian, the religious content of the painting is a matter of academic interest, because it tells us something about Titian's ideas about painting, and about his patrons' expectations. An art historian would not normally consider whether Titian's enormous *Assumption of the Virgin* might in some sense be a picture of heaven as Titian believed it to exist. Given the sophisticated and often cynical intellectual climate of Titian's Venice, it seems terribly unlikely that Titian could have thought that heaven is occupied by rows of saints in elegant ochre and vermilion robes. But his paintings do seem to profess faith, at least in the sense that they are evidence he believed painting could be adequate to the task of depicting faith. An art historian would normally say such questions about Titian's faith are unanswerable, and that what matters is the way that the *Assumption* was received, and how the subject is handled in the painting. This is not to say there is a lack of scholarly books on religious art. Books such as *Divine Mirrors: The Virgin Mary in the Visual Arts* can be elaborately sensitive to religious meanings, but they are not themselves religious: they chronicle other people's beliefs with the same

scrupulous sympathy and intellectual detachment that you might give to someone explaining his own religion. Hans Belting's *Likeness and Presence*, perhaps the best book on the slow disentangling of art and religion, is not itself a religious book: it makes no judgments on art or religion.

Religion is even further from art history's understanding of modern and postmodern art. I think the people who avoid talking about religion together with contemporary art are absolutely right. I couldn't agree more with the ferocious observation made by the art historian T. J. Clark, that he doesn't want to have anything to do with the "self-satisfied Leftist clap-trap about 'art as substitute religion.' " Clark is right because serious art has grown estranged from religion. Religious artists aside, to suddenly put modern art back with religion or spirituality is to give up the history and purposes of a certain understanding of modernism. That separation is fundamental for a number of art historians. Karl Werckmeister has said that even Clark "relapses into a romantic, middle-class penchant for substituting art for religion" by juxtaposing a story about the modernist alienation of art and reality with a nostalgic glimpse to a previous period in which religion was preeminent. In other words: just by putting the two themes together on a page Clark betrays the "middle-class" nostalgia that he works so hard to think through, if not to finally extinguish.[8]

And yet there *is* something religious or spiritual in much of modern art. Somewhere John Updike calls modern art "a religion assembled from the fragments of our daily life," and I can see the truth in that notion, just as I can agree with Clark. "[I will have nothing to do with] that self-satisfied leftist clap-trap of 'art as substitute religion' "—this is discussed in the seminar.) Yet it does seem awkward to be unable to speak about the religious meaning of works that clearly have to do with religion. The first generations of abstract painters, for example, were full of spiritual and religious enthusiasms. Current scholarship on Mondrian, Malevich, Kandinsky, and others tends not to focus on their theosophy or their mystical beliefs as much as on their philosophic theories and their senses of history. But how far is it possible to go without the quirky, apocalyptic, and messianic notions that drove first-generation abstraction? Clark does say that he would like to find out how "God is Not Cast Down" by modernism (the quotation is the title of an essay by the

painter Kasimir Malevich), but he does not come close to speaking about it.

It has proven difficult to write sensibly about modernism and religion. The French political historian Alain Besançon, who has written a history of divine images from the Greeks to Mondrian, tends to draw on philosophy rather than art history for his explanations. He knows it is a problem, but it seems inescapable. "It is not necessary to refer to Hegel and Kant to understand modern art," he says; but he finds it very difficult to break the habit, and his book is really a history of Plato, Plotinus, Augustine, Calvin, Pascal, Kant, Hegel, and Schopenhauer, and only incidentally Cézanne, Picasso, Mondrian, and Kandinsky.[9] Other writers draw on theology for their explanations: the Protestant theologian Paul Tillich, for example, saw modernism through the lens of religious doctrine.

There are signs that the secularization theory of modernity might be losing its grip. Scholarship on American art in particular has recently become more open to religious meanings. Sally Promey, Kimberley Pinder, David Morgan, and others have been exploring religious meanings in American art, and some European scholars have been following suit.[10] One of the few texts written from a European perspective on the subject of religious meanings in modern art is Thierry De Duve's *Look, One Hundred Years of Contemporary Art*.[11] Near the beginning De Duve raises the problem of looking at work that would—if it weren't modern—be considered as religious art. His example is Manet's painting *Dead Christ and the Angels*, painted in 1864.

De Duve takes note of several religious inconsistencies in Manet's painting. A rock in the foreground records a reference to the Gospel according to St. John, 20, where Mary Magdalene looks into Christ's tomb and sees two angels where Jesus' head and feet had been. In the painting, Jesus is still there, and as De Duve notes, his eyes are slightly open. In art historical terms, the picture is a combination of four moments that are usually depicted in separate paintings: the episode in John 20; the Dead Christ, which was depicted by Hans Holbein and others; the Deposition, in which the body of Jesus is brought down from the cross; and the Pietà, in which Mary holds the dead Jesus, sometimes with angels in attendance. Because Jesus' eyes are open, the painting also refers to a half-dozen episodes in which

the resurrected Christ appears to the Magdalene and the Apostles.[12] Hence painting may compress over ten overlapping episodes: it is not possible to make an exact count. A list of the nearest sources would be enough to secure an art-historical analysis of the painting. The *Dead Christ and the Angels* would be an innovative attempt to make a single painting out of several religious narratives.

De Duve wants to know what meaning this experiment in religious meanings might have *as painting*. "The best modern art," he says, "has endeavored to redefine the essentially *religious* terms of humanism on *belief-less* bases," and he cites Kasimir Malevich's abstract painting *Black Square on White Ground* as an "inoculation" of the Russian icon "with a vaccine capable of preserving its human meaning" for a period when the faith in God could no longer sustain human meaning.[13] That kind of formula follows from the observation that "faith, for us, has become a private matter to be settled according to individual conscience. And religious practice is no longer the social mortar it once was." I do not want to subscribe either to that assumption about faith or to the interpretation of Malevich that follows from it, because I would rather leave those large questions open. (In the terms I am setting out here, the "private matter" of faith is spirituality, and the "social mortar" is religion.) But I cite De Duve's assertion in order to introduce the very interesting conclusion that De Duve then draws: he says that "only the beholder's gaze can bring back life" to this "Christ touched by loss of faith and despair." So, leaving aside the possibility that the painted figure is "touched by loss of faith and despair," in what sense, exactly, can the "beholder's gaze" restore the painting's religious meaning?

It is certainly true that in the context of the Salon where it was first shown, Manet's painting was not religious. It was a work of art, "offered to the hordes jockeying their way into the Salon to see some art, pass the time, be seen and flaunt their attire, and, in the best scenario, brush up on culture a little, maybe even to seek out the soul which the materialism of modern life has deprived them of—but definitely not to perform their devotions." The best of the viewers would perhaps stop and really look, and begin to "wonder about the Christ in this astounding painting, [saying] 'Perhaps he's in the throes of rising from the dead under the wings of two attendant angels.' As if the mere willingness to let oneself

be visually touched by the picture were tantamount to an act of faith."[14]

That's it, in that last sentence: the idea that merely looking, and allowing yourself to be moved, might be an act of faith that answers what the painting proposes. Such a viewer no longer asks what Manet was trying to do by conflating a half-dozen particular episodes in the life of Christ. What matters is only to notice that the painting does not behave itself in a proper religious or art-historical manner: that is enough to signal that something else is going on, that Manet was trying to do something *in painting*, and not in doctrines.

"Belief or non-belief in the Gospel doesn't play much of a role in the judgment of the critics of [Manet's] day," De Duve continues. "Cultural habit and mental sloth, on the contrary, do play quite a considerable part. We think we're seeing a church painting because that's just what it looks like, and that's enough to stop us from asking what meaning a church painting, *painted for a Salon*, might have."[15] It seems right to say that the uncanny power of the "still dead gaze which stares deep into our eyes" provokes a "doubt" about the usual ways of interpreting religious pictures. I am not as sure about De Duve's conclusion that the doubt "becomes the vaccine against the loss of faith," although it does seem plausible that it might be, as De Duve says later in the book, "the vaccine for loss of faith in art."[16] What happens, I think, is less dramatic and more abstract. Looking at Manet's painting, you realize that the concatenation of Biblical references is not the point: the point must therefore be that the concatenation itself is intended to provoke the thought that painting has to re-make religious meanings *as painting*. "We cannot separate faith in God from faith in painting . . . as easily for the nineteenth century as we think we can nowadays," and Manet's painting does ask for an act of faith in both: the painting makes us ask how much we might have faith in the painter, or in painting, and that leads, by a subtle thread, to faith in religious meanings that might be communicated *only* in painting, or only in this painting.

There is so little writing on this subject that it feels odd to keep going. Certainly the argument I am extracting from De Duve's book does not work as orthodox theology: you can't make a collage out of a holy narrative and expect that it will result in a truth that fits together. Nor is it clear what can be meant by a religious truth that

can be expressed only *as* painting. In past centuries, religious truths were expressed *in* painting, meaning with the help of painting, or simply using painting.

In order to believe that Manet's idiosyncratic picture can function as a "vaccine" against what De Duve calls the "loss of faith," you have to subscribe to his assertion that "faith, for us, has become a private matter to be settled according to individual conscience." Such a faith could, I suppose, be reinstated by the "vaccine" of painting. Without De Duve's assumptions about the erosion of religion and the rise of private "faith," the painting cannot operate that way. What it can do is tentative and tenuous: it can provoke thoughts about how modern painting might address religion by putting itself in question. What is the *Dead Christ and the Angels*, exactly? It is a modernist painting, but one that risks undoing itself in order to have something to say about religion through or as painting. It is not at all clear what the painting does say: certainly not "Religion can be continued in, or as, painting." Perhaps it says something about how the thought of Christ's resurrection appeared, to one painter in the middle of the nineteenth century, when it came to mind as a single image. It is terribly difficult to push on from here, and say what has happened to the half-dozen episodes that the painting conflates, or what the painting may have done to other contemporaneous religious paintings. (Has it made them seem to be less about painting? Can the *Dead Christ and the Angels* also propose what kinds of painting about religion might come next?)

You may or may not choose to follow this path: but it seems unarguable to me that only "cultural habit and mental sloth"—and here it is necessary to include most of the routine identification of Biblical sources in conventional art history—can account for the impression that Manet's painting is *not* problematic, that it doesn't raise difficult questions of religion and painting.

I think De Duve's is the best recent attempt to think seriously about religious meaning in modernist art. Anything short of it would capitulate to easier solutions: "Faith in art is reborn out of doubt," or "Religion can be continued in, or as, painting," or "Art historical studies of Manet's sources bring us as close as we can reasonably get to what he intended." In Manet's painting *something* has happened between religion and art: painting has not exactly contradicted

religion, or quite absorbed it, or recreated it, or identified with it. The case is harder to solve than that.

Notes

1. *Jesus 2000*, special issue of the *National Catholic Reporter*, December 24, 1999, edited by Michael Farrell.
2. *Jesus 2000*, p. 7, has statements by Sister Wendy and Janet McKenzie, contradicting one another on this point. Neither the artist nor Sister Wendy refer to the figure as a Black man; Sister Wendy says the painting is "a haunting image of a peasant Jesus—dark, thick-lipped, looking out at us with ineffable dignity"; and McKenzie does not characterize her figure, except to say that together with the symbols he is intended to convey the idea that "Jesus is in all of us." Ibid.
3. Greg Bischof, "Artist Depicts Christ for New Millennium," Corpus Christi *Caller-Times*, January 1, 2000, D11.
4. Her work is available on the Internet at www.bridgebuilding.com/catalog/jm1.html.
5. Sontag, "Notes on 'Camp,' " in *Against Interpretation* (New York: Dell, 1969), pp. 275–92.
6. Kuspit is perhaps the best example of how a widely-published writer can still be ostracized by the academic community when the work is seen to depend too much on issues of religion or spirituality. See Kuspit, "Reconsidering the Spiritual in Art," *Art Criticism* 17, no. 2 (2002): 55–69, a position paper on modernism as spiritual crisis, taking Kandinsky as a model and example. Robert Rosemblum's writing on spirituality can be approached through his *Modern Painting and the Northern Romantic Tradition: Friedrich to Rothko* (New York: Harper, 1975).
7. See his critique of Catholicism's spurning of abstraction in "Abstract Art and Religious Belief," *America* 168 (1992): 114–19. In that essay he asks why "our church and people, so de-Tridentified in other respects, cling to a fundamentally Counter-Reformational, now naïvely pictorial-naturalistic sense of painting and sculpture" (Ibid., p. 114.) For the art-world perspective, see Masheck, "Iconicity," *Artforum* 17 (1979): 30–41; and Masheck et al., "Crucifomality," *Artforum* 15 (1977): 56–73. He has expressed his alienation from the secularized art world on several occasions. "My only disappointment as editor [of *Artforum*]," he wrote in 1993, "was the cynical derision that met any religious reference." Masheck, "Yours Faithfully, Joseph Masheck," *Artforum* International 32 (1993): 124. I thank Ed Schad for bringing Masheck's essays to my attention.
8. Karl Werckmeister, "A Critique of T. J. Clark's *Farewell to an Idea*," in *Critical Inquiry* 28, no. 4 (2002): 855–67, quotation on p. 864. Werckmeister's argument depends on Clark's reading of a passage in Hegel's *Phenomenology of the Spirit*; my own sense is that Clark's treatment of Hegel is too allusive to make it certain that Werckmeister's reading has any purchase. It is instructive to compare Karsten Harries' review of Clark's book, because Harries argues that modern art achieves transcendence through matter and material. "What is being transcended" in passages of

apparently pure nonrepresentational paint, Harries writes, "is the reach of our concepts and words." In my reading, Harries' formulations are too quick: they fail to take notice of the fact that the material's very resistance is what gives the art its grip on the modernist imagination. Harries, review of Clark, *Farewell to an Idea*, in *The Art Bulletin* 83, no. 2 (2001): 358–64, quotation on p. 360.

9. Besançon, *The Forbidden Image: An Intellectual History of Iconoclasm*, trs. Jane Marie Todd (Chicago: University of Chicago Press, 2000), p. 221, and cf. p. 229.

10. The quotation is from Promey, "The 'Return' of Religion in the Scholarship of American Art," *Art Bulletin* 85, no. 3 (2003): 581–603, quotation on p. 598. See also Pinder, " 'Our Father God; Our Brother Christ or Are We Bastard Kin?': Images of the Suffering Christ in African American Painting, 1924–45," in *African American Review* 3, no. 2 (1997): 223–33; and Morgan, *Protestants and Pictures: Religion, Visual Culture, and the Age of American Mass Production* (New York: Oxford, 1999).

11. De Duve, *Look, One Hundred Years of Contemporary Art*, trs. Simon Pleasance and Fronza Woods (Brussels: Ludion, c. 2000).

12. De Duve suggests Manet might have read Ernest Renan's *Life of Jesus*, published the year before, which proposed a human Jesus is sufficient for Christianity. De Duve says there is no evidence Manet knew the book, but even if he did, the painting's range of references is wider than Renan's humanized Jesus. De Duve, *Look*, p. 13.

13. Ibid., p. 14. I have paraphrased this. What De Duve actually says is "[Malevich] was inoculating the tradition of the Russian icon with a vaccine capable of preserving its human meaning, for a period which faith in God could no longer keep alive": but in that sentence, the antecedent of "alive" is "period," implying faith could not sustain the period. I take it he means faith couldn't sustain "human meaning."

14. Ibid., pp. 14–15.

15. Ibid., p. 15.

16. Ibid., pp. 18, 27. Compare the reading by Joan Copjec, in the essay "Moses the Egyptian and the Big Black Mammy of the Antebellum South: Freud (with Kara Walker) on Race and History," in Copjec, *Imagine There's No Woman: Ethics and Sublimation* (Cambridge MA: MIT Press, 2002), pp. 82–107, especially p. 104, where she argues that, "De Duve's critical argument . . . is that it is not as God but as man that Christ will resurrect himself." My reading of De Duve's text is at variance with Copjec's.

RELIGION AS MEDIUM[1]

Boris Groys

In our present post-Enlightenment culture, religion is generally understood to mean a collection of certain opinions. Correspondingly, religion is usually discussed in the context of a demand for a freedom of opinion guaranteed by law. Religion is tolerated as an opinion so long as it remains tolerant and does not question the freedom of other opinions—that is to say, as long as it makes no exclusive, fundamentalist claim to its own truth. Thus religion seems to be in a quite comfortable situation. It is no longer, as it was in the dark times of the radical Enlightenment, criticized, ironized, or even combated in the name of scientific truth. Rather, scientific truth itself has since acquired the status of mere opinion. At least since Nietzsche, and especially thanks to Michel Foucault, we now know that the claim to scientific truth is dictated primarily by the will to power, and it must, therefore, be deconstructed and deterred. Scientific opinions circulate in the same media and in the same way as religious opinions. Opinions in both cases come to us as news that is disseminated by the mass media. Sometimes we read about a new apparition of the Mother of God; sometimes we read that the earth is getting warmer. Neither piece of information can be tested directly by those who hear it. The experts always disagree in such cases. Hence either bit of news can be believed or not.

Consequently our culture today knows no truths, be they of

religious or scientific nature, but only opinions, whose dignity is, however, inviolable, because it is protected by law. The various opinions are either shared or rejected by autonomous citizens. Thus the value of an opinion can be measured precisely by determining how many people share it. The market of opinions is constantly being studied, and the results of this research tell us which opinions belong to the mainstream and which are marginal. This data offers a reliable basis for each individual's decision on how he or she wishes to draw up the budget of his or her opinions. Those who wish to be compatible with the mainstream will adopt opinions that are either already part of the mainstream or have a chance to become so in the near future. Those who prefer to be thought of as representatives of a minority can seek out a suitable minority. Those who speak of a revival of religion today clearly do not mean anything like the second coming of the Messiah or even that new gods and new prophets have appeared. Rather, they mean that religious opinions have moved from marginal zones to the mainstream. If that is true, and statistics seem to confirm that assumption, then the question arises: what could have caused religious opinions to become mainstream?

The survival and dissemination of opinions on the free market is regulated by a law that Darwin formulated: the survival of the fittest. The opinions that are best adapted to the conditions under which they are disseminated will automatically have the best odds of becoming mainstream. The market of opinions today, however, is clearly dominated by reproduction, repetition, and tautology. The standard diagnosis of today's civilization is that, over the course of the modern age, theology was replaced by philosophy, an orientation toward the past by an orientation toward the future, tradition by subjective evidence, fidelity to origins by innovation, and so on. In fact, however, the modern age was not the age in which the sacred was abolished but the age of its dissemination in profane space, its democratization, its globalization. Once ritual, repetition, and reproduction were matters of religion; they were practiced in isolated, sacred places. In the modern age ritual, repetition, and reproduction have become the fate of the entire world, the entire culture. Everything reproduces itself—capital, commodities, technology, art. Even progress is ultimately reproductive; it consists in a

constantly repeated destruction of everything that cannot be repro-
duced quickly and effectively enough. People like to talk about inno-
vation and change, but in fact they are referring almost exclusively to
technological innovations. Innovation in the realm of opinion can occur only if people not
only believe it is possible to recognize the truth but also expect it,
strive for it. As noted above, however, our post-Enlightenment cul-
ture does not believe in truth. Truth claims are seen as advertising
gimmicks, as a pushy and hence disagreeable sales strategy, as decep-
tive packaging par excellence. Or worse: as totalitarian coercion, as
an order to share an opinion even if one doesn't really want to, as an
insidious attack on freedom and the dignity of the consumer. Under
such conditions religion clearly has better odds to succeed on the
market of opinions than philosophy or science does, for two reasons.
First, the historical religions are established brands. For that reason
alone they are more effective at reaching people than philosophical or
scientific doctrines. Whatever people might say, Christ, Muhammad,
and the Buddha are genuine superstars. Not even Plato or Descartes
can measure up to them, to say nothing of today's philosophers. If
you want to succeed on the market of opinions, you are thus well
advised to appeal to the founders of religions. The universities still
bristle at this, but it is only a matter of time before they abandon their
resistance.

There is, however, another—if you will, deeper, weightier—rea-
son to turn to religion. Religion can indeed be seen as a certain set of
opinions, to the extent this refers to the role of religion in profane
space. There, religion is associated with opinions about whether con-
traception should be permitted or women should wear headscarves.
All religions, however, have another space: sacred space. And reli-
gions have a different attitude toward this space—namely, the view
that it is the space of a lack of opinion, of opinionlessness. For the
will of the gods or God is ultimately hidden to the opinions of mor-
tals. And that means that while people in our culture are first and
foremost holders of certain opinions, religion is a place where this
task, this mediality of human beings is reflected on—and precisely
because religion marks and describes the state of opinionlessness, the
zero level of freedom of opinion. Just as Kazimir Malevich's *Black
Square* symbolized this for the medium of painting, because it caused

all figuration to disappear, so the sacred places of religions are the places where the mediality of the human being can be thematized, precisely because they are places where people lose all their opinions and find themselves once again in a state without opinions. As men without opinions, they practice repetition tout court, that is, the kind of repetition that is no longer repetition of a certain opinion but rather a ritual of the opinionlessness. That is what the hero of Andrei Tarkovsky's film *Nostalgia* does when he finds himself in a state of a total lack of opinion; he begins by going back and forth on the same path. This path does not by any means bring the hero forward— however "forward" might be meant here. Rather, by so doing the hero connects to the movement back and forth whose very radically solitary, inescapable repetitiveness marks him as a medium of this lack of opinion.

The experience of a lack of opinions, which is a genuinely religious experience, is not necessarily tied to certain places, however. This situation of a lack of opinions is a much more common and more ordinary experience than is usually assumed. Such an experience occurs, for example, when people are confronted with a situation in which all existing opinions fail. The same situation can, however, also arise when people no longer want to have opinions, when they have definitely had enough of opinions as such, the market of opinions, and the creation and dissemination of opinions. When they suddenly notice that all existing opinions cancel one another out. Then they find themselves on the zero level of freedom of opinion again—and become conscious of their own mediality. The freedom of opinion becomes the abandonment of opinion: people are equally free of all opinions, all opinions equally abandoned. What are they to do then? How are they to react to this state of the complete abandonment of opinion? Religion and philosophy offer different answers to this question, or so it seems at first. Philosophy believes that in such cases people have to invent a new opinion, a new truth, to lead them out of the state of opinionlessness. Religion, by contrast, considers such a reaction too superficial and optimistic, because a person who thinks in religious terms anticipates from the outset the next step in which the new truth is absorbed by the market of opinions. Instead, religion offers another solution: insisting on this lack of opinion, connecting to the long history of the absence of opinions

that is, ultimately, the history of religion. Religious people are not people of opinions, representatives or producers of opinions; rather, they are media people, people as media. Caring for the lack of opinion—whether of individuals or a collective—demands a special place, a heterotopia, as Foucault called it. This is a place outside the space of opinion, outside the market of opinions. There the distinction between true and false and between good and evil is neutralized. But that is precisely what makes so distinct the line between the quotidian market of opinions and a sacred lack of opinions. Those who advocate certain opinions can easily position themselves in public space. Those who insist on a lack of opinions, however, need a different space, namely, a sacred space, and another time, the repetitive time of ritual. Thus it is also inevitable that they connect to certain places in rituals that in the past were defined as other, sacred places, as heterotopias. Those who enter such spaces and participate in such rituals leave their opinions at the coatroom by the door. The space of the temporary suspension of all opinions needs an outer boundary in order to guarantee its freedom *from* opinion.

Hence this lack of opinion is first and foremost conservative. It remains the same through time, whereas opinions change with time. The resulting aversion to all possible opinions often seems intolerant and even irrational, because it is difficult to justify rationally. The question is often asked what it really means to want to be religious. What objectives are set? What opinions does one want to assert? The answer is: to finally be rid of objectives and opinions altogether. Or, to put it another way, to find oneself, to free oneself from the obligation to have opinions, the servitude to opinions and objectives—to celebrate one's pure mediality, one's pure ability to reproduce and be reproduced. Now, however, it gets difficult when the traditional sacred places are lost, when the reflection on one's own mediality no longer has a place or time. At that moment the effect of the religious impulse is no longer conservative but instead extremist. Because when sacred spaces are lost or go unprotected, they have to be created by force. A piece of territory has to be reclaimed from the global market of opinions in order to create another space, a heterotopia. Then one subjects oneself to violence and transforms one's own body into a site of the sacred, a place of

the silent, repetitive martyrdom, as happens, for example, in Mel
Gibson's film *The Passion*. Or the cross is used as a weapon, as in
Roberto Rodriguez's film *From Dusk till Dawn*, to defend the human
body, which is also shown as a silent body, as a place of indifference
and boredom with respect to all conviction or ideology—as a body
beyond all opinion.

Thus to the extent that religion is the site of a revelation of the
mediality of humanity, religion can be understood as the avant-garde
of our present world, determined as it is by the mass media, just as
the artistic avant-garde functioned as the revelation of the mediality
of art. Yet the interest of the mass media in religion is not simply a
theoretical one, for the revelation of the mediality of human beings
is also an event, a piece of new, that can and should be communi-
cated. Without the mass media this news would be suppressed; the
revelation would remain secret. Sites of the sacred are by definition
closed, hidden, dark places. And there are still such places in our
globalized world. First, they include the still well protected sites of
traditional religions. Second, ever-new sites are emerging: of secret
conspiracies, violent separations from the general public, places of
dark individual and collective ecstasies.

These places incessantly draw the attention of the media,
because it is precisely the hidden, closed, dark, and marginal that
interests today's media. The media are quite naturally striving to
bring the hidden and marginal to the light of the general audience.
That is why the media are repeatedly fascinated and provoked
by the inaccessibility of sacred rituals. For decades there have been
novels written and films made about the secret love affairs of priests.
Today it seems the da Vinci code has been cracked once and for
all, finally making Christ himself a star, a celebrity, who of course
cannot be thought of as such without a disclosure. The mass media
are constantly to outdo revelation by disclosure—and in doing so
they demonstrate their essential repetitiveness. The greatest oppor-
tunity open to the mass media is a new good message, a new good
news, which is that things are announced to the mainstream that
were once marginal and hidden. It is constantly writing a new
gospel that may perhaps contradict the old gospel on the level of
opinion but nonetheless repeats the familiar ritual of revelation.
The machinery of disclosure in the mass media today is merely the

technical reproduction of the religious ritual of revelation. Religion is an urmedium that always celebrates its return when news is disseminated and believed.

Note

1. Translated by Stephen Lindberg.

MARY WARHOL/JOSEPH
DUCHAMP

Thierry de Duve

I'll take things from where they were left—at least for me—at the
end of the conference organized by Karl Lüdeking two and a half
years ago with and around Arthur Danto, where a group of us
discussed his last book, *After the End of Art.*[1] Essentialism versus
anti-essentialism in matters of aesthetics was one of the topics that
regularly cropped up at this conference. I myself remember having
professed radical agnosticism in the matter, while Danto maintained
his own very special and well-known brand of essentialism. Towards
the end of the conference, Martin Seel said that after all, he had to
agree with Danto's pivotal thesis from *The Transfiguration of the
Commonplace*, namely, that aboutness and embodiment were the two
necessary and sufficient conditions for art. He added: perhaps there is
not a third. He said this very abruptly, as if something had suddenly
clicked in his mind that made him yield to the definitiveness of
Danto's minimal definition of the essence of art. Then and there, I
yielded too. Perhaps it was Martin Seel's peremptory tone of voice
that stopped me and made me wonder if, after all, Danto had not got
it right. Letting go of my previous agnosticism, I became suddenly
willing to admit that aboutness and embodiment might indeed be
the only necessary and sufficient conditions defining art as such.
What helped me was that I understood, then and there, that I could
translate Danto's words into words that I had already pondered on

for a while. Aboutness I translated as reference, and embodiment as incarnation.

My sense of reference in connection with a theory of art would be too long to explain here. Suffice it to say that in the sentence "this is art," used as an aesthetic judgment, the word "this" is a pointer *referring* to some object, and that the word "art" is also a pointer, *referring* to the collection of objects the speaker has already baptized as art in previous aesthetic experiences. Hence my little one theorem-theory: art is a proper name. (In other words, so far as art is concerned aboutness is extensional, not intentional.) Some small consequences of this theory will transpire from what I'm going to say later when I will refer to specific objects, but reference is not my topic in this paper. Incarnation, on the other hand, is. Arthur Danto can tell us why he rarely uses incarnation to mean embodiment, though he sometimes speaks of enfleshment and sometimes lets the religious background of this problematic come to the fore. Meanwhile, I'll take my clues from something else that happened at the same conference, something that Boris Groys asked that day: "Why is the distinction between a work of art and a mere object indiscernible from it so important?" There is a parallel, he said, between Danto's analysis of works of art and Kierkegaard's analysis of the figure of Christ, who, Kierkegaard reminds us, is the first God indiscernible from a man. The question of indiscernibility—Danto's main one—is thus not a philosophical but rather a theological, more precisely, a Christologi-cal question. With wry humor, Boris proceeded to tell us that Christ's second coming had taken place in the shape, indeed in the body, of a Brillo Box. That was a stroke of genius if I ever witnessed one. I shall adopt his argument in a moment before I take it elsewhere, hoping to keep the humor on the level.

There is an apparently minor point in what Boris said that day where I might part with him. Concluding his exposé of Christ's second coming in the body of a Brillo Box, Boris said that this repre-sented the fulfillment of Protestant theology. He probably said this because of Kierkegaard, but it didn't have the ring of truth as far as I was concerned. Indeed, two things struck me that day, or perhaps a little later. The first is that Warhol was a Catholic, the second that Boris Groys, if not an Orthodox himself, comes from a country and a culture where the Orthodox religion is dominant. For him to speak of

the fulfillment of Protestant theology with respect to Warhol seemed doubly odd, especially in view of the fact that Protestantism is so damn iconoclastic. When dealing Christologically with incarnation, the Byzantine *Bilderstreit* is the obvious place to go. We don't need Warhol for that. The history of Western painting is inextricably intertwined with that of Christianity, whose novelty vis-à-vis Judaism, from which it stemmed, is that it is precisely a religion of incarnation. The culminating if not the founding moment in this intertwined history took place in Byzantium in the eighth and ninth centuries, with the quarrel of iconoclasm. Then and there, a theory of the image was laid down by the iconodules or iconophiles, which was one with the Christian doctrine of incarnation, and would become the ground for the Church's visual propaganda while protecting the faithful from the temptation of adoring idols. In a nutshell: just as God the Father gets incarnated in his Son, so his Son gets incarnated in the icon. The analogical structure of this equation, which can be written as:

$$\frac{God}{Christ} = \frac{Christ}{Icon}$$

forbids that a direct equation (God = Icon) be drawn, thereby preventing that the icon be confused with an idol. Whereas, on the left side of the equation, God the Father and his Son consubstantially share their divine nature, no such consubstantiality exists on the right side of the equation. The passage is merely analogical or, as Nicephorus would have stated it, "economic." (Nicephorus was the great theoretician of images, writing in the aftermath of the council of Nicea II, 787.) Such is the iconophiles' defense vis-à-vis the accusation of idolatry leveled against them by the iconoclasts. As Marie-José Mondzain has convincingly argued, it is the Western, not the Eastern—that is, the Catholic, not the Orthodox—part of the ex-Roman Empire that drew all the consequences of the Byzantine theory of the image.[2] When we speak of incarnation in the strongest sense from within the Western, Catholic tradition of painting, we inevitably attach this Christological dimension to it, however forgotten or repressed it has become.

It is definitely to Boris Groys' credit to have pulled the repressed out in the open regarding Warhol's Brillo Box. Kierkegaard and the

fulfillment of Protestant theology notwithstanding, what Boris has done, it seems to me, is actualizing the Byzantine formula of the "economy" of images to make it fit what remains of a catholic tradition in post-Nietzschean times—I mean times for which nihilism is the true religion. Indeed, let's look at what the formula becomes in Boris' account:

$$\frac{\text{Christ}}{\text{Man}} = \frac{\text{Man}}{\text{Brillo Box}}$$

The formula's structure is the same: whereas, on the left side of the equation, Christ and Man consubstantially share their human nature, no such consubstantiality exists on the right side of the equation. The box is a mere object, indiscernible from the commodity which is its counterpart at the supermarket, just as the icon is a mere wooden board covered with paint, indiscernible from an idol. To "see" the difference is not to believe that humanness has somehow magically come to reside inside Warhol's Box any more than it is to believe that divinity resides in the icon. Because the difference is invisible, it was all too easy for the iconoclasts to accuse the iconophiles of entertaining such a belief and of adoring idols, which is why the iconophiles had to reply with their elaborate "economic" theory. Today's equivalent of the iconoclast is the Marxist art critic who accuses Warhol of worshipping commodity fetishism and, again, I think we can credit Boris for having revived and actualized the apposite alternative economy.

Whether revived and actualized or not, there are several problems in the legacy of this theory of images subliminally present in the Western tradition of art. The first is whether truly secularized art is at all possible. Boris doesn't seem to think so, at least not where Warhol is concerned. According to him, Warhol, acting as God the Father, has sent his Son to this world, incarnated in a Brillo Box, to redeem us all. I don't remember the sinuous path on which Boris then embarked his audience before he concluded that the redemption had not entirely succeeded. But I do remember him struggling with this Christology, a bit uneasy, perhaps, at the prospect of being taken for a true believer. I guess this is why he enlisted Nietzsche to his side, who said: better to be a slave to Apollo or Dionysus than to be liberated by Christ. All the same, it seemed to me that Boris was still a bit

nostalgic for redemption. What about myself? Though I am a convinced agnostic, I'm willing to go a much longer way with the Christian doctrine, as you will see. On the other hand, if there is something I don't want art to do at all, it is to redeem us. Easier said than done, as Nietzsche certainly experienced, driven mad by the twin figures of Antichrist and Superman. The number of sacrilegious gestures and deliberate desecrations strewn along the path of modern art and matched by an equal number of consecrations, fetishizations, and auratic recoveries (very often applied to the same works), is another indication of the difficulty. An artist taking up the challenge of making radically non-religious or non-redemptive art has a virtually impossible task ahead of him or herself. Indeed (and this is the second problem), when this artist is a woman, the difficulty is compounded by that of "authoring" a work of art from a female standpoint—also a legacy of the ninth-century theory of the icon.

Why is that so? Why is authorship of art intrinsically more difficult for a woman than for a man? Let's have a second look at the formulas on the screen, and let's focus on the analogical or "economic" status of the unnamed, and for this reason as yet unnoticed, elements in the formulas. I'm talking about the fraction bars, which symbolize the mediation. Just as Christ, deemed to be the image of his Father, acquires his human incarnation via the womb of the Virgin Mary, so the icon, which is the image of Christ and thus the image of God at a second remove, acquires its incarnation via the blank surface of a wooden board deemed to be, quite literally, the womb from which the image will be born. Incarnation conceived as mediation assigns the feminine position to the medium and the masculine to the author. "At the beginning was the Word and the Word became flesh": the Father speaks, and the Virgin Mary conceives. Only from being the support of her divine offspring does she then acquire a visibility of her own, as the so-called Blachernae icons make clear. Analogically, the virgin canvas, inseminated by the intellect of the (male) artist, bears an incarnated image from which, in return, it receives its own visibility. The quasi-Christological mediation of the virgin canvas, endowed with the enigmatic power of offering a visible access to the invisible and a finite circumscription of the infinite, remains, even to this day, at the root of the semiotic status of images in the West. The result is that women are confined to the role

of image-breeding images, an unbearable condition for all women and for women artists even more.

When Boris tells us that Warhol sent us the Brillo Box to redeem us all, I think he has seen beyond the artist's apparent cynicism a religious dimension which is there but which I don't think we should call a desire for redemption; perhaps, rather, an acknowledgement of the endurance of the desire for redemption when it survives in the post-Nietzschean era. When he says that Warhol, in so doing, was acting as God the Father, I flatly disagree. Warhol was a closet-Catholic who worshipped his mother and went to mass with her every Sunday. He was also gay. Not a "straight" gay, if I may say so, rather, someone who systematically projected an uncanny and enigmatic non-sexuality, a perverse virginity of sorts. He was not likely to identify with God the Father in his practice as an artist. Gerard Malanga will no doubt tell me if I err, but I tend to see him identifying with the mother of God instead, with the Virgin Mary, with the medium and the mediation. He would rather *be* the virgin canvas than utter the word that impregnates the canvas. He would be the reproductive machine that generates the image from what other people say. Or he would be a mirror, and what is a mirror if not an empty surface fleetingly pregnant with the image of whoever addresses it? He would not speak much in a conversation, and perhaps not listen much either. But he would assume the position of the addressee, blandly, staringly, expressionless and yet constantly wondering, as if perpetually poised in the amazement of Mary hearing Gabriel's announcement. And now and then he would pop a Polaroid camera at the visitor as if to prove his acquiescence. Instantly, the miracle would be confirmed and the machine give birth to an image. Warhol is the womb exposed. No redemption at the horizon, however. Whereas Mary gave birth to one Son, who saved the world, Warhol could not stop churning out images. How many will we need before we are saved? How many will we need before we can say: this one is its Father's true image? The Father is definitely missing.

What I have said does not invalidate at all how Boris read the Brillo Box; on the contrary. A mere glance at the two equations above tells us why the Father is missing. Boris was right in enlisting Nietzsche to his side, because we might say, by way of shortcut, that between the two equations there stands Nietzsche. All of Nietzsche,

madness included: the death of humanism inevitably following the death of God. Christ doesn't count as a father, if I may summarize boldly. Though the Byzantine theory of the image might have been carried on, down to Warhol, the break is there, irredeemable. Let me illustrate this with the following, illegitimate, equation:

$$\frac{God}{Christ} = \frac{Christ}{Man} = \frac{Man}{Icon} = \frac{Icon}{Brillo\ Box}$$

It might fit what remains of a Catholic tradition of the image, if it were not for the fact that we live in post-Nietzschean times—and I mean again: times for which nihilism is the true religion. Another theory of the image is urgently needed, a theory that would not be nihilistic (there is plenty of that around) but would be truly post-Christian. At this juncture—which is where my talk really starts—I want to make a few remarks. (1) The new theory takes sexual difference into consideration and rephrases Danto's indiscernibility problem accordingly. (2) The question of the missing father is central. (3) For this theory, the Brillo Box and its counterpart from the supermarket will not do. With Danto's permission, I shall replace it with Duchamp's readymade. I said with Danto's permission, because I hope he will grant it to me, given that he seems to be treating the Brillo Box as if it were a readymade anyway, when he assumes the indiscernibility of the two boxes and then submits the remaining compound to a sort of Turing test.

I have in mind two drawings, neither of them by an established artist. One is a men's pissoir; the other is a bidet. The image of the pissoir can be found in the second volume of the "Y" catalogue published in 1902 by the New York-based company, The J. L. Mott Iron Works. The other drawing most probably comes from the catalogue of the Maison Pirsoul, sometime in France around World War I. Do I need to remind you of the destiny of the Mott company's urinal? In 1917, a certain Richard Mutt managed to have an imaginary label attached to it saying, once and for all, "This is art." Now every museum in the world has a replica of the thing. The destiny of the Maison Pirsoul's bidet is less known. As far as I know, neither the object nor its replica ever crashed the gate of a museum. But the drawing of the bidet appeared as an illustration to the title page of Chapter Two, entitled "Autres icônes—Les musées," of Le Corbusier's *L'art*

décoratif d'aujourd'hui, published in 1925. "In order to illustrate our idea," says Le Corbusier, "let's constitute today's museum with today's objects; let's enumerate: a plain jacket, a bowler hat, a well sewn shoe; an electric light bulb in its socket, a radiator, a tablecloth in fine white linen, plain glasses we use every day, bottles. . . ."[3] And the list goes on: Thonet chairs, Ronéo filing cabinets, Innovation luggage pieces, Maple leather armchairs, and a complete "bathroom with its enameled tub, its porcelain bidet, its washbasin with its copper or nickel shining faucets," everything accompanied by "labels explaining that all the exhibited objects really had a use."[4] Thanks Corbu. I can't wait to read the explanation of the bidet.

Puritan that he is, Le Corbusier forgets to list the pissoir. But don't worry, it's there, his museum being "the true museum, the loyal and honest museum,"[5] the one that will simply "contain everything and that will be able to document on everything once the centuries will have passed."[6] Fine. The one thing that Le Corbusier avoids like the plague is to write the word "art" above the door of his museum. There, of course, is the point of disjunction separating his bidet from Duchamp's urinal, the point of bifurcation that has propelled both objects on divergent historical tracks. Even though Le Corbusier has high aesthetic ambitions for some of the objects in his museum, namely those that he hopes will later be seen as having engendered the best design of this century, he doesn't want them to be called art. That it be called art is, on the contrary, the only thing Duchamp wanted—and obtained—for his ready-made urinal, and not that its machine aesthetics have a progeny in tomorrow's good design. As a pair, the two objects that I've described embody the art/non-art dichotomy, or, if you prefer, the symbolic difference separating art from life. Oh, and yes—I've waited long enough now for you to get impatient with my silence about this—the two objects are gendered. As a pair, they also embody sexual difference. I just hope that when I say "embody" while you're envisioning a couple of disincarnated images, you'll let your own imagination supply the body fluids—and fragrances. This is to tilt Le Corbusier's Puritanism a little towards Duchamp's eroticism—eroticism that he said he wanted to turn into an artistic "ism."[7]

The scandal in the idea of eroticism as an artistic "ism" is that Duchamp puts the difference between art and life exactly where the

difference between the sexes is. The one is as irreducible as the other, and as symbolic as the other. For a while, I thought I could avoid drawing the obvious but embarrassing consequence that art is male and that life, or non-art, is female, by imagining that the two dichotomies might cross perpendicularly to one another instead of falling on top of each other; but no, nothing doing. I had to settle for the formula: art stands to the male sex the way life, or non-art, stands to the female. The signifier of difference had to go to the urinal, and so the marked object is the male object. This would be the case even if Duchamp had chosen a bidet instead of a pissoir, which in a way he did with his claim: *On n'a que: pour femelle, la pissotière et on en vit.* Whether male or female in look or usage, an unassisted readymade is a work of art reduced to the phallic dimension of its access to the symbolic. There is indeed no other way of telling an unassisted readymade from its ordinary counterpart in life than asking it whether or not it bears the name, "art." Yes, I'm following Lacan here, and yes, I'm reading the word "art" as a name-of-the-father. It's the only way that makes sense, and it doesn't matter whether Lacan confirms Duchamp or whether Duchamp confirms Lacan. What is clear, in any case, is that with the unassisted readymade, authorship of a work of art is reduced to the purely symbolic paternal function. A readymade is an already-made child, an adopted child, whose father is the bachelor who takes it upon himself to go to City Hall and acknowledge paternity. Please notice two things: (1) this father-bachelor doesn't need to be Duchamp—anyone can adopt a readymade; and (2) there is therefore no reason why a woman couldn't do it. But why would a woman do it? Why would she play at being father—such a boys' game? I don't know yet. What I do know is that the temptation of such easily acquired authorship (that is, fatherhood) was apparently strong enough among Duchamp's grandchildren to have incited more than one "appropriationist or simulationist" to readopt a readymade— witness Mike Bidlo. I wonder if he thinks the following quote applies to him. It's actually a collage of quotes, from Amelia Jones' recent book, *Postmodernism and the En-Gendering of Marcel Duchamp,* whose subject meets my preoccupations in this essay head on:

> Duchamp's significance as originating father is generally seen to
> be identical to the significance of the readymades in relation to

postmodernism. [. . .] As paternal, theological origin, Duchamp *is* the readymades and the "readymade Duchamp" . . . has become a powerful authorizing function by which works produced by contemporary artists claim nepotistic validation as begotten by the Duchampian seed.[8]

I can see how this would be valid for the boys; and I wonder if Duchamp would go to City Hall to declare Mike Bidlo his legitimate son. But, as you will see, it's the daughters who interest me. For them, killing the father is not enough. They have a real stake in the reinvention of what Jones calls the paternal, theological origin.

It would be fun to evoke another Swiss besides Le Corbusier, another Protestant—namely Jean-Luc Godard—and his fascinated and fascinating interest in Catholicism, to introduce the next sequence, but I can't assume that you have *Passion, Je vous salue Marie*, and *Hélas pour moi* vividly in mind. So, instead, I'll evoke a film sequence that is so short and so easy to tell that you don't really need to see it. I saw it in 1967 at the experimental film festival in Knokke-le-Zoute (where Michael Snow won the prize with *Wavelength*), and it has remained printed in my memory ever since. I don't remember the film's title or the filmmaker's name, though he was German. Here it goes: the screen is black with a tiny, scintillating light both powerful and fragile, like a distant star or a diamond shining in the dark. An off-screen voice says, "Dieser Zauberstein hat die Macht die Welt zu ändern" ("This magical stone has the power to change the world") . . . "Aber nur ein Mal" ("But only once") . . . "Und dies ist geschehen" ("And it's happened"). I've never seen a more concise, more effective, or more moving statement on the disenchantment of the world than this one.

"The disenchantment of the world" is, of course, Max Weber's expression to describe the modern condition, the condition we humans are in once God and the gods have retreated. *The disenchantment of the world* is also the title of an important book by the French philosopher Marcel Gauchet, in which he argues that Christianity is the modern religion, the religion that signals the exit from religion.[9] We still have a long way to go, but we're getting there. A truly postmodern world would then mean a truly post-Christian world. I like Gauchet's thesis; it allows me to see beyond both the

romantic idea of art as a substitute for religion and the Hegelian reading of romantic art as disappearing into religion—really two sides of the same coin. It also allows me to let the pre-modern/modern/postmodern periodization problem breathe in the *longue durée*. Finally, it allows me to reconnect art with life, political life, love life, for the century to come. The reinvention of paternity is central. It is central to both art and life, and if Christianity is the religion that signals the exit from religion, then a good working hypothesis is that the Christian reinvention of paternity stands in relation to post-Christian life as the Duchampian reduction of art to the paternal function stands to post-Duchamp art.

Of course, to speak of the reinvention of paternity is to suppose that paternity is an invention, not a natural fact. It is to say that paternity has been invented and reinvented several times over the course of history; and it is to claim that it can be reinvented again. It is not to deny natural facts altogether. Maternity is a natural fact if we mean that women bear children, men don't (so far). Biological paternity is a natural fact if we mean that it takes the conjunction of gametes of both sexes to procreate (this was written before Dolly). And what is also a natural fact, and one that plays a particularly determining role in the fact that paternity is not a natural fact, is that there is no somatic signal informing both partners that a sexual act was fertile—no special kind of orgasm, for example, felt by both sexes in case of procreative "success." Hence man's fundamental uncertainty about his fatherhood. Hence his anxiety. Hence patriarchy. I'm taking shortcuts because I'm stating the obvious. Amelia Jones, who seeks to undo the patriarchal view of Duchamp-the-father-of-postmodernism, seems to agree:

> Patriarchy's investment in systems that ensure proof of authorial possession results from the necessity of overcoming male anxiety over the ultimate uncertainty of biological paternity. Although the woman always knows she is the mother—through her physical connection with the developing fetus—the man never knows for sure that he is the father, and thus has a high stake in maintaining a system by which he can claim paternal "ownership."[10]

Let me restate my working hypothesis: the Christian reinvention of paternity stands in relation to post-Christian life as the

Duchampian reduction of art to the paternal function stands to post-Duchamp art. Everything now hinges on the understanding of the Christian reinvention of paternity or, in other words, of the new Christian way of "overcoming male anxiety over the ultimate uncertainty of biological paternity." New as compared to what? Obviously, as compared to a prior invention of paternity situated in the culture and in the religion from which Christianity sprang, the Jewish invention of monotheism. Gosh, I started by kidding Boris on Protestantism, Catholicism, and Orthodoxy, and now I'm stuck with comparative theology myself. There's no way I could do this seriously. But I'd like to follow my intuition, with a shortcut. How else? *Court-circuit, au besoin*, said Duchamp. To keep with the Duchampian mood, allow me to make a Dadaist pass at comparative theology by asking a slightly sacrilegious question: why isn't the Virgin Mary a Jewish mother?

The Jewish God is terrifying. He is sheer absence as Law, or Law as absence. He is the One whom it is forbidden to name because He does all the naming. Men belonging to the religion of the Book have not received from God the power to name, but only a power to name by proxy. They are in charge of the names as long as their names descend according to a genealogy that climbs back to Him, to the Origin. In this genealogy, women are nothing and they are a lot. They form a chain of wombs whose links are not even attached to each other since upstream it is the name of their father and down-stream the name of their husband that attach them to the lineage. They are the interminable canal in which the names are in transit. As such, however, they are extremely precious. For if men lend their name in view of the final count, women give life, and then milk, and then honey and all earthly food, and then they seek to give a wife to their son. They are in charge of giving, as the men are in charge of naming. They are the exclusive keepers of love. It's a heavy load to carry, and we can't blame them if they become Jewish mothers.

The Jewish solution to keep in check the uncertainty about the identity of the father is to imagine that God is the superfather, the patriarch overcoding all paternity. Instead of doubting the fidelity of his wife, let alone his mother (ah, women are well-guarded), a Jewish man of the Old Testament will doubt that he is the son of someone who is the son of someone who is the son . . . of Adam, who

is God's creature. The fact that this second uncertainty is the displaced translation of the first one is attested to by the fact that one is Jewish on the mother's side, not the father's. It's like taking a second insurance policy. The great invention, the great coup of Christianity, is to short-circuit all this. On the one hand, the production line of sons is brought to a sudden halt: no, no, my dear Joseph, you won't touch your Mary; I'm taking care of that Myself; you just marry her to save appearances. On the other hand, God's Son Himself is sent to earth—born from a woman, however. And the status of woman changes drastically. Oh, she is still a womb, yes, fertile but unspoiled. Virgin and mother, rather than virgin and then mother, and then mother-in-law, and then grandmother, and then old. This means that her function is no longer to take her place in the production line that fabricates sons. One Son is enough. He will have no offspring. He will save the world instead, which is not that bad. From this moment on, each Christian mother will produce little Jesuses for the Church rather than a little Jacob, son of Isaac, son of Abraham, son of Thare, son of Nachor, son of Seruch, son of Ragaü, son of Phalec, son of Eber, son of Sala, son of Noah, son of Lamech, son of Mathusala, son of Enoch, son of Jaret, son of Malaleel, son of Caïnan, son of Enos, son of Seth, son of Adam, son of God. Each good Christian woman will be permanently virgin and mother at once. The bad Christian woman is the whore (while the bad Jewish woman, by contrast, is the unfaithful wife).

This has been going on for two thousand years; not much has changed in the heads of men, let alone in their social, political, and religious institutions, though in the heads—and bodies—of women a revolution has occurred. Meanwhile, things get quite nicely compressed in reality. Madonna is the impeccable symbol and symptom: she is the virgin, the whore, and the mother, all rolled into one. Pardon me if I don't think that Madonna is singing tomorrow's hits when it comes to ending the war of the sexes. Rather than staying obsessed with virginity-maternity, why not have a look at virginity-paternity? Yes, I'm speaking of Saint Joseph, the divine cuckold. You don't take him seriously? Too bad. In Godard's *Je vous salue Marie*, his fiancée is a gas station attendant; thus, when he marries her he'll get a nice long hose which he knows how to use, so that's not the problem. In the Gospels he abstained—good boy. But let's look at

the story from his point of view. All of a sudden he learns that his darling is expectant. You'd think he'd beat the sh . . . out of her, you bitch! Not at all, he believes her. He believes her! Do you see how extraordinary the Christian solution to the fatherhood uncertainty principle is, and how revolutionary, compared to the Jewish solution? It's like Popper's falsificationism: the only probative proofs are negative proofs. Joseph knows that he's never had sex with Mary. Yet Mary is pregnant. Thus, God exists. Gee, he must have loved her. Provided your love for your wife is strong enough, you don't need an unbroken chain of names from your father's to Adam's to prove that you are eligible for salvation. Your wife's pregnancy is the tangible proof of God's existence, of God the Father's, as He is now called. Even though the God of the Old Testament was the super-patriarch overcoding all paternities, He was not called Father. Actually it is quite logical that, like any human father, God the Father would be born nine months before God the Son. The remarkable thing is how He accessed fatherhood: through Mary's acquiescence to Archangel Gabriel and not through rape, violence, or possession, and not thanks to exchange either. Being at the origin of every genealogy, God is not involved in the homoerotic exchange of women by men. He still depends on a woman saying yes, though, and on a man's saying yes to his woman's yes. That's where paternity, the function of fatherhood, splits in a very unexpected way. The new God is Love instead of Law and, as a result, women are no longer alone in charge of love; they can afford to cease being Jewish mothers. They can also afford to let themselves be loved. And men look towards God as the cause of their women's *jouissance* and the omnipotent symbol of their own powerlessness. Their privilege and their duty is to take on, like Joseph, the purely symbolic function of recognition, of transmitting the name, the phallic function. Those of you who are readers of Lacan, especially feminist readers of Lacan, may have understood that I tend to see his "return to Freud" as a tentatively Christian translation of Freud's "Jewish science" (as psychoanalysis was called by anti-Semites), and that I think he didn't go all the way beyond Christianity. But that's beside the subject.

Four recent urinals, all by contemporary women artists, make my point. One is the very first artist's replica of Richard Mutt's *Fountain*, by Sturtevant (1973), entitled *Duchamp Fontaine*. The art of Elaine

Sturtevant, who insists that her first name be dropped, is one long paternity suit.[11] She usually paints, and what she paints are "fake" Jasper Johns and "fake" Frank Stellas, which, on second sight, don't look like Johns or Stellas at all and are authentic Sturtevants. She claims she is not at all a simulationist: to paint somebody else's subject matter (like an American flag or a black "deductive structure" painted with a 2.5-inch brush) is just as legitimate as to paint a still life with apples. Do they belong to Cézanne? Sturtevant addresses the male artists belonging to the canonical genealogy of modernism and challenges them to prove their paternity over their work. As long as she paints, she succeeds brilliantly. The work is witty and challenging, and one is tempted to applaud at the strategy that makes her want to replace this or that name-of-the-father with her own. However, when she redoes Duchamp, the guy who has reduced the making of art to the paternal function, she bumps into her own blind spot. Anybody can father a readymade, even a woman, and the paternity suit backfires.

A second urinal is Sherrie Levine's *Fountain (After Marcel Duchamp)*, from 1991. Having started her career by re-photographing photographs signed Edward Weston and Walker Evans, Levine moved on to re-do, by hand and sometimes with a shift in technique (such as from oil to watercolor), paintings by Mondrian and Egon Schiele, or drawings by Malevich. The exquisite tenderness with which she does or re-does them, twice over, betrays her as a real Jewish mother. Paternity suits are not her affair, but rather motherly or step-motherly love. She seems to fear that the male heroes of modernism are so uncertain of their own genealogy that they should be given a maternal filiation to make sure they land in the heaven of mainstream art history. (It's the double insurance policy again.) She is the womb, the mother who humbly attends to the transmission of their names-of-the-father (*After Mondrian, After Egon Schiele*). She knows she's late but she's got faith. She's the old Sarah. But when she redoes Duchamp, the guy who has reduced art-making to paternity and has dispensed with mothers, her capacity for love reaches its limit and her faith falters. And you know how it is: as soon as faith falters, as soon as Moses has turned the corner, the golden calf reappears.

The third urinal I want to refer to is a piece by Lea Lublin entitled *Le corps amer (à-mère), l'objet perdu de M.D.* It was made for

the *Fémininmasculin* show at Beaubourg, almost four years ago. Lea Lublin, whose culture is both Polish and Hispanic (she was born in Poland and raised in Argentina), whom I like to imagine as a naughty girl in a catholic boarding school, who's also a perverse reader of Lacan and who's got a fixation on the genitals of the Child-Christ (just like Leo Steinberg), well, Lea Lublin succumbed. She just couldn't resist giving this urinal reduced to the paternal function a mother, literally. A superb bell-shaped swollen skirt festooned with flowers and transparent like the *Large Glass*, a belly with breasts and all it takes, and no head, with a shining ready-made urinal inside! The ultimate version of the Virgin with Child, she said. Madonna should buy it.[12]

And finally, a urinal that was the very first piece ever done by Sylvie Blocher, in 1980. She had finally decided she would challenge all fathers and become an artist, and this is her statement. It's not a readymade, and she didn't even have Duchamp on her mind at the time. But it's definitely a men's urinal, a five-place public pissoir tiled like a bathroom, and it's entitled *Le parloir* (The Parlor). At face-level, each of the booths is pierced by a grid that looks like a vent but that the artist calls an *hygiaphone*—actually a brand-name for the kind of see-through-speak-through glass partition that separates you from your cashier at the bank teller or from the civil servant at City Hall, where the Saint Josephs of this world go and declare their offspring. The idea that you, as a male, address some public agent behind the wall while you are performing the most private act of evacuating some superfluous body fluids is the uncanniest result of this conflation of *pissoir* and *parloir*. It makes sense, though, for every pisser is a Saint Joseph. Every man is virgin and renounces his biological paternity in the very moment when he urinates. And that's a natural fact: you can't urinate and ejaculate at once.

I'm sure there must be other women artists who have done something with or to Duchamp's urinal. And then there's Robert Gober, whose sexual orientation as a gay artist might have given him an acute and "feminine" sensitivity to the Duchampian issue of authorship reduced to fatherhood. What remains is that at least four women artists felt the necessity to reply to Duchamp's equation of art with the phallic function, two by supplementing him on the mother's side (Sherrie Levine with a Jewish, Lea Lublin with a catholic

"solution"), and two by confronting him on the father's side. But whereas the confrontation remains a symbolic power struggle for Elaine Sturtevant, conducted at the cost of her own femininity (as is witnessed by the dropping of her first name), something new, something perhaps truly postmodern is indicated in Sylvie Blocher's uncanny conflation of *pissoir* and *parloir* and unexpected rehabilitation of Saint Joseph as a paternal "model." I'm still following Marcel Gauchet in my tentative definition of the postmodern: it means post-Christian, and inasmuch as Christianity is the religion that signals the exit from religion, it also means radically non-religious. Once the disenchantment of the world is accomplished, that is, once the gods have retreated, once the God of monotheism has been definitively mourned, once the patriarchal origins of theology have been exposed and the longing for authoritarian fathers and paternal deities has become a thing of the past, then Joseph is on his own, and the acknowledgment of fatherhood gets redefined as the sheer act of faith it actually is.

At this point, it also becomes clear that only the radical atheist and the convinced agnostic need faith. The true believer is content with superstition. In other words, faith is an ethical act, an act of confidence in the other's freedom, whereas belief is a state of submission—or alienation, as it used to be called. What does this have to do with Duchamp, Le Corbusier, bidets and urinals, and the symbolic difference between art and life as institutionalized by the art museum? Everything. Today's art institution is a Church but a nihilistic Church, a Church no longer united by a common belief and yet not ready to abandon its members to the freedom of their individual aesthetic judgments. I hope I'll find the time some day to write an appendix to *Kant After Duchamp*, in which I'll argue that Kant's conception of the aesthetic judgment represents the first radically non-religious definition of an act of faith. In any case, in that book I stated my conviction that the sentence "This is art," by means of which a readymade (or any candidate to art, for that matter) is baptized, is an aesthetic judgment in the Kantian sense, and that, therefore, it empowers any and all of us with the freedom to judge by ourselves in spite of art's institutionalization.[13] This is why, in the end, the issue of "nepotistic validation as begotten by the Duchampian seed" (Amelia Jones) is an optical illusion, if not a red herring. True,

Duchamp reduced authorship to paternity and revealed the word "art" as being a name-of-the-father. Tradition is patrilinear, in that sense. It doesn't have to be patriarchal for all that. Anybody can father a work of art, including women; such is Duchamp's legacy when he said "*Les regardeurs font les tableaux*," equating authorship with spectatorship. Not by chance, women artists have more stakes than men in the reclaiming of this legacy, especially since they are still too often denied full "access to the symbolic."

I can feel resistance in the ranks of feminists to this "generous" reading of Duchamp.[14] Abandoning fatherhood and appropriation to the viewers—subsequent female artists among them—might be the last straw by way of misogynist ruse. That's right, though I believe Duchamp's ruse was even more perverse. The ruse was to have hijacked motherhood for his exclusive profit the better to deprive women artists of their artistic fatherhood. "The artist is but the mother of the work," he said. Consequently, he took on a female pseudonym, and the very first work he produced under his new nom-de-plume was entitled *Fresh Widow* and inscribed with the typewritten phrase, *Copyright Rose Sélavy*. Figures of women in Duchamp's work come under three guises: that of the Virgin, who by definition cannot procreate, that of the Bride, who is a woman "caught" on her wedding day (after which she becomes a spouse—a category for which Duchamp had a definite aversion until late in life), and that of the Widow—the latter appearing only in that particular "French window" over which the "mother" retains copyright. Whether she is a womb or a Xerox machine, her domain is reproduction, not creation. One thing is certain about widows: there is no father in the picture any longer. Did Duchamp anticipate the advent of Dolly? Symbolically, perhaps. Did he simply take stock of the tremendous shattering of the paternal function that has resulted from the dis-enchantment of the world and is one of the names of modernity? Certainly, but he fought a backwards battle; his denial of paternity is a symptom. Did he pave the way for a new, post-Christian reinvention of paternity? Only in spite of him, and in the work of women artists such as Sylvie Blocher, who understood that they had to depose the father before they could move on as artists and as women.[15] If there's a feminist critique that I would like to see leveled against Duchamp, it is to have dispossessed women of the possibility of

artistic creation by having equated motherhood of the work with widowhood. And to have denied women artists access to the paternity of their work while so generously granting it to "the viewers who make the paintings"—a genderless universal category.

Notes

1. This previously unpublished text was written for a conference on *Andy Warhol's Brillo Boxes*, organized by Karlheinz Lüdeking at the Nurenberg *Akademie der bildenden Künste* in November 1999. The other participants were Mike Bidlo, Arthur Danto, Boris Groys, and Gerard Malanga.
2. Marie-José Mondzain, *Image, icône, économie, Les sources byzantines de l'imaginaire contemporain* (Paris: Le Seuil, 1996).
3. Le Corbusier, *L'art décoratif d'aujourd'hui* (Paris: Vincent Fréal, 1925; reprint, 1958), pp. 16–17. My translation.
4. Ibid., p. 17.
5. Ibid.
6. Ibid., p. 16.
7. "I believe in eroticism a lot, because it's truly a rather widespread thing throughout the world, a thing that everyone understands. It replaces, if you wish, what other literary schools called Symbolism, Romanticism. It could be another 'ism,' so to speak. You're going to tell me that there can be eroticism in Romanticism, also. But if eroticism is used as a principal basis, a principal end, then it takes the form of an 'ism,' in the sense of a school." Marcel Duchamp, in Pierre Cabanne, *Dialogues with Marcel Duchamp*, tr. Ron Padgett (New York: Viking, 1971), p. 88.
8. Amelia Jones, *Postmodernism and the En-Gendering of Marcel Duchamp* (Cambridge: Cambridge University Press, 1994), pp. 8 and 14.
9. Marcel Gauchet, *Le désenchantement du monde, Une histoire politique de la religion* (Paris: Gallimard, 1985).
10. Ibid., p. 14.
11. "The paternity suit: who ever heard of a maternity suit? A maternity dress, yes, but a maternity suit?" Jane Gallop, *The Daughter's Seduction, Feminism and Psychoanalysis* (Ithaca, NY: Cornell University Press, 1982), p. 48.
12. Upon returning from Nurenberg, I learned the sad news that Lea Lublin had just died of cancer. I hope the body of her work will soon receive the attention it deserves, as one of the most serious attempts with that of Orlan at securing a *symbolic* place for women artists from within the Christian iconological tradition.
13. Thierry de Duve, *Kant after Duchamp* (Cambridge, MA: MIT Press, 1996).
14. Accessorily, I also feel resistance in the ranks of critics of religion to my "generous" reading of Christianity. In the Gospels, Joseph was warned by an angel appearing to him in a dream that Mary was pregnant with the works of God the Father. From the post-Christian vantage point, however, this episode appears as a concession to superstition, presupposing the belief in angels and in the literal truth-value of dreams. To a Freudian reader, this particular dream carries another truth: one pertaining to the wish-fulfilling function of dreams with regard to man's anxiety as to his fatherhood. Once

the episode is demystified in such a way, the need for an act of faith remains, whether directly, as faith in Mary's faithfulness, or indirectly, as faith in the angel's message. My "generous" reading has the advantage of emphasizing the link between faith and love.

15. Sylvie Blocher's peculiar relation to Duchamp doesn't stop with *Le parloir*. Ten years later, she did a work entitled *Déçue la mariée se rhabilla* that really works out the mourning of the utopias of modernity at the hand of the motif of disappointment. See my book, *La deposition* (Paris: Dis-voir, 1995).

3
THE ART SEMINAR

This conversation was held April 17, 2007, at the School of the Art Institute of Chicago. The participants were: Gregg Bordowitz (School of the Art Institute of Chicago), Thierry de Duve (Université Charles-de-Gaulle Lille 3), Wendy Doniger (University of Chicago—in the morning session only), James Elkins (School of the Art Institute of Chicago), Boris Groys (Hochschule für Gestaltung, Karlsruhe), Kajri Jain (University of Western Ontario), Tomoko Masuzawa (University of Michigan), David Morgan (Valparaiso University), and Taylor Worley (PhD candidate in the University of Durham—in the afternoon session only).

James Elkins: Welcome, everyone. All the volumes in this series, the *Art Seminar*, have been dedicated to problems that are unsolved, in the sense that there is no consensus about how the problem might be framed: whether it is a single problem or several, whether it is amenable to one methodological approach, or requires several; whether it has leading concepts or metaphors. Volume 1, *Art History versus Aesthetics*, documents a series of, I think, fundamental misapprehensions of art history by aesthetics and vice versa. Afterward, Arthur Danto, who was on that panel, said the conversation was "like herding cats." The book is scrappy, but for a systemic reason. Volume 2, *Photography Theory*, has deep disagreements not only about the leading concepts of photography but over the relevance of *any* definition of those concepts, and even the possibility of conceptualizing photography—*any* photography—at all. In that book Rosalind Krauss argues with Joel Snyder about the interpretation of Peirce's index and Barthes's *punctum*, and a few authors join in, but several others completely ignore the problem—they don't disagree, they don't misunderstand the argument, they don't devalue the issues involved: they just don't participate.[1] Volume 4, on art criticism, shows an especially interesting division between critics who judge, such as Dave Hickey, and others, such as Steve Melville, for whom criticism is more about understanding the conditions under which someone might make a judgment. It's hard to imagine a more intractable difference, and no one in the book resolves it.

I think that today's event may well produce even deeper differences. I have doubts over whether this issue—the inclusion, or rejection, or place of religion or spirituality in contemporary art—is resolvable or even definable: but that is our project for today.

I want to preface our talk by telling a brief story that has to do with the composition of this panel. I invited a couple of art historians whose positions against the inclusion of talk about religion in talk about contemporary art are particularly severe and consistent. Michael Fried and T. J. Clark both politely declined to participate. In different but very similar ways, they both said—in so many words, although one of them actually used the word—that it would simply be too "painful" to sit at a table at which people would talk about religion and art at the same time. The name,

Re-Enchantment, has an interesting history, which I hope we'll explore later, but one reason I chose it was to include both Fried and Clark, who have used the word in speaking about modernism.[2] (Fried has found evidence of a kind of "re-enchantment of the world" in painting by Adolph Menzel.[3]) I also chose it because both Fried and Clark deliberately ignore the previous use of the word by Suzi Gablik (where it names the hope that some of modernism can be understood as a spiritual enterprise with roots as far back as the Neolithic). That exclusion is an epitome, for me, of the tremendous distance between two discourses on art.[4] I also tried to invite several people who have engaged their disengagement, especially Karl Werckmeister, who wrote a brilliant and challenging review of Clark's *Farewell to an Idea*, accusing Clark of admitting a kind of bourgeois interest in religion even—or rather, especially—where he hoped to exclude it.[5] Werckmeister couldn't make it, but I've found that the virus of the fear of the religious is virulent and contagious. On the other side, there are people for whom our subject here is a non-issue. The claim there would be that all art *is* spiritual or religious if it is looked at correctly. That kind of difference produces a situation where one side refuses argument as being outside of any recoverable understanding of the subject (that is, of modernism), and the other side claims that any conversation that does not include religion or spirituality can only be partial and may be more seriously misleading. In my own book, I took two epigraphs as an emblem of this difference. The first is Tim Clark's line from *Farewell to an Idea*: "[I will have nothing to do with] that self-satisfied leftist clap-trap of 'art as substitute religion.'" The other is something Updike said somewhere: "modern art is a religion assembled from the fragments of our everyday life." So that is one form of the division—one of the divisions—I hope we can explore today.

I

I thought it would be helpful if we divided our conversation into three subjects. First, let's look at the histories that could be said to have led to our contemporary condition, perhaps starting with the widest and most cross-cultural accounts that can make

sense. Then, as our second topic this morning, I thought we could look at the leading concepts that emerge from those histories—words like religion, spirituality, belief, enchantment, and any number of others. And let's reserve the afternoon session for a discussion of specific examples of the difference in contemporary art and the writing that addresses it.

Kajri Jain: Before we talk about modernism, which I think some of you are probably dying to do, I would like to introduce a model that goes slightly further back. I blame this on Hegel, basically. I propose that the kind of choice you have placed before us, Jim, either saying art was always religious, or saying they can have nothing to do with each other, *becomes* that kind of choice because of guys like Hegel. I'm sure you're all familiar with his *Aesthetics*, where he starts to talk about art in terms of the movement of the Spirit. Immediately you get art and religion as projects of the Spirit, which begins to then define what happens to the fate of images in the West, as opposed to the fate of images in other kinds of cultures, where they are perhaps not so clearly aligned to the progress of the Spirit, but speak more to material practices. I am thinking here of Hinduism, and other kinds of Asian, African . . . many other religious trajectories.

What happens in the West is you get Hegel, you get a spiritualization of religion, and at the same time you get a privatization of religion, this idea that religion is a matter of religious faith, which takes it out of a collective sphere of practice and makes it into a matter of belief—it becomes abstract, remote, etc. And then, if we are to follow Hegel, Spirit is no longer satisfied with what art can do for it, and Spirit goes into the province of philosophy. Or, we could say Spirit is sublimated into a different kind of art practice. In that case, the issue is a polarization of art and religion, and so I perfectly sympathize with Tim Clark and Michael Fried. I think contemporary art just doesn't *do* religion. That is so, in any case, if we are looking at this from the perspective of contemporary art, as many of us here would probably like to do. If we're taking a visual studies perspective, we can look at various kinds of art production, such as some of those incredibly kitschy images you showed us yesterday, Jim.[6]

JE: Well, some of what I showed was partly private or idiosyncratic, yes, but much more of it represents widespread groups, and recognized religions—very large communities of Protestants and Catholics—and it still seems kitschy. But if you mean the art that sometimes represents new religious movements, NRMs, then yes.

KJ: That is the fate of art that tries to be religious in this private, spiritual way, because it is not speaking to a community of practice. So it has no alternative but to be kitsch.

David Morgan: Jim was reading that imagery through a fine-art lens, and asking it to do things that it was not designed to do. He was lifting it out of its social context. It was fun, it was clever, but it violated the work itself, which shouldn't be treated as fine art, because it's not. It should be treated as another kind of imagery.

KJ: Right, it requires a different lens. But I am saying we can look at this problem through the lens of contemporary art discourse, and modernism—you're all welcome to do that.

[*Laughter.*]

JE: Kajri, I am happy to enlist Hegel as a place where our issue begins. David, your objection is perhaps a different issue, which we can return to later on.

Thierry de Duve: I agree with you, Kajri, in making Hegel the bad guy who forced us to think in contrived alternatives. Either we go along with him and we admit that art is intrinsically religion practiced with imperfect means, or we claim that art and religion are totally different and have nothing to do with each other. The way out is simply not to be Hegelian, and to consider this alternative as an open question; then the open question becomes a matter of choice: you have to decide whether something is art or religion—I mean, a work of art or a religious artifact or both. I, as a modern Westerner interested in aesthetic issues, have no more difficulty looking at an African fetish as a work of art than recognizing that a Memling Madonna is *also* an object of religious worship; but I know historians and anthropologists who might challenge my views. Whatever, I personally feel free to choose, and sometimes obliged to. The nature of such choices—whether they are

scientific or ethical or aesthetic decisions—is a very complicated question for me.

Personally, I find it necessary to state my approach and perspective. It never came to my mind to say that I would find it painful to sit at a table with people who have religious beliefs about art—not at all. Nevertheless, I do situate myself as a grand-grandchild of the Enlightenment, and that entails a particular conception of what the word "religion" means.

DM: For the sake of clarification, my point was that the images that Jim showed did not purport in most cases to be, or at least in fact were not fine art, but commercial illustration, didactic imagery for religious instruction, or devotional images.

TdD: The basic question is asking ourselves whether there is a God out there. Do we believe there is a God, or don't we? And what does "a God" mean? Let's define God from within the Christian tradition (which is the only one I know a little) as the idea that there is a creator to the world, and that he is good (he or she, but in the Christian tradition he has to be a *He*). Notice in passing how the idea of God bridges the scientific and the ethical. God is the original cause (Aristotle's first motor) that has generated all other, subsequent, cause and effect relationships that science accounts for; and he is fundamentally good, that is, he wishes humankind happiness. He guarantees that virtue will be rewarded, if not in this life then in the next. He acts as a warranty for our moral acts. Therefore hope in a better world has to be articulated with religious eschatology. I think that what the Enlightenment has brought—and this is where I situate myself—is that we don't need that. We're on our own; we don't need a primal cause to explain the world as it is, and we must do without a warrantor for our ethical behavior. We can be in the world without the crutch that is the idea of God.

So, now that I have positioned myself in this debate, I would like to submit my postulate: that art and religion were born together. I call it a postulate, though for paleontologists it might be a working hypothesis open to further discoveries, because I cannot prove it—I was not around. The context is that very long and slow Darwinian process of hominization, where the unfathomable question is: at

which point did the animal become human, fully human? What kind of traces do we have that might indicate that a threshold has been crossed? Some say, and I find that a reasonable assumption, that the minute those primitive beings began to bury their dead, they ascertained their humanity. Well, it seems that that very same minute, or not much later, they also began to put things in the tombs that were useless and looked as if they had been deemed beautiful: red ochre, for example, which is merely pigment and is found everywhere in tombs from the Middle Paleolithic on. Perhaps it was meant to nourish the soul of the deceased; nobody knows. Whatever other meanings it may have had, an *aesthetic* gesture was made at the very same time as respect began to be paid to the dead, and therefore, I suppose, at the same time as the concept of afterlife must have come to the mind of those primitive humans. With the cult of the ancestors, we witness the simultaneous birth of religion and of art. And since then, what we (at least what we, modern Westerners) call art, or high art, has been religious art, in every culture on the planet . . . until the Enlightenment arrived.

The question I am asking, then, as a grand-grandson of the Enlightenment who thinks that we don't need gods any more, is this: can art and religion be disentangled? Have they been disentangled? Modernism is best described as an attempt at this disentanglement, successful or unsuccessful—I don't think this has been decided yet. It probably won't be for quite a while for the simple reason that we lack the historical distance. Imagine a time line, between here and there. [*Stretching out his arms.*] It is perhaps 100,000 years long if we date the left end of the line from the first tombs, and at least 35,000 years long if we wait for more sophisticated manifestations of aesthetic activity, such as cave paintings, to appear. [*Measuring a very thin slice of space between thumb and index.*] Well, *this* would be the duration of modernity: the last 200, 250 years at most, of that long, long line. We—and then not all of us—have been learning to live without God, or gods, for a mere 250 years. It's extremely brief. We are only beginning to see what this may lead to.

JE: Let me register two things about that long history, because it

illuminates two aspects of the very difficult problem we're considering here. First, there would be people on this panel—perhaps Tomoko would be one—who would want to say something about your use of the word *religion* in describing Neolithic tombs. And many people, I think, might want to say something about your use of the words *art* and *aesthetic* in relation to those objects. For example, someone like Hans Belting would say that *art* can't be legitimately used for objects made before the end of the middle ages.

TdD: I know, I know.

JE: And second, I note that your history could lead to two opposed conclusions. In one, we might say to ourselves: Well, Clement Greenberg isn't a deity, so let's continue to pay attention to that longer tradition, and think of it as our lineage instead of developments since the Enlightenment. But in the other, we might say: We are, in fact, children of the Enlightenment, and we need to think seriously about how different we have suddenly become. These two readings are compatible with your sense of the undecided nature of the question, but they also show how treacherous the very long duration history can be.

Wendy Doniger: There is another way to look at this, which sheds light on what Jim described as the "painful" aspect of our subject. There is a division between people who believe in god, and people who study god. The second category is what the Enlightenment was all about. On the one hand, you have fundamentalists, and people who blow up abortion clinics, and all those things that make people say, religious maniacs! Religious fanatics! But the idea that people who would argue that art is religious should themselves be religious people is, I think, completely wrong. The study of religion by people like Freud and Marx, who hated religion and wanted to talk about all the harm it did—the study of religion, which is the Enlightenment, the modernist moment, presumes that the people doing the study do not believe in god. The argument we're interested in here, about whether art is religious, has nothing to do with whether religious people are right or wrong.

Boris Groys: Thierry, we have to look at the *topology* of the question. Where do we find god? Do we find god in heaven, or somewhere else outside of the image? The modern intuition is that god is *behind* the image, that he is the medium. That is very much a Hegelian point of view, and I completely agree with Kajri in this sense.

But it starts even earlier, with German mysticism, centuries before Hegel. It's a change in the topology of the relation between the human and the divine. The divine, god, is something which is behind the image, and which shows the image to us. This is something that we can even find in Heidegger, formulated in a very modern and suggestive way.

This changed topology is something we are still living within. Even Greenberg is in this new topology, except that there, god is flatness—it's one of the possible interpretations of the divine.

Gregg Bordowitz: I am afraid of starting with an already established opposition between the religious and the secular, between believers and non-believers as the basis of the conversation. Polemical divisions have a way of reproducing discussions. They discipline us and ultimately imprison us within current ideological formations that we must change. I am wary of reproducing what Foucault warned us against in his "repressive hypothesis." Starting with the presumption that there is a hidden bias and/or a ban against religious art in the fine art world is a disingenuous way, an invidious way, of discussing the shared terrain between religion and art. Presuming there is a ban on contemporary religious art in the galleries or museums—without really demonstrating that such a thing exists as a systemic bias—leads us to police both art and religion along the lines of ideological investments. I have difficulty establishing a strong, clear division among religionists and secularists when it comes time to discuss aesthetics. The gray area between religion and art is vast. My fears arise because of the political context of this discussion. Our conversation occurs at a time when politics are being determined by various kinds of religious fundamentalism. The issue of religion is extremely charged. We can't ignore that. Recent events cause us tremendous anxiety around these issues and we must pay attention to the sources of our

current anxieties to explore the relation between religion and art today.

JE: Well, the aim of breaking ideologies is unarguable, but I think you're just wrong in your assessment of the place of religion. Outside of specifiable, minor exceptions, it is systemic and it could easily be systematically demonstrated. Clark's anxiety, for example, comes from his experiences in the 1960s, and from his understanding of the claims of modernism going back through people like Pissarro to Courbet and beyond. The anarchist project at the beginning of twentieth-century modernism was deeply alienated from what it understood as institutional religion. And I suppose I might add that my own involvement with the issue came partly from the difficulty I saw art students experiencing when they wanted, or needed, serious instruction on religious issues in their art. So that's by way of saying I think there are other genealogies at work—not to disagree that oppositions with no middle terms are unproductive. My epigraphs from Clark and Updike were meant to show the possible distances, not maybe the typical ones.

Tomoko Masuzawa: I'm drawn into this conversation and find myself curiously in sympathy with several points other panelists already made—curiously because these points may seem contradictory. But I think there is a logic to them. Thierry, you said a moment ago that art and religion were born together, long before *you* were born, most probably at the dawn of humanity. And you also implied that these twins were in a state of pre-critical cohabitation until the Enlightenment, at which point art walked out on religion, to be on its own, I guess, as humanity itself came of age. Now, we could say that all sorts of things followed from that moment of awakening or maturity, for example spiritualizing of religion *and* art—at least as far as *real* art is concerned, or *high* art—and for that, we could either thank Kant or blame Hegel, as Kajri would have it. And Jim, I take it that you also suspect to find in the Enlightenment something like a root cause of the present condition, where art shuns religion. Meanwhile, Gregg bristles at this "prohibition," or I should say he wants to caution us against giving into this regime of separation before we even get started on our conversation; and of course he has Foucault on his side.

I'm in sympathy with all of these sentiments, but I want to add something to do with "religio," or "religion as we know it," or the *concept* of religion, though I'm hesitant to put it this way because it puts me on the defensive. I'm not talking about a *mere* concept as opposed to the real thing. I won't get into fights over matters of ontology, but just let me say, as plainly as possible: "religion as we know it" has a rather recent birth date, and this means that whatever people were doing, which we *now* recognize, organize, and regulate *as* religion, *became* religion in some important sense. And that's what we're dealing with here today, a certain conceptualized object, "religion." We couldn't be having a roundtable discussion about something that hasn't already consolidated itself under some epistemic regime.

So on one hand there is "religion" as we understand it, and on the other, so-called secularization—the "evacuation of religion from the world," disenchantment. These two things, religion and secularization, were born together, and their birth date was roughly around the Enlightenment.

BG: I would like to refer to the term "re-enchantment," and ask why it is that we feel there is a re-enchantment in the art world. It is of course partly due to fundamentalist movements, but I would argue that has to do with something equally recent: digitalization. We read everywhere about the *immaterial*, about a new spirituality (on the left and the right—everywhere), that has to do with the new way of experiencing the digital image. I don't believe in immateriality per se, because of course digital media are material, but what's interesting about it is that it's invisible. A digital code, a digital image file as such, is invisible. You have to be the hero of *The Matrix* to actually look at the digital code as such. That means the digitalized image actually visualizes something that is itself invisible. Every visualizing of digital code produces an image of something that is invisible. In a certain way this harks back to the time of the icons, because each digital image is an image of the invisible code. We know that if we perform digital codes in different circumstances, using different equipment, we get very different results. Now, what is the digital? It is something that has its truth in electricity and magnetism. In modernity we have a very long

history of enchantments using electricity and magnetism as their paradigms. For me, this is a specific way of thinking about re-enchantment today. It is a theme that suddenly brings us back to the problematics of the Byzantine icon: it is a visualization of the unvisualizable.

JE: That is an interesting history—it has resonance with a broad spectrum of current concerns about the unrepresentable in art.[7] But I would say the lineage goes in directions other than the digital and, ultimately, the iconic.

BG: To a certain degree. Canvas, for example, is invisible because it is covered in paint, and so Greenberg's problematics is also pertinent. But I would pursue a different genealogy. There is interesting research about the metaphor of electricity. In the eighteenth century, there are romantic images of the cross as an electrical device, bringing divine power to the earth.[8] So there is a long history here; Marshall McLuhan is also part of it—and he also speaks, of course, about a kind of re-enchantment of the world. In my reading, Antonio Negri's "immaterial worker" is like a medieval monk (he is very Catholic!). So digitalization is a complex model, which permanently—consciously or not—influences our imaginations.

JE: That is an *extremely* odd genealogy, but an interesting one. Philosophically, it links German mystics (I assume you're thinking of Böhme and Ekhart) with Hegel and Heidegger—

BG: It is a fundamentally changed topology in the relation to the divine. Digitalization is like the *zero-medium spirit*, which is Hegelian. The image has the immaterial bearer, but at the same time it shows us everything that we can see. It occurs in Heidegger, in the *Origin of the Work of Art*, as Being, *das Sein*: a kind of zero-medium that shows us everything we can see. Digitalization is nothing other than the new avatar of Spirit or Being. We are still in this new topology; we cannot escape it.

JE: Boris, your theories are great! But I am also drawn to very familiar genealogies, like the one that looks back to the early twentieth century, to international abstraction and to the *fin-de-siècle*, as places where painting was sometimes understood to

have transcendent purposes that were later doubted or reinterpreted. It's not that I wonder if those histories are effectively independent of histories that find their origins in Hegel or Böhme: it's that I wonder about the explanatory power of philosophic histories when it comes to the self-descriptions of modernist art movements. (I had the same problem with Alain Besançon's book, which keeps to Plato, Plotinus, Calvin, and Pascal in tracing its own history of iconoclasm, and barely mentions Kandinsky, Mondrian, and other artists.[9])

TM: I agree. I think you are pointing to a huge issue, about the universal viability of the conceptual apparatuses and genealogical schemata that we all use and desperately need. These conceptual devices constantly refer us back to those highly mediated Western philosophical brand-names, among which Greeks and Germans are particularly over-represented. Isn't this a giveaway? What are these apparatuses made of? What is their date of manufacture and their historicity? These questions point to a yawning abyss, I think. We often try to cross it over by saying something like: "well, at least in the West . . ." (as if we knew what that meant!), relinquishing responsibility to say anything about the rest. That mantra may tie you over for the moment, but it doesn't resolve the issue.

DM: One may object with good reason to the exclusive dominance of Greek and German thought in constructing the intellectual history that bolsters prevailing ideas of "the West," yet the momentum of the history continues to press forcefully on discourse today. This is very evident from the many invocations of Kant and Hegel in our conversation so far! Right or wrong, historians of religion need to account for its influence. To say "in the West" is not an idle or clueless utterance. It means something powerful: it bequeaths on the speaker a privileged genealogy. What is "the West" but a history of ideas fixed to political, religious, and social institutions? It is no chimera.

JE: I would like to make a rough count of the genealogies that we are proposing here. So far, I count four: (1) Thierry's account of the *longue durée* from the Paleolithic to the Enlightenment, which Wendy enlarged upon; (2) Kajri's reminder of Hegel's influence,

which several of us would agree with in somewhat different forms; (3) Boris' idea of a topology of the divine, which leads back into fifteenth-century German mysticism and forward into Heidegger and now the digital realm. And (4) I have just briefly conjured an account which traces the skepticism about art's religious or spiritual affiliations to a time just after mid-century.[10] That history would have everything to do with the rise of a certain kind of academic study of modernism and postmodernism—but more on that, I'm sure, this afternoon.

GB: I would like to introduce another genealogy. Instead of going back to the prehistory of humans, I want to go back to our own prehistories, our childhoods. That's where art and religion get confused within the more primary formations of the psyche. We must look at the development of belief in the psyche. For example, you can read a psychoanalyst like D. W. Winnicott. Winnicott taught us that what we believe is not nearly as remarkable as the fact that we believe at all.[11] How do children come to believe in anything? From a psychological and a psychoanalytic perspective, how we come to believe is nothing less than a process of world creation. Each one of us has to believe that we create the world for ourselves. That is a necessary fiction. Hopefully, that fiction never gets undone for anyone in this room. At some point, you realize that the world preceded you, but, according to psychoanalysis, on some very basic level you must also believe that you are the creator of the world. Maintaining that you are both the inheritor and the creator of the world is a fundamental structuring contradiction and it is the very foundation of psychological well-being. I think that the fundamental faculty of belief is where we can locate connections between art and religion. I think it is possible to draw connections between art and religion by understanding the necessary psychic function of belief. (I also think that art and religion are each autonomous spheres. That may be a contradiction. I'll have to work that out.) I have formulated a few questions about this:

1. Is it possible that the job of art is to give everyone concerned—the artist, the viewer, the critic, and the collector—an ethical part of creation? We see in religion and in art two different answers to that question.

2. Is the ideal of every aesthetic program to reinvigorate the beholder's interest in the world? What is the job of the work of art? The dispositions and affects produced by various works of art may differ dramatically, but the production of interest may be a common consequence of aesthetic experiences.

3. What are the many ways that works of art invite, elicit, and stimulate sensual engagement with existence? This question points to the area where religion and art coincide. Although they may perform different functions, both religion and art bear directly, and reflectively, on the meaning of our sensual engagement with existence.

These three questions unfold from a psychoanalytic perspective.

DM: May I add a question to that? There is a point most of us face when we realize we actually didn't create the world. You describe that point as "ego shattering." Is there, then, a dimension of artistic experience where this becomes definitive of religion, spirituality, or the sacred?

GB: You mean how ego-shattering is related to religion?

DM: Yes, if world-making is part of what art helps us do, does art also help us negotiate the destruction of our sense of reality, or of the world—in some way to re-create it? Or is the function of serious art principally critical or deconstructive?

GB: If you look at Klein and other psychoanalysts, they talk about the "reparative drive." Ego-shattering cannot exist without its relationship to repair. The process of the ego, and the psyche, is a constant dynamic of renewal and shattering. Both of those experiences have great pleasures and great dangers. There is tension in the psyche between two tendencies, between eros and the death drive; between conjugation and the tendency to an absolute zero degree of tension. These conflicting tendencies are relevant to the study of both religion and art. Neither religion nor art is reducible to one of these two tendencies. Both religious practice and/or art-making proceed from a central conflict in the psyche between creation and its negation.

TM: I realize I am adding yet another genealogy as a kind of overlay. I am very much in agreement with Thierry's emphasis on the Enlightenment (it is also decisive for my genealogy), which is about the modern epistemic regime that I referred to earlier. I called it the regime of "religion as we know it" or "religion as we recognize it and regulate it." But for me it is decisive in a different way. I want to emphasize that the significance of the Enlightenment is in that it was a moment of crisis—and in a way, we're still in the same crisis. The Enlightenment marked the inception of something definitively different, of course, but at the same time it was the moment when, all of a sudden, a certain kind of past was created, or conjured up—a past that was supposed to have preceded it. In a way, at that moment, past becomes something essentially ahistorical, something like sheer anteriority.

In my own work I try to understand this moment of critical emergence, *historically*, as the moment when a new conceptual regime emerges and a new ahistorical past comes with it. "Religion," as I see it, comes into visibility during the Enlightenment precisely as something essentially allied with this ahistorical past. "Religion" as a Western discursive object fascinates me because of this: it signifies a powerful historical imaginary. And I don't think this is unrelated to the fact that religion is one of the last—if not the very last—conceptualized objects to be historicized. At least in the academy, I think people have generally acknowledged the notion—even if they haven't really accepted it—that entities such as "race," "nation," and "gender" were not anything naturally given but they were historically constructed. But the very same people seem to go on talking quite comfortably about religion as if it were a self-evident category; as if it simply referred to something they knew to exist out there, ubiquitously if not eternally, only we can't know it whole because it exists in infinite varieties. That seems to be the overwhelmingly common assumption. "Religion" remains essentialized, un-historicized, un-analyzed. The only thing I know that's worse than "religion" in this respect is "spirituality," which has a much more recent birth date—in the 1970s, as far as I know.[12]

The Enlightenment is the moment when we see the emergence of "religion as we know it," the discursive regime that's more or

less ours. And from that moment on, "religion" has become a matter of *belief*. Also, in this regime, "religion" is in the plural. The use of the word "religions" can be traced back a couple of centuries before the Enlightenment; it may be convenient to say that it was sometime after the Council of Trent (1545–63), when Europe no longer could hold Christianity as a single entity.[13] So, from the beginning the discourse on religion has been predicated on a very contentious kind of pluralism.[14] This, I think, is the genealogy of our modern "religion" discourse in a nutshell, and I offer it as an overlay or substructure of the Enlightenment narrative, though this layer seems largely invisible behind the master narrative. It's definitely underwriting and constraining our discussion of genealogies, though, and I would like to contest it by bringing it out in the open.

TdD: Do you, then, challenge my postulate? You see religion as a construction? As a text that is projected back upon the past?

TM: Yes and no. Sure, what we *intend* to refer to when we name something "religion," those myriad varieties of things *we* call religion, obviously had reality well before this discourse on religion was invented; or we might say, they do have reality with or without this discursive regime. But with the advent of this regime, we can't deny that something about them changed rather dramatically. We would recognize this change if we remember, for instance, the fact that there was no term or concept equivalent to "religion" anywhere else in the world, and that it was only as a result of their encounter with the West—which wasn't all that friendly—that the rest of the world came to forge a new word; they had to scramble to calibrate their own discourse and come up with a translation so that they could finally institute a new policy, say, on "freedom of religion." Imagine the challenge![15] Or we might recall that "Hinduism," "Buddhism," and all those "isms" were neologisms no older than the nineteenth century and these were concepts utterly unknown to anyone, including the ancestors a few generations back of those very people who now call themselves Hindus, Sikhs, and so on. Or you can also discern this transformation in the difference in the ways in which Europeans wrote about the variety of religions before and after the Enlightenment.

Before, books on "religions of the world" were always about the diversity of rites, customs, and ceremonies—to put it in contemporary terms, they were about cultural technologies; those devices variously available in different locations and to different peoples, so that they can get things done, in their social production and reproduction. But as of the late nineteenth century, religion has become a matter of belief systems.

The challenge of studying religion, I think, is that we need to attend to both these levels—or, I should say, we need to look at the friction and the interface between them. I mean, on the one hand, the level of practice on the ground, if you will, as social technologies, and on the other hand, the level of discourse that developed after the Enlightenment, which itself is very much a part of our social technology today. This discourse on religion has done a lot of work—in creating the regime where we have something like "separate but equal" religions.

So, I'm not challenging your postulate in the sense that I'm not saying religion is just about that second level. But if we are talking about the history of religions, we need to attend to the messy interrelation between these two levels.

TdD: I agree—*if* we are talking about the history of religion, which is not my field and which I think is not really at issue here in this debate. By the way, my own opinions on the history of religion—a layman's opinions, obviously—are entirely shaped by what Marcel Gauchet wrote in *Le désenchantement du monde*, a book that has influenced me a lot.[16] Gauchet paradoxically sees the history of the great world religions as the development of a process that gradually challenges the religious and ultimately does away with it. The three main stages in this process are: the emergence of the State, the advent of monotheism, and the inner movement of Christianity, which Gauchet unhesitatingly proclaims to be the "religion of the exit from religion." Gauchet's views clearly entail an anthropological and thus trans-historical and cross-cultural conception of the religious phenomenon. The more primitive the religion, the purer the phenomenon. Now, Tomoko, in respect to your post-Enlightenment production of a supposedly ahistorical and in fact retroactive notion of the religious, I see your point:

Gauchet and myself walking in his footsteps might be victims of a typical post-Enlightenment prejudice. However, I think it is very difficult, and also counter-productive, to renounce all anthropological notion of the religious. I find it more fruitful to run the risk of essentialism, given that Gauchet has provided us with the means of not being stuck with supposedly eternal and thus unchangeable essences. The essence of religion, according to Gauchet, is a kind of pact with nature, whereby people consent to a cosmic order shot through with supernatural forces beyond their control, in exchange for a stable place in this cosmos, guaranteed by the perpetuation of the social order willed by the ancestors. It is clear that it's been a long while since we stopped living in compliance with this pact. It is also clear that the longing for such a pact has recently made a spectacular and ominous come-back, in the shape of religious fundamentalisms of all sorts: Christian, Islamic, Jewish, even Hindu. This is why I find Gauchet's pact useful as a sort of infra-level to your first and second levels: it allows us to see that religion *is* after all some sort of belief system, without for all that essentializing the notion of religious belief.

TM: I'm saying that is something like an after-effect of the second, discursive level.

KJ: The idea of religion-as-belief comes out of a specific discourse on religion. This connects a little bit with what Gregg was saying: we can locate belief in different ways, and it is important not to decide that belief is merely a psychic matter. If I may illustrate this with a personal anecdote: I was once on a flight, and my usual vegetarian meal arrived, and the man sitting beside me—an Indian man— said, "You don't look like a vegetarian." I don't know what that meant! But then he asked me an interesting question: "Are you a vegetarian by choice or by conviction?" I had no idea what that meant either. I think what he was saying was, Did you choose? Was it a secular choice, or a religious matter? *Conviction*, here, means not having a choice. In this case, it fits very well, because my vegetarianism is just the way I was brought up. For me, meat is not food. I would rather starve. It is something that happens at the level of the body, not really at the level of conscious belief, or some abstract mental process.

TdD: Just to help you out: there's a remark by Wittgenstein somewhere: conviction is, after all, mostly habit.

DM: The history of Christianity is of two minds on belief. And it's much older than Hegel. The history of violent debates during the first several centuries and beyond regarding what was to be orthodox and what heterodox tended very strongly to push matters into a sharp distinction of right belief versus wrong, into formal prescriptions or creeds. But it was not just a matter of saying something. What you said meant where you stood in the arena of political and social affiliation. Moreover, practices always embodied the religion as much as creeds. The word "orthodox" meant "right teaching," but teaching pertained to the practice of baptism, communion, worship, ritual, images, and building no less than to the abstract doctrines. The singular emphasis on belief as assent, a prescribed content in our day, owes much more to modern fundamentalism.

GB: From a psychoanalytic standpoint, belief arises as a factor of both mind and body. And belief arises at the place where nature and culture overlap. The development of belief in the individual is a matter of sensations. Our belief in the world arises through touch—by touching and being touched.

JK: Right.

GB: Because one's beliefs arise through contact with the world, one is not the origin of one's own emotions. We are not the origins of our beliefs. Psychoanalytic theory understands belief as a function of civilization. The problem of how an organism takes up residence in civilization is an urgent problem in psychoanalysis.

KJ: So it's not a matter of the individual, but the individual in society, and in a realm of practice—the ethical realm.

JE: Our reading at the moment is a blending of Wittgenstein—I think that idea is in *On Certainty*—and some strands in psychoanalysis, which is itself interesting given the wide distances between those texts.[17] But it's especially interesting that we're putting both to use in an account of belief as partly immune both to volition and to individuality—a position that I would think that

you, Tomoko, would want to situate in a certain history, rather than take as a starting point.

TM: Yes, but perhaps even more important to note is that, when we speak of religion as belief, or "belief systems," for the most part we are not really guided by anything so interesting as Wittgenstein or Freud—or Thierry, or Boris for that matter!—but rather, I find that belief is routinely reduced to something far less subtle, something pedestrian and funky: say, some sort of exotic cosmology, a slightly outlandish world view, or a certain type of mind-set, or closed-mindedness. This is really not analytically helpful. It's a far cry from the resources available from the tremendous archive of the Western intellectual tradition—like Kant, Wittgenstein, and Freud, I mean—which we have no choice but to mine.

BG: We are speaking of Enlightenment, but it's an old question, where the *light* of Enlightenment comes from. It is also a Hegelian question: he was very skeptical of the idea that the Enlightenment itself brings the light into the world: the light was already there, because it was a product of Christianity. But if you look to Heidegger, you find the same idea, but in an abstract form: the light must be always already there, so that we are able to see something in this light, and judge it. We are not sources of the light. So when we are speaking about visibility, about art, the central question for me is this: What is the medium? What brings light, and shows us things? From this perspective, we can see it is not personal belief, and not subjectivity itself.

In considering and making art, we are involved in certain kinds of practices, which have a strongly impersonal level: they are actually based on the impersonal. For me, the place of religion is within that impersonal. Whatever our personal conviction or subjective attitude, what is decisive is how our practice is structured *beyond* our control. Our subjective control—the possibility of controlling the world, our judgments, our convictions, our beliefs—is, as we have said, very limited. It is this very limitation that opens the way to any religious genealogy: it makes genealogy possible.

II

JE: I would like to intervene here, because I think the subject of our conversation is turning, I think inevitably, from the enumeration of historical genealogies to a doubt about those genealogies impelled by concern about the terms that make them possible. Let us turn, then, to the second of our topics for today, the work we are asking certain fundamental concepts to do, and the ways our genealogies depend on certain understandings of those concepts. There are a number of possibilities. Tomoko, you began by talking about the concept of religion. We haven't said much about art, although we will, I hope, in the afternoon. Belief, and the historical constructions of the idea of belief, are certainly central.

One way into this question might be to ask about the differing uses to which our five genealogies put the concept of *history*. It could be argued, for example, that the psychological and psychoanalytic model functions as a non-historical model, in that it understands periodization or influence differently, and because its own historical ground would be restricted to the last hundred years, from Freud onward.

TdD: Psychoanalytic genealogies are easily historicized, since they run "from Freud onward," as you just said. Which is why I do not see Gregg's intervention as ahistorical, or as cutting itself off from historical approaches at all. What he said about the involuntary nature of belief is crucial. I would like to join in the conversation about belief and introduce a distinction, which I think is important, between belief and faith. Gregg said we inherit our beliefs, we are not our beliefs' creators: we are born into the beliefs of others. I agree. Now what is belief? People believe in ghosts or in magic or in the signs of the Zodiac or in the actual virginity of the Virgin Mary, and why not? Belief in that sense is superstition, delusion, and false consciousness. As Gregg said, you are born into belief, into the beliefs of whatever tribe you belong to. But you are not born into faith. Faith is an act: you make an act of faith. And I am convinced that the act of faith is not inherently religious at all. It is an ethical act. Whereas when I believe I surrender my freedom of thought to conform to the rites and customs of other people, when

I make an act of faith I yield to other people's freedom without surrendering mine in the slightest. Blaise Pascal was right to see the act of faith as a wager: "I have faith in you" means "I bet that you will make good use of your freedom, go ahead." Faith, faithfulness, fidelity, confidence, all these words derive from the same Latin root: *fides*. To have faith is by necessity to have faith *in* someone else, whether that someone is a person or a god. Take for example (by no means an example taken at random) my faith in my spouse's fidelity. Fidelity is faithfulness, so my faith is faith in faith. Reflexive faith, you might say. There is nothing religious in this act of faith, yet one religion—and not by chance, the one Gauchet called the religion of the exit from religion—was born out of precisely *this* act of faith. Allow me to give you a non-believer's reading of the mystery of God's incarnation, a reading that marvels equally about the mystery (I dare not utter the word "re-enchantment") but that shifts the story from religious belief to ethical act. As the story goes, Joseph has not yet slept with Mary, and yet she is pregnant. Any normal man would say, "Bitch! You slept with someone else!" But Joseph believes her. It takes quite a bit of faith in faithfulness, doesn't it, to conclude that if the Virgin is pregnant, there must be a God out there who has had a hand in this. Joseph's belief in God is no longer inherited superstition; it is second to his act of faith in the faithfulness of his fiancée, itself the result of his love for her.

DM: So faith is not faith unless it is a leap with a significant risk of failure. Mary might have turned out to be a tramp, after all—that was the risk Joseph took. But then why not regard belief as an encounter with a divine other?

TdD: For me, belief is superstition, false consciousness, although not in the Hegelian sense. People believe in ghosts and phantoms: that is superstition. I want to distinguish belief as superstition from belief as faith. In my little vocabulary, I distinguish belief from faith, and I think the Christian religion makes that distinction. As Gregg said, you are born into belief, into the beliefs of whatever tribe you belong to. But faith is an act: you make an act of faith. My theory of faith is that it is an ethical act of the surrender to the freedom of others. Therefore it is not inherently religious at all.

Now faith, faithfulness, confidence, and other such words are all the same, so that to have faith is by necessity to have faith *in* someone else, whether that someone is a person or a god. Take for example my faith in my spouse's fidelity. Fidelity is faithfulness, so my faith is a faith in faith. This is crucial to the question of religion, because it bears, for example, on how Christ was born. The Virgin was pregnant and Joseph believed her: that is the mystery, because any normal man would have said, Bitch! You slept with someone else! But as the story goes, Joseph has not yet slept with Mary, and yet she is pregnant. So it takes quite a bit of faith to conclude that if she is pregnant, God must have had a hand in it. That is a fantastic act of faith if I ever saw one: Joseph's act of faith in the faithfulness of his fiancée. A whole new religion is born out of that act of faith. Hence faith is surrender to the other: it is the *I believe you*.

Now, can this be universalized? Can I address not just one person, the one I love, but everyone? That is how modernity rephrases the religious issue, as an ethical issue—because every religion has an ethics inside itself. Before, you had ethics disguised as religion. Now we can have *bare ethics*. But can it be universalized?—that's the big question.

TM: I would like to align your exposition on belief and Boris' discussion on "opinions," though I realize they are different projects.[18] It seems possible to collate what Thierry calls an act of faith—as in, Joseph's pronouncement to Mary: "I believe you"—and what Boris describes as the state of the absence of opinion. If these moments epitomize religion in some way, then I think we have here not one but two instances that seem to be suggesting an alternative conception of religion, alternative to what I've been calling the reduction of religion to belief.[19] Boris, you describe religion as the space where you check your opinions at the door, so that it is a zero degree of the freedom of opinion.[20] Now, I suppose it's possible to read this as saying that you have a zero degree of freedom in religion because your opinion has already been chosen, chosen *for you*, perhaps. But you seem to recommend another reading—and this is the one I'm finding most intriguing—it's zero degree because opinions absolutely don't matter. And in this

reading "religion" would be precisely the space where whatever is done happens not because you've given assent to this or that measured opinion or to a particular view on how things are. Rather, things go on in religion for altogether different reasons, or perhaps for no plausibly explainable reason at all. That's where I see a connection to Thierry's notion of "act of faith." In both instances, I see you each bringing religion in a very different direction, different from where I think people ordinarily bring it whenever they claim that religion is a matter of belief; the more ordinary idea being that religion is something that provides a certain structured world view, which you feel you have the right to hold (at least where there is freedom of religion) and in light of which you feel you can explain and justify what you do and how you do it. Well, if religion is a zero degree, out goes all that.

Of course, it might seem frightening to think that religion could be such a state of total absence of measured opinions; but it's also possible to conceive of this space as ludic—and I would recommend entertaining this possibility. That's how Lévi-Strauss saw totemism.[21] He criticized those theorists who assumed that those primitive practices they found in Australia were stemming from a particular kind of belief system; and he criticized them for failing to recognize that what they saw in fact were so many operations of cultural technology—not a system of rules and constraints, but an ingenious set of tools, with a lot of room for play.[22] I find this compelling. Totemism understood in this way—I mean, not when it is construed as a primitive belief system—seems to me a good example of how religion works.

KJ: We have been linking belief to some kind of ethical or civic responsibility—to a community. But Thierry, how does that sense of community map onto the notion of the intersubjective in the Kantian aesthetic?

TdD: On the one hand, you have belief as habit, as in the Wittgenstein joke I mentioned a few minutes ago. On the other hand, you have faith, which I see as an ethical act. So we have religion (superstition) on one side and ethics on the other; where does the aesthetic come in? Where does Kant come in? And where does the sense of community come in? That's how I understand your

question, which is triple, really. I'll give you a tentative answer: it seems to me that the first modern secular formulation of a universally addressed act of faith was the aesthetic judgment in Kant's sense. Imagine I put a rose here on the table, and say, "What a beautiful rose." Gregg and I are discussing the rose, and he says, "You're crazy, that's the ugliest rose I've ever seen." We would disagree, but Kant's understanding of the situation would be that we are both right in claiming the other *should* agree. What matters, Kajri, is indeed community: a community of two, at this point. By claiming that Gregg should agree even though he and I actually disagree, I grant him the faculty of agreeing. I declare that I have faith in his judgment, in spite of its discrepancy with mine. He does the same with me; and we both generalize to all of us. The community of two Gregg and I are struggling to establish is universalizable *de jure* (not *de facto*), because when we use sentences such as "This is beautiful (or ugly)," we are not just talking to each other. Such sentences bear an indeterminate and therefore universal address. So, what Gregg and I claim, in talking in this way, is that humanity as a whole is capable of forming a community based on . . . what? On actual universal agreement? Certainly not: disagreement is the rule. On potential agreement, then? Gregg and I do not feel the same about *this* rose, but perhaps *another* rose will prompt us to be in affective communion with each other. . . . Kant's answer is: don't dream of that! Even if another rose reconciles you both, don't delude yourselves in hoping that the rest of humanity will join you! What Gregg and I claim, Kant would say, is that humanity as a whole is capable of forming a community based on the mere *idea* that all humans are endowed with the capacity of agreeing by dint of feeling. Kant's great discovery is to have understood better than anyone before or after him that aesthetic judgments have something to do with the building of community—not a real community, however, but a merely transcendental community—as signifying the possibility for humankind to live in peace. If beauty and art have that role, then they *seem* indeed to have appropriated a role that has been traditionally attributed to religion (I put the emphasis on *seem*).

GB: When Thierry and I both contemplate the rose together, are we

feeling the same thing? Or, are we feeling two different things at the same time? What guarantees our judgments about the rose? We must consider the role of belief. Understanding belief is one of the most urgent concerns we face today. What is the substance and nature of belief? How is it binding to community? I think Durkheim established how early forms of religion are the origins of society. For Durkheim, concepts of the abyss, and the existential nature of religion come much later in history than the founding religious laws and the religious regulations of social relations. But belief—and this is why I go back to psychology—has to do with what is shared, with the intersubjective moment. Belief in the world, belief in one's place in the world, belief in the existence of others, all this comes into existence through an encounter with the Other. One's continuing and habitual contact with the world gives rise to belief. Belief, as Thierry has said, is a probability, and you have to look at Hume, not Kant, for that. The philosopher David Hume taught us how belief arises through the experience of observable repetition in the world. Consider this: the sun might rise tomorrow, but we can't prove it. Scientific observations can predict it, but there is no *guarantee* that the sun may rise tomorrow. Our belief in tomorrow's sunrise is based on habit. The *guarantee* is an issue of belief.

TdD: We have to look at Hume in order to understand what belief is, but we might have to look at Kant in order to understand what faith is. The sun *will* rise tomorrow, if only out of habit. Such beliefs do not found a community, certainly not in the religious sense. On the contrary; think of the Aztecs: their community was founded on the premise that the sun would *not* rise tomorrow unless we fed it the hearts of our enemies. I like Kant so much, and I think he is such a superior philosopher when compared to Hume (even though Hume awakened Kant from his dogmatic slumber) because he pushed skepticism so much further without ever lapsing into defeatism or nihilism. Gregg, are we feeling the same thing, you and I, in front of the rose? In my example, no, we disagree. Are we capable of feeling the same thing? Are we capable of agreeing (universally, that is)? Notwithstanding his relativism, Hume assumes that we are. There is at bottom a good-natured

human being underlying Hume's essay. Kant, by contrast, is aware that human nature includes radical evil. He does not wish *sensus communis*—what you called the intersubjective moment—into existence. *Sensus communis* is a mere idea. If this is so, belief in the intersubjective moment will not do; to retain hope in humanity requires an act of faith.

GB: So, it's important to back up and look at the structure and nature of belief in order to understand that belief is the background against which this very conversation occurs. We have to believe in order to perform the most basic acts. Think of all the things I must believe without question, all the assumptions I must make, so that I can navigate the twenty feet between here and the exit. That, if you think about it, is astonishing in and of itself. The very presumption of it—me, you, the floor, the door, all of it!

Consider this: In O'Hare airport the same public announcement is repeatedly delivered over the public address system, "The Department of Homeland Security has elevated the terror threat level to Orange." (Or something close to that.) What kind of command is Orange? I think this is one of the most compelling aesthetic questions of our moment. What is Orange supposed to enlist? How do you perform Orange?

JE: Wonderful. Well, we have to stop in order to leave time for questions. I've been listening to the way this conversation has been going, from large genealogies to more tentative or contentious ones, and from there into these very fundamental questions, the basic terms of which I think are the only way forward—the only way to underwrite a shared conversation between religion and art. Based on the texts we have been reading, our conversations yesterday [in preparation for the panel], and again this morning, it seems there is no way to do serious work on the question while at the same time discussing the particulars of contemporary art: but I promise everyone, we'll get to that this afternoon. For now, the floor is open for questions.

Peter Heltzel [*Question from the audience*]: Hi: I'm Peter Heltzel, from the New York Theological Seminary. I wonder how you can relate the re-enchantment that's current in film and fiction to the

collective struggle for justice in a time of global crisis. One starting point in film is Tolkein's *Lord of the Rings*, and there's also C. S. Lewis' *Narnia* and even the Harry Potter phenomenon as an entry into the medieval imagination. But in a more modern, digital idiom there's *Star Wars* and even *Fight Club*—they can all be understood as emblems of re-enchantment. And yet global warming is the worst it's ever been, and we're in an age of fundamentalisms and violence. How can artists and activists work together, given that the solutions proposed in *Fight Club*—going into bars and beating one another up, or blowing up the financial district—just can't work?

BG: I would stress that religion has its foundational function, historically, as Thierry described it: it gives some guarantees, and creates a *sensus communis*. At the same time, it also provides a chance to split from the community, to be individual, to be alone, and at the same time to act in the society. It's a Kierkegaardian impulse, and it also affords the possibility of transcendence, without any guarantees or security, and without any *sensus communis* or community—even, or especially, a universal community. This is an impulse with an old and strong tradition, and re-activating it would give a kind of inner certainty and opportunity to the individual. The problem is so much greater than the individual—incommensurably so—but at the same time it *is* individual. Certain religious traditions teach that there is a possibility for individual transcendence of every kind of communal form of existence. I have already mentioned Kierkegaard, but I would also remind you of Nietzsche, Bataille, Caillois—all of them believed that an individual has a chance to discover in itself a dimension that transcends every kind of community, of society. To a certain degree, this dimension was opened already by Plato. The individual is here not simply a part of society—it is more than that.

WD: One thing we haven't talked about, an element among many elements of the many religions, as Tomoko says, is irrational hope. That is one of the subjects of these art forms, these films, which you're talking about. On the one hand, there is a flight to other people's religions, out of Judaism, out of Christianity, out of Islam, and into artists' religions—the "world of Narnia," the "world of

Tolkien," and so forth. (Those are not, actually, specifically religious worlds, although they are heavily Christianized.) Then there's the flight to Hinduism, the flight to Buddhism, and the interest in yoga in North America—they can be understood as attempts to transcend one's own religion in order to have *someone else's* hope, in place of our own rather dashed hopes.

Bryan Markovitz [*Question from the audience*]: The discussion this morning began with an examination of art in religion as objects received by an audience. Fortunately, that object-centric perspective was stalled by the discussion of faith and belief, and some fundamental aspects of the definitions of religion itself. Now that we have talked about religion in these terms, I would like to return to the discussion of art by connecting art practice with another fundamental element of religion, that of ritual. I am speaking here in terms of ritual as an ongoing act of faith, and not simply a symbol of faith received in an object. For example, ritual often serves to re-enact historic events as a way to examine the validity of shared values or the ethics of a group. I believe that secularized contemporary art often functions as a ritual practice detached from religious faith and used to re-examine values and ethics. In the afternoon, I'd like to talk about how ritual, and re-enactment in particular, connects to contemporary art. For example, do we see aspects of ritual in the work of artists who archive the past to examine the validity of historical narratives, such as in the film work of Stan Douglas or performances by The Wooster Group? But more generally, beyond that example, I wonder if you could talk about ritual from this perspective.

TM: There is a strong tradition in the study of religion to describe the form of ritual as a reenactment of the past, as well as an army of critics taking issues with this school of thought.[23] If I were to choose some names within our living memory, probably Mircea Eliade should stand as a monument to the ritual-as-enactment theory; on the other side, Jonathan Z. Smith has made a tremendous contribution to the field while critiquing the Eliadean position.[24] All this is to say that, well, ritual, too, is a contested notion, just as much as the belief business that we thought we'd just left behind. In fact, it's the same debate. My point here is merely

informational, though I'm tagging my usual plea not to foreclose the discussion at the outset by going along with a certain notion of ritual that seems to come naturally to mind. I think this is a safe and reasonable working assumption: Nothing about religion is natural; everything is historical.

BM: Yes, it is true that re-enactment is just one of the many possible functions of ritual. Ritual is also present in celebrations, rites of passage, and in ceremonies that connect religious faith to familial and societal events of life and death. However, this expansion of the term supports my belief that ritual and art share a great deal of unexplored territory, and it also prompts another question of potentially greater significance. I was attracted to the subject of this panel discussion because I believe there are many aspects of religious experience that art practice serves in a secular culture. Art is carried out as a serious way to engage questions of values and ethics where religion no longer operates. For many, this form of artistic ritual is what prevents art from being entirely consumed by commodity culture. At the same time, there are societies where art practice is limited or suppressed by the authority of fundamentalist religions. In those cases, ritual is much more strictly defined. Ritual seems to be an activity that crosses divisions of religion, politics, art, and everyday life. Can a clearer examination of how ritual functions help us to better understand the often-violent differences that have come to divide secular and fundamentalist societies?

JE: It's interesting to me that there is so little useful literature that bridges ritual, as it is understood in the study of religions, to ritual as it is theorized in the visual arts, especially in performance and—although this is your expertise—theater. The literature in the visual arts seems largely independent of anthropological literature, except for a few common touchstones—Victor Turner, Clifford Geertz, James Clifford.

BG: A couple of years ago, I was lecturing in Israel, also in the Palestinian Territories. I had chosen the topic of art and religion in the time of war. In Tel Aviv and in Ramallah, I was asked the same question: "When will great art come to us? We are waiting for a new Goya, a new Picasso—the Picasso of *Guernica*. We are waiting for

great art that will show to us and to the world our own suffering under the conditions of war and terror." I was stunned by that question because, for many years now, the world has been inundated by photo and video images from Israel and Palestine. That is, in fact, already great art, but it is overlooked in a strange way, precisely by the people living in the war zones, out of a false notion of what constitutes art. These powerful images, which have had so much influence on our generation, are regarded as not being art. They are associated instead with television and video games. That is why I am interested in the subject of video: it is an enormous body of image-making, driven by political and religious ideas. The propaganda and documentary videos constitute a kind of new, modern ritual, a kind of repetition in which concepts of ritual come alive.

Frank Piatek [*Question from the audience*]: I wonder if I could bring up a notion of Mircea Eliade's, "the camouflage of religion": the idea that various secular practices carry on or project religious or sacred or mythic gestures and meanings in disguised form?[25]

I am also wondering, in relation to systems of belief (which I am suggesting exist in both the world of religion and the spiritual, but also, in disguised form, in the secular materialist and rational dynamics of the art world system), if this notion of Eliade's might be helpful in addressing the unanswered "Why?" that existed at the head of the title of Jim's lecture last night ("Why Religion and Contemporary Art are Incompatible"). I am wondering if this notion of camouflage might not be helpful in uncovering some of the dynamic of those figures and authorities who assume the role of taste makers, who define the art world system, who determine what is allowed and what is not, what is perceived as real and what is not, and who also define and literally name the nature of the time in which we live and work. What delicious power it must be, to proclaim a new historical epoch, or the ending of another, and to set new and restrictive aporias and prohibitions. Could we not perhaps see in this dynamic a collective enterprise that is deeply engaged in a clash with other myths? (I use the idea of "myth" in the Eliadean sense, not as "false story," but as deeply hidden and meaningful dynamics that are not necessarily what they appear.)

DM: I think that's great, and I'd like to endorse it. It seems to be behind Clark's apparently prescriptive statement that there is a set of rules, and it seems that some people know what they are, can speak with confidence about them, and the rest of us are scratching our heads. I still find Clark's position disappointing. Jim, sometimes when you talk it sounds like you're saying religion and contemporary art *cannot* be linked, axiomatically, whereas Clark seems to be saying even if they could, they shouldn't. It's a kind of prescriptive distinction. From my point of view, doing ethnography, the study of lived religion, and visual piety, all that seems silly. I'm not working on fine art, mostly. If I want to know what people do with their images, I just go ask them, and I watch them. I see what they do, in their homes, churches, or synagogues, or in the streets, and then I compile descriptions of their practices.

So popular religious practices are one thing, but I wonder if we might take some of these discussions of belief and practice and apply them to fine art practice. In relation to your question, Frank, a sociological framing of the question could be very helpful.

FP: I think that approach may be useful in order to open up questions that seem to be sealed.

JE: Frank, you had a nice phrase yesterday: you said that for you the art world seems to be comprised of a "system of refusals."

WD: In relation to Eliade, part of the idea is that religious concepts re-emerge in systems where they are not allowed. This is what Jim Scott called the "arts of resistance."[26] Camouflage allows religious ideas to be presented as non-religious ideas, sometimes with bad effects—you see it for example in the political arena in our country. But I think we can also see this in the art world, where it is possible to get around these perceived refusals by presenting work as something other than what it is. Sometimes these meanings are deeply submerged, and concealed even from the person who *has* the ideas. This is also connected to ritual, because these can be things that are done over and over, and once upon a time in the genealogy of these acts there could have been a religious purpose, which is no longer perceived as such. So I think this is a fruitful way of entering into these submerged elements of art practice.

JE: *Unconscious religion*, I called it.[27]

Lisa Wainwright [*Question from the audience*]: I am wondering about issues of gender in relation to the subject at hand, and in particular how this discussion may intersect with the renewed interest in first-wave feminism that we're seeing on both coasts.[28] How does your interest in re-enchantment, Jim, and everyone's interests, bear on an earlier moment when many feminist artists deliberately took up similar questions? Indeed, if modernism was predominantly a male enterprise, perhaps that's why religion faded out as permissible content. If the practice of women in the arts has often taken up the subject of religion, what do we see when we employ their feminist lens on the topic?

GB: I'm a male feminist. The future of feminism, as well as many other liberation movements, seems to be in question now. You see this in a wide range of art today: people producing art from images of past protests, like Sam Durant or Mary Kelly. Mary Kelly's recent work, restaging images of past feminist protests, is particularly relevant to the discussion here. There is a current preoccupation with the problems of representing past liberation struggles. This occurs at a time when it doesn't seem possible to stage a credible opposition to the current war in Iraq.

With regard to gender, we learn much about volition, conviction, and belief from transgender theory. Current theories of gender distinguish between gender and sex. Biological gender is not identical with one's performed, embodied gender identity. Current theories make distinctions between feminine and female, between masculine and male. They also question heteronormative ideas about the link between gender and sexuality. All these are enormously useful and powerful ideas coming out of gender studies and queer theory. Current discussions coming out of transgender studies have re-energized feminist practices and they have great influence in contemporary art. I can give only one example here, the group LTTR. They identify as a gender queer and feminist group. LTTR produces a journal. They organize screenings and performance events. All their various efforts explore what it means to be a feminist now in view of transgender politics.

TdD: I wouldn't dare qualify myself as a male feminist—it's not up to me to say that—but I would add just one thing. The Christian religion, the one I was referring to with my Joseph and Mary story, harmed the cause of women and especially women artists tremendously. There is an implied art theory within the Christian religion, and it casts women in the role of the medium, depriving them of the possibility of being in the role of the author.[29] This is a political question with huge implications for art theory; it concerns the articulation of art and *this* particular religion, not religion at large.

JE: Thank you everyone: we start again at two o'clock.

III

JE: Welcome back everyone. What an interesting, tumultuous conversation that was this morning. Talking about it over lunch, it occurred to me that the way our historical models became at once more abstract and interdependent, and then the way we turned to conceptual issues—especially belief—was very promising. Our development of belief and faith, in particular, seems to be the only way a real bridge can be constructed between the discourses—the self-descriptions—of religion and contemporary art.

But now we need to turn to contemporary art, and I have in mind a different kind of conversation, in which we might try a provisional survey of the principal metaphors that organize the relation between religious or spiritual issues and specific art practices. Not the specific occasions—the scandals, the ostensively religious artists—but the tropes that help make sense of those occasions. We have several already in play: *camouflage* came up at the end of the morning session; it can be used to describe a covert practice, which presents itself as non-religious. (And as Wendy pointed out, such practices can be entirely honest, and the religious content uncognized.) Frank also mentioned refusals and resistance—the persistent holding-at-arm's-length of art practices that seem beyond the pale. I'm suggesting metaphors, rather than occasions, because they stand more of a chance of surveying the field, and because a listing of metaphors can function in a

nonjudgmental manner: we don't need to decide the relation between a perceived "structure of refusals" and the truth as it seems from the side doing the refusing.

I'll start out with an example. Here at the School of the Art Institute, we offer a degree in visual studies, which is a field that advertises itself, here and elsewhere, as a place to go to study the entire visual world, beyond the attention art history traditionally pays to fine art, and to painting, sculpture, and architecture. There are many difficulties with that image.[30] One that pertains to our subject here is the way that visual studies describes religious practices and religious meaning. This is nicely marked by the fact that since the *October* "Visual Studies Questionnaire" in 1996, visual studies has had a problematic relation with anthropology: the *October* statement associated visual studies with anthropology, but visual studies scholars in my experience don't generally perceive themselves as anthropologists, or even as borrowing from anthropology.[31] The general result of this triangulation of art history, visual studies, and anthropology has so far been a general lack of coincidence between visual studies' claim to study the world of visuality outside fine art—which would necessarily include a great deal of religious work—and visual studies' interest in an anthropological, or sociological, approach, which would enable it to bridge religion and art practices in a way significantly different from art history.[32] David, this goes back to a couple of comments you made in the morning about the study of images outside of the fine arts.

DM: Well, visual studies is not so much an object-centered discourse that wants to root spirituality (or whatever sacred quality one might have in mind) in an object. It is concerned with a visual field in which the object participates, but is not the only actor. The object, in this sense, is engaged by viewers, by values, by histories, and that makes it possible to produce a taxonomy of different ways of seeing—different gazes, to take that term temporarily out of its ordinary context in film theory and feminist criticism.[33]

This may not be of interest to scholars of contemporary art, but the value of an approach that is less object-centered than practice-centered is that it lets us understand the worlds, the life-worlds, in

which images function: the ways they gather meaning and participate in different social occasions. For the subject of religion, and perhaps also the production of art, that can be very important: the sacred is created as a social process, an effect of engagement. This seems to me very promising, so I welcome an ethnological, anthropological approach. It seems to me that visual studies takes very little interest in religion—a fact that I haven't been able to fully understand. It may parallel the absence of religion and contemporary art, so maybe we can think about these along parallel lines.

JE: I would say that the near-absence of religion as a subject in visual studies is directly related to visual studies' ongoing commitment to the discourse of fine art and the avant-garde. You have put the difference in methodologies very well: the object as instance of meaning, as distinguished from the object as center of practices. It is a gulf that has not yet been bridged.

DM: This issue, in general, can perhaps illuminate some of the anxiety or pain that some people have in dealing with religion and fine art. It is a pain that I don't really understand. I'd like to learn about this pain. [*Laughter.*] It's not that I want to promote religion in art: I want to understand it. It marks life-worlds that are not mine, and they can be fascinating.

KJ: I think an anthropological view can be useful in addressing this issue, in part because it can help train an ethnographic gaze on the West itself. I know that many of your concerns turn to Christianity, but for me, situated elsewhere, there are differing issues. I look at popular religious imagery, at printed images of Hindu gods and goddesses sold in the Indian bazaar. From a Western point of view they may seem like kitsch, but I don't think they are, because it's a matter of [what David, borrowing from John Berger, calls] the ways of seeing. The images are connected to commercial practices in India, and to actual economies of circulation, value, and meaning, which are not those of fine art or contemporary art. From that point of view, I see that the Western tradition has gotten itself into some terrible trouble by privatizing the sacred. Any kind of public expression of religious affect is deeply uncomfortable. It's kind

of taboo. It's embarrassing. We see this in public monuments everywhere. Why is public art so bad?

JE: This is also a problem in teaching, when you have an art student who is dealing with religious or spiritual content. One of the many moments of what Frank calls the structure of refusals is the feeling that it would be inappropriate for the teacher to articulate such meanings.

KJ: This maps on to the problem of why religion sits so uncomfortably with art. Religion becomes embarrassing, confessional, sentimental.

JE: The dogma is that one can't communicate these inner states. The feelings and the discourse are imbricated: the shame, or embarrassment, also nourishes a dogma of interiority.[34]

Taylor Worley: In other words, it goes against what Jürgen Habermas calls the "inner logic" of the practice of artists and art critics in modernity.[35] In his essay "Modernity—An Incomplete Project," Habermas gives us that description of the segregated cultural domains of science, morality, and art, which seems to imply within it what we have termed these "systems of refusal." He views "inner logic" as that which dictates that art should concern itself with aesthetic questions and other issues, religious or spiritual questions for instance, are simply beyond the pale.

GB: What we feel and how we embody our feelings must be discussed in view of current developments in media and technology. Today, we are subject to an unprecedented conflict between cognition and stimuli; our technological world has intensified sensations in ways that some of us celebrate and some of us loathe; emotion has been elevated to the status of a commodity under late capitalism. All of these things complicate our discussion of emotions. We are sold lifestyles and packages of emotions daily; we purchase emotions. The iPod is a good example of that: it's a self-stimulating device, a mood elevator, on a continuum with anti-depressive drugs. (I've been on both, and I'm not speaking against either.) The iPod is very much part of how we cope, protect ourselves from a cacophonous auditory environment that impinges on

us. It intrudes into our thoughts, everywhere we go. Our very interiority is in jeopardy, both theoretically and practically. It's threatened by the ways that our emotions are rendered as a matter of public affect. What do we feel now? How do we feel it? How do we represent it? These are all questions that must be answered in view of a general set of conditions—the current modes of production.

JE: I would agree with that, actually, but I take religion as an exemplary case, in the art world, of a discourse that is under a lot of pressure. It cannot easily emerge into the discourse of art pedagogy or visual culture.

GB: As an artist, I don't feel that. There is religious content in all of my work, in every video. In my book, *The AIDS Crisis is Ridiculous*, I talk about belief, non-belief, and my struggles with it.[36] I do not experience this prohibition that you are talking about.

JE: That is an interesting perspective. I do not think it would represent the position of many people here today—most of them have registered for this event on account of an interest in the troubled relation of contemporary art and religion, if not in the "structure of refusals" or any specific model of that relation. Speaking for myself, I see the difficulty of bringing the two discourses together as one of the most pressing problems in art discourse. So I wonder if you could say a little more about the contexts in which you find this freedom.

GB: I can't imagine the two discourses standing apart. I think one of the most powerful works of art in the twentieth century was Arnold Schönberg's opera *Moses and Aaron*. That opera poses the central problem of twentieth-century aesthetics—Which is more powerful, the image or the idea? Schönberg's opera draws that question out of the biblical story of the golden calf and makes it the central problem of aesthetics in the modern world.

JE: In considering these confluences and disjunctions of art practices, visual studies, anthropology, sociology, ethnography, and art history, it's also important to consider the effect of judging a given object as art.

TdD: Right. I was struck, not to say shocked, by what Boris said this morning about the Palestinians expecting a new Goya or a new Picasso; in other words, hoping that an artist of today would produce a work that addresses their ordeal while being on the level of the *Disasters of War* or *Guernica*. Boris said they had a false notion of art. Did I hear right? For Pete's sake, what would be the right notion of art if *Guernica* doesn't qualify? And who are you, Boris, to dare say that the Palestinians don't get the notion of art right? Did I actually hear you *regret* that the flow of video images submerging us from war zones is not seen as *art*?

BG: I differentiate between the terrorist act itself and the production and presentation of the videos documenting this act of violence. I don't think they coincide, really.

TdD: Of course they don't coincide. Video doesn't kill. I did not say 9/11 is reducible to its image. But the image is part of 9/11, not merely its representation. Actually it was an essential element in the terrorists' strategy.

BG: I also do not think the act of destruction is a work of art in itself. The videos are works of art. The cameramen are the artists, not the terrorists.

TdD: I disagree. I find it both more challenging for the intellect and more faithful to the facts to see the terrorists, or their master planner, as the artists. Seeing things this way has the great advantage of radically severing the artistic or the beautiful from the morally or religiously good. There is no more a priori connection, à la Plato or à la Plotinus, between the two. We are forced to think the connection anew and to make it depend on our judgment as to whether something—anything, and that includes deeds proceeding from radical evil—is art or not. Seeing things this way also entails an ironic critique of the terrorists' fundamentalist motivations, because it makes the Islamist ban on images backfire. Now the terrorists appear blasphemous by their own standards.

JE: I'd like to introduce a work of art in a more conventional sense: Thomas Ruff's large, high-resolution chromogenic prints of the

Twin Towers, taken from small JPEGs posted on the internet.[37] The images are in grids of about 100 pixels, ten by ten, where each pixel is represented on the print by a large number of resampled pixels. The effect is a little like looking through a wall of glass bricks, and a little like cubism. At the Association of Art Historians' conference in Belfast, the photographs were the subject of a paper by Rachel Wells. In the discussion afterward, part of the debate concerned what made Ruff's images acceptable as art—and part of the answer was their aesthetization, their ever-so-slight reference to formalist modernism and cubism. Transcendence, if not overt religion, is lightly camouflaged as fine art, giving it access to a certain portion of the art market.

TdD: Awful! Such aesthetization disqualifies the artist to begin with. (I'm making a moral judgment here, not an aesthetic one.)

JE: In the last few minutes, our examples have been refusals and camouflage: the refusal of the artists you encountered in Israel, Boris, to see an unexpected form of transcendence; the camouflage of transcendence in Ruff's photographs.

Smuggling is a related metaphor. Let me introduce this with an example. Tomoko, I'd like to read your essay on the history of the idea of the fetish as an incisive critique of an account of surrealism expounded in the book *Formless: A User's Guide* and elsewhere.[38] In that book, "base materiality"—a refusal of transcendence, a concentration on hypostasis and material substance—is taken as a crucial strategy of surrealism. In the authors' version of Bataille, the insistence on the absence of transcendence, on incarnation without revelation or redemption, is a kind of inverted anti-Christian epistemology, which is, in the end, the only possible form in which transcendence can still be thought. Tomoko, I know your essay isn't aimed at *Formless*, but you completely undermine that account by showing how the very same ideas were projected in the late nineteenth century as parts of a problematic account of religion. (One in which the fetish was excluded from the history of religious practices.) For me, the poststructuralist interest in "base materiality" is an instance of smuggling: religious ideas are taken into art theory through what the authors perceive as a non- or anti-religious context (Bataille's criticism): but in fact,

those same ideas are part of a longer history of refusals of the religious.

TM: It's interesting that, of all the neologisms that Europeans came up with to describe outlandish religions of the so-called savages, "fetishism" seems to have acquired a life of its own, so, it's still with us.[39] What would we do without it? My impression is that those twentieth-century writers and artists who utilized the concept in their practice—including Bataille—were almost entirely oblivious to its history in the previous centuries. The dynamic of the fetish discourse is, I think, largely unconscious, and all the more powerful because of that. It's as if we ourselves have been possessed by this idea—the very word and concept that was invented to name and describe the lowest and the basest kind of religion, or proto-religion, really. So, "smuggling" sounds to me a bit too intentional—as if they were aware of what they were doing when they were brandishing this idea of fetish.

But I guess you are right about seeing in fetishism an interesting moment where art and religion intersect inadvertently. I mean, to the extent that art-making involves materiality at some elemental level (including the digital media), it makes sense that it should immediately attach itself to the idea of fetishism, because this was an idea conjured up to refer to the type of religion that was reduced to sheer materiality; zero degree of spirituality. But then, this conjuring occurred in the first place because of the presumption that religion has to do with spirituality, and because of the refusal to consider religion as an essentially material practice. (Religious rituals don't have to be thought of as a material enactment of an idea, or a belief; but that's been the predominant assumption.) So I think what "fetishism" is smuggling in is in fact something more specific: religion's anxiety about material things. That has a long history before the nineteenth century, of course, as the problem of idolatry.

JE: Yes, and there is a developed discourse of idolatry, iconoclasm, iconophilia, and "iconoclash."[40] The fetish is especially interesting because in the twentieth century, it has been a way of bringing back a kind of religious discourse, with the severe restriction that the condition of its appearance is its unambiguously non-religious

status. The fetish is the zero degree of discourse that then comes
to include idols and idolatry, problems of representation and the
unrepresentable, and so forth.

GB: I wonder about the notions of camouflage and smuggling dis-
cussed before. They're vaguely paranoid. Talk about smuggling
and camouflage gets everyone searching for hidden religious con-
tent. The idea that artists hide content as a matter of choice is a
problem. It creates the illusion that the artist is completely aware
of his or her intentions.

JE: You don't have to believe in volitional control to say that artists
can worry about how to orient their work, in practical terms, in
order to get good critiques or reviews.

GB: I'm an artist and I take issue with the contention that there is
some kind of ban on religious art. I do not see that operating in the
contemporary art world. I'll give you an example of a very promin-
ent and visible work of art generated in response to the events of
9/11. I'm thinking about Paul Chan's contribution to the 2006
Whitney Museum Biennial, a video installation titled *1ˢᵗ ~~Light~~*. It
received a lot of attention and I think it is a religious work of art.
How is it religious? Well, it recalls the history of religious art in a
number of ways. The video installation is simple and solemn. An
animation loop is projected onto the floor. The projection makes a
trapezoid shape on the floor of the room. The installation and the
projection draw people into the act of staring, of paying deep
attention. It elicits a kind of meditation. *1ˢᵗ ~~Light~~* produces many
affects associated with some forms of religious observance. To
stare at the projected images, the viewer has to stand, head bowed,
eyes cast downward, for a long time. Walking into the room,
before one can even look at the projection on the floor, one first
encounters others, standing as if they are mourning at a funeral.

The figure of the cross is a key element of the projected anima-
tion in *1ˢᵗ ~~Light~~*. Is it a cross? Actually, it's a line drawing of a
telephone pole placed prominently within the frame. All around
this cross-like figure, line drawings of common objects—like cell
phones, automobiles and eye glasses—float in and out of the
frame, in all directions. There is no one direction of gravity.

Drawings of human figures also drop through the projected field. The placement of the telephone pole is an ambiguous gesture. It's a provocative gesture. *1ˢᵗ Light* begs the question—What is a religious work of art today? *1ˢᵗ Light* is a profoundly religious work precisely because it invites the viewer to imagine the religious dimensions of our everyday experience, NOW, at a time when the everyday is fraught with mourning, loss, fear, and anger. The installation does not propose or endorse any particular interpretation of current events, nor does it guarantee any particular explanation of history. It does all this at a time when religious fundamentalist factions, in our country and elsewhere, are competing for political power.

JE: Two questions could be put to that account. One is that Chan's artwork is unusual. It was not statistically the norm even within the Biennial context, or biennale culture. The other question would have to do with what happens "outside" the biennale culture, "outside" work that circulates in the international art market. There is the larger world of ordinary art production, art schools, art students, where the problems we are discussing, and the metaphors of smuggling and refusals are absolutely commonplace. They are at work throughout this School. And beyond academic art production, there is the ocean of religious works made for other contexts, which can appear kitschy, schmaltzy, saccharine, old-fashioned, and conservative—and in those contexts, when the work encounters art world institutions, it experiences "structures of refusal."

You can look at this problem statistically: the Biennial is a tiny sample, the international art world a larger sample, the sum total of art students and graduates a much larger sample, and the sum total of contemporary art production vastly larger.

GB: I am relating to these questions as a practitioner—I make art and I write. I'm also Jewish. When I go to a Passover Seder, I can appreciate a beautiful handcrafted seder plate. I can go to a number of Jewish museums in the world and admire beautiful seder plates. I don't expect to see a seder plate hanging next to an Ellsworth Kelly in the Art Institute anytime soon. Why?

For the past hundred years, the avant-garde has interrogated

how contexts, interests, and habits lay claim to works of art. I think *that* inquiry remains an urgent and worthwhile endeavor. BUT, that is not what's going on here. Jim, you repeatedly return to a conspiratorial narrative. Basically, you're blaming Clement Greenberg for a ban on Christian iconography in fine art galleries! And I disagree. That ban does not exist!

TdD: I think there are very good reasons for prohibiting Christian iconography in the gallery—unless, of course, we are talking about things on the level of, say, Gerhard Richter's remakes of Titian's *Annunciation*.

GB: Well, you should make that argument then.

TdD: As Kajri said, public displays of affect are embarrassing, especially in regard to artworks. Several of us agreed that the issue of faith is crucial to our discussion, so pardon me if I come back to that. As far as I know, and in regard to Christianity (the only religion with which I have had close contact), faith has to be proclaimed. One proclaims one's faith, which is why faith is an act; St. Paul insisted on that. The act of faith is public, and so is a work of art; it is a publicly declared aesthetic gesture, or act. As I argued this morning, this aesthetic act is also an act of faith, a declaration of confidence in the viewer's taste. So, in case of religious art, we have a religious and a lay act of faith embedded or enmeshed in one another, and it's up to the viewer's aesthetic judgment to disentangle them. This brings me to the reason why I think many of us have problems with overt religious iconography. The aesthetic judgment that I am expected to make approves of the work, on the basis of my response to the work's public declaration. The work is, as it were, asking: "Do you approve of me aesthetically?"—and I am answering, "Yes (or No, or More or less, etc.)." But if the work also declares an act of faith *in* religion, if it is calling on religious affects confused with aesthetic quality, then I am bound to approve of its religious content by the same token. That can be profoundly annoying. I feel I am hostage to someone else's belief system.

There is no problem as long as I am looking at a work of art from a period where I sense the immanence of religious meaning

to the work's purpose, so that the collective approval of the individual act of faith expressed in the work is somehow sensible, perceptible. For example: I go to Venice, and I look at a Bellini painting, and it is obvious that Bellini must have been a deeply religious person to paint the Madonna the way he did. When I listen to Bach, who is perhaps my favorite composer, it is clear that only a person with a profound religious belief would have been able to compose such music. When dealing with Bach and Bellini, *their* faith is part of *my* aesthetic pleasure. I can recognize the faith, and it resonates in me, even though I am not a believer, because Bach and Bellini were embedded in a society that shared their faith. What I mean is that authenticity in religious art hinges, even at the collective level, on the difference between belief as cultural habit and common superstition, on the one hand, and shared *individual* faith as true religious fervor, on the other. Such authenticity is not available to contemporary artists, and it's not the artist's fault, it's not my fault, it's nobody's fault: it's that we no longer live in a society that is united by a collective, shared faith. Therefore every expression of religious affects inevitably sounds fake.

DM: You assume that the present world is as uniformly non-believing as Bach's was a uniformly Christian world. But both assumptions are wrong. His world was violently split between Protestants and Catholics, Jews and Muslims. And if polling is accurate, our world today has more believers by far than non-believers. Perhaps only 5 percent of Americans do not believe in a deity, according to recent surveys.

JE: Thierry, could you include Paul Chan's work?

TdD: I haven't seen that work. But when you were telling that story, Gregg, I thought: Wow, what extremes we have to go to in order to make a religious-aesthetic experience plausible again! Do we need a 9/11 each time we want a true, authentic, religious experience from art? Mourning, and mourning collectively, were the key words in your story. Wherever a community of mourners is assembled—and with 9/11 it extended worldwide—the conditions of what we might call, for lack of a better word, religious aesthetic experience, are restored. I only hope that the people who

do not believe in God are not banned from that community of mourners, as I am afraid was implied by George W. Bush's insane crusade.

BG: I spoke this morning about the visually non-identifiable level of religious meaning in art, but there is also art with identifiable religious iconography: for example, Douglas Gordon, Maurizio Cattelan, Andres Serrano. For me, these works are, actually, religious ones. I disagree that they embody a critique of religion: they are blasphemies, but blasphemy is a religious act. (That is in Bataille, Bakhtin, and others, who theorized blasphemic rituals as parts of the religious tradition.) In that sense, I would not say that we don't have identifiable religious iconography in contemporary art. The only difficulty is that it is now thought necessary that artists use specific blasphemic artistic devices to present such iconography—but if those devices are applied, it is perfectly possible to use religious iconography in the contemporary art context.

JE: For me, it would be a question of those devices: they can be very obvious (for instance when an anti-religious gesture attracts media attention) and also extremely complex. Cattelan, for example, has become very proficient at producing smokescreens of mutually conflicting, often evasive statements—as witness the mass of press statements, books, and magazines around the Fourth Berlin Biennial for Contemporary Art.[41] I'm not saying misdirection has any particular relation to aesthetic or non-aesthetic content: I'm noting how complex the "devices" can sometimes become.

Taylor Worley: I think you're right, Boris, regarding religious "content." I don't think smuggling is a particularly good metaphor, because the "device of critique," as you say, is really the only option available to artists that allow for religious meaning as a component of their practice. I mean, Georges Rouault could not feature in this conversation, but Douglas Gordon or Andres Serrano fit well within it.

In this scenario, artists that allow for religious meaning rely for the most part on a specific use of personal narrative.[42] But this use of personal narrative for religious content actually comes to resemble something more like the exercise of identity politics

rather than a simple endorsement or criticism of religion. And successful artists, and not just "religious" artists, are the ones who can maintain a hierarchy in their practice, in which the aesthetic developments or innovations remain the primary concern of the work, and the use of personal narrative or identity politics is maintained on a secondary level. I think this is one of the main reasons that the work of Félix González-Torres has remained so preeminent in the decade since his death. The purity of his conceptual gestures is what actually guarantees his aspirations to live on in his work. And the biographical content of his art further solidifies his legacy beyond that.

And I agree with you, Thierry, that we don't live in a world of simple relations between art and religion anymore. In bringing religious elements into a work, an artist also has to, must, incorporate a sense of self-critique and irony. That irony should also manifest a level of respect and freedom for the other.

TdD: Or use blasphemy as camouflage. Andres Serrano, for example, uses blasphemy as camouflage, but it is transparent camouflage. I have hated the work from the very first time I saw the images, because I recognize the Christian who wants to convert me. In regard to what you describe as opening a space for the freedom of the other, I think Serrano's morgue pictures do the exact opposite. They are unethical because he photographed anonymous, family-less bodies that no one will claim. No one can speak for the dignity of those dead people or protest on their behalf. And the viewer is taken hostage, too. Serrano perhaps thinks he can launch a Council of Trent on his own, but all he has achieved to my eyes is to have hijacked everyone's freedom with aestheticized images disguised as Baroque painting. For me the work is despicable both on the aesthetic level and the ethical level.

TW: I also have problems with his morgue photos, but I think you give him too much credit when it comes to trying to elicit converts with the *Piss Christ*. Obviously, the work alienates both sides, and I haven't come across any sympathetic readings of it from the Christian perspective. If we take it in its more didactic sense, which I think you imply, then I think it is directed more at discourse of identity formation within his own religious context and

not to a broader audience. In other words, it could be aimed at releasing Christians from a certain image worship rather than recruiting new worshippers.

JE: These examples are unsuccessful smugglings, in the sense that we can easily occupy critical positions that demonstrate the rift between aesthetic and religious meaning.

TdD: Serrano has a lot of success! He plays the perverse game of "Head I win, tail you lose." He caters to the cynical art world that grins at the blasphemy in his *Piss Christ*, all the while telling the people who are genuinely shocked that he has produced a contemporary, redeeming, and truthful representation of Christ's humiliation on the cross.

KJ: Thierry, this characterization of religion as a matter of faith, as a declaration of faith, is very Western. It speaks to your interest in Christianity as the last religion before the exit from religion.[43] Because if you have to declare faith, you are already in doubt. I contrast this with a lot of Hindu practices, or perhaps the kinds of religious practices that Tomoko is talking about, which seem superfluous or ornamental, and would not need to declare themselves. A lot of Hindu music, poetry, and dance concerns the *enjoyment* of the divine. It's about saying, Oh, that is the divine, and there it is! It's a kind of performative reaffirmation. That's where rituals come in, because they are about constantly reaffirming the divine through performance.

DM: Thierry, I like your idea about Christianity and its cultural situation, and Kajri, I agree that faith as a proclamation is very much a part of the Christian world. It is important to keep a global perspective on our reflections. But returning to self-critical, post-Kierkegaardian Christianity: there, doubt and paradox are not signs, at least in the world of belief, of the slow ebbing and death of the religion. They are the signs of its possible renewal, its survival in the modern world. You can't just believe innocently anymore: you must enfold any act of faith with search, with self-criticism, and potentially with severe doubt. You must risk giving up belief. That is the way a lot of the more interesting theologians talk. Faith is not a matter of simple certainties. It's not about the

affirmation of propositions that one holds to be true. Doubt is at the heart of it.

I am trying to think of artists who take *that* seriously. Is there art being produced that could satisfy the criteria of gallery art, that is serious, interesting, hard-hitting, and also engaged in these practices of doubt?

JE: For me, that opens the question of writers like Mark C. Taylor, and more broadly Jean-Luc Marion, Jack Caputo, and others. Taylor, for example, has written on Anselm Kiefer, so there are artists who would answer to that configuration of post-theology and contemporary practice.[44] That kind of scholarship succeeds in adequately modeling only a very small fraction of contemporary art production, and it tends to focus on works whose articulation of the erasure or absence of God involves strategies (such as blur, darkness, abysses and voids, smearing and spilling, and the insignia of negative theology, kabbalah, German mysticism, or alchemy) seem disproportionately easy in relation to the very serious theological issues they are taken to embody.

TW: Along these lines, I think of the influence of Michel de Certeau and his impact on the development of "Relational Aesthetics."[45] This is another small faction within the broader world of contemporary art, but de Certeau's efforts at identifying live options for religious sociality have effected a good deal of thought more generally about the social interstice of post-industrial life, particularly in the writings of Nicolas Bourriaud. And these concerns are the mantle of relational aesthetics practitioners today.

JE: So far, we have been mentioning uncommon art practices—well-known examples, internationally famous artists. Let's say art practices are a spectrum. On one end is the high-energy ultraviolet, which in this model stands for the few works that achieve the most concerted critical attention and, often, highest market value. Thierry, Gregg, and I have each adduced examples. The other end is the diffuse, low-energy infrared, which here denotes the many practices of art-making outside the art world, including the popular religious imagery David and Kajri study. In that range, works may be judged very differently, and practices can be very inclusive.

Before we run out of time, I want to introduce some mid-range colors: common practices in art schools and in the dispersed communities of working artists, which together vastly outnumber the number of artists who participate in the international art market. They are in turn outnumbered by the many ways of making art that do not engage the art world.

Two colors, then: performance art and some video that is strongly body-centered, and depends on embodied, often multisensory experiences, is often taken as a locus of the spiritual or even the religious in contemporary art practice.[46] David's essay is among several that make this kind of connection.[47]

Another color—another place where religious or spiritual values have been assigned to art practices—is the whole re-reading of twentieth-century painting, especially abstraction, as a fundamentally spiritual undertaking, whose spiritual content has been submerged in much postwar criticism. In that realm, the exhibition *The Spiritual in Art* is a touchstone, a rare moment in which spirituality inherent in the practices of abstraction was acknowledged by the academy.[48] The proposal that painters like Rothko and Newman need to be taken at their word, and considered in terms of their anxieties about transcendence, has a strong life in art schools, if not in universities.[49]

My proposal here, initially, is just that we cannot do justice to our question unless we also work in the gap between internationally viable contemporary art and the many forms of art-making that operate outside the art world. In between are practices that represent, I think, the majority of people here today. There is a big middle ground, within the art world, of average practices, whose conflicts and possibilities differ from the ones we've been considering.

GB: For some reason I feel compelled to explain why I think that art can change the world. I do not believe that art feeds people, or that art ends AIDS, but I do believe that the job of art is to return the viewer to herself or himself estranged—feeling strange and feeling the world as a strange unfamiliar place. This is an inherited modernist ideal. I accept it. That is why I would argue for the autonomy of art. I am deeply invested in creating a space where the

significance of my encounter with the work of art is not guaran-
teed; where I am forced upon myself, both at the level of pleasure
and danger; where I'm pushed to confront myself as weird *to*
myself. That experience is enormously valuable. I cannot really
account for this, except perhaps through psychoanalysis. I often
think about my own development as an artist. Somehow at a very
young age the aesthetic experience I just described became the
most meaningful thing to me. I decided to make it my job.

While I understand that I am a postmodern subject—I have
dismissed high and low distinctions, I go to the movies, *and* I go to
the museum, I'm interested in raiding the sensibilities of all kinds
of music, from opera to punk—still I remain deeply committed to
protecting this one area of practice where there are no guarantees,
where I confront myself as strange and singular. Regarding art, I
am not interested in sharing a common taste with another. I prefer
that the object presents itself as a uniquely novel fact. I do not
want to share a taste with the viewer standing next to me, as if
we're in a courtroom of taste. I want to be radically thrust upon my
very own engagement with what I am facing.

The market effectively forecloses the possibility of this kind of
enjoyment. That makes me despair. I understand that my desires
follow a trajectory of the avant-garde, and I have lost my faith in
the avant-garde.

[*Applause.*]

TdD: Pardon me, Gregg, for not joining the applause.

GB: That's okay, I want to be alone. [*Like Marlene Dietrich*] I vant to
be ah lawn.

TdD: What you just said, and the tone in which you said it, made me
think that if someone—an anthropologist, let's say, from outer
space—were to come and get the tape of our conversation, and cut
it from its context, he or she would have heard you preaching.

[*Applause.*]

What you said about art was tantamount to the foundation of a
new religion, and I am a bit wary of that.

To return to points made by Kajri and Jim: when I deal with art

that comes from a culture where faith or belief seems to be still functioning, I don't have the wincing reaction I have to Andres Serrano, for example, or Bill Viola. Viola is always calling on you to approve of his religious experience. You have to bathe in the same baptismal water as him, and that's enough to make me say, Yee!

JE: It is religiosity.

TdD: Exactly. I have nothing against religion, but everything against religiosity.

TdD: I must admit that I am a lot less critical vis-à-vis religiosity in art (with the kitschy and the schmaltzy that Jim said go with it) when I deal with non-Christian art. Indian art, or the little I know of it, is a case in point. Bhupen Khakhar and Vivan Sundaram are painters that touch me, because they never hold me hostage. My aesthetic judgment is mysteriously separated from the judgment that approves of the (perhaps feigned) religiosity emanating from their work. I do not have to be a born-again Hindu, whatever that might be, in order to experience the work in this way.

JE: I see Khakhar as entirely of his time and place, with no special authenticity beyond the mixture of 1980's Indian and Western neoexpressionist influences.[50] I haven't personally had any experience of contemporary practices I could take to work in that way.[51] But I take the point about the *possibility* of such an experience, which I would understand as a condition of contemporary art.

TdD: We have not yet talked about modern art that is overtly religious and has been commissioned as such. The best examples are done by non-believers. Matisse's *Chapelle de Vence* is one of the finest examples of religious art in the modernist idiom. And yet Matisse was a non-believer. Le Corbusier's chapel in Ronchamp would be another example. He came from a Protestant family, and was himself a non-believer. And yet he made a Catholic chapel that provides you with an elated aesthetic *and* spiritual experience. Closer to us, the only example I have in mind is Jean-Pierre Raynaud, who made stained glass windows for a Cistercian abbey in the south of France.[52] It is very convincing work. By contrast,

Manessier, who did lots of stained glass and was a pronounced Christian, produced bad art.[53]

JE: Why was it bad? Because of his lack of doubt? Manessier was in many ways a typical ecclesiastical artist of the kind I describe as "watered-down modernism": his forms, and not only in his stained glass, are a simplified cubism. It seems there should be a way to link that observation to your judgment.

TdD: Perhaps Manessier was bad because he so badly wanted to infuse his cubism with the extra spirituality that he thought our time needed. And the contrivance shows.

JE: This is a pessimistic message for those artists here today, who feel themselves to be religious, and want to create religious art—

TdD: Yes, of course—

JE: The moral would be: find a source of doubt, become an unbeliever, and then come back and make art!

GB: And only have certain feelings! I think this is interesting—it's a pedagogical moment. Thierry, why did my enthusiasm immediately become a problem and the reason for you to dis-identify?

I don't understand. I'm willing to unpack this in a totally disinterested way. I am willing to go through it: I was feeling a little agitated, as if something needed to be represented . . . an idea excited me, I was moved to enthusiasm but I'm not sure why, even if it is narcissistic it doesn't matter, because it has effects, it still registers socially because it has affects and effects on the audience, there was applause . . . and yet there's something uneasy about applause. I was uneasy about the applause, although of course I enjoyed it—

TdD: You called for it!

GB: I called for it, yes. The issue is ambivalence.

TdD: Right. Be reassured; you will fortunately never become a good televangelist.

GB: I am not trying to. What I am trying to do is talk about this issue of ambivalence, and also something that was an urgent concern of

Jim's talk last night: the issue of passion and its relation to religiosity—

JE: Or sincerity and religious meaning—

GB: What happens to a student who *has* a passionate relation to her or his own work? What happens when passion and enthusiasm arise during school-sponsored critiques? Often, the very enjoyment of a work, or a concept, is immediately flagged as suspicious. At best, enthusiasm is often viewed as self-delusion. At worst, it's criticized as mindless and therefore dangerous. Can the experience of art be embodied as enthusiastic enjoyment? Critique is not a process intended to kill the object and move on to the next. Unfortunately, too often, that is what passes for critique in the academic art world.

TdD: Gregg, I agree about critiques. I'll give you a quick answer on the subject of enthusiasm. I identify with Kant, who is generally extremely skeptical vis-à-vis enthusiasm and aligns it with *Schwärmerei*—one of his words for superstition. But there is one instance (in the *Conflict of the Faculties*) where he speaks of the enthusiasm certain people felt for the French Revolution and, while not participating in it, seems ready to share it at a remove, so to speak. He noticed that some people who had no class interest in the Revolution, for instance aristocrats, were enthusiastically endorsing the Revolution nevertheless. He saw a sign of progress in the fact that people who would have every material interest in fighting in the camp of the counter-revolutionaries, would support the Revolution. I'm interested in that particular brand of enthusiasm: you don't quite share it, and you keep at a distance, yet you endorse it as a sign—not as a proof—that some hope is possible somewhere. The minute you think enthusiasm is proof, then religiosity enters in, and with it *Schwärmerei*. Then I feel I have to part company with the crowd.

JE: Gregg, I wonder if you could say something about exactly what prompted your astonishing speech. Now, in light of this conversation on passion (what I would call sincerity) and enthusiasm, I wonder if it was because the two "colors" I mentioned are rife with compromises and halfway measures? (Because, just now, you

responded when Thierry and I were talking about religious artists, skepticism, and doubt.) Or was it more because the two "colors" are practices that do not, perhaps, always aspire to the self-alienation you describe? I'm asking in order to situate your enthusiasm with the conversation we were having at the time.

GB: I don't know why I was moved to say what I said. In my own work, I am rethinking an inherited opposition between thinking and feeling. I am asking myself, how does sensation play a mediating role between thinking and feeling; how are affects produced? To think about these questions, I have to stretch my limits. I must open myself up to different lines of thought, different intellectual histories. I feel trapped by antinomies: to believe or not to believe. To endorse or reject. As I said before, I am much more interested in the structure of belief. I'm interested in how beliefs change. It's actually very difficult to hold on to some beliefs. And yet, there are some beliefs that refuse to die. What are the mechanisms of that? Regarding enthusiasm and passion, I can't endorse or reject these emotions. They're just facts. They arise as facts. How do they arise and what unfolds from them? Those are the questions.

BG: Installation art is interesting in this regard. It is not about individual objects, but the sacralization of a certain space. It is an interesting medium, because it has to do with the marking of a void space as an art space: everything that is inside the space automatically becomes art. That is absolutely different from the traditional way of dealing with art as the sum of certain objects. Of course the antecedents of installation art are temples and churches, where lines are also drawn between sacred space and secular space.

To a certain extent, one can say that installation art is the leading art of our time, and it is only conceivable as an outgrowth of those older traditions.

JE: Installation art, understood in that way, could be added to our list of refusals. There is the alternate historical model, which sees installation as developing from constructivist and surrealist installations, from minimalism, and from the white cube—

BG: I do not mean this in terms of institutional sacralization, but only in terms of installation art itself, which can be done anywhere, in

museums or outside them. Every object that goes inside the installation becomes an auratic object, an art object.

This is for me also a way of rethinking Benjamin, and his theory of aura. Installation is actually a reversal of reproduction, and a reversal of the ordinary mode in which art objects travel and are distributed. Benjamin believed that when art works start to travel or to be reproduced they lose their aura of originality. Benjamin uses *aura*—and aura is a kind of sacral dimension of the things—as a name for the topological inscription of an artwork into *here* and *now*. But that means that every installation re-creates an aura of originality precisely because it installs things—gives them topologically defined here and now. So installation can do something mysterious, quasi-religious, making an original out of a copy.

JE: Benjamin's aura, the revived aesthetics of the fragment, and the postmodern sublime are good examples of concepts that function in the art world as camouflaged religious terms. This pertains to the humanities in general, where the postmodern sublime has a history of functioning as a placeholder for otherwise unacceptable discourse about religion.[54]

DM: Benjamin's aura is the effulgence of an object's power, the luminous manifestation of its reality as a source of something compelling. That is clearly a religious or sacred idea, and works of art might be said to descend from sacred objects enthroned for veneration, such as relics of a saint's body displayed in reliquaries on altars. What Boris says about installation tweaks sacrality in an important way, pulling aside the curtain and letting viewers of art see how spaces are constructed, dismantled, reconceived. But I don't mean to imply that this treatment of space is only disenchanting. To the contrary, the magic remains even if the space is not charged with a religious duty. The magic consists of the transformation, the deft metamorphosis that the artist pulls off.

JE: What I meant a moment ago, Boris, was not that your history of installation art would be refused by an institutional critique: I meant that a history that taps into sacred practices would be refused by accounts like Rosalind Krauss'. For her, installation is

an unfortunate moment in the postmodern exploration of media: it's a misunderstanding of the possibilities of media, and the ways they can be questioned, and so it's a secular question.[55] I am, myself, very sympathetic to your history of installation art.[56]

BG: Krauss' account is based on a misconception. She believes that installation is an *assemblage* of different objects in a space. For her, it is an exhibition that proclaims itself as an individual artwork. She overlooks the fact that the space itself becomes the medium. She asks, Where is the medium of installation art?—and she doesn't see it, so she concludes that there is no medium, and therefore that the installation art is not good.

But the space—pure, Kantian space, if you will—*is* the medium, just as it is in churches and temples. The moving of objects from one installation to another, with all the strange processes of *Auratization, de-Auratization, re-Auratization*, is a good example of enchantment, re-enchantment, disenchantment.

JE: I would like to start to bring our conversation to a close by returning to another possible sense of freedom. Gerhard Richter sent a monochrome gray painting, called *Gray*, to the exhibition *100 Artists See God*, and part of the statement he sent along with it contains this statement: "A monochrome gray painting, oil on canvas, in any common size, is simply the only possible representation/image of God."[57] It is significant he was willing to commit that to print, no matter what other dimensions *Gray* could be said to have. The history of monochromes embodies the distance between the metaphorics of constraint, refusal, camouflage, and smuggling, and the tropes of freedom and passion that Gregg has articulated. Monochromes have repeatedly been the dead ends of painting, and at the same time painting's most transcendent, hopeful moments. There is a well-developed secular literature on self-reference and self-referentiality, and an equally well-developed religious or spiritual literature on transcendence in paint, and its possibility or impossibility.

DM: Richter's position is not an atheism, but an agnosticism.

JE: Yes, but one well-balanced between agnosticism and another kind of opposite, a non-religious understanding of the same enterprise.

At the monochrome, the two discourses on abstraction are separated by a paper-thin divide.

TdD: Every painter in that tradition could have endorsed what Richter said about the gray monochrome. They are living in a period in which it is the only representation *left* of God. It is an instance of what the Fathers of the Church and the iconophile theorists called *kenosis*: the emptying of the medium so that incarnation can take place.

DM: This says little if anything about god, who remains unsaid, but much about the history of culture, ideas, and representation. *Kenosis* has serious possibilities. What happens after the death of god? The post-theology literature of the 1960s said, That's it, now we're on to post-Christian culture. In many ways the "death of god" movement anticipated the "end of art" that has been discussed in recent years by Danto and others.[58] The idea was that by dying, really, finally dying, Jesus ended the distance between humanity and divinity. You'll recognize a Hegelian synthesis of opposites here, which some may regret, but the point was to take the death of god seriously, as a radically new metaphysical and ethical situation. It was a kind of philosophical millennialism—the horizon had changed because the conception of the divine had changed, even ended.

A comparable immediacy between life and art undergirds a great deal of performance and installation art, Fluxus, Happenings, Pop, and so on. Here's the thing: belief can be as sophisticated as art—this is something not many art world inhabitants seem prepared to recognize. They want to see faith only as reactionary, unreflective, authoritarian, and simplistic. That is why I think it is important to include doubt in our understanding of religion when approaching the study of art and religion.

TM: My concern is to alleviate the constraints on our discussion. And for that reason I wonder about the valorization of doubt. To backtrack a bit, something like a theology of doubt—here, I'm talking of a certain disposition or sentiment, rather than any doctrinal stance—the kind of theology of high seriousness was quite fashionable in the mid-twentieth century, and maybe we're still a

hangover from it. In any case, the consideration of religion from that standpoint is extremely constraining.

JE: I would agree, from the narrower standpoint of art theory, because the post-theological discourse by Taylor and others has had only a narrow range of application, and is arguably separate from the main streams of art writing.

DM: I have no interest in "valorizing doubt." No more than in valorizing belief or valorizing religious practices—or valorizing art, it's important to add. I am interested in accurately characterizing religious behavior in order to study it constructively. Thierry characterized faith very well when he pointed out it was an act, not merely an utterance or a propositional assertion. Belief as faith consists of more than an affirmation of a creedal declaration for the sake of certainty. If one examines what believers say and how they act, it becomes very clear that belief is not a sunny, naive disposition untroubled by its own internal contradictions. We will never get anywhere studying the relation of art and religion if we don't work with a more robust view of what belief is in practice— which means what believers actually do, not what intellectuals think they *ought* to do.

TM: I guess I am suggesting—pleading, really—that we shouldn't start with the assumption that religion—or for that matter, art, I guess—is always a matter of high seriousness, a life-and-death question, salvation-or-damnation question. That's so narrow! Just because the question is big, that doesn't mean the conception of religion based on such an assumption is also broad. Far from it. A great deal of things people do, which we recognize as religious, won't fit into that. And if you manage to fit that in, then it's possible that you missed the whole point of that practice.

DM: That's a very good point. Belief needn't be limited to the agonistic. It also has very much to do with the mundane and prosaic, the virtually insignificant. No less important, to take Thierry's definition seriously and recognize the covenant in which two parties, neither of which is divine, are engaged in an ethical relation, we must expand the definition of religion to include the non-divine. The anthropologist Malcolm Ruel argued for this

in his analysis of an African group that had no theological beliefs.[59]

TM: I would like to suggest that it's equally feasible and profitable to conceive of religious practice as a certain kind of redundancy— something superfluous, excessive, even ornamental. By the way, it's interesting that art-making, too, is often thought of that way by many people. Maybe none of them are in this room. But why do we bristle at a mere mention of it when we are perfectly familiar with that line of thinking? In any case, when I suggest that we should entertain the possibility that religion or art has to do with redundancy or excess, this doesn't mean devaluing religion, or art. It doesn't make it dispensable either. I'm simply expressing my sympathy with what Lévi-Strauss has to say about totemism. For him, totemism—and, for me, religion—is a cultural technology. It's great that we have it. The redundancy comes from the sense of play that's necessarily involved in any such technology; where there is no play, there is no function.

You might say this is another assumption. Right, but it's a good antidote to the ruling assumption, which obviously comes from a particular theological and culturally dominant tradition. Let's not reduce religion at the outset to some preconceived, pre-critically constrained notion.

KJ: Yes, we are not constrained to the modes of faith and doubt that Christianity has set up for us. There are other modes of image-making and religiosity, and if we don't try to access those, then the religious right will just continue to do what it does. As thinkers and makers of art, we are constraining ourselves by thinking only within that particular Christian, Western morass, the kind of problem that has led us to that silly gray square.

KJ: If Gregg's passion and enthusiasm are a new religion, then I'm joining.

JE: But Gregg himself recognizes his ideals as inherited modernist ones, and he is infused with doubt about their articulation. I am much more pessimistic than you, Kajri, about the possibility of stepping outside the Judaeo-Christian framework: it informs the entire discourse of art itself. And Tomoko, I have to say I also

doubt the possibility that religion can be rethought in the way you propose, although I understand perfectly that an historical study of uses of the concept of religion leads directly to the hope that discourse need not be so constrained.

KJ: But Jim, this is not a matter of optimism or pessimism: luckily for us, modern artists have *always* been in the business of exceeding the genealogies that have been handed down to them—indeed, in a sense this defines what they do! Here you're putting your finger on the contradictory impulses that inherently characterize modernist practice: the weight of tradition versus the radical imperative of incarnating the unimagined. Modernist art has been in the business of engaging with the materiality of objects, working in the sensuous, experiential register that Gregg spoke about, in a way that confounds the excessive spiritualization or digitalization of the image that stems from the Judaeo-Christian genealogy we've been continually harking back to here. It's also been in the business of tapping into other vital realms of image-practice that have been taking shape under rubrics other than that of art, and expanding its own arena of influence. I think the enabling thing about a conversation like this is to alert us as art makers and writers to the nature of our engagement with one specific post-Enlightenment, Judaeo-Christian genealogy, in the hope that we might all find ways to trouble, if not refute, it. Call it a kind of postmodernism, if you will, that hasn't been sufficiently articulated or explored.

TdD: Tomoko, I cannot go along with your parallel between art and religion as ornamental and superfluous things. That's too easy. Both have been around for such a long time. . . . I hope some day humans will be able to do without religion, but I fear that if they do without art they'll stop being human.

JE: In graduate school, when I was studying as a painter, a teacher informed me that modernism was all about the impossibility of transcendence, and that all we could hope for was a description of our prison bars. Clearly that is itself a view taken within a secularism that I hope we have broken. But I do not think we have left it behind.

As moderator, I am taking my option of closing here, so that we have time for questions.

Susan Mulder [*Question from the audience*]: This goes to a brief statement that David Morgan made in the morning session, to do with interpretation. How do you feel about the validity of an interpretation of contemporary art informed by a religio-spiritual context? Take for example, Jeff Koons: his Michael Jackson with Bubbles, though not a religious work, is, to me, a satirical contemporary allegory of rabid (fan) idol worship, which refers back to the Old Testament and the Israelites' worship of the Golden Calf. . . . Is there validity in that kind of interpretation?

JE: Well, art historians can accept all sorts of religious interpretations with equanimity, because they are part of the critical reception of the object. (Assuming your response is not wholly idiosyncratic—that it belongs to an interpretive community, and is responsive to a deeper past.)

SM: Maybe I should elaborate. Religious interpretations, not necessarily historically based, but in contemporary critique, are often treated dismissively or ignored, especially in the academic arena. These interpretations may be thought of as interesting but certainly not intellectual and they are often met with awkward silence, until someone can come up with some more acceptable interpretation based on contemporary theory. Why are spiritually-based responses so unacceptable?

JE: That's the $64,000 question. There is a complex structure of refusals—many of them. I think we have named about a dozen, arranged in three metaphors (camouflage, refusal, smuggling), beginning with the strongly polarized epigrams I introduced at the beginning and ranging into more complex cases, such as Richter's statement.

From my point of view, one of the unresolved issues in our conversation is how much the discourse of modernism and postmodernism informs all discussions of artworks. Is that discourse avoidable? Some of us, like Kajri, would say it is, and others, like me and, for other reasons, Thierry, would say it isn't.[60]

DM: This is a matter of contexts. One of the things we were doing in

the morning was trying to establish a context, a discursive community within which we could agree or disagree with one another. In a church or other setting, you have a different community, with its own concerns, world view, sense of unity, knowledge, hierarchies. Interpretation always has a context. I guess your question is: Can we identify the boundaries of the community that leads us to make the statements we've made?

JE: Or, from my point of view: When any community sets out to address contemporary art in a serious manner, how independent will it be of the discourses of modernism and postmodernism? David, I think this is the principal difference between us: I think that talk about art outside academies, galleries, museums, and art schools is conceptually dependent, often at several removes, on discourse inaugurated and developed in the academy, and ultimately even in a fairly small number of universities over the past hundred years. Your practice, your interests, are based on conversations where—so I would say—those dependencies are not acknowledged. (They have, in that sense, an actual freedom.)

TW: I view this issue from a different, but mutually engaged perspective. I do not think artists working in religious contexts or communities *need* to submit themselves to the discourse of contemporary art. They are doing something different, with different purposes. *But* they have an opportunity to come to the critical discourse of contemporary art, and ask questions, and have their practices evaluated. If religious artists are concerned about being relevant in contemporary society, and being able to respond to a whole host of perspectives and opinions, then they are not going to want to pass up the opportunity to have their practice analyzed, critiqued, and refined.

It is also the case that more traditional, religious modes of interpretation (like the example you give) haven't done justice to a lot of modernist work or really accounted for the layers of significance within modern or contemporary art. Paul Tillich, for example, said some really outlandish things about modern art—he did a lot of smuggling in his theological existentialism.[61] So I would suggest that people who make theological interpretations take care to do a lot of work, and do justice to the art, investigating

them more carefully. In this way, we can avoid running over work just to make illustrative points about it and hopefully engage with the work and inductively develop a line of thought that adds to or expands the prominent discourses already established.

JE: But what limits their care and accuracy? Is it possible to take the whole academic reception of, say, Koons, and import it into a religious discourse? From my point of view, the approaches may be immiscible, because the fundamental terms that give us art and modernism may not mix with the uses to which those terms may be put.

TW: Well, I think that's a very important issue. How much does the plurality of critical perspectives in contemporary art permit or exclude various "ways of seeing?" I don't know, but religious "ways of seeing" happen. And they happen in galleries and museums too. That much, in my estimation, will not change, despite the rigors of art theory, history, and criticism.

I only hope to balance out those "ways of seeing" by calling religious thinkers to become more informed in their advocacy of those types of approaches. Not so that their discourses might someday surpass the influence of the art critics and historians, but in an effort to enhance the conversations that take place around art. I don't foresee any simple disentanglement of art and religion on the horizon, so I'm only interested in improving a dialogue between them.

Unidentified speaker [*Question from the audience*]: Can you please address Barnett Newman's *Stations of the Cross*? How does it fit into the issues you've been discussing?

TdD: Earlier, I was saying that the only convincing religious work in modernism was done by non-believers. In this case we have the best Christian art being done by someone in the Jewish tradition. I don't know whether Newman was a believer. I'd say he was a mystic, rather. He wasn't a practicing Jew, that I know. And for him, Christ was the archetypical suffering man. The *Stations of the Cross* are religious in a humanistic sense.

JE: Well, Rothko had increasing doubts about his relation not only to Judaism but also to God.[62]

TdD: In any case, *kenosis* is common to both Jewish and Christian traditions. The Jewish tradition would forbid images altogether, and the Christian tradition would produce images in such a way that absence becomes presence—that is, a Christian image tells you you're looking at what you cannot be looking at. God is infinite and invisible, and yet what you're looking at is a finite space, made visible. As Lyotard said, you cannot make the invisible visible, but you can make it visible *that there is an invisible*. A beautiful formulation that fits both Newman and Rothko, it seems to me.

JE: *Kenosis*, as you describe it, has resonance with Leo Bersani and Ulysse Dutoit's writing on the Rothko Chapel in *The Art of Impoverishment*.[63] In other words, there are contexts for addressing religious issues without engaging specifically religious texts—while remaining, as Bersani and Dutoit say, "rigorously secular." Kenosis, the sublime, the erasure of self, the void . . . a number of concepts have been brought to bear on art like Newman's and Rothko's without leaving what is taken as secular philosophy. There is a rich but ambiguous ground between the two extremes of (say) Greenberg's formalism and Newman's apocalyptic, eschatological rhetoric.

DM: I still don't understand why a work like the *Stations of the Cross* is an embarrassment.

JE: It's not an embarrassment to us; but it's "officially" an embarrassment that Newman understood himself in terms that fail to correspond to what any number of writers, from Greenberg to Bersani and even Thierry de Duve, may wish to say about him.

Gregg, as you know, coming out of the same milieu that produced *Art Since 1900*, there *are* strong attempts at prohibition and exclusion in the academic discourse on art. (This is not to say that Derrida, Lyotard, and others weren't deeply engaged with religious issues.)

There is also—this is a partly separable issue—the question of whose art world we're talking about. These difficulties do not affect the international art world, as much as they affect the ordinary production of art and its pedagogy—as I said earlier, speaking about the people who have come for this event.

GB: But there is no organized cabal. This is a conspiratorial fantasy. Each one of the authors of *Art Since 1900* deserves to be rigorously understood on their own terms. I'm sorry, but I bristle at the characterization of these positions as a unified position.

JE: Absolutely, they and others have to be taken as individuals with their own trajectories. But it is tremendously important, I think, not to assume that their individuality means they are an unencompassably diverse or random set of people. I don't picture the exclusion of religious work—and again, I mean sincere religious work, especially when it represents major religions—from the art world as a conspiracy. But that is not because there isn't a definable set of positions and judgments involved, or because we are somehow acting deliberately, as conspirators: it's because non-religious discourse is deeply embedded in modernism, and has been long before *October*. Its history, as Tim Clark and others have shown, goes back to the late eighteenth century, to the generation of David in Clark's case, and to impressionism and post-impressionism. So this is not a conspiracy, but it is a very real situation, which reflects the concerns of many people here, which affects the pedagogy of students at the School and at other institutions in many other parts of the world, which continues to pose difficulties for the production and reception of art outside the international art world.

Alena Alexandrova [*Question from the audience*]: Can we think of any art that is entirely non-religious, that is free of any religious residue, trace, or reference? There are many concepts pertaining to religion in circulation today that are used to explain the status of contemporary art. This has to do with mediality of religion and not with something particularly spiritual.

There are also contemporary artists who include references to Christian iconography in their work. Is there not a space for art that would refer to religion, without being qualified as kitsch? I am thinking of Jan Fabre, or Berlinde de Bruyckere,[64] who refer to Christian iconography in a critical way; they are aware that Christian images have iconoclasm built into them, as Koerner points out.[65]

JE: We need to qualify the identification of kitsch and sincere

religious art. In the lecture yesterday, I was showing examples of religious art that are not engaged with art-world interests, and they appeared kitschy, sentimental, unironic. As David says, art-world criteria do not adequately address such work, although it is an open question whether sociological or cultural studies accounts can substitute for fine art criteria when the work is considered—as it inevitably is—as art.[66] But there is an equally large body of religious work, which would include Fabre and de Bruyckere, which uses contemporary fine art strategies such as installation, video, and fiber art to address religious themes. Especially when that work is installed in churches and temples, it raises different questions: some—here I'm not including your examples—can appear as conservative, ineffectual, or misplaced in relation to contemporary art concerns.[67]

TdD: Both Fabre and De Bruyckere are Flemish artists, deeply embedded in Catholicism, and its whole tradition of image-making.

Frank Piatek [*Question from the audience*]: I think we are trying to untangle and interpret these issues of religion or spirituality (and most probably forms of the psychological) in too narrow a framework, within the dominant order of the art world system. I think rather that the complexity of the issues warrants a virtual architecture of interpretation which would allow us better to sort out the layers of assertion, exclusion, bias and disavowal, deception (self or otherwise), displacement and counter-assertion that marks this discourse.

I tend to see the art world as an extremely contentious arena, a multidimensional force field of a kind of combat or game. In this context I have to energetically disagree with Gregg, where he questions or contests the idea here that there is a system of denial at play between multiple forces (although I agree that the issue is more complex than a simple binary opposition). He sees no conspiracy. Perhaps "conspiracy" is a word that is too consciously intentional, but some kind of collective dynamic is at work here.

I disagree with Greg on the basis of my own experience as an artist-practitioner who identifies with being a painter. I would like to put forward an issue about painting that I think is germane to

our discussion: what I will call an instance of modern mythology in the art world system—the issue of the "death of painting," so often proclaimed in the twentieth century. There's the embarrassing fact that painting refuses to die or never did die, or else its supposed corpse keeps coming back to life as vital as ever. This mythology is not unlike the mythology of the "death of God," who somehow remains alive in innumerable forms of belief held by the majority of the people on the planet.

For me, ideas of the "death of painting," the proclamation of which come from positions most often outside or against painting, are a good example of camouflaged religious or mythic thinking mobilized and projected by forces that share a collective critical set of opinions, world views, and ideas of history. I experienced such a phenomenon in the earliest years of my art school education in the early 1960s. The message came from filmmakers and proto-conceptualists. I didn't believe the message, but the dynamic of projected restriction and denial by critical forces arrayed against what I was interested in, was inscribed in my knowledge base.

In 1964, as an unprepared, ignorant first-year student, I found my way into a lecture at the Art Institute by Ad Reinhardt; it was one of his "Art As Art Dogma" lectures, and it ended with something like, "Art about art is the end of art, the end of art is not the end." At the time I had no perspective or frame of reference to process the message, but I was certainly awakened by it, and I have been aware of the whole genealogy of such aporetic proclamations since that time, and this awareness has sharpened my skepticism against the continued pattern of denials various forces in the art world project onto "other" areas, the main target being painting. But the point of this illustration is not painting, but how in the art world painting becomes the special target for a projected religio-mythic language of denial. Painting is like the world chaos monster that the hero attempts to slay in order to raise his or her own new world. But the embarrassingly ancient chaos monster refuses to die as it is supposed to do.

GB: I can't disagree with you if you say you felt that at the moment of the death of painting—

FP: No, Gregg, that is not what I meant at all! It wasn't my feeling

that painting had died, but that others were projecting onto painting their own schema for their own reasons that had little to do with painting.

GB: I encountered "the death of painting" in the early 1980s (as a young painter in art school) when neo-expressionism dominated discussions in the art world and reinvigorated the art market. Julian Schnabel seemed to epitomize that moment. That work seemed to embody all the principles of Reaganism—a kind of thoughtless triumphalism committed exclusively to the interests of the wealthy.

I am pleased that paintings from the seventies are being reconsidered. Currently, there is a traveling exhibition considering abstract painting of the seventies that was eclipsed by neo-expressionism. That show is called *High Times, Hard Times*.[68] It looks at a whole generation of painters from the seventies who were dealing with interesting formal problems and questions about the status of painting in the modern world.

The "death of painting" that was much discussed in the eighties when I was a student—the dismissal of painting in favor of critical and conceptual strategies—was a response to political conditions. Painting seemed dead when so-called neo-expressionist painting looked like the state-sponsored art of Ronald Reagan.

FP: My death of painting moment was the 1960s. One of my formative moments was seeing Ad Reinhart deliver his "dogma" talk as a freshman. So there is another background. But I am aware of a whole rhythm, throughout the twentieth century, of times when painting was said to have died. So we can't have one single model. There is a deeper model.

Kimmy Noonen [*Question from the audience*]: I am young; I'm an active Protestant Christian, and also an artist. I have had to deal with the fact that religion and art often combat one another in their methods and focus. Perhaps Christianity, as well as all the major religions of the world, is no longer in an iconographic stage. There was a time and place for such methods of communication in art, but contemporary society has simply moved to a different level. Religion and art can mix only if the focus of the religious artists

appears legitimate to the people of the world. Speaking on behalf of the socially oppressed, for and about those who cannot find justice, minorities and peoples who are perishing without concern from those of us with voices: there are many in the world without faith in God who concern themselves with these circumstances, but not many with faith who do. High art has long prided itself on not only portraying beauty, but also accuracy as to the time and nature of the place it is from. In that way, all artists are showing truth to their viewers, and all truth is God's truth. Until the people of faith can become relevant in the world at large, there will consistently be a tension between art and religion.

JE: Thank you for that: it is a good, open-ended note on which to conclude. We are out of time.

Notes

1. This assessment is expanded in "Is Anyone Listening?," *Photofile* 80 (winter 2007): 80.
2. Re-enchantment comes, via Max Weber, from Schiller. It has a range of resonances that are pertinent to this discussion. Aside from those mentioned below, there is Marcel Gauchet, *Le désenchantement du monde, Une histoire politique de la religion* (Paris: Gallimard, 1985) and Mark Schneider, *Culture and Enchantment* (Chicago: University of Chicago Press, 1993).
3. Michael Fried, *Menzel's Realism: Art and Embodiment in Nineteenth-Century Berlin* (New Haven: Yale University Press, 2002), pp. 76, 232. A discussion of Fried's and Clark's uses, with further references, is in my *The Strange Place of Religion in Contemporary Art* (New York: Routledge, 2005), partly reprinted in this book.
4. Suzi Gablik, *The Re-Enchantment of Art* (New York: Thames and Hudson, 1991), not mentioned by either Fried or Clark.
5. Karl Werckmeister, "A Critique of T. J. Clark's *Farewell to an Idea*," in *Critical Inquiry* 28 no. 4 (2002): 855–67, especially p. 864, where Werckmeister criticizes Clark's relapse "into a romantic, middle-class penchant for substituting art for religion." This is also discussed in Elkins, *Strange Place of Religion*.
6. In the introductory lecture, not reprinted here—Eds.
7. Further references are in Elkins, "Einige Gedanken über die Unbestimmtheit der Darstellung [On the Unrepresentable in Pictures]," in *Das unendliche Kunstwerk: Von der Bestimmtheit des Unbestimmten in der ästhetischen Erfahrung*, ed. Gerhard Gramm and Eva Schürmann (Berlin: Philo, 2006), pp. 119–40; also "Visual Culture: First Draft," review of *Iconoclash!*, eds. Bruno Latour and Peter Weibel, in *Art Journal* 62 no. 3 (2003): 104–107.
8. Siegfried Zielinski, "Theologici electrici," in Bernd Witte, Mauro Ponzi,

eds., *Theologie und Politik: Walter Benjamin und ein Paradigma der Moderne* (Berlin: Erich Schmidt Verlag, 2005), pp. 254–68.

9. Alain Besançon, *The Forbidden Image: An Intellectual History of Iconoclasm*, trans. by Jane Marie Todd (Chicago: University of Chicago Press, 2000).

10. A starting point for that genealogy might be 1949, when Greenberg wrote that, "our period style" needs to remain "uninflated by illegitimate content—no religion or mysticism" ("Our Period Style," *Partisan Review* [November 1949], 1138).

11. D. W. Winnicott, "Home Is Where We Start From, Essays by a Psychoanalyst," compiled and edited by Clare Winnicott, Ray Shephard, and Madeleine Davis (New York and London: W. W. Norton and Company, 1990).

12. Jonathan Z. Smith once remarked that the concerted use of the term "spirituality"—at least in English—can be traced to the Alcoholics Anonymous and their Twelve-Step Program. I came to the same observation independently in the 1990s when I was surveying casually the publications that mentioned "spirituality" in the title or as a subject field.

13. Cf. Jonathan Z. Smith, "Religion, Religions, Religious," in *Critical Terms for Religious Studies*, ed. Mark C. Taylor (Chicago: University of Chicago Press, 1998), pp. 269–84.

14. Discussed at length in Masuzawa, *The Invention of World Religions: Or, How European Universalism Was Preserved in the Language of Pluralism* (Chicago: University of Chicago Press, 2005), especially Ch. 9, pp. 309–28.

15. In recent decades a number of studies among the historians of religions have studied this process taking place in various non-Western locations: in colonial India, in the Islamic domains, in East Asia, for example. There is a major conference planned on this topic at Hofstra University, "The Politics of Religion-Making" (www.hofstra.edu/CampusL/Culture/ Culture_Religion_Making.cfm).

16. Marcel Gauchet, *Le désenchantement du monde, Une histoire politique de la religion* (Paris: Gallimard, 1985); translation *The Disenchantment of the World: A Political History of Religion*, tr. Oscar Burge (Princeton: Princeton University Press, 1997).

17. Wittgenstein, *On Certainty*, eds. G. E. M. Anscombe and G. H. von Wright (New York: Harper and Row, 1972).

18. In the Starting Points essay reprinted in this book—Eds.

19. It's not that I think the cognitive aspect, or convictions, or emotional attachment to certain ideas, etc. are not important; it's the simple-mindedness and the hopeless muddle that this reduction usually lead to that I find irksome, because it preempts any serious attempt at analysis—TM.

20. In the Starting Points essay, this volume—Eds.

21. *Le Totémisme aujourd'hui* (Paris: Presses Universitaires de France, 1962), in English as *Totemism*, trans. Rodney Needham (Boston: Beacon, 1963).

22. This is articulated at length in the companion volume, *La Pensée sauvage* (Paris: Librairie Plon, 1962), in English as *The Savage Mind* (London: Weidenfeld & Nicholson, 1966).

23. One of the best places to start reviewing this voluminous literature is Catherine Bell, *Ritual: Perspectives and Dimensions* (New York: Oxford University Press, 1997).

24. Mircea Eliade, *The Myth of the Eternal Return, or, Cosmos and History*, trans. Willard R. Trask (Princeton: Princeton University Press, 1954); *The Sacred and the Profane: The Nature of Religion*, trans. Willard R. Trask (New York: Harcourt Brace Jovanovich, 1959). Jonathan Z. Smith, *Imagining Religion: From Babylon to Jonestown* (Chicago: University of Chicago Press, 1982); *To Take Place: Toward Theory in Ritual* (Chicago: University of Chicago Press, 1987).

25. Eliade, *Myths, Dreams and Mysteries: The Encounter between Contemporary Faiths and Archaic Realities* (New York: Harper and Row, 195), especially the chapter "Myths of The Modern World," pp. 23–38, and "Religious Symbols and Modern Man's Anxieties," pp. 231–45, and also *Myth and Reality* (New York: Harper and Row, 1963), especially the chapter "Survivals and Camouflages of Myths," pp. 162–93.

26. James C. Scott, *Domination and the Arts of Resistance: Hidden Transcripts* (New Haven, CT and London: Yale University Press, 1990); *Weapons of the Weak: Everyday Forms of Peasant Resistance* (New Haven, CT and London: Yale University Press, 1985).

27. This is developed in Elkins, *Strange Place of Religion in Contemporary Art*, the chapter called "Joel's Story Explained: Unconscious Religion."

28. In the first months of 2007 alone, Connie Butler organized "Wack! Art and the Feminist Revolution" at the Los Angeles Museum of Contemporary Art, 2007; there was MoMA's two-day symposium (January 26–27, 2007) "The Feminist Future," organized by Deborah Wye; and "Global Feminisms," curated by Linda Nochlin.

29. Thierry du Duve, "Silver and Exact," in *Sylvie Eyberg/Valérie Mannaerts*, exhibition catalogue of the Belgian Pavilion at the 2003 Venice Biennale (Brussels: Yves Gevaert, 2003).

30. Elkins, *Visual Studies: A Skeptical Introduction* (New York: Routledge, 2005) explores the disjunctions between visual studies' self-descriptions and the scholarship it produces.

31. "Visual Culture Questionnaire," *October* 77 (summer 1996).

32. There are significant exceptions, such as James Herbert's *Our Distance from God* (Berkeley: University of California Press, 2007).

33. For a discussion of the gaze in the study of religion, see David Morgan, *The Sacred Gaze: Religious Visual Culture in Theory and Practice* (Berkeley: University of California Press, 2005).

34. Here, Wayne Booth, *Modern Dogma and the Rhetoric of Assent* (Notre Dame, IN: University of Notre Dame Press, 1974) is still an excellent resource.

35. See Jürgen Habermas, "Modernity—An Incomplete Project," in *The Anti-Aesthetic: Essays on Postmodern Culture*, ed. Hal Foster (New York: New Press, 1999), pp. 3–15, quotation on p. 12, and further developments in *The Philosophical Discourse of Modernity: Twelve Lectures* (Cambridge, MA: MIT Press, 1987).

36. *The AIDS Crisis is Ridiculous and Other Writings, 1986–2003* (Cambridge MA: MIT Press, 2003).

37. He altered the JPEGs by changing "their pixel structure," enlarging them, and changing the color "slightly." The meaning of the first of those alterations isn't clear, but it seems from the context that he meant

resampling. Interview, conducted by Vicki Goldberg, June 2005, www.thebrooklynrail.org/arts/june05/ruff.html, accessed April 2007. I thank Rachel Wells of the Courtauld Institute of Art for bringing these to my attention—JE.

38. See the Starting Points essays in this book. Rosalind Krauss and Yve-Alain Bois, *Formless: A User's Guide* (Cambridge MA: MIT Press, 1997).

39. "Totemism" and "animism" also have had interesting discursive histories but are not nearly as prevalent and viable as fetishism today—TM.

40. "Visual Culture: First Draft," review of *Iconoclash!*, eds. Bruno Latour and Peter Weibel, in *Art Journal* 62 no. 3 (2003): 104–107. See also the forthcoming book by Joseph Koerner, *Last Experiences of Painting*, in the series *Theories of Modernism and Postmodernism in the Visual Arts*, vol. 4 (New York: Routledge, 2008).

41. These are helpfully archived under "Press" on www.berlinbiennale.de. I thank Sarah Hromack for drawing my attention to the site.

42. Here, we could name several artists that employ personal narrative as a feature in their work that on some level becomes a vehicle for either positive or negative religious meaning. In addition to those named by Boris, I would argue this for artists like Francis Bacon, Joseph Beuys, Robert Gober, Kiki Smith, and Chris Ofili. See another interesting list given in John Alan Farmer, "The Reception of Christian Devotional Art," *Art Journal* 57 no. 1 (Spring 1998): 64–76—TW.

43. See the Starting Points essay in this book—Eds.

44. Mark C. Taylor, *Disfiguring: Art, Architecture, Religion* (Chicago: University of Chicago Press, 1992).

45. Michel de Certeau, *The Practice of Everyday Life*, Vol. 1, trans. Steven Rendall (Berkeley: University of California Press, 1984), "How is Christianity Thinkable Today?," in *The Postmodern God: A Theological Reader*, ed. Graham Ward (Oxford: Blackwell, 1997), pp. 142–55. Nicolas Bourriaud, *Relational Aesthetics*, trans. Simon Pleasance and Fronza Woods (Dijon-Quetigny, France: les presses du réel, 2002).

46. See *Representations of Pain*, eds. Maria Pia Di Bella and James Elkins, forthcoming, for perspectives on this connection by Kristin Ringelberg, Helge Meyer, Valentin Groebner, Sharon Sliwinski, and others.

47. David Morgan, "Visuality and the Question of God in Contemporary Art," *Material Religion* 3 no. 1 (2007): 135–43, quotation on p. 142; see the final section, which speaks of "pain and radical embodiment."

48. *The Spiritual in Art: Abstract Painting 1890–1985*, ed. Maurice Tuchman (New York: Abbeville, 1985).

49. This is documented in the case of Rothko in my *Pictures and Tears: A History of People Who Have Cried in Front of Paintings* (New York: Routledge, 2001).

50. In this I am agreeing with Geeta Kapur's account of Indian modernism, and its difference from Western modernisms, as in her "Bhupen Khakhar," in *Bhupen Khakhar*, retrospective exhibition catalogue (Madrid: Museo Nacional, Centro de Arte, Reina Sofia, 2002)—JE.

51. This argument is given in "Naïfs, Faux-Naïfs, Faux Faux-Naïfs, Would-Be-Faux-Naïfs: There is No such Thing as Outsider Art," in *Inner Worlds*

Outside, exhibition catalogue, ed. John Thompson (Dublin: Irish Museum of Modern Art, 2006), pp. 71–79.

52. In Noirlac, completed in 1975. See for example *Les Reynaud de Renaud*, ed. Gilbert Perlein (Nice: MAMAC Nice, 2006).

53. Alfred Manessier (1911–93), who made stained glass windows in Saint-Sépulcre, Abbeville, France, and other churches. See, for example, Hélène Claveyrolas, *Les vitraux d'Alfred Manessier dans les édifices historiques* (Grignan: Complicités, 2006).

54. This is thematized in Thomas Weiskel's excellent *The Romantic Sublime: Studies in the Structure and Psychology of Transcendence* (Baltimore MD: Johns Hopkins University Press, 1976). Other texts, such as Neil Hertz, *The End of the Line: Essays on Psychoanalysis and the Sublime* (New York: Columbia University Press, 1985), and Peter De Bolla, *The Discourse of the Sublime: Readings in History, Aesthetics, and the Subject* (London: Basil Blackwell, 1989), treat varieties of the postmodern sublime as products of discursive fields, abstracting—but, I would argue, not avoiding—the religious valence of the term. A starting point in this discourse is Jean-François Lyotard, "The Sublime and the Avant-Garde," trans. Lisa Liebmann, *Artforum* 22 (April 1984): 36–43—JE.

55. Krauss, *"A Voyage on the North Sea": Art in the Age of the Post-Medium Condition* (London: Thames and Hudson, 1999).

56. A work in progress, *Thirty Modest Proposals for Curators*, is informed by a history of installation art—including Ilya Kabakov's—as sacralized practice.

57. *100 Artists See God*, eds. John Baldessari and Meg Cranston (New York: Independent Curators International, 2004). This is brought out in Morgan's essay, "Visuality and the Question of God in Contemporary Art."

58. Thomas J. J. Altizer, *The Gospel of Christian Atheism* (Philadelphia: Westminster, 1966); Arthur C. Danto, "Narratives of the End of Art," in his *Encounters & Reflections: Art in the Historical Present* (New York: Farrar Straus Giroux, 1990), pp. 331–45; Danto, *After the End of Art: Contemporary Art and the Pale of History* (Princeton: Princeton University Press, 1997).

59. Malcolm Ruel, *Belief, Ritual, and the Securing of Life: Reflexive Essays on a Bantu Religion* (Leiden: E. J. Brill, 1997).

60. For defenses of this position, please see the texts *Master Narratives and Their Discontents*, with an introduction by Anna Arnar. *Theories of Modernism and Postmodernism in the Visual Arts*, vol. 1 (Cork, Ireland: University College Cork Press; New York: Routledge, 2005), and, for multicultural questions, [author] "Writing About Modernist Painting Outside Western Europe and North America," in *Compression vs. Expansion: Containing the World's Art*, ed. John Onians (New Haven: Yale University Press, 2006), pp. 188–214.

61. See for example "Existentialist Aspects of Modern Art," 90ff, "Authentic Religious Art," 231ff in Paul Tillich, John and Jane Dillenberger, *On Art and Architecture* (New York: Crossroads, 1987).

62. *Pictures and Tears* (New York: Routledge, 2001). It is pertinent here that the fourteen Rothko Chapel paintings were at one point conceived as Stations of the Cross, and were even to be given numbers. Later Rothko thought of putting the numbers on the *outside* of the building, so people inside wouldn't see them; eventually all reference to the Stations was deleted.

Newman's beliefs are difficult to assess, although his public persona, as a Jewish artist, is well documented (and provoked resistance at the time). For this information on Newman, I am indebted to Sarah Rich (Pennsylvania State University), who is preparing a study of the *Fourteen Stations of the Cross* (personal communication, April 2007).

63. Leo Bersani and Ulysse Dutoit, *Art of Impoverishment, Beckett, Rothko, Resnais* (Cambridge, MA: Harvard University Press, 1993), especially pp. 132–37.

64. Berlinde De Bruyckere, *Eén*, exhibition catalogue with an Introduction by Harald Szeemann and Barbara Baert (Gli Ori: Prato, Italy, 2005).

65. Joseph Leo Koerner, "Icon as Iconoclash," in *Iconoclash: Beyond the Image Wars in Science, Religion and Art*, eds. Bruno Latour and Peter Weibel (Cambridge, Massachusetts: MIT Press, 2002).

66. In that lecture, for example, I cited John Bell, who makes sentimental Christian e-cards, www.jrbell.com/index.html; Paul Myhill, who paints post-impressionist religious scenes, www.paulmyhill.com/petra.html; Felix Espinosa, who has a School of Paris tourist-art style and a style that reproduces vernacular popular religious imagery, www.methownet.com/felix/index.html.

67. Among many examples: *Kan et figentrae baere oliven?*, exhibition in Copenhagen, 2003 (thanks to Mette Sandbye for bringing this to my attention); *Faith*, ed. Jason Hyde (Hartford, CT: Real Art Ways, 2005), or www.realartways.org/visualarts.htm; and *Five Artists / Five Faiths*, exhibition in Chapel Hill, NC (www.ackland.org/art/exhibitions/faff/intro.html).

68. *High Times, Hard Times: New York Painting 1967–1975*, eds. Dawould Bey, Anna Chave, Robert Pincus-Witten, David Reed, and Katy Siegel (New York: Independent Curators, 2006).

4
ASSESSMENTS

Jeremy Biles
Re-Imagining Religion: A Ghost Story

... the sacred today cannot be proclaimed ...
Georges Bataille

[in the field of the human sciences] the little prefix re– is perhaps the most important signal we can deploy. It guarantees that we understand ... the relentlessly social character of the objects of our study.
Jonathan Z. Smith, *Relating Religion*

A specter is haunting contemporary art—the specter of religion. Perhaps it's just because I'm writing as Halloween approaches, with ghosts flickering about porches and in windows, but I'm pervaded by the sense that religion, though by some accounts absent from "fine" or "high" contemporary art, in fact haunts art at most every turn. In this short response, I want to revisit, extend, and qualify some of the points in the conference transcript that I find most intriguing. In doing so, I'll be speculating freely, even contradictorily, playing at once skeptic, believer, and maybe even medium in approaching that intractable, ghostly double and other to contemporary art: religion.

Repressing religion: the uncanny

Discussing the etymology of "the uncanny" (*das Unheimliche*) Freud concludes that the meaning of *heimlich* "develops in the direction of ambivalence, until it finally coincides with its opposite, *unheimlich*." The word means both "what is familiar" and "what is concealed and kept out of sight."[1] Freud thus gestures toward the very goal of his clinical practice: to return to light that which has been kept from sight—the sources of anxiety, the repressed desires or memories that haunt the analysand. But the repressed returns not only on the analyst's couch, but in the psychopathologies of everyday life: slips of the tongue, gaps in memory, puns, and dreams. The repressed may also find expression in art.

The hypothesis guiding my speculations here is that in the discourse of contemporary art, religion itself is repressed—but it is also

"what succeeds in returning."[2] In suggesting that contemporary art stages a return of religion, I'm indulging in a perhaps dubious catachresis, applying a Freudian schema to religion and art, while bracketing what Freud himself had to say about these two spheres of human activity.[3] Yet, I believe that the logic of repression supplies an apt framework for further illuminating three salient tropes developed by the conferees in attempting to adduce the relations (or lack thereof) between religion and contemporary art: the system of refusals, smuggling, and camouflage.

Re-turning religion: system of refusals

If, as Thierry de Duve postulates, "art and religion were born together,"[4] one might inquire into the primordial act of union that made this shared birth possible. The union from which these strange twins issued constitutes something of a primal scene, the memory of which some contemporary critics might just as soon repress.[5] If the Enlightenment, as several of the panelists discussed, brought with it the attempt to separate art from its twin, leaving religion for dead, religion has proven strangely resilient, returning within the structures that seek to repress it: the "system of refusals."[6] Religion thus plays the role of a revenant haunting contemporary art—not only as an anxious memory of discomfiting origins, but as an active force expressed through the incessant turns of artistic imaginations, including those of numerous artists whose works help define what contemporary art is.[7]

It is not these artists, then, who are somehow out of step or retrograde; rather, it is the art critics and theorists who are lagging in their failure to register the religious (re)turn that has for some time inflected other realms of discourse, such as philosophy and literary theory.[8] In any case, if religion returns in contemporary art, it returns not (or not only) as a figment of the past, but in new, ever-changing forms: repetition with difference. To understand the return of religion as regressive would therefore be a mistake. One symptom of this mistake among some critics is the almost reflexive association of religion with sentimentality, saccharine expression, and candid public affect. But to mechanically associate religious beliefs and expressions with sentimentality, schmaltziness, or kitsch is simply to ignore the

most interesting and vital forms of contemporary religious thought, which, far from being reducible to cloying expressions of "precious moments" with Jesus, is rife with skepticism and risk, guided by critical inquiry, and informed by a sophisticated irony.[9]

So I want to reiterate what David Morgan claimed in the course of the conversation: "[religious] belief can be as sophisticated as art—this is something not many art world inhabitants seem prepared to recognize."[10] James Elkins has suggested that high or fine postmodern art is difficult, complex, ambiguous, and ironic.[11] Those adjectives apply equally to postmodern religious thought. Our best contemporary artists seem to understand this better than the critics who disavow the religious meanings embedded in the art they seek to analyze; critics' proclamations of embarrassment are thus evidence of ignorance, prejudice, or lack of a certain theoretical sophistication.[12] Such critics seem to believe that religion profanes contemporary art with banal sentimentality and uncritical faith; they thus fail to recognize and assess the fact that religion is often an animating force of art.

Re-presenting religion: camouflage

What is inadmissible in critical discourse speaks in aesthetic gestures: artists keep returning to what some critics seek to repress. This situation is aptly characterized by Mircea Eliade's concept of "the persistence of the sacred." Eliade claimed that religion "haunts" modern art, in distorted, disguised, or camouflaged form.[13] The distortions of the sacred, like the distortions of dream work in the psychoanalytic paradigm that informs Eliade's thought, often take place at an unconscious level. Recognizing this dynamic responds to Gregg Bordowitz's concern that "talk about smuggling and camouflage gets everyone searching for hidden religious content. The idea that artists hide content as matter of choice is a problem. It creates the illusion that the artist is completely aware of his or her intentions." I think we can helpfully distinguish between "smuggling" as a conscious tactic (discussed below) and "camouflage" as the unconscious (not to say unthinking) importation of religious content in disguised form.[14] As Wendy Doniger puts it, "Sometimes . . . [religious] meanings are deeply submerged, and concealed even from the person who *has* the ideas."[15]

It is up to scholars of religion to provide examples to their counterparts in contemporary art in developing religious interpretations of ostensibly non-religious art. If religion haunts the "optical unconscious"[16] of artists, bringing the analytical tools of religious studies to bear on contemporary art will reveal unconscious or "submerged" religious meanings. In this connection, some panelists discussed the use of ritual theory in disclosing the religious dimensions of art. This strikes me as an eminently productive way of approaching art as both practice and product. Eliade's work, for example, might illuminate the religious roots of the repetitive nature of aesthetic practices, as Doniger hints.[17] On the other hand, I can imagine Jonathan Z. Smith's critical departures from Eliade and his attention to ritual space speaking to, for example, installation art, performance art, or to the very act of visiting galleries and museums.

Art critics would do well to avail themselves of the work of scholars of religion, whose vocabulary and concepts would help expose the spectral presence of religion in contemporary art. "The paradoxical state of the specter," Derrida remarked, "is neither being nor non-being." Both there and not there, religion is re-presented by artists whose work manifests, in disguised forms, the religious ideas that circulate in the unconscious.

Re-covering religion: smuggling

The system of refusals that represses religion can also be resisted, sometimes by tactics that uncannily resemble those of the unconscious in keeping what's hidden out of sight: distortion, displacement, disguise. Artists sometimes use such techniques consciously and critically, to resist "the institutions and mechanisms of *repression*." In this regard, we can speak of the smuggling of religious ideas as a *tactic*, in Michel de Certeau's sense of the term—a practice of deception, "a calculated action determined by the absence of a proper locus. No delimitation of an exteriority . . . provides it with the condition necessary for autonomy." The institutions of repression may be inescapable, but artists can resist them by consciously returning (to) religion, importing ideas surreptitiously through "guileful ruse[s]" of distortion and surprise, or through novel forms whose religious meanings are not openly recognized.[18]

If, as Freud claims, puns play on unconscious meanings, then a deliberate pun might be suitable for naming these tactics of smuggling. I propose the term "recovery" for the calculated incorporation of religious ideas and meanings in disguised or novel form in contemporary art, for recovery suggests at once a recuperation, renewal, or return of the religious, as well as its covering-up. In this way, artists may use, modify, invert, or pervert religious ideas, images, tropes, or structures as means of sincere expression of religion (Bill Viola might be an example here) as well as of irony, skepticism, critique, or "profanophany"[19] (Andres Serrano is an obvious reference).

Recovery might also be used to incite a quasi-religious enchantment. For example, consider the conspicuous public sculpture that stands adjacent to the School of the Art Institute, where this conference took place: Anish Kapoor's eye-grabbing *Cloud Gate*, a smooth metal elliptical structure that reflects downtown Chicago on its polished surface. Kapoor, who often incorporates mythical ideas into his artwork, refers to the reflective vault of the sculpture's underside as an "omphalos." The omphalos is a favorite concept of Eliade, who compares it to a sacred "axis mundi," around which a community is built. It manifests a kind of sacred centripetal force. And as a site of intercourse between the transcendent and the earthly, it arouses awe.

I imagine Kapoor reading Eliade like a how-to manual for inciting fascination, making tactical use of the structure of the omphalos. Indeed, the giddy droves of people who congregate within the chamber of the sculpture evoke something like a communal religious experience, akin to Durkheimian "effervescence"—another concept that might provide shared ground in interpreting art and religion.[20] Hidden in plain sight, the uncanny omphalos of *Cloud Gate* is an emblem of enchantment elicited through a recovery of religion.

Re-imagining religion: re-enchantment

In whatever form—enthused or ironic, faithful or skeptical, impassioned or critical[21]—the enchantment produced by at least some contemporary art suggests that artists might rightly be considered religious thinkers, agents of the always-evolving "imagination of religion."[22]

And if artists are religious thinkers, critics and theorists from both discursive spheres would do well to turn their conversation toward discerning and evaluating the religious ideas, images, and sensibilities in contemporary art, easing the barrier of repression that has estranged the critical discourses around those uncanny twins, art and religion.

This strangeness itself is instructive.[23] "Is the ideal of every aesthetic program to reinvigorate the beholder's interest in the world?" Gregg Bordowitz asked during the conference. He answered his own question when remarking that "the job of art is to return the viewer to herself or himself estranged—feeling strange and feeling the world as a strange unfamiliar place."[24] This defamiliarizing effect of art is also a theoretical desideratum. In *Imagining Religion*, Jonathan Z. Smith points to the "extraordinary cognitive power in ... 'defamiliarization'—making the familiar seem strange *in order to enhance our perception of the familiar*."[25] In plumbing the mystery of the familiar, Smith thus recommends an *uncanny* mode of theorizing or re-imagining religion, for the uncanny describes the strange return of that which was always there.

While Smith would resist this interpretation, I would go so far as to suggest that the theoretical defamiliarization he proposes evokes a religio-aesthetic experience. Rudolf Otto famously analyzed the idea of the holy in terms of fascination, awe, mystery, and uncanniness: the "numinous."[26] He compares the numinous element of religious experience to the "ensnaring attraction of the ghost-story," which "entices the imagination, awakening strong interest and curiosity." Art, religion, and theory converge here, in "[arousing] an irrepressible interest in the mind."[27] Engagement through estrangement is one way of continuing this conversation: the re-imagination of a ghost story, enchanting and without end.

Ann Pellegrini
Taking Pain(s), Talking Religion

The question of pain hovers over this rich exchange about the relationship between religion and contemporary art. James Elkins tells us up front that two leading art historians invited to take part in the forum declined, with both asserting in one way or another that it

would be too "painful" to take part in a conversation in which people talked about religion and art at the same time. I have been puzzling over this association between religion and pain. What makes simply talking about religion "painful"? Of course, there is talking about religion, and then there is talking about religion. Had the panel been framed as an occasion to talk about the dangers "religion" and "religious" people posed to the Enlightenment project and to the models of human progress embedded in artistic modernism, perhaps talking about religion would not have seemed so painful after all. Another way to put this point: when talk about religion is framed as talk *against* religion, for many secular scholars pain may turn to catharsis, even to a sort of pleasure.

This dynamic is part of what Wendy Doniger is pointing to when she distinguishes between "believing" in religion and "studying" religion. But, as Doniger says, you don't have to believe in god or religion in order to study them. In fact, the opposite may be true. In many precincts of secular culture (and the academy imagines itself to be one such secular space), "hating" religion, to use Doniger's term, or at minimum expressing deep concern over the harm it causes in the world, seems to be a principal qualification for talking about it authoritatively. This does indeed set up a "painful" division in which one must come out for or against religion before even sitting down at the table to talk. This coming out for or against religion is also a coming out for or against *secularism* and the secular values of Enlightenment: modernity, progress, reason, universalism, and freedom. Including, perhaps, freedom from painful links to religion?

In today's world, this pain conjures up images of religious fundamentalisms of various kinds (Christian, Hindu, Islamic) and the violent conflicts associated with them. As Janet R. Jakobsen and I argue, the often violent particularisms of "religion" are among the things secularism, with its promise of universal reason and freedom from religious dogmatism, was supposed to provide a bulwark against.[28] The secularization narrative correlates modernity and progress with the privatization and, ultimately even, the disappearance of religion. Things have not exactly worked out that way. Religion never did go away, and no amount of wishing will make it so. Thus, if there is an enchantment here it is not with or by religion, it is with the secular structures of feeling that would wish away religion and,

with it, wish away violent conflict and, even, pain. However, as Jakobsen has provocatively suggested elsewhere, the enlightened belief that secularism is less violent than religion actually impedes our ability to ask into and intervene in the multiple sources of violence—and multiple sources of "terror"?—in modernity.[29]

One of the many problems with the Enlightenment narrative of secularization—and this is a point made in a different way by Tomoko Masuzawa—is that it leaves out of view the particular histories and investments that shadow the supposedly universal values of reason, progress, and freedom—and that shadow and shape the categories of "the religious" and "the secular" themselves. The context of Enlightenment was changes within European Christianities and their relation to emergent nation-states. The asserted separation between religion and secularism does not so much leave "regressive" religion behind as it does produce religion as a universal category along Protestant lines, thereby inscribing belief and interiority as at the core of what makes different cultural practices recognizably "religion." Thus, secularism in its dominant form masks relations of power in which religion is at once something to be transcended even as particular Christian notions of "religion" are the guideposts for marking the line between progress and regression, religion and secularism, peace and violence, and maybe even pleasure and pain. Must we choose so absolutely?

Jakobsen and I have been accused of wanting to have our secular cake and eat it too. Well, why not? As we write in *Secularisms*, "While there is no doubt that some religious formations are dominating, it is both a poverty of imagination and a continued entanglement in the various assumptions that go along with the secularization narrative that leave us in the bind where we must choose between (supposedly) conservative religion or (supposedly) progressive secularism. Not only does this opposition force us to ignore or deny the ways in which religion can be central to progressive politics and the ways in which secularism can limit such politics, it limits our imagination of secularism to only one narrative." It also limits our ways of talking about and generating social feelings less burdened by pain.

Chris Parr

Where's Ganesha When We Need Him?
Removing Obstacles to Re-Enchantment in the Borderlands of
Religion and Art

Here's the thing: belief can be as sophisticated
as art—this is something not many art world
inhabitants seem prepared to recognize.
David Morgan (p. 167)

Reading this transcript continually made me feel I am lucky enough to be listening to three or four National Public Radio or BBC stations at once, all carrying extremely intelligent provocative conversations— but with some Cagean character hiding somewhere who keeps changing the stations randomly as various people finish speaking. Consequently just about every topic gets curtailed, diverted, cut short, recombined with some earlier point, in very (dis-)concerting ways. Jim Elkins himself calls it a "tumultuous conversation," and a tumult it is, but does it eventually add up to something? There are moments that are very effective, as in Section 2 (pp. 131–34), when Thierry de Duve distinguishes "faith" via Kant from "belief" via Hume (though his ethicism doesn't prevent him from coming on like the Archbishop of Art when later he excoriates artists Andres Serrano and Bill Viola with the same righteous conviction he perceives and despises in those artists [p. 156]); and in Section 3 the discussion Boris Groys initiates about installation art and Benjamin's notion of "aura" (p. 165).

But does the discussion ever get to sketch out lines of practice and thinking that would give rise to Re-enchantment, let alone actually reach Re-enchantment itself? I find it reaches a very different conclusion—and a far more pessimistic one—which is first articulated by Frank Piatek, a questioner from the floor (p. 141): that the High Artworld's discourse has become "a system of refusals" and restraints. It comes to sound like a closed-circuit system with strict rules of entry, a jargonistic discourse one must be proficient at to be heard, and a police state mentality to secure its borders and creeds. Not unlike a closed theological secret society, much as Dan Brown misrepresents Opus Dei in *The DaVinci Code*. Hardly the conditions to allow for any kind of Re-Enchantment.

To me, Re-Enchantment is a wonderful ideal—Re-Enchantment with the world we find ourselves in, with the clarifications of perception and response that art makes possible, and with the insights and transformations so many religions have for centuries brought to reflective human beings. Both religions and artworks enliven my day every day. So I want to pull forward from the tumult two voices that get buried early on, and suggest by extending what I hear in them some ways that religion might be unbound from the oppressive over-intellectualization and the persistent over-simplification that together bedevil most of this serpentine discussion.

First, I want to clarify a distinction that Wendy Doniger offers, because it will more precisely identify the possible stances people take towards religion. Then I want to respond to a crucial question David Morgan asks about the re-creative possibilities of art, which throughout the rest of the discussion no one answers. There is a way of discerning how art and religion overlap so that their relationship is not inevitably conflicted, religion coded as naively superstitious while "the function of serious art [must be] principally critical or deconstructive" (p. 123).

Wendy Doniger introduces a familiar distinction from religious studies, that between the religious *adherent* or *believer*, and the religious *scholar-observer*: "There is a division between people who believe in god, and people who study god. . . . [T]he idea that people who would argue that art is religious should themselves be religious people is, I think, completely wrong" (p. 116). With all due respect, the whole discussion here, plus general experience, indicates this distinction is a little more complicated than a straight binary opposition:

- There are those who hold to or manifest in their lives a set of religious choices, whom I would regard as *adherents*. This includes those who believe in God, deities, or some equivalent, or in some path of transformation or transcendence, or equally those, like Nietzsche or Richard Dawkins, whose distrust or virulent dislike of religion causes them to adhere to a specific attitude towards religion—they expressly challenge believers.
- The *non-participants*—those who have no use for discussions of religion, who see no point even in sitting at the table (T. J. Clark

and many Marxists, but equally those secularists who simply see no point in paying religion any mind). For them, religious matters are irrelevant, inoperative, a non-issue. They are thoroughly disenchanted, and some are surely the modern avatars of those Schleiermacher called religion's "cultured despisers." This group would see no point in this Art Seminar.

- The *scholar-observers*—those for whom religion is (as Tomoko Masuzawa shows here) "fascinating" as a human activity (p. 124), and in need of careful understanding. These folks are all, in some sense at least, *enchanted* by religious expressions.

It is absolutely crucial to recognize that this last group is made up of people from the first group (both take religion to be significant), *but* they cover the whole gamut of possibilities. Some are convinced and sincere believers (a large proportion of those in the religious studies professional organization the American Academy of Religion appear to be such), others are ambivalent or disillusioned, all the way across to convinced skeptics and debunkers (such as Russell McCutcheon, who insists that religious studies *must not be* about curating our received traditions, but about radically critiquing them[30]). Still, no matter where they are on the spectrum regarding whether any religious insight is true, *scholar-observers* share two convictions: Religion matters; and it must be studied dispassionately, bracketing as far as possible the observer's own belief or faith position, adopting a stance I have come to call "sympathetic critique."

Artists can manifest any of the stances I've just described: committed or ambivalent faith, distrust of or distaste for religion, disinterest, fascination, dissection or apathy. But teachers and critics need some other stance so as to engage, critically and sympathetically, this whole array.

I've seen all these attitudes expressed in the art world and art criticism generally, and many present themselves in this particular conversation-transcript. Yet I suspect that the conversation might have gotten less clogged up, and that art students might gain more helpful guidance from their teacher-mentors, if the obstacle of confusion between taking religion seriously and subscribing to a faith could have been removed. To those who want to acknowledge that art can engage actual religious positions *and* quasi-religious hunches,

inquiries and speculations (as it seems to me motivates James Elkins' entire enterprise here), I would urge them to allow themselves to adopt this acquired stance. It requires both *sympathy*, to imagine what it is that someone has faith in and why, and *critique*, to perceive the implications, paradoxes, limitations, uncertainties, historical entanglements, and perhaps self-delusions that religions, like other human enterprises such as artworks, inevitably entail.

An even more obstructive obstacle that needs removing is the misleading and unhelpful presumption that religions can be encapsulated merely as faith or belief. Jain and Morgan persistently appeal for others to recognize equally significant dimensions such as material objects and rituals of piety, Mazuzawa addresses the complexity of practices included as "religion" by scholars, and Gregg Bordowitz at least tries to get passionate feeling into the picture along with thinking. Yet Elkins and de Duve in particular (partly out of admitted unfamiliarity with any other approach, either in religion or in its study) keep dragging the discussion back to the monolithic paradigm of faith. It is as though they are determined to prove by sheer tenacity Elkins' avowedly "pessimistic" view (pp. 120–21, 169) that the issue of religion and the arts can only be resolved through a discourse pre-determined by the Judeo-Christian premises underpinning modernism and postmodernism (though surely postmodernism offers grounds to resist such discursive hegemony). Their insistence is puzzling, however, since it becomes self-defeating for the avowed purpose of this symposium, and keeps spurning the potentially most fruitful ways to resolve the problem Elkins has now spent two or three books wrestling with.

Fully accepting both the value and urgency of the impasse that Elkins has identified, I want to offer another take that might do an end-run around that impasse which is, to my mind, predicated on a misprision of what gives religion its energy and persistence. The definitional approach to "religion" I have long found most useful and versatile for engaging works of art as well as literature or any other arts builds on a phrase Joseph Kitagawa borrowed from the popular psychologist M. Scott Peck: religions provide people and cultures with "maps of reality."[31] While religions cannot be *reduced* to being maps of reality, they can be accessed and distinguished by means of this model.[32] Religious practices, rituals, dogmas, heresies, spiritualities,

and notions of transcendence all express in one way or another their religion's map of reality. The connection with the arts is that all works (or at least bodies of work) of painting, poetry, dance, music, prose, ritual-performance, video, and so forth presuppose and rely for their meaning on some such map of reality. You can't make art without at least implying one. And while most if not all maps of reality derive from some vision of the world we can nowadays describe as religious, artists are forever interrogating, re-examining, re-configuring, and re-conceptualizing our received maps of reality. As all the artists whose voices we hear in this text manifest, artists are constantly in dialogue with religions and their pronounced verities—sometimes very fractiously, sometimes surprisingly sympathetically (as in Thierry de Duve's examples from modernism at various points in this text). But if my claims above are about right, we will be missing what is going on in art if we don't see how any artwork is shaped by its implied map of reality, and that differences in those maps make for many of the differences between artists, between art periods, and between artworks. Not to mention that artists are forever testing their inherited maps of reality.

Studying maps of reality relieves both observers of religions and art critics and viewers from feeling they have to subscribe to any believer's *faith*. We perceive what makes the art and artist tick (assuming they do), just as knowing their theories about materials, or post-colonial history, also may. This notion of religion is also, importantly, far from simple-minded. In fact, for all the high-minded terminological histories and philosophically fine distinctions voiced in these pages, the discussants never get to as accurate or *applicable* a definition of religion as this model provides. There is a constant refusal to get to grips with the point that Kajri Jain and David Morgan keep trying to insist on—that far more is going on in the religious practices and lived faith-worlds of people whose mundane lives are woven together with some received or chosen map of reality than scholars whose discourse is shot through with alienation and disbelief can bring themselves to allow.

That doesn't mean that all believers create great art or untroubled communities. But it does give us a better purchase on why Bellini and Bach made great art in avowedly religious contexts than de Duve's historical oversimplifications do (p. 154). Bellini and

Bach *engaged* their map of reality, their faith, and mined it not as something "reactionary, unreflective, authoritarian, and simplistic" (as Morgan accurately characterizes the view "many art world inhabitants" have of faith [p. 167]), but as something liberating, deeply reflective, authoritative, and demanding. For them it was a rich soil of contemplation, insight and affect, not something dusty and arid, nor a deceptive mirage. Equally, neither of these artists was alienated, aloof, cynical, or sentimental. That might be a worthy warning to those who so readily dismissed (pp. 147, 151–152) Gregg Bordowitz's exclamation of passion, enthusiasm, *and* ambivalence.

Norman Girardot

An Inquisition into the "Art Seminar" on Art and Religion

Introduction

What follows are some appreciative, yet hurriedly truncated and randomly cantankerous, comments on the Art Seminar conversation about the conflicted relationship between religion and art in the contemporary art world. As the old Monty Python routine, "The Spanish Inquisition," would say: there are two—no, no three, perhaps four or five—points to make concerning this often interesting but also odd and unsettling colloquy. While imagining Michael Palin grinning idiotically in scarlet Cardinal Ximeniz garb, I first want to underscore the fact that the conversation recorded and discussed here deals with an issue—that is, the strange and checkered relation of those two especially peculiar and manifestly non-utilitarian human traditions known as "religion" and "art"—which is very much in evidence these days. It may not be that there is a discernable populist arts revival or "born again" abstract expressionism (although within elite circles auction prices for contemporary art have reached amazing new highs and there is a global expansion of trendy biennale and miscellaneous art fairs), but most would agree that in these dark post-9/11 days at the start of the twenty-first century there sure is a lot of religion around just about everywhere—conservative, liberal, and every shade in between, including all manner of anti-religious religions.

As we see almost every day now, dogmatic fundamentalism of both the religious and non- or even anti-religious kind is rampant. What is too often lost is the possibility of a middle ground, some Archimedean point from which to leverage or assess the maelstrom swirling about us. This middle ground or place is, of course, the special ritual space that the university, the academy, should normally and tactically provide. Unfortunately during these benighted times, there is a pervasive vocational emphasis on taking the given corporate and consumerist world for granted (whether the mainstream academic or art world) and, as a response to the woes of political correctness, the subterfuge of a so-called "fair and balanced" approach to the culture and theory wars of higher education. These tendencies often tend to preclude any kind of liberal and liberating interpretive challenge to conventional worlds of meaning. And this situation has special import when the discursive worlds are concerned with religion and that equally dangerous but also conventionally trivialized matter of art.

It is enough to know that "religion" (acknowledging here the historically problematized and culturally biased nature of this terminology but insisting also on its continuing usefulness—much like the equally problematic yet necessary category of "art") is a phenomenon (or "cultural/social technology" if you will) common throughout human cultural history and prehistory. At the turn of the millennium, many would have thought that religion and its misshapen ilk should have—like the Vampiric reaction to the sun—withered away in the guiding light of reason and science. However, as we know so well, we confront exactly the opposite situation. Thus in this post postmodern and latter-day 9/11 era we are witnessing not only a worldwide revival of certain fundamentalist forms of religious and non-religious faith, but also a harrowing dramatization of the terrible cultural power and global reach of especially scary forms of religious behavior. It's not "girls gone wild" in the silly and quasi-religious celebratory spirit of YouTube. Rather we are now treated to the voyeuristic pornography of violence and the "wide stance" of sexual hypocrisy best thought of as "religions gone berserk!"

So also is there another disturbing consideration regarding the horror and disaster film-like spectacle of 9/11 that seems to link the expressionist auras of religion and art—that is, the seemingly easy

connection of "end time" religious belief and cinematic performance art. And there are many other examples of this heightened response when religion is made visual and public (thinking of the "blasphemous" Danish cartoons of Mohammed or, most recently, the Teddy Bear Mohammed incident in the Sudan, not to mention Jesus in the pizza and the elephant dung Virgin—see Brent Plate's *Blasphemy: Art that Offends* on some of these issues). One of the lessons here is the special theatrical and conjuring power of word coupled with image, belief with practice, myth with ritual, and religion with art. The imaginary in this way is made powerfully and dangerously real (see, for example, Greil Marcus' discussion in *Dead Elvis* of the collective art project defining the religiosity of the Elvis cult).

Regarding religion and its ilk, therefore, there is certainly much to be interested in or, perhaps more often, to be frightened about. And things become curiouser and curiouser when that other ubiquitous yet often disturbing and elusive tradition called art is more fully brought into the mix. Thus the topic taken up in this seminar is truly fascinating or as James Elkins has asked: what, pray tell, "is the strange place of religion in contemporary art?" Cardinal Ximeniz would, no doubt, respond to such an inquiry by fondling his jewel-encrusted crucifix and calling for some aesthetically enhanced waterboarding (alternatively the Spanish Inquisition's notorious kitchen "rack" or insidious "comfy chair") of his interlocutors. However for the fearless Elkins, as the person who generated and framed the seminar topic, this is an issue that is mostly a matter of delicious dichotomy. That is, the mainstream contemporary art world largely rejects the significance of any special relationship between the two (as too "painful" or trivial; a relationship seemingly definitively severed in the Enlightenment), while at the same time and in the spirit of what some (most notably and controversially, Suzi Gablik) have called the current "re-enchantment of the world," more and more artists, art students, and the general public affirm some ambiguous intrinsic relationship between religion (or the "spiritual"—keeping in mind the curious history of this term!) and art (see, for example, the work of Robert Wuthnow). This clean distinction is made all the more problematic by the messy ambiguities lurking (or "camouflaged" as so often suggested by the seminar) in the middle ground

between these polarities. And it is this spontaneous ambiguity that makes the seminar conversation simultaneously intriguing and frustrating. Just when it seemed that the world had achieved some steady-state semblance of Enlightenment dis-enchantment with regard to religion and art (both discursive categories being fixed in the Western world at this historical juncture), we seem to be entering into a kind of post-secular age where all such neat categorical distinctions begin to collapse in the spiritual truth of a web-world made visible, salvific, and terrible by an invisible digital codex or matrix. That is—Gnostic gospels written by Microsoft and revealed by Google. This is, incidentally, a point made both by Boris Groys in the Seminar and independently by Bill Viola at a recent American Academy of Religion conference.

As someone in charge of educating young aspiring artists who have increasingly shown an interest in the religious or often "spiritual" aspects of their artwork, Elkins has a vested interest in asking about religion's "strange place" in relation to art. However—and now speaking from my own perspective as a historian of religions interested in how art is strangely related to religion and, as a matter of fact, as someone dealing with general liberal arts students who are hungry for a more aesthetic approach to religious meaning and practice—the question of relations obviously goes both ways. The real issue (as a form of wonderment or amazement) is that strangeness abounds in relation to both religion and art and in terms of their explicit and implicit relationships in time and space. I draw attention, therefore, to the strangely roundabout nature of the recorded seminar conversation and especially to the artist Gregg Bordowitz's culminating declaration of his "faith" (in the sense of belief and faith, practice and psychology, ontology and ethics) in the self-revelatory power of artistic process and aesthetic strangeness. In fact, there is a kind of phenomenology of strangeness that sporadically oozes out of the discursive interstices of the seminar. And it is this, strangely enough, that provides some meaningful armature for what transpires among the sometimes obtuse, self-centered, and undeveloped discursive riffs dominating the seminar. Such spasmodic results are, of course, the common fate of academic discourse.

What is suggested is that both religion and art—whatever else they may deal with—represent a response to the common human

experience of the "strangeness" (incongruity, ambiguity, otherness, sacrality, beauty, sublimity) of the self and world. I would maintain that there is, finally, an underlying neo-Romantic symbolic truth and performative reality in religion and art that speaks primarily and imaginatively—if not exclusively—to the strangeness and "deep play" of the human condition and cultural enterprise. It is not so much the super-naturalness or utter transcendence of the sacred that is at issue. Rather it is, as Mircea Eliade has reminded us, the basic banality and disguised nature of the sacred—the fact that what is extraordinary in life is always in and part of the very ordinary material thing-ness of things. The Dao (the invisible fractal pattern of things or, indeed, the digital—*yin* and yang—code of life), as the Chinese Daoist sage, Zhuangzi, said, is *in* the "piss and shit" and is (partially) known only by means of the "art" of life. The art of religion, as well as the art and technique of art itself, comes in expressively acting in tune with—and making visible and effective for others—this realization.

Four or, perhaps, five more points

I will elaborate no further on these large and difficult matters. The prevailing strangeness of the seminar is what it is, while the possibility of a philosophy or phenomenology of strangeness that links religion and art is yet to find its twenty-first-century Gaston Bachelard. Here I will only enumerate a few additional issues that came to mind as I read through the seminar conversation. The assembled interlocutors are clearly distinguished, knowledgeable, and articulate exponents of different disciplinary points of view (as artists, art historians, and as scholars of aesthetics, visual culture, and the history of religions), but too often the discussion, while often provocative, remained maddeningly open-ended and convoluted. Many examples could be cited, but I note only the following points:

1. After an initial flurry of Hegel-talk, the seminar takes a turn in the direction of the evolutionary history of religions (de Duve, Jain, and Morgan). This discussion was, however, too quickly sidetracked by the debate over "religion" as a discursive category (somewhat more interesting was the distinction regarding "belief" and "faith"). What is remarkable is the failure

on the part of the religionists and the art folk to even consider some of the more interesting attempts to talk about the evolutionary origins, and historical–cultural interrelationship, of art and religion (e.g., Ellen Dissanayake, Colin Renfrew, Ester Pasztory, David Lewis-Williams). The contested nature of the category of religion is, of course, nothing particularly new (see especially J. Z. Smith), although it is again peculiar that a similar debate over the terminological history of "art" never entered into the discussion (for a popular discussion, see Mary Anne Staniszewski's *Believing is Seeing* and, more substantially, Larry Shiner's *The Invention of Art*). This is particularly perplexing since both these words were fixed as academic categories at roughly the same time in the Enlightenment and both drew upon similar affirmations about certain "beliefs" coupled with various kinds of denials. An example of this affecting both "religion" and "art" is the whole Protestantized emergence of "pure," "mystical," or "ethical" forms of religion—a kind of "religion without religion" (see, for example, Steven Wassertrom's *Religion After Religion* and Jeffrey Kripal's *Esalen*)—that in some ways (perhaps) links aspects of the new academic, comparative, or historical study of religion with later conceptions of "art for art's sake" (or "art without religion") independent of the ritual corruptions of the Catholic religion and its sacramental iconography. It would seem that there is an interesting connection between the emergence of both the comparative history of religions and art history that is yet to be explored (Morgan and Sally Promey's work has touched on some of these issues).

2. As a general issue, it seems that although art discourse (somewhat more than academic religion-talk) is still infatuated with theory-chatter, many of the heroes of traditional and currently fashionable theory (Hegel, Kant, Freud, Benjamin, Foucault, Derrida, Mark Taylor, and so forth) don't always fare too well in assessing the basic historical and cultural relations of religion and art (noting that Morgan's introduction seems to suggest that a careful reexamination of some Romantic theorists like Friedrich Schiller would be more profitable). It is also noteworthy that the religionists in this conversation seem

oddly subdued (Doniger) or overly fixated on the particular categorical issue of "religion" (Masuzawa). The unfortunate outcome of the seminar is that too often the art and religion scholars were talking past each other—despite Elkins' always gracious and probing efforts to keep the discussion partners engaged and moving forward. It was Morgan who repeatedly tried to open up the conversation to the broader cultural studies concerns associated with the visual practices of all kinds of religious phenomena. While this perspective had some potential for bringing the religionists and art folk together, it remained largely unrealized.

3. Another issue as it relates to theory is the sequestering of Mircea Eliade's still helpful views on these matters. Admittedly, Eliade has not been particularly fashionable these days (dismissed as a kind of crypto-theological believer in the ontological reality of the "sacred" and condemned as an anti-Semitic Fascist sympathizer during World War II; for a compelling counterpoint to these views, see the important revisionist work on Eliade by Bryan Rennie). Most recently, however, there have been some significant signs of a revival in the proto-postmodernist and constructivist implications of Eliade's key methodological principles (see especially Rennie and William Paden) and in Eliade's own personal linkage of imaginative literary art and academic scholarship (that is, his many fictional writings, one of which, "Youth Without Youth," has just been filmed by Francis Ford Coppola; see also the work of Matei Calinescu). More than the theological existentialism of Paul Tillich or the quasi-Jungianism of Joseph Campbell (to name two culture heroes of Eliade's earlier 1960–70's generation of theologians and religionists), Eliade's approach to the religiosity of art and the art of religion continues to have interesting implications for a contemporary consideration of the *coincidentia oppositorum* of religion and art. One powerful example of this is the whole theme of the "camouflage" of religion in modern art forms. This is an issue that is brought up in the first question period and becomes one of the key interpretive metaphors throughout the last part of the seminar, but Eliade is never directly discussed or evaluated by the

religionists or art folk (even though Doniger is the "Mircea Eliade Professor" at the University of Chicago). Curious.

4. Perhaps weary of all the meandering theory-talk during the first part of the seminar, the conversation promisingly turned to a more concrete consideration of various metaphors and examples of the relationship, or lack thereof, of art and religion. It is in this concluding section that Bordowitz—seemingly out of pent-up frustration—has his epiphany linking artistic practice, religious-aesthetic experience, and the strangeness of the human condition. In response to this pivotal moment, de Duve waxes acerbic, Mazusawa retreats, Morgan pleads, and there is much interesting banter about actual artists and their religious/spiritual practices (including some passing swipes at the likes of Andreas Serrano and Bill Viola for being, it seems, too overtly religious). In the midst of this wrangling over specific and diverse examples of the art–religion interrelationship, there is one unfortunate omission that I'd like to mention—that is, the case of so-called outsider, vernacular, or self-taught art. This is noteworthy for the simple reason that in contemporary art circles, the field of outsider art (linked as it is to the earlier Art Brut movement of Jean Dubuffet) has become increasingly popular as both a counterpoint to the mainstream art world and as a tradition of artists who often un-ironically and obsessively link their art with traditional and eccentric visionary forms of religion (the maverick Baptist preacher artist and visionary, Howard Finster, is a good example). Elkins has, in fact, written about this tradition and it seems somewhat surprising, therefore, that it never comes up, even tangentially, in the conversation (not, of course, that every possible subject could be covered in the seminar).

Conclusion

I conclude these comments by observing that the seminar's designated representatives of art and religion mostly ended up cruising past each other on their particular disciplinary frigates while frantically signaling themselves with mutually unintelligible semaphores. One exception to this was the indefatigable Elkins, whose erudition

and curiosity are amazingly broad. But even Elkins seemed strangely attenuated in this circuitous conversation. It was Morgan's pioneering "visual studies" approach to both religion and art that suggested a way out of the impasse—at the very least dramatizing the importance of a critical appreciation of both art history and the history of religions, linked with a completely inclusive and culturally contextualized engagement with all forms of religious and artistic practice.

It is worth saying that there are some promising developments in the academic study of religion these days (thinking here of the "everyday," "lived," or vernacular religion methodology of scholars like Robert Orsi, David Hall, and Thomas Tweed; much of this represents what I would call a new kind of applied or practical "phenomenology of religion") that approximate the contextualized breadth and interdisciplinarity of Morgan's approach to art and religion. The difficulty is that, aside from Morgan and Brent Plate in the academic study of religion and Sally Pomey and Erika Doss in art history, there is very little general attention to these conjoined matters and very little attempt to bridge the disciplinary gaps (keeping in mind the interesting eccentric work of Lewis Hyde). Beyond the impact of this seminar and its various appended "assessments," it seems that one of the most important ways to address these issues concerns a reformed approach to an education of both art and liberal arts students (perhaps some more controlled version of the Black Mountain College model) that comes to grips with the strange, even monstrous, relation of religion and art (the pedagogical theme, it should be said, of a recent national conference at the School of Visual Arts in New York).

Suffice it to say in harmony with Monty Python's Cardinal Ximeniz that "no one ever expects the Spanish Inquisition!" Nevertheless, there it *is* in all its diabolical glory. In like manner, no one really expected the Art Seminar to take up the messy issue of religion and art. But Professor Elkins' seminar is known for its wicked weapons of surprise and ruthless efficiency—not to mention its fanatical devotion to the various popes of theory and its determined use of computer-generated three-dimensional bar charts. Very strange. But we can be grateful for Elkins' and the Art Seminar's relentless and entirely un-dogmatic pursuit of these matters.

S. Brent Plate

From Iconoclash to Iconomash

Just down the street from where I teach is one of the largest modern art museums in the United States, the Modern Art Museum of Fort Worth, with over 53,000 square feet of display space. When the new building opened in 2004, the permanent collection included: Mark Rothko's quasi-spiritual, abstract expressionist, *Light Cloud, Dark Cloud* (1957); Melissa Miller's Genesis reinterpretation of *The Ark* (1986); Jonathan Borofsky's *The Radical Songbirds of Islam*, a sound installation inspired by Muslim prayer chants; Bill Viola's *The Greeting*, which displays Mary and Elizabeth's greeting as indicated by the Gospel of Luke, Chapter 1.39ff.; Andres Serrano's cibachrome prints of *Klansman (Imperial Wizard III)* (1990), and *The Church (Soeur Yvette II)* (1991); Anselm Kiefer's kabbalistic-influenced multimedia works such as *Book with Wings* (1992–94); and ultimately the magnificent Zen-invoking architecture of the building itself by Tadao Ando, whose double-skinned interiors and ample use of water surfaces are drawn from Buddhist-inspired Japanese teahouses.

And just down the street from where the current Art Seminar took place is the Museum of Contemporary Art, whose inaugural exhibition in the new building opened in 1996 was entitled *Negotiating Rapture: The Power of Art to Transform Lives*. The list of artists there included Rothko, Kiefer, Viola, and several others, though this exhibit is never mentioned in this Art Seminar. Other large exhibitions exploring religion and contemporary art in recent years are *Heaven*, *100 Artists See God*, and *Iconoclash*.

So, in the first instance, I find it difficult to understand how religion can be considered separately from modern art. It is hardly a marginalized mode of artistic production; rather, religion permeates the modern, as well as modernity, though at various levels of visibility. There is camouflaged religion in art (for which I'd include Rothko), critical stances toward religion in art (Gilbert and George's "Sonof-aGod Pictures"), work that provokes something at least akin to a religious experience (installation art in general, Viola in particular), and work that utilizes religious symbols as one more stock set of images in our cultural warehouse (e.g., Chris Ofili's *Holy Virgin Mary*). To what extent the religious and sacred can or should be

depicted is part of what Bruno Latour's concept of *iconoclash* is about, and that continues to be an important and critical mode of analysis. Yet I suspect part of the oversight concerning the status of religion in contemporary art stems from a general religious illiteracy, especially when it comes to religions outside Christianity. The focus on "belief" that forms the first part of this conversation is not a "religious" interest *per se*, but a deeply Protestant one. Protestants speak of belief, of belief particularly in a single God, and are heavily influenced by attention to the Bible. One of the problems with the study of religions, including those of Tomoko Masuzawa, is that Protestants who figured they could understand the world's religions by reading others' doctrines and texts invented it. It pretends religion is primarily a linguistic enterprise. To define religion beginning with terms like belief and faith exposes the Christianized background of those who are attempting to discuss the topic.

The examples I gave above from the collection at the Fort Worth Museum of Modern Art point to a second theme relevant to the work of contemporary artists: multicultural, multi-religious, perspectives. The religious presence in modern and contemporary art stems just as much from Buddhist and Islamic traditions as it does from Christian or Jewish ones. To point toward histories of, and events within, Western aniconism and even iconoclasm are fine, but what is happening is that artists are finding inspirations, new practices, and critical fodder from all over the world. In the era of diverse cultures living side by side, and of wholesale exchange between traditions, it becomes impossible to separate out a single line of history and tradition. Then again, it always has been impossible.

Because of this, I would like to supplement the concept of iconoclash. My undocumented, arguably unsupported suggestion is this: The real issue in the future of the religion–art relation is not about iconoclash, whether the holy/transcendent/divine can or should be depicted and how, but in *iconomash*, how this sense of otherness and Otherness will be depicted in light of, in response to, and in conjunction with various religious traditions that currently coexist. Issues of representation and likeness will fall away, as visual-material issues surrounding pluralistic presentations will come to the fore.

Kajri Jain points out how the conversation about religion and art should not be constrained by Christianity, but that there are other

modes of image-making and religiosity. In like manner, Iconomash proceeds from the lived pluralism on the streets of regions around the world, from New Delhi to New York, York to Dubai. Jain and David Morgan point toward the religious behavior (not strictly the "beliefs") of people who practice religion. This includes the making of visual objects, but also the display, ritual use, and veneration of religious objects. Sometimes these end up in museums, but just as regularly in shrines and temples. And in these cultural exchanges new work is produced that transcends the local and global, past and present.

Two brief examples from two distinct traditions at least go some way to supporting my claim. Japanese-American sculptor Isamu Noguchi (1904–88) merges the aesthetics of a Japanese garden with modern modes of sculpting. Hard stones are carved, smoothed, and cut into, just as they are consciously placed in the ground for viewers to see and often touch. In so doing, Noguchi replicated the Zen aesthetics of a dry rock garden and produced it for a contemporary Western audience. Similarly, the Iraqi artist Issam El-Said (1939–88) borrows from the long historical reach of Islamic calligraphy and self-consciously mixes these with Western-influenced modern art. The form of his work was a modern Western one, but he was able to infuse it with the kind of historical cogency the West tends to lack. His work is thoroughly modern, but infused with the traditionally Islamic work on calligraphy.[33]

Religion and the arts connect through processes of iconomash. Religious images morph, move, and mask themselves. To make sense of religion in the contemporary arts, the reach of art history must continue to move chronologically, but also synchronically, across presently existing cultures and religions that continually cross in the present age. What we will continue to find into the future are the multiple ways religions and arts connect, but only if we understand the broader practices that constitute that potentially non-thing called religion.

Stephen Pattison

Response to Re-enchantment and Art Discussion

It's always good to see genuine, open-ended scholarly debate going on in the academy. This corrects the perception that there is a right

way of understanding things and shows that the scholarly world reflects the confusion and muddle of reality. The contributors to the Chicago discussion have done readers a great service by washing their linen together in public—it sounds as if they had fun doing this.

It's a privilege to be asked to eavesdrop on their conversation and then, impertinently and naively, to comment and criticize from the sidelines without the possibility of immediate correction or redress! I write as a theologian of practice whose job is to ask the question, What do contemporary people do and believe, and how do their beliefs and actions relate to one another?[34]

I want, first, to note the emotional and polarized nature of some of the debate. Passions and feelings are engaged in various strongly-held positions—this is part of what makes the debate interesting. But am I wrong in hearing a certain over-assertiveness in some contributions that might indicate defensiveness over the robustness of particular positions? This kind of dualistic defensiveness is associated particularly with James Elkins' assertion of the complete, hostile stand-off between Western contemporary high art and conventional institutional religious belief and practice. Elkins and others are right to say that few artists of international standing are interested in formal religion. Furthermore, many artists who would self-identify as religiously interested are not producing great art. But while there is formal public institutional atheism in many parts of Western culture, the picture of the hostile or indifferent relationship between religion and art is overdrawn.[35]

Willy-nilly, ironically, critically, or sincerely, artists, like novelists, are shaped by the residue of institutional religious culture; they continue to draw upon the common store of symbols and myths bequeathed to the West by Judaism and Christianity. Even the existence of rectangular pictures still harks back to the form of the icons from which they developed. Whether we like it or not, many of our institutions and the individuals who inhabit them will continue to be haunted by religiously inflected practices, symbols, and rituals for years to come.

Perhaps it is this kind of inevitable haunting that makes some artists and art theorists so keen to draw the hard lines of division that Elkins seems to detect. Three centuries after the Enlightenment, the denizens of the high culture consuming classes still seem surprisingly

anxious about the present power and possible return of the religious and a-rational and what this might mean for individual freedom and expression. Rather like adolescents, we still fear the power of the fantasized returning vengeful religious parent, in our case, basically Western institutional Christianity. It seems we have to deny the existence of this monster in order to cope with it, thus perhaps offering a backhanded tribute to its continuing power and influence.

This kind of dualism is, I suspect, an unhelpful and unresolved pathology. It does not help us to understand how art and religion do, or might, relate today. It forces people into the over-polarized positions exemplified in the seminar discussion.

I want to suggest that the boundaries between art and religion, conceptual and practical, are not actually so absolute and monolithic as some seminar contributors imply. They are less like Hadrian's Wall—a single structure made of one impervious material that runs more or less straight through a terrain dividing it absolutely in twain—than like the borders between continental countries where rivers, hills, road lines, fences, and all manner of other things can be the locus of a border, but often the actual boundary is invisible, transparent, and winding in nature, so that people may not necessarily know all the time which side of it they are on. Furthermore, they can see, wave to, and talk to others who are theoretically on the "other side" of it. Thank goodness some of the seminar audience seemed more convinced of the reality of invisible and porous boundaries than that of impenetrable walls—despite the best dualistic efforts of some of the main speakers! If the existence of the nation-state is now being problematized as more human construct than geographical essence, it seems difficult to defend the notion of two autonomous "real" institutions called art and religion in theory or in practice other than for the purposes of tribal identity and cohesion, colonization or warfare.

Given that seminar participants mostly decided that they were content to reify religion and art, however, it was not helpful that there was no agreed understanding of the concepts, "religion" or "art." Art is not my area of expertise. However, in religious studies, a useful basic distinction is often made between substantive and functional definitions of religion.[36] Substantive definitions of religion mostly include some explicit reference to belief in God and in the transcendent, i.e., they take what members of conventional religions

themselves say they think they are involved with, and take to be real, seriously. Functional approaches to definition ask from a basically external point of view, what do religions consist in, and what do they do for individuals and for society? If you adopt a functional definition of religion as, for example, a distinguishable collection of rituals, habits, morals, beliefs, practices, texts, symbols, and myths that help to develop a canopy of meaning and build up community, then it can be argued that art and sport do this as much as any kind of traditional institutional religion. So art cannot avoid being "religion," or at least religious, in its uses and effects. However, a substantive understanding, in which religion is defined in relation to particular cognitive beliefs in transcendental realities, e.g., in God, in Jesus, would certainly leave much contemporary art as very different and separate from religion.

It is the substantive type of understanding of religion that predominates in the Chicago seminar, with the discussion focusing around cognition, belief, and faith commitments to certain ideas or religious figures. However, much of religion, functionally understood, has little to do with cognition and much to do with practice.[37] And it is here that I find the seminar most frustrating.

David Morgan makes occasional valiant attempts to try and get participants to think about how actual real people interact with religiously significant visual artifacts in everyday life. It is here, in the phenomenology of the actual practice of creating and looking, rather than in abstract theorizing, that we might hope to find the most useful illumination as to what part art (or should that be visual creation and consumption?) is playing in religion and *vice versa*. It is therefore tantalizing that so little attention was paid to the interestingly ambiguous relations that occur across the transparent boundaries between art and religion.

Just as individual seers and creators of objects transgress, or transcend, the borders between "religion" and "art," objects, too, enter into interestingly complex relations with these ostensibly separate institutions. Many museums and art galleries, the fruits and temples of rational religion, are now recognizing that the "art" objects originally wrested from sacred or cultic contexts may continue to have religious significance and power beyond passive aesthetic contemplation.[38] Thus, museum-imprisoned icons in Russia are once again

becoming objects of active religious devotion.[39] More strangely, some modern objects are making a transition into the inhabited devotional world. So, for example, in 2007 a sculpture, "Cleansing of the Temple" created by self-confessed atheist artist, Brian Burgess, began emitting sparks from Jesus' eyes in the thoroughly secular locus of Liverpool Academy of Arts, where it is displayed after being rejected by its original ecclesiastical commissioners. It is now an object of spontaneous devotion for some viewers, to the surprise of its creator.[40]

It seems to me that these kinds of relationships are but the tip of a very complex set of important relationships that viewers and objects continue to engage in with each other, whatever the views of academics and theorists of high culture.[41] Many ordinary people go to art galleries, as they go to cathedrals, in the hope, however vague, that something special will happen to them.[42] They are looking for significant, quasi-transcendent, even revelatory encounters in the galleries that are the secular, rationalistic shrines (even down to their Greek temple architecture) of the Enlightenment. They want to experience some kind of "otherness," or sense of wonder, with objects in a particular social context to which they make a kind of special preparatory pilgrimage. Otherwise they would not bother, being mostly unequipped with the hard-earned esoteric vocabulary of art criticism that would allow them to dissect, rather than to wonder at, art.

So I would suggest to be maximally illuminative and useful, discussions of religion and art need to be earthed much more firmly in the complex, ambiguous phenomenology of viewer–object–institution–society interactions in which people of all kinds make and explore life and meaning in everyday life. This is often done through the medium of artifacts (graffiti, tattoos, photographs, mass produced reproductions, plaster images) that lie beneath the gaze of artists, art critics, and academics generally.[43] It is here that rather speculative, ungrounded theory might find some answers and some new, perhaps more pertinent questions about the real state of relationships between "art" and "religion" and how these play out in contemporary life and culture.

A final comment upon disenchantment and re-enchantment. It seems to be common ground between many of the seminar

participants that we are now living in a disenchanted, rationalistic world in which transcendent religious and a-rational experiences are really a species of madness or compensatory wishful thinking amongst those who cannot live with the harsh realities of meaningless modernity. Both religion and art can then be seen as part of a quasi-romantic quest to make a soft, habitable nest of symbolic and mythological meaning amidst the unremitting rational and scientific materialism that underlies capitalism—arguably the dominant religion (unquestionably real world view) prevalent in the West.

But perhaps the implicitly patronising and progressivist terms of this debate, which relegate both art and religion to some kind of marginal compensatory activity, should be questioned. Maybe it is not helpful to think that the world has become disenchanted. The a-rational and non-propositional quest for meaning and purpose has perhaps not gone away. Furthermore, it might be a mistake to see capitalist materialism itself as a rational world view, dependent as it is upon stimulating imagination and desire and creating powerful fantasies and illusions that hold its adherents in unquestioning thrall.[44] Maybe the world is just differently enchanted, not disenchanted. And in this connection it is worth remembering that the vast majority of the world's population does not share the chilly modernist illusion that objectifies creation and separates humans from their surrounding ecology. It was Plato, no particular friend of art or religion, who believed that "wonder is the feeling of the philosopher, and philosophy begins in wonder."[45] Even contemporary science is not without its moments of awe and wonder that motivate and attach people to their world and their work.[46]

Maybe, then, religion has not given way to art. And perhaps neither art or religion should allow a strangely distorted populist version of the rational "scientific world view" to define their own boundaries, concerns, and values, or the terms of the debate and relationship that might be engendered between them and between the creators and ordinary viewers of visual artefacts of all kinds. If we "have never been modern," or at any rate are not as modern and rational as we might sometimes like to think, then we should not allow the restricted terms of a modernist debate to determine our engagements with art and religion or their relations with each other.[47]

Ultimately, then, I think the disenchantment/re-enchantment

polarity, while intellectually and conceptually seductive, and to some extent illuminative (as the seminar illustrates), distracts from the more significant matter of thinking about human interaction with meaning-, symbol-, and artefact-making. This is nothing less than the business of understanding how we make and keep the world fully human and habitable beyond cliché and artificial theoretical barriers and turf wars. In this sense, we need to move beyond the kind of interesting but "theological" (abstract, minute, unrelated to everyday life) discussion exemplified in parts of the seminar to engage more broadly and fully with understanding everyday living relations between people, objects, and inhabited world views.

Lisa DeBoer
Faith in Art

If art worlds can be imagined as Venn diagrams, James Elkins and I inhabit different but overlapping sets. Elkins, at the School of the Art Institute of Chicago, inhabits an institution that creates and sustains the very notion of "art" which he finds so puzzlingly and troublingly resistant to sincere religious engagement. As a professor in an art department at a Christian liberal arts college, I inhabit an institution that generates, every year, twenty-some young artists who are typically very interested in pursuing sincerely religious themes and questions in their art. A number of these students hope to pursue further study at places like the School of the Art Institute of Chicago. You can see the challenge. For them to make it into the small area where our two sets intersect—the place where you enter the mainstream high-art world *and* engage religious interests—those students will need to become smugglers, camouflage artists, and disciples of doubt.

On the one hand, this is not a problem. Interesting, engaging, challenging works can be produced by smugglers and doubters. Most people of faith are all, at some level, smugglers and doubters anyway. On the other hand, it does, as James Elkins recognizes, constitute a challenge. Not so much for my students, who can always finish their MFA degrees and then, as properly certified artists, go on to follow their own artistic trajectories and create their own networks of patrons, galleries, and critics—as all successful artists must. Rather, the challenge is to our larger art world, the one sustained by places like

the School of the Art Institute of Chicago, which risks being "disciplined and imprisoned by current ideological formations that we must change" (to borrow Gregg Bordowitz's apt charge).

I found it telling that the few gestures in the conversation toward examining the social and institutional origins of "art" were overwhelmed by the interest in examining the origins of "religion." I appreciated Tomoko Masuzawa's insistence on recognizing the invented character of "religion." What I missed was more attention to the invented character of "art." As someone who has one foot in the art world as it is imagined at the School of the Art Institute of Chicago, and the other foot in a very different art world of sincere religious practice, the culturally and historically specific character of these worlds has always been a source of fascination for me. The language of "resistance and refusal," for instance, used to characterize the stance of the art world over against the religious, is a curious inversion of a persistent current in the history of Western art, from the Nazarenes to the Bauhaus, that "resists and refuses" the disenchantment, or at least the disengagement, of post-enlightenment art.[48] But, of course, most of those resistance movements have been written out of the teleology of modernism—especially the ones that are the artistic ancestors of religious kitsch.

At the moment, I'm writing about the resurgence of the visual arts in Protestant churches in North America. My central challenge in this project has been to find a bridge (a metaphor that came up twice in the roundtable, once with respect to art and ritual and once with respect to art and anthropology) that would allow me equal access into the "art world" as represented by the School of the Art Institute of Chicago, and the art worlds that exist within Christian churches. At one point in the roundtable, David Morgan, in conversation with Frank Piatek, suggested that "a sociological framing of the question could be very helpful." For me, this has been essential. Theologically speaking, "sacramentality" is the key rubric for the church-based discussion of art. But beginning and ending there would give me little meaningful access to the art world outside the church. "Ecclesiology," however, as a particular form of sacramentality, does. The bridge it provides is that of a social institution—an institution with theological freight, to be sure, but an institution nonetheless. Similarly, general notions of "spirituality" or "transcendence" or "the

sacred" sustained by certain locations, practices, and commitments in our art world do not gain much purchase in the concrete rituals and practices of Christian community. But BFAs and MFAs, not to mention graphic designers and K-12 art educators, the very human and often (still) sincerely religious products of the educational wings of our art world, do. Beginning with "art" and "church" social institutions has allowed me to build a bridge between the various beliefs about art shaped and sustained by our institutions of art, and the practices of art that are shaped by various institutionalized ecclesiologies. In my analysis, the rather recent flourishing of interest in the visual arts in Protestant churches has more to do with the success of our educational institutions than with any deep shifts in belief or theology. The challenge for Protestant churches, now, is to help all those smugglers and doubters shed their camouflage and develop new strategies for working in good faith, in a community of faith.

Kevin Hamilton
Belief in Public

The theory that there exists some form of prejudice against religion in the worlds of contemporary art is not new to me. I have encountered this suspicion in students and in colleagues, expressed even by artists whose work I respect. From my view, the sentiment has never rung true. Even as a "system of refusals," and not a unified conspiracy, this way of looking at art practice is just too general, too broad, to be of use. At the very least, such suspicion ought to examine more specific sites. We might talk about the role of incarnational aesthetics in the experience of Manhattan-based collectors of contemporary art, for example. We might examine attitudes toward transcendence in the experience of East-Coast undergraduate painting students whose professors who are over 50. Though such detail might sound absurd, the worlds of contemporary art are just too fragmented, decentralized, and fleeting to allow for sweeping overviews about permitted or prohibited material.

That said, as an educator and artist I certainly experience gaps in the languages of modernism and its critics. There are aspects of human experience for which my inherited models of art critique,

education, or production have few words. These gaps, addressed but also exemplified by Elkins' moderated conversation, include:

1. *Social organization or transformation outside of instrumental human agency.* Art can change the world, but is it always because a person wanted it to? Are there other forces at work besides human intention in the material transformation of societies?

2. *Divinity outside of human subjectivity.* Can we talk about God without talking about human understanding or perception of God? How might the mere fact of God's existence, regardless of our knowledge of it, change life?

3. *Being (ontology) outside of perceiving (epistemology).* What are we besides what we know, or what we produce through encounters with other knowers?

4. *"Standing" or value of the living or inanimate non-human, outside of its role in ritual or trade.* How do animals, plants, the earth change who we are through their existence independent of us? What power might objects, even art objects, bear other than their value to humans?

5. *Public expressions of love or worship that are neither individualist nor anti-corporeal.* Are there acts of adoration born not out of ego or anti-ego?

Such questions have not been singled out and eliminated within contemporary art; they simply aren't sensible questions to ask in art today. Modernity is based on assumptions that preclude such questions as cogent concerns. Or, rather, when they emerge as concerns, especially in times of crisis, modernity and its arts have no way to address them.

Any contemporary artist who encounters these sites of questioning is likely to find herself at odds with a surrounding discourse. For those who approach such topics in connection with their lives as members of a religious order, this should come as no surprise. Many faiths emphasize the ways in which a life lived in obedience to doctrine is also a life lived against other dominant modes. Doctrines differ over how to live in relation to counter-belief. Persuasion, evangelism, violence, service or retreat are all religiously-ordained responses to living and working within an environment that does not recognize the existence or validity of one's most urgent questions. In

the case of religion and contemporary art, I suspect that whether an artist experiences a "system of refusals" has everything to do with her cultural apologetics—what she expects from the institutions in which she participates, and how she chooses to address lacks, injustices, and deficiencies there.

All of the questions I described above are important to me, and so I look for and find other company and institutions that allow me to explore them. I've found plenty of artists and students who encounter some of the same limits in our inherited languages. How we deal with these limits varies in similar ways to how religious orders vary in their cultural apologetics. Some feel disenfranchised, and locate the problem as one of representation, as did the adherents of "identity politics" in the 1990s. Others seek to progressively expand or transform the institutions in which they play a part. Still others seek to set up wholly new institutions to counter those that are ill-prepared to talk about what matters to them. Like many of my closest colleagues, I navigate these questions of cultural apologetics one situation at a time. I try not to bring the same set of expectations to every site.

Here, we should remind ourselves that there are artists who experience a "system of refusals" that may coincide with differences in religious faith but which are actually based on racism, sexism, and class bias. At times my perception of a dominant discourse as ideologically exclusive may be homologous to another's experience of that same discourse as racially exclusive. As Bourdieu noted, alliances formed on such homologies may offer strength in numbers, but the two sorts of refusal should not be confused.

Now about my own cultural apologetic: As someone who aspires to be like Christ and who is also an artist, I have experienced none of the "systems of refusal" described by Elkins and others. That said, it will probably come as a surprise to many of my close colleagues that Christian orthodoxy is central to my life and practice. I admit to making implicit concessions in any or all of the areas I have outlined here in order to earn my living and remain in cogent conversation with those who don't share my beliefs. But I do the same by paying taxes "to Caesar" that support violent action, when I believe Christ calls us to pacifism.

I suspect that many of those who feel excluded from contemporary art worlds because of their religious faith are experiencing some

of the real gaps I mentioned above. More importantly, I suspect that they bring a cultural apologetic that expects representation or inclusion or public exchange where I do not expect such equanimity. The model of a free market or open exchange in which all have an equal chance at identification with success, canonization, or spectacle is naive, and not in line with either modern definitions of "public" or economic reality. This is as true for Atheistic still-life painters as it is for Jesuit abstract expressionists.

I may not follow the same cultural apologetic when it comes to justice issues, but that's another discussion, and one that should not be confused with this debate.

I have every confidence that the art markets will eventually assuage those who identify as excluded for the religious content of their work. The market will do so in the same way that it has for popular music, publishing, television, and film, where a niche is created and allowed to flourish on its own, a "religious" branch of a secular institution. Meanwhile, advertising and product design will provide ever more enchanting moments of escape. And unless art institutions place themselves in some precarious places, there will be no more words than there are now for addressing some of the most pressing questions of belief, origin, and being through art.

Sally M. Promey
Expanding Conversations: Theories, Histories, and the Study of Contemporary Practices

In recent decades new energy has informed interdisciplinary exploration of the visual cultures of religions. In large part, this scholarly engagement shares an increasingly expansive and increasingly intimate understanding of its subjects. When it considers religions, it does so acknowledging plural religious landscapes while also attending closely to the specific lived experiences, beliefs, practices, and communities that religions embody and shape. Equally expansive and intimate is its approach to the category of "art," conceived as one historical possibility within the larger range of objects included in the category of visual culture and enlivened by reversing the directionality of study (from objects to persons) to emphasize the human activity that puts these objects to work and play.

In light of this growing literature, the most extraordinary thing about this panel is the distance it maintains from its subjects. Far from being a conversation about contemporary art and religion—or even about the activity of theorizing contemporary art and religion—it is instead a conversation that illuminates a chasm between the assembly and the object of study. While the panel purports to represent relations among contemporary art and religions, its most insistent voices offer a fairly insular and rarefied conversation, expressing an elite discourse of the (historically constructed) Western fine arts and an equally limited (historically constructed) Western notion of religion. The presumptive definitions of "religion" and "art" here are as outmoded as the secularization thesis of modernity upon which several participants depend for the evolutionary trajectories they endorse.

Though interesting as an artifact of modern academic engagement, this particular conversation, on these particular terms, is also, sadly, irrelevant if the goal is to study relations among contemporary arts and religions and to persuasively theorize these relations. While much of the discussion is theoretical, this is theory divorced from the study of contemporary practice: hermetically sealed, unable to enter into conversation about actual arts and practiced religions. Several voices on the panel attempt to interject other terms and to engage what's missing, but these strands are not pursued and ultimately they read as tangential to the larger conversation.

An alternative approach would be to start with contemporary art(s), to examine together those objects and performances that seem to various audiences (artists, critics, historians, practitioners of religions) to represent religious experiences, practices, beliefs, or communities—and then to explore the ways that content is articulated, interpreted, and enacted within these parameters. On the foundation of this exploration, scholars might then theorize the activities, behaviors, and objects observed.

I am not suggesting that we dispense with theory (that would be an unhappy and impossible task), but rather that we shape more compelling theories based on the study of visual practice. My interest lies in theory from the bottom up rather than the top down, in growing theory in conversation with a set of experiences in time.

Theory works when engaged with history and practice. Theory is also a production of its own historical moment; it is itself a practice

in time. Meta-discourse is not necessarily more intelligent or refined or useful than micro-discourse. Both theory and history count—and both are accountable to a degree of "match" with experience and practice. Beyond this, theory has its own politics as well as its own histories. The practice of theory sometimes obscures, or even obliterates, other histories and other polities. Renée Ater has observed a curious coincidence in this regard: the discipline of art history became obsessed with theory (to the virtual exclusion of history) at just the moment when long excluded histories began to gain scholarly traction in the academy.

The panel discussion transcribed here suggests to me that the "current disarray in theorizing on the subject of contemporary art and religion" reveals considerable hesitation to embrace the relatively recent scholarly dismantling of secularization ideology. Massively influential, especially in the academy, the secularization thesis charted the sure demise of religion in company with the rise of modernity. In the last fifteen years, however, most academic disciplines have debunked this paradigm for its singularly inaccurate predictions about human culture. Far from vanishing, religion remains a powerful agent in the most "modern" of Western cultures. In the United States, as Tracy Fessenden has demonstrated, even secularism took shape in specifically Protestant ways—and the same can be said of American versions of modernism.

This makes all the more surprising the disinclination of historians and critics of contemporary Western fine arts to meaningfully engage in the study of these relations. For some involved in this conversation, and for some who decline to be involved, it would appear that devotees at the altar of art can tolerate no competing gods. While some critics and theorists may consider relations between contemporary art and religion to be "undesirable and anachronistic," the pervasiveness of those relations in artistic practice would suggest that it is rather the position of these theorists and critics that is the anachronism. With respect to religion, a kind of enchantment continues in parts of the academy where some scholars seem to believe that if they pretend religion doesn't exist, it will disappear. Academic fantasy of this sort almost always takes place in deliberate imaginary opposition to a stereotype of conservative, usually Christian, religio-political expression. But religions differ, and denominations differ,

just as arts and visual cultures differ, such that each constituent as well as each set of relations is a complex affair, ill-served by over-simplified generalizations.

It is a curious reversal that some who would dismiss religion for its "moralisms," themselves adopt a moralistic perspective about religion. Their presumption is not simply that contemporary fine art does not have anything to do with religion, but that it *should not* do so. It is sheer isolationist fantasy to assume that academics and critics can keep religion and art apart if they just will it to be so, that scholars can function as gate-keepers, policing the practices of arts and religions. Perhaps this model appeals for its elegance and its authority, but it is also irresponsible to imagine that the experience of much of the world's population counts for little in the ivory tower.

Scholarly inquiry ideally concerns the full range of human experiences, emotions, sensations, practices, thoughts, and inclinations. The course of this panel places severe constraints on that view when it minimizes attention to the visual cultures of lived religions. Happily, the panel is not representative of art history, theory, and criticism as practiced by many in the contemporary academy and culture. Rising generations of scholars, in art history and religious studies as well as other disciplines, have embraced the study of visual culture. New conversations, recognizing that contemporary art and religion are deeply implicated in each other—and that, even in the West, religion cannot be neatly separated from other aspects of a person's or a community's life-worlds—have taken shape over the last two decades. These are ongoing conversations of many voices and multiple disciplines. They acknowledge many geographies and localities, many forms of visual culture, and many religions. This present volume helps to chart good work to be accomplished.

James Panero
Overcoming Our "Post-Enlightenment Prejudice"

Like the sorcerer's apprentice, once again James Elkins has cooked up a fascinating discussion—fascinating especially for me, because I have an interest in some of the more "spiritual" moments in modern art: Tonalism in the United States and Symbolism and early abstraction in Europe. Part of my interest comes out of what I believe to

be an historical un-willingness, a discomfort, and even an embar-
rassment, to consider the issues of spirituality and religion in art.
Rodolphe Rapetti addresses this phenomenon in his recent book
Symbolism, and I discussed it further in an essay I wrote for *The New
Criterion* ("The Secret History of Art," December 2006).

So I was not surprised to find some of this same "post-
Enlightenment prejudice" (to borrow a phrase used by Thierry de
Duve) in the panel discussion. Many of the panelists have certainly
never been challenged on their assumptions of this topic. I would
even say they at times lacked the vocabulary and the knowledge to
consider it properly. Tomoko Masuzawa locates the "birth date" of
spirituality in the 1970s. This would be news to Emanuel Sweden-
borg. De Duve says that the Christian religion "harmed the cause
of women and especially women artists tremendously." Really? The
early Christian church held a great attraction for women, who were
excluded from mystery religions like the Cult of Mithras but could
have equal access to Christ. Wendy Doniger divides her world
between Enlightenment thinkers and people who "blow up abortion
clinics," then goes on to say, unchallenged, "that the study of religion,
which is the Enlightenment, the modernist movement, presumes
that the people doing the study do not believe in god."

De Duve and Boris Groys also seem to represent two national
traditions on this subject without the burden of self-awareness. Groys
praises the confluence of art and religion even where it does not exist.
He calls the propaganda videos taken by Palestinian terrorists "great
art" and complains that both his Israeli and Palestinian audiences
don't agree. Of course, to identify videos of murder as "art" is repre-
hensible and also false, and I was pleased to see de Duve take him to
task for it. Groys epitomizes the excesses of German idealism. He
reminds me of Benjamin's famous final lines from "The Work of
Art in the Age of Mechanical Reproduction," where Benjamin
says that Fascism "expects war to supply the artistic gratification of a
sense perception that has been changed by technology. . . . This is the
situation of politics when Fascism is rendering aesthetic."

But then we have to consider de Duve's hostility to religion,
which is absolute, unquestioned, and so totally French (strange for
a Belgian, no?). How else to explain his hyper-reaction to Andres
Serrano: "I have hated the work from the very first time I saw the

images, because I recognize the Christian who wants to convert me"? Or that "Public displays of affect[tion] are embarrassing, especially in regard to artworks. . . . I feel I am hostage to someone else's belief system"? Or that the Matisse of Vence was a "non-believer" (which is not true)? Or finally his haut disdain for Gregg Bordowitz's impassioned defense of his artistic practice: "Pardon me, Gregg, for not joining the applause. . . . What you said about art was tantamount to the foundation of a new religion, and I am a bit wary of that"? Regarding the non-English speaking people of Europe, I have often felt that the two poles of political thought always boil down to Fascism and Socialism. The extreme statements of Groys and de Duve have not proven me otherwise.

Which is why I was so pleased to hear from Gregg Bordowitz, a practicing artist whose statements clearly resonated with his (I would imagine) artist audience. Bordowitz says that, "the job of art is to return the viewer to herself or himself estranged—feeling strange and feeling the work as a strange unfamiliar place. This is an inherited modernist ideal. I accept it." (This is what received the applause.) Bordowitz then proceeds to say something that gets to the heart of the matter: "I feel trapped by antimonies: to believe or not to believe. To endorse or reject." It is within this framework that I believe we can locate Western art from the nineteenth century on—not as a dialectical extreme (religion in art: yes or no), but as a dynamic conversation "to endorse or reject." Bordowitz is right to see the story of Moses and Aron as a parable of art in our times.

James Elkins properly identifies the development of abstract art under Kandinsky as "religious." Kandinsky was directly influenced by the spiritualist practices of theosophy. For evidence, just compare the illustrations of the theosophical book "Thought-Forms" with Kandinsky's early abstract work. And the Symbolists who preceded Kandinsky were also deeply "spiritual," drawing on everything from Swedenborgianism to Rosicrucianism to even arch-Catholicism. Then, sometime in the early twentieth century, a distaste for religion in art arose so that the spiritual discourse that once surrounded abstraction and even gave rise to much of modern art was removed from further consideration. "Kandinsky's work can appear quaint in light of what follows," writes David Morgan. Very true, but that does not mean art history should ignore its origins.

My hope is that this discussion, for however much it plays to party lines, will nevertheless open up new fields of inquiry into this "embarrassing" topic of religion in art.

William Dyrness

Response to Colloquium on Religion in Modern Art

The child wonders at the Christmas Tree:
Let him continue in the spirit of wonder.
 T. S. Eliot

Members of the school of faith and the party of art seem unable to communicate. How has this come about? It is hard to pinpoint the blame for this breach, though all sides, surely, bear some responsibility.

For my part, I have to lament the fact that religious communities in general, and religious leaders in particular, for much of the twentieth century, have been unconcerned with or actively hostile to developments in the visual arts since Impressionism. Indifferent in that, while they might actually applaud these modern styles, they see no reason why they should have anything to do with their own church communities. Alfred Barr is a case in point here. Hostile in that these developments have often been perceived as threatening to religious belief and practice. G. K. Chesterton may stand for this point of view. How sad that heirs of traditions that for centuries produced great works of art, should insist on declaring the gulf between art and faith unbridgeable in the contemporary period.

The relevant fact here, however, is how drastically these attitudes are changing. Pope John Paul II in 1999, while acknowledging the gulf that has intervened between these worlds, famously called for artists to pursue their creative vocation, noting: "Even in situations where culture and the Church are far apart, art remains a kind of bridge to religious experience." Even Protestant churches, traditionally hostile to the visual arts, are increasingly supporting artists and embracing the diversity of contemporary artistic expression. Secular artists raised in religious traditions, even when they are no longer believers, are enriching the modern vocabulary by exploring the imagery of their religious heritage. Although this does not always find reference in current reviews of art, it impacts increasing numbers

of people. Surely this should be of interest to art scholars and critics whose work it is to reflect on developments in the arts.

But this touches on a corresponding, and equally disturbing reluctance, on the part of art professionals, to address religious issues openly. Answering to the indifference and hostility of religious communities has been an equally fierce and insistent antipathy toward religion on the part of the art world. As James Elkins notes in the colloquium: the "virus of the fear of the religious is virulent and contagious." To be sure, this is not limited to the world of contemporary art—the prejudice characterizes much of the academic world, where there is an endemic incapacity to recognize the intellectual achievement of religious scholars and writers. In both sectors there is an unwillingness to acknowledge that religious people can be as intelligent and articulate as their secular colleagues—or, more to the point, that they might produce art that is just as worthy.

Without too much exaggeration, even the participants in the discussion hinted at the presence, among art professionals, of an almost papal power to declare what is in or out of bounds, complete with its own "theology" and ordained hierarchy. Even if many (indeed most) contemporary artists and critics have chosen to live in a world that does not need God, it would seem perverse to stipulate that art can *only* exist in this recently discovered territory. Surely the cost of preserving the autonomy (and freedom) of art is too high if it means excluding, a priori, the burgeoning contemporary interest in the spiritual in art, and, along the way, discounting (in the literal sense) most of the history of Western art.

Art and faith both strain at the boundaries in which they are placed. They slip out of our grasp because they both deal in wonder. Maybe our conversation ought at least to remember this fact, and acknowledge that both are, ultimately, not within our control. That would be a start. All sides, it would seem, have much to gain from such humility.

Ena Giurescu Heller

From the Trenches of the Museum of Biblical Art

I have been in the hard-to-define field of art and religion (wait, is it a field?) for ten years, and one thing that has been a constant is the

need for disclaimers. If you are a museum that shows religious art, like we are, you need to explain first what you're not, before you can properly define yourself. So, true to form, I start with a disclaimer: I am not a specialist in contemporary art, nor do I navigate comfortably the field of theory. So my perspective is quite different from most of the seminar's participants: from where I sit (a New York City Museum of Biblical Art director's chair), theory can be rather divorced from the day-to-day reality of the galleries. There, we are confronted with a general public and a press who recoil when presented with anything even remotely related to religion, faith, and the Bible, and on the other hand, with artists or would-be artists who think their works belong in the museum precisely because they come from a place of faith. Two quotes from our visitor surveys will suffice to illustrate the range of perception, from: ". . . what kept me from visiting in years past was a vague sense that the museum was a 'storefront' for Protestant fundamentalism," to: "I feel that the truth of Christianity is not well displayed here." Clearly, we are either too religious or not inspirational enough. I thus react to the transcript from my daily experience of navigating that reality, and trying to make sense of that divide.

My first thought upon reading the transcript was that it is an accurate rendition of the minefield that "art and religion," and particularly "contemporary art and religion," represent. Nobody can agree on anything, everything is contested, and one cannot please everybody—or, more to the point, one is sure to offend at least somebody. And yet, much of the conversation seemed remote from the reality of religion in contemporary art. The informal presentation concealed a rather sophisticated and highly theoretical conversation: and while fascinating to academics and useful from a strictly theoretical point of view, I felt it hovered above, rather than plunging into, the reality in the trenches.

The discussion, while moving deftly between various theoretical approaches, tried very hard to stay away from any definitions implying or accepting a system of belief. And yet, when one looks at contemporary art that comments on the religious (whether endorsing it, reacting against it, making it the object of a polemic, etc.), it is always almost informed by a system of beliefs. After all, the artists in question either embrace it or attack its taboos. Like David Morgan, I

would have liked to see the conversation go in the direction of apply-ing a discussion of belief and religious practice to specific artistic examples. And I would suggest taking it one step further. David's point about visual culture's slight advantage over the fine arts in the process of engagement (through a practice-centered approach, instead of the traditional art historical object-centered approach) is well taken. I believe it would serve us all rather well to envision using this approach always when exploring art and religion together. Whether we are talking about contemporary or older art, the artwork (imbued with, or expressive of, a religious dimension) is always best understood (and here I suggest should be studied as) a combination of intent, function, and the (material) work itself. The latter has always been the valid object of analysis. It is the other two that often lack in the art historical approach to contemporary art. The intent, as I see it, has to do with the religious notion or feeling or practice that is behind the object (is it an expression of belief? Is it its denial? Can it be used in a ritual/performance?, etc.). The function is three-fold, as it relates concomitantly to the maker/creator, to the ceremony or ritual itself, and to the beholder. They can be one and the same, or they can vary greatly. I don't believe that all of us at the beginning of the twenty-first century react uniformly (i.e., with great skepticism, as indicated by a number of seminar participants) to art that dialogues with our religious traditions. The reality is much more complex, and applying this tripartite approach (much like we do, uncontested, for older art) would help sift through it. It is what we have set out to do at MOBIA, and, in the spirit of this transcript, our own conversation is ongoing and often heated, and the jury is still out as to whether we have any chance to succeed.

Some of the metaphors discussed in the seminar help greatly the process of analyzing intent and function. I am most intrigued by the "camouflage of religion," as I have often encountered it as a stratagem that artists today use to protect them from being labeled "religious," or, worse still, "Christian." In that case, it is not so much presenting religious ideas as non-religious ones (Jim's "unconscious religion"), but rather conscious camouflage, hiding the real meaning that would give an inkling of what the artist's beliefs are. I have heard this from artists who are practicing Christians but acknowledge that professing their faith through their art, or even intimating that faith has a role in

their creative process, would harm their standing in the community and their chances to be exhibited and/or reviewed. Against that background, Gregg Bordowitz's (encouraging) comment rebuffing the existence of a ban on religious art operating in the contemporary art world brings up another question: if there is no ban, then why is there so little religious art today (and here I exclude the many "artists" who create art as an expression of faith, i.e., whose primary impulse is their faith, not their creative energy or search. I am thus only speaking about art visible in the contemporary art market, made by professional artists)? Is it simply because artists are no longer interested in exploring those realms? Have the realms of faith and symbolism and their history and potential modern interpretation(s) completely lost their appeal and their capacity to stir artistic energy and lead to creativity and innovation? In other words, is the long and powerful Judeo-Christian artistic tradition tired? Judging by the preeminence, within the body of contemporary works that tackle that world, of works that are at least controversial, or can be characterized, to use Boris Groys' term, as blasphemies—and I fully agree with Boris that blasphemy can be a religious act—the answer seems to be yes. So perhaps what's needed is a jolt to our contemporary artistic imagination, whereby the legacy of religious art, iconography, and symbolism can become one (valid) tradition to be taken into account and translated into twenty-first-century language. For that to happen, however, we would have to rid ourselves of the baggage associated with "religious," "religion," and particularly "religiosity." Judging by my experience in the trenches and, more to the point, by the very transcript I am commenting on, that would be very difficult indeed.

Daniel A. Siedell

Beyond "Religion" and "Spirituality":
Liturgical and Sacramental Presence in Contemporary Art

I am not a religious man but I cannot help seeing every problem from a religious point of view.
Wittgenstein

Modernity freed art from service to religion. Or so critics and historians have vehemently asserted. But religion did not go away. In fact, it

has haunted modern art. Artists have, in various ways and to varying degrees, felt this presence, to which their constant use of and reference to religious imagery and language to describe their work testifies. But critics and historians have insisted on whistling in the dark, as panelist Thierry de Duve says optimistically that we have only just begun to "live without God." Such optimism in the Enlightenment secular project, of which modernist art is merely a part, appears now to be a quaint, even reactionary relic of the failed utopian project of modernist art criticism, which could only be achieved by a heroic act of reduction, chopping down both "art" and "religion" to fit the Procrustean Bed of Enlightenment secularism.

But artistic practice has continued to be a stubborn victim, refusing to submit to such violent reductive purposes, defying the strict parameters imposed on "art" and "religion" by modernist critics. As panelist Gregg Bordowitz stated, "I can't imagine the two discourses standing apart" (p. 147), and then, "I'm an artist and I take issue with the contention that there is some kind of ban on religious art. I do not see that operating in the contemporary art world" (p. 151). But modernist art criticism, as defended by de Duve, wants to see it otherwise, hence the dubious distinction he draws between "faith" and "belief," the latter is passive, something you are "born into" (apparently like religion), while the former is an "act" (a secularized Kierkegaard?) and not inherently religious, although it is, to his mind, ethical (pp. 131–32). But with Tomoko Masuzawa, I am skeptical of de Duve's "reduction of religion and belief" (pp. 132–33), which misconstrues religion as merely a sum total of inherited dogmas and doctrines to which one gives intellectual assent predicated only on the accidents of birth. De Duve and his fellow modernist art critics, as the grandchildren of the Enlightenment, consistently misconstrue religion and the nature of belief. As David Morgan aptly observes, "we will never get anywhere studying the relation of art and religion if we don't work with a more robust view of what belief is in practice—which means what believers actually do, not what intellectuals think they *ought* to do" (p. 168). However, de Duve and modernist art critics do not want any relationship between art and religion. Morgan's suggestion that religion and belief have to be understood *in practice* is certainly right. "Religion" is not merely the sum total of dogmas or doctrines to which intellectual assent is given,

as if belief or disbelief in God is the sum total of one's interior "thoughts," but are a complex network of practices and disciplines; it is a comprehensive way of ordering one's life. This is in part why religion does not do what de Duve and his Enlightenment ancestors crave, and just go away. It is certainly not as clunky, monolithic, and oppressive as represented by modernist criticism and it cannot be dismissed simply by a pithy turn of philosophical phrase. Religion is, in fact, a remarkably flexible set of practices that adapt to shifting contexts, frameworks, and ideas. De Duve operates with a caricature of religion derived almost unaltered by the Enlightenment polemicists. But viewed as a set of practices, not something someone "inherits" uncritically, religion and belief begin to find some common ground with certain aspects of contemporary artistic practice, particularly installation art, as Boris Groys rightly and insightfully observed (p. 164). And so Bryan Markovitz is surely right to suggest, "ritual and art share a great deal of unexplored territory. . . . I believe there are many aspects of religious experience that art practice serves in secular culture" (p. 138).

The reductive nature of modernist art criticism is an attempt to deny the presence of this "unexplored territory" and the vehemence with which art's "purity" is advanced, including the Greenbergian tendency to treat as "cant" what artists say about their art, which masks an anal fear of contamination by the messy, smelly Other, religion. But things change if contemporary art is regarded as itself a complex network of practices, like religion, with complex sets of beliefs, rituals, and practices, which are the material means by which meaning and significance are achieved. There is what could be called a sacramental and liturgical presence in contemporary art, in which artists explore the potential of banal materials and gestures, in defined spaces, to embody and serve as a vehicle for profound meaning and experience. The liturgical dimension of contemporary artistic practice, which incorporates and re-performs the power of sacred space, ritualized gestures, and sacramental objects that testify to what philosopher William Desmond calls, the "porosity of being," which requires more expansive and richly-nuanced notions of both "art" and "religion" than those offered by modernist critics. Against the protests of both modernist art critics and religious fundamentalists, contemporary artistic practice could very well play an important role

in enriching both artistic and religious practice which the current cultural context desperately needs. In the final analysis, religion does not "haunt" art because it has yet to be fully exorcized, but because it not dead but is indeed a vital, living presence.

Robin M. Jensen

Looking for Art Inside the God Box

My position as a professor of the history of Christian art and worship in a university divinity school presumes both a historical and contemporary relationship between religious practice and art. When this newly funded chair was announced at my home institution, faculty in other departments of the university were slightly dismayed, and some members of the Art and Art History Department later admitted to me that they did not understand the need for such a position. I was not surprised by this ambivalence, because I recognized it as part of a larger, general discomfort with the study of religion in an academic context, especially if pursued by adherents to one of the traditions. What I have experienced since my arrival, however, has been at worst tolerance and often open-minded welcome and even appreciation. Reading through the statements by the panelists in this transcript, however, saddens me since they indicate a kind of compartmentalization of art, religion, and the academy that appear almost unbridgeable.

As I read, I recognized an all-too familiar prejudice against religion (particularly Christianity) that I encounter among academics who hold the post-enlightenment view that religious belief is essentially primitive and irrational. Believers are thus presented as fanatics or fundamentalists, unaffected by reasonable arguments. Such characterization exhibits a kind of simplistic and unsophisticated understanding of the complex of beliefs, values, practices, and conceptions that make up what we might call religion. For example, one of the panelists insisted that in Christianity "God *has* to be a he"—a claim which not only revealed his lack of knowledge, but a perception that there was little one would want to know. Such a judgment allowed this same panelist to sweepingly dismiss the "idea of God" as a mere "crutch" a little later in the conversation. Thoughtful people undoubtedly disagree about whether human beings still need or can

learn to "live without God or gods," but I had expected a more learned or nuanced discussion of the intersections between the spiritual and the religious, and some acknowledgment that theologians might be mentally competent members of the intellectual community.

To be fair, as I read I also encountered statements from other members of the seminar that demonstrated some luminous thinking on the relationship between art and religion, even though they confessed that doing so was "painful." For example, I was heartened by Gregg Bordowitz's call to resist further polarization between secular and religious aesthetics, even as he admits that religion makes people anxious—a response that is made quite obvious in this transcript. Of course, one wants to point out that religion also makes other people hopeful, and gives their lives purpose, and meaning. But these folks, one suspects, were not really in the purview of this conversation.

I *was* particularly struck by Jim Elkins' statement that his own involvement with this issue arose when he perceived that art students wanted, or needed "serious instruction on religious issues in their art." No one seemed to pick up on that statement—at least to ask Jim what he meant by it. Quite a bit later he returns to this topic, assessing the conversation thus far as a "pessimistic message for those artists here today, who feel themselves to be religious, and want to create religious art." They would, he claims, have concluded it necessary to "find a source of doubt, become an unbeliever" to make art. Bordowitz responded to Elkins with what I thought was a powerful statement of the essential problem: "What happens when passion and enthusiasm arise during [art] school sponsored critiques? Often the very enjoyment of a work, or a concept, is immediately flagged as suspicious. At best, enthusiasm is viewed as self-delusion. At worst it's criticized as mindless and therefore dangerous." He notes that such critique often is meant to kill the object and then move, murderously, to the next poor victim. That sad image was somehow instantiated by the plaintive statement of the young self-identified "active Protestant Christian artist" in the audience (Kimmy Noonan), who said that she often had to deal with the hostility between religion and art. In her view, artists are called to expose the plight of the perishing and oppressed in our secular, self-absorbed society. She concluded that "religion and art can mix if only the focus of the

religious artists appears legitimate to the people of the world" and that legitimacy is not established by separating from or transcending religion, but by telling the truth.

Perhaps that last statement was received by Elkins as an optimistic answer to his query—and I wonder if it might have been pursued if there had been time enough. I would like to think so, and I hope that Kimmy Noonan's work is not dismissed merely because she is a Christian or because she thinks that "all truth is God's truth."

A few days after I finished reading this transcript, I viewed the traveling exhibition, "The Société Anonyme: Modernism for America" at a local museum (the Frist Center for the Visual Arts). This collection, made up of some of the most important European and American works of the mid-twentieth century, is filled with works that are self-consciously spiritual, if not religious. Katherine Dreier along with Marcel Duchamp and Man Ray were referenced throughout the exhibition as having been profoundly concerned with the immaterial, divine, or transcendental dimensions of art. One might suspect the Art Seminar had something of this in mind in raising the topic "re-enchantment." However, from the outset, I think, that concept was largely dismissed as bourgeois, dated, and possibly even kitschy by many of the panelists. And since no one wants to be the one who came to the party wearing last year's designer outfit, it doesn't surprise me that the subject almost never re-emerged in the conversation. Still, I find the fact that the question could even be raised at the high table (e.g., the School of the Art Institute of Chicago) a sign of life—if not hope—for those of us who disagree with the statement that contemporary art simply cannot "do religion."

Diane Apostolos-Cappadona
Ithaka Has Given You the Beautiful Voyage

Reading over the edited text of what must have been an intriguing series of discussions on the *Re-Enchantment* themes of "the inclusion, or rejection, or place of religion or spirituality in contemporary art," I am struck by the uncomfortable—at least for me—reality that something is clearly missing. As I read through the pages of theoretical and historical analyses of the transformation of religion into the more

modern concept of spirituality, and the evolution of both contemporary art and art theory, I recognize that the German Romantic poet, Rainer Maria Rilke, is right when he waxed poetically that the archaic head of Apollo is a work of art that speaks out clearly saying to she who is prepared to listen, "You must change your life."

It is exactly that evocative and vocative power of art that is missing from the content, context, and conversations of this latest installment of the Art Seminar. Reading these edited transcripts is akin, I recognized, to the distanced ability to analyze and discuss art, or religion, without any personal or primal experience. As a reader, I am not able to see the faces or "read" the body language of the participants, either on the panel or in the audience. Such a distancing may allow for a more intellectual reflection on the "what" that is being discussed but, for me, the why and the how of the discussants is more important. So my individualized silent reading is the proverbial "horse of another color" toward my experiencing of the pattern of both the discussions and the mosaic that has resulted from the comments of the varied speakers. It is something like looking at works of art in a book but never seeing them live, never really knowing the truth of the colors, or never moving with the flow of the forms.

The absence of the experiential dimension of art, like its religious parallel of belief without faith or doubt, is a significant lacuna. While the theoretical and historical commentaries which the varied discussants engaged in are interesting, and often helpful, in recognizing how others see the interconnections between art and religion, there were clearly moments I wanted to scream out—ironically, as I was reading silently—"Stop all the blather and get to the heart of the matter!" The traditional categories of religion and spirituality, and of high art and low art (or fine art and popular art), are interwoven in these conversations with the newly recognized academic categories of popular culture, material culture, and visual culture. That, however, is the problem—the overtly academic nature of it all. The pulsating quality of religious or artistic experience seems to be sadly absent except for some insightful audience comments.

While the reality may be that discussion of either those nineteenth- and twentieth-century poets and philosophers, like Kierkegaard on Grünewald, Rilke on Cézanne and Rodin, Heidigger on Van Gogh, or Nabokov on Leonardo, may be deemed passé or

romantically subjective, the reality is that these creative minds were so engaged by the altogether different creations of painters and sculptors to the point where they were moved to respond—just as for example the heart and soul of an Augustine or a Merton was moved. As we walked one afternoon, deep in conversation, in his sculpture garden on the island of Shikoku, the Japanese-American sculptor Isamu Noguchi turned to me and said, "That is exactly what the experience of art should be—like falling in love *again* for the first time."

Difficult, perhaps better said amorphous, as it may be to discuss and define, especially in twenty-first century terms, the evocative and vocative power of art, and of religion, this crucial element cannot be left out of the equation as it makes the equation into "a whole." Knowledge without wisdom is an empty place filled with facts, not the inspiration that is Ithaka. As the poet Cavafys reminds us ". . . if you find her poor, Ithaka has not deceived you."

<div align="center">

Theodore Prescott

"Legislation is Helpless Against the Wild Prayer of Longing . . ."[49]

</div>

I enjoyed the intellectual mud wrestling in the seminar questioning the place of religion and spirituality in contemporary art. It was spirited, informative, and civil. But I wondered about the adjudicative principles, which at first seemed opaque and slippery. So I sought to identify referees, those characters and ideas that participants appealed to as authoritative. My first candidate for seminar referee is the Enlightenment, which was identified as both the source of art's disenchantment and religion's disestablishment. Few would dispute that, but it was intriguing how much the Enlightenment figured in the historical and conceptual discussions. Some participants apparently believe that the Enlightenment's engagement with religion was wholly beneficial. Thus, for Thierry de Duve, the separation of art and religion is not so much a problem to be discussed, as a position to be maintained.

I wonder to what degree the Enlightenment dictated how religion was understood in the seminar, and whether that might distort as much as illuminate. When Wendy Doniger asserts that the "idea that people who would argue that art is still religious should themselves

be religious people is . . . completely wrong," I agree. But when she goes on to note that people like Marx and Freud, "who hated religion" were instrumental in the rise of its study, I want to ask, "Gee, do you think their hatred might have skewered their studies?" And, "Would it be possible to have a theorist who *is* religious at the seminar?" Or, "*Were there* religiously oriented theorists in attendance who bracketed their convictions in deference to Enlightenment sensibilities?"

This response is not a condemnation of the Enlightenment per se. Tomoko Masuzawa's description of the rise of the category "religion" as a discourse during the Enlightenment is itself a wonderful fruit of enlightened thought. David Morgan's repeated emphasis that we examine what people *do* to "accurately characterize . . . behavior in order to study it constructively" is a good, self-limiting Enlightenment methodology. He then accurately identifies a primary conflict within the seminar as being between description and prescription, or "what people (believers) actually do" as opposed to "what intellectuals think they *ought* to do."

This leads to my main candidate for seminar referee. In the series preface James Elkins has two compelling tables, demonstrating the rise of art theory in art historical literature. They support his assertion that people who "have sometimes hoped that 'theory' would prove to be a passing fad" are going to be disappointed. I agree. It strikes me that art theory has a long lineage, far older than what is suggested by Elkins' tables. Evidently we will always have theorists with us, like the poor. Unlike the poor, theorists seem to have plenty to eat. If works of art are food for theorists, it seems obvious that something happens to those works as they are broken down and reconstituted by theoretical digestion.

It may be easy to read this as the whine of the artist, but my major concern here is not with the reception of art, since many people encounter art unaware of or unmoved by the idea that its significance is theoretically determined. My problem is with theory's teleological temptations. The older theorists I alluded to, such as Renaissance humanists, were quite clear in their beliefs about what art should do. They *knew* the purposes of art and were happy to project those ends into the future. When Enlightenment thinkers worked to discredit religious teleology, they were apparently unable to eliminate

the human teleological impulse. Thus the Enlightenment stance of description and interpretation may camouflage a powerful historicism. I don't doubt Elkins' sincerity when he identifies the disconnect between religion and art as a pressing problem. But I think for him the solution must be theoretically achieved. We hear something like this when he tells Morgan that Morgan's practices and interests are really dependent on discourses that originate in the academy. Given this view, unless the discourses change, all of the artists who *think* they might be making contemporary religious art of some kind are simply deluded, since their art does not conform to a theoretical canon of contemporaneity.

The only person on the panel who was avowedly religious was also the only person identified as an artist, Gregg Bordowitz. Interestingly, he contested the premise that contemporary art can't be religious. At one point, Bordowitz made an impassioned little speech about what he believed art could do. This elicited applause from the audience—the only applause mentioned in the transcript. What I heard in that applause was a hunger to move beyond the series of refusals that constitute beliefs about the meaning and the trajectory of modern and contemporary art. For someone like de Duve, it is imperative to maintain those beliefs, because they ensure ideological superiority and the perquisites of rhetorical power. The presence of so much religion at the gates of art, with such incontinent beliefs and irrational hopes for transcendence, is an affront to him—as well as an inconvenient truth.

My argument is not with theory or theorists. I have been engaged by my theoretical encounters here, and have learned from them. My argument is with the belief that theories legitimize art, reveal its meaning, and should discipline our perceptions. The best response to such totalizing belief is not more theory. It is art's wild prayer of longing.

Amy Sillman

Brief Notes

Enchantment may have waned, but even in our disenchanted state, we still come equipped with an imagination. For me, this conversation felt remote from this molten and generative function, from an

account of what might be called the experience of inner life. The discussion in the book didn't seem to encounter a practice that is more oozing and overlapping, more Kristevan, I suppose.

Any discussion of art and faith would have to account for the specific phenomenology of inner life, because both art and faith are marked by simultaneous leaps of faith and acts of doubt. These are acts performed by individual senses of imagination and ethics. Thierry de Duve makes this distinction between private and public on page 130, when he says, "you are not born into faith. Faith is an act, you make an act of faith. And I am convinced that the act of faith is not inherently a religious act at all. It is an ethical act." And Boris Groys arrives at the individual on page 137: "the problem is so much greater than the individual . . . but at the same time it is individual."

Inner life is marked by fluidity, confusion, polyvalence—Gregg Bordowitz gets at this when he compares art and religion as sharing roots in the psychoanalytic—the sensual and the conflictual. On page 123 he says: "Both religious practice and/or art-making proceed from a central conflict in the psyche between creation and negation." One could take Bordowitz's remarks about ego-creation and ego-shattering and apply them literally to an examination of the material procedures of studio practice, where the nuts and bolts of the day are to do exactly that: to figure out how to shatter, how to negate, question, and negotiate between conflictual states of mind and body. If the ins and outs of practice are not articulated clearly, a conversation of this nature can easily fall prey to cliché and easy polarities about both faith (or ethics) *and* form.

If I had been on the panel, I would have wanted to discuss the way *time* is experienced psychoanalytically, aesthetically, as something layered and non-chronological. Is the experience of time a way to get at the contemporary idea of enchantment?

I found it strange that the idea of *doubt* did not really raise its head until page 168, when David Morgan said, ". . . belief is not a sunny, naive disposition, untroubled by its own internal contradictions. We will never get anywhere studying the relations of art and religion if we don't work with a more robust view of what belief is in practice. . . ." To this I can only heartily agree and add that in the practice of art, doubt *is* belief.

Graham Howes

A European Critique

In very general terms, I think the project "works" in the sense that it is a debate in which, not unlike Plato's *Dialogues*, the reader feels intellectually and emotionally engaged. Mercifully, there's very little navel-gazing by any of the contributors (although some get close to it!), and there's a freshness, verbal coherence, and sheer articulacy that makes for compelling reading and a strong sense of reader participation.

Writing from Britain, you might expect me to say this, but there were times when the whole *artistic* frame of reference seemed suffocatingly ethnocentric, even parochial, i.e., within an almost exclusively North American frame of reference. Apart from occasional mention of, say, Kiefer or Beuys, it was almost as if European, Latin American, or even Australian contemporary artists were operating in a different cognitive as well as temporal time zone. They're clearly not, and many if not all the cultural and aesthetic predicaments raised in the discussion are ones that European readers (especially artists and cultural commentators) will clearly recognize, identify with, and even "own."

Similarly, with an historian's background, I would have welcomed a clearer and tighter historical frame of reference for "contemporary." Are we talking post-Renaissance, post-Enlightenment, post-Industrial, post-Modern, or what? Or is the presumption—which the reader is supposed to share—that the "contemporary" carries trace-elements of all of these? Similarly, the academic sociologist of religion in me would want more clarity and rigor in discussing secularization's precise Western trajectory, and also a stronger awareness among the panel that religion's most significant "contemporary" mutations are (a) towards fundamentalisms—Christian, Jewish, Muslim, etc. (indeed Martin Marty's major Fundamentalisms project emanates from Chicago!), and (b) a cultural shift from institutional religion towards "spirituality" (Bob Wuthnow's *Creative Spirituality: The Way of the Artist* documents its impact on artists themselves. *Both* mutations make the current ambivalences between art and religion (a central theme of the symposium) even more paradoxical, and meriting more sustained discussion than evidenced in the transcript.

In general terms, I thought the discussion picked up after lunch. Though I'm no philosopher, I confess I experienced a certain impatience with the lack of conceptual rigor and semantic subtlety which characterized the morning discussion of key terms; instead, too many banal vacuities and theological naivetés. Some good things in this first section too, of course—Thierry de Duve's and Gregg Bordowitz's contemplation of the rose really takes off, and Boris Groys' discussion of "digitalization," and its aesthetic consequences is very illuminating. But a weak discussion of ritual, and surely Bordowitz's discussion of belief in the most crudely reductionist, oddly psychoanalytical way ("the development of belief in the individual matter of sensations") would have disgraced any first-year student and should not—as here—have gone virtually unchallenged.

Samantha Baskind

"There is No There There": Commentary from a Pragmatic Scholar of Jewish American Art

In James Elkins' introduction to the day's conversation about "the inclusion, or rejection, or place of religion or spirituality in contemporary art," he noted that there were three subjects he hoped the roundtable would address. The first was the histories that brought the group together. This topic does not interest me so much as I am more concerned with where the study of religion in art is going rather than where it has been. The second issue of the day most interests me; Elkins aimed for the group to "look at the leading concepts that emerge from those histories—words like religion, spirituality, belief, enchantment, and any number of others." I see this second goal as paramount, for without an understanding of these terms a conversation about religion and contemporary art is too ambiguous to be fruitful. As such, when reading over the discussion transcript I found several questions that need to be clarified. In the interest of space I introduce only a few here: What religion(s) are we talking about (I ask because in the Western world the word religion is frequently a synonym for Christianity)? What is contemporary art: art produced currently, art produced since World War II, art made since 1960, or something else? And—are we dealing with only what is traditionally recognized as fine art or is material culture included in this broad

designation of contemporary art? The third goal of the day was to look at specific examples, which the group did do, but not in much depth and not across a spectrum of art-making practices and religions. Accordingly, in this brief assessment I offer some comments about the importance of elucidating the nomenclature at the heart of the day's discussion, and I will also introduce two contemporary Jewish American artists whose art conceptually and visually engages religion (one works abstractly and the other representationally) in diverse ways.

What I am trying to say is that there cannot be a single unified characterization of religion or spirituality, or even contemporary art, for that matter. A serious understanding of "the strange place of religion in contemporary art," to co-opt the title of Elkins' recent book, requires the development of new interpretative strategies, and even before that, definitions need to be made. To that end, this is the flaw that I see in an otherwise fascinating dialogue recorded in *Re-Enchantment*. Comprised of a group of scholars and artists discussing religion in art, or not in art, the *Re-Enchantment* discourse is much welcomed but it fails to provide answers because the basic terms have not been laid out. For example, religion for Jews is different than religion for Christians; Judaism encompasses conventional religious aspects (e.g., monotheism, sacred book), along with a strong ethnocultural element. Although not always related to God, the cultural aspects of Judaism are indeed a rich and pervasive component of the religion and need to be considered. Too, I was surprised that there was some generalization of "religion." How can one try to define religion in art without noting differences between Judaism, Buddhism, Hinduism, Islam, and Christianity, among other faiths? Similarly, the term spirituality is ambiguous. I again use Judaism as an example. "Spirituality" in Judaism, let alone other religions, means something different in various times and places—even in the "contemporary" period, a span of time of which I am still uncertain—and therefore needs to be historicized. For instance, the ways that American Jews perceive the spiritual has differed over the years, ranging from Mordechai Kaplan's Reconstructionist approach as outlined, for instance, in his magnum opus *Judaism as a Civilization* (1934), to the current JewBu phenomenon.

As to religion in contemporary art, which I label in this commentary as art from 1970 onward, I note a few examples to counter

Kajri Jain's assertion early on that "contemporary art just doesn't *do* religion." This is another generalization that mars the important discussion in this book. Because of space constraints, I restrict my comments to Archie Rand (1949–) and Tobi Kahn (1952–), Jewish American artists who make "fine art," for lack of a better term, that engages Judaism in its varying dimensions. Neither of these artists' work is kitschy, an aspersion Jain uses in reference to some images Elkins showed the group to which those of us writing assessments were not privy. The kind of Jewish art that I will refer to here appears to be out of Elkins' introductory context and also the framework of the conversation reprinted in this book. Again, the definition problem arises—would 13,000 square feet of murals for Congregation B'nai Yosef in Brooklyn (1974–77) by Rand not be considered contemporary religious art? More recently, Rand has also made several Jewishly motivated easel painting series. These include *Sixty Paintings from the Bible* (1992), loosely painted canvases that portray familiar stories from the Bible, rendered in colorful tones and with comic book bubbles that add a fresh and sometimes humorous perspective to the story at hand; *The Eighteen* (1998), wherein each canvas includes one of the Eighteen Benedictions (*Amidah*), part of the daily Jewish prayer service; and *The Nineteen Diaspora Paintings* (2002), images of biblical figures and text rendered in a pulp fiction style. Rand's work is accepted by the establishment, appearing in museums around the world, including the Metropolitan Museum of Art, the Museum of Modern Art, and the Victoria and Albert Museum.

Concerned with the relationship between his art and the sacred, painter and sculptor Kahn creates work in several media prompted by his Jewish heritage but in many cases broadly accessible to the spiritual needs of all peoples. He has made large-scale, abstract installations for both Jewish and non-Jewish organizations, including a non-denominational area for contemplation at New York City's HealthCare Chaplaincy Administrative Headquarters titled *Meditative Space* (2002). His signature Sky and Water paintings (begun in 1987), a series that conveys landscape through color rather than by representational means, evoke a sense of horizon and sky, and sometimes suggest other landscape elements like hills. These quiet landscapes remain ambiguous enough so that individuals can reach their own appreciation of what the canvas means,

thereby—ideally—achieving personal transcendence. Akin to Rand, the establishment accepts Kahn's art, which also appears in prestigious public collections, including the Museum of Fine Arts in Houston, the Neuberger Museum of Art, and the Solomon R. Guggenheim Museum.

Thierry de Duve argues that one has "to decide whether something is art or religion—I mean, a work of art or a religious artifact or both." Why do we have to decide this? De Duve gives readers the option of a work embodying both religion and art and that is the option I choose to apply to the art of Kahn and Rand (and I think that they would concur), as well as other contemporary Jewish American artists (e.g., Eleanor Antin, R. B. Kitaj). Moreover, neither Kahn nor Rand would argue that their art is a "religious artifact." Sure, the category "religious artifact" is an important one—and again a more explicit definition here would be helpful—but the term, it seems to me, signifies a ritual object, like a menorah in the Jewish religion or a cross in Christianity, not the sort of imagery I have presented in this assessment.

Kahn and Rand clearly work in the realm of religion in the contemporary period and yet each characterizes their approach to Judaism and *raison d'être* differently. Importantly, though, neither sees art as didactic, devotional, or affirming of God or specific rituals. This is why specificity is an imperative for the *Re-Enchantment* discussion. Although peers, American Jews, and fine artists, Kahn and Rand maintain a unique perspective—so how can different religions be classified under a single rubric? Nonetheless, despite diverse perceptions, each unequivocally terms his art as "Jewish." Kahn eloquently elucidates his inspiration and position:

> Since my consciousness, sensibility, and visual acuity all derive
> from a self that is profoundly Jewish, my art inevitably comes from
> that place. Which does not mean that I represent Jewish symbols
> or narratives in my paintings and sculpture. Recognizable Jewish
> symbols do not particularly engage me as an artist. Nevertheless, I
> consider my work, which is abstract and conceptual, profoundly
> Jewish. . . . Everything I see, touch, and make is imbued with my
> love of Judaism and the way it has shaped me. My interest in art as
> healing, in sacred spaces, in art's spiritual dimension, in the unique

individuality of work marked by the hand of the artist, are insepar-
able from my being a Jew.[50]

Too, Rand feels an internal imperative to make art inspired by
Judaism, but with dissimilar results. While Rand's imagery is more
obviously Jewish than Kahn's as he delineates themes from the
Hebrew Bible and Jewish ritual, Rand also does not create such
imagery because of a desire to participate in organized, faith-based
Judaism. While calling himself a "non-religious artist," Rand sees his
explicitly Jewish art as emerging from a desire to augment Jewish
culture not the sacred:

> I realized that one of the rights and obligations of any culture is to
> manifest a visual exponent of that culture. Judaism had been forced
> externally and internally to ignore that impulse. I wanted to make
> tangible artifacts that were Jewish, simply so unmistakably and
> unapologetically Jewish work would exist in the fine arts.[51]

I have presented Kahn and Rand as examples (and there are many
more) in an effort to demonstrate that contemporary art does *do*
religion, and that a theory of religion in contemporary art needs to
take a broader approach. In other words, although Judaism is a major
world religion it is only mentioned six times in the seminar—
barely—as opposed to forty-two notations of Christianity. That is to
say, religious art in the contemporary period is more than Andreas
Serrano's oft-cited *Piss Christ* or the recent, undeniably kitschy,
derivative, and controversial chocolate Jesus by Cosimo Cavallaro.
At the same time, such a theory also needs to be more specific and
even comparative: how does contemporary Jewish art differ from
contemporary Christian art, how does contemporary Buddhist art
compare to Jewish art, and even how does Jewish art compare to
Jewish art? No doubt, the permutations are many.

It seems to me that David Morgan provides the voice of reason
in this dizzying yet stimulating conversation; he tries to recontextual-
ize the art early on, noting that Elkins lifts art from its context in an
attempt to be clever. Being clever or sounding erudite is not more
important than understanding the art, and understanding the art
means defining the terms of discourse—hence my call for specificity.
Both of these goals certainly require theorization, and they also

require tangible examples and distinct nomenclature. Without those fundamentals, to quote Gertrude Stein, another notable Jewish artist, "there is no there there."[52]

Jens Baumgarten

Art and Religion Beyond . . .

The invitation to write an assessment about the very controversial and stimulating discussion means a great challenge and has also helped to focus my own approach: How can I write about contemporary art and religion, especially concerning its conceptualization; and how can I define the related positions of a critical New Art History and Visual Studies about popular visual piety in general? Or to ask myself critically: Where are my own blind spots?

My first impression, without entering into the concrete debate, has been that the proposed questions seemed rather problematic for theologians and contemporary art critics and less polemical for visual studies scholars or early modern art historians, because the last two groups are used to dealing with religion from an already distant perspective. But the discussions also revealed many of my own blind spots. Therefore, by connecting different blind spots, I would like to continue the conversation and propose four steps to go beyond the presented text.[53]

Modernity versus modernities

Can we talk about one modernity or about many modernities? The discussion developed amongst many other very stimulating topics and debates the question of an historical or ahistorical approach. There were some necessary affirmations concerning the importance of the variety of non-European aspects for the discussion about the question whether there is a ban, and a taboo of religious art in contemporary art critics or a ban on religion in contemporary art. But the debate focused primarily on the "usual suspects" in constructing a caesura for modern and modernist arts and theory: Kant and Hegel. It was impressive to read the reinforced idea of this main caesura that happened universally by the formulation of the aesthetic concepts by Kant and Hegel. There were two results—to exaggerate

polemically—that, first, all pre-enlightenment cultures were collect-
ive,[54] whereas post-enlightenment ones are individualized, and, sec-
ond, that there occurred therefore the creation of a very complex but
single or unique modernity.

Following exactly Kant and Hegel means that there would
remain very little space for a historical or discursive analysis, which
would place in question the universality of one single process of mod-
ernization. This wouldn't imply that there is one concept of modern-
ization and different speeds of progress, but there exist different
concepts and forms of modernizations and therefore of modern-
ities.[55] Therefore, I would like to raise the question whether it is
possible to talk about one particular form of modernity, or are there
other modernities, for example Iberian ones? This would also include
other non-European ones like those in Africa, India, China or Japan,
amongst others. The possibility is noteworthy since arguably the
Iberian and/or Latin American form of modernity,[56] with its affirm-
ations of archaic versus modern, is nearer the idea of enchant-
ment and its proximity to religion. This also refers to the problem/
non-setting of a complete distinction between subject and object or
private and public. With its absence of a clear distinction of subject
and object, the Latin America/Iberian world presents an alternative
idea of modernity.

The discussions apply its interpretation ex post-facto on earlier
periods to establish this caesura of the Enlightenment and its impli-
cations for the relation between art and religion. With the disen-
chantment and the shaping of autonomous spheres like religion and
art it seems to start the problem but also to commence the exit from
superstition and the establishment and validation of skepticism.

The emphasis in the discussion of the Enlightenment as caesura
for the further disenchantment and the respective presumptions of
art and religion can be seen as topos in describing the development of
the relations between the two. What differs seems to be only the
drawing of the political and therefore their connected theoretical
consequences. I don't want to analyze the cultural skepticism and
conservative content of certain concepts of Ortega y Gasset's writings,
yet it seems apparent that he developed other ideas of modernity, that
were influential not only to Heidegger, but especially for the concept
of another theory than the (central) European or Anglo-Saxon main

currents. Ortega's concept of a dehumanized art distinguished between an art for the masses and a modernist art for certain groups.[57] His "conservativism" recalls Hans Sedlmayr's later *Verlust der Mitte* (The Lost Center),[58] which proclaimed the loss of religious content since the sixteenth century with the Protestant Reformation and especially a de-sacralization of humanity since the French Revolution and therefore a distinction between art and society. This disenchanted art, in Sedlmayr's opinion, would no longer be rooted in a religious content and would lose its human center. Ortega would share the analysis of the two distinct spheres of art. Yet despite a certain cultural pessimism, he didn't share the negative implications of Sedlmayr's account. Instead, he saw in the modernist, elite art a pedagogic instrument to educate the masses. It was a surprise to read in some panelists' remarks the same affirmations about this intransigent distinction and opposition concerning the most recent methodological approaches. Perhaps it would be more helpful to understand the developments and the transgression around 1500 and 1800 in Europe, which would mean recognizing the historical complexity of different apparent paradoxes, such as the simultaneity of the un-simultaneousness or the survival or renaissance of enchantment in different modernities. I would like to ask what these circumscribed tendencies mean for a generally dichotomous approach and to develop some critical remarks under my fourth point below.

These different concepts of modernity can also be understood in their particular distinction between public and private. Their incomplete distinctions of different spheres were formed in Western Europe and North America rather than in Latin America. This incomplete formation of different spheres resulted, for example, in different developments of the discipline of art history and contributed, in contrast, to stabilizing the differentiations between deeply interrelated spheres of visual production that included religious imagery.

Religion beyond Western European Christianity

The discussion also focused on Western European Christianity and a very particular concept of Catholic and Protestant unity. Especially non-European communities in Asia, Africa and Latin America

developed different aspects of religion and spirituality and therefore also very distinct forms of visual piety. Hybrid forms of Christianity have created different and very creative solutions for representing religious topics beyond Western modernist questions of realism and abstraction. These different forms of spirituality are important to understand the "identity" constructions within modern and post-modern society. These religious systems are somewhat less uniform. The Catholicism in Latin America comprehends very different forms of religious and spiritual concepts that also include the idea of religion as a Western discursive object. But this also leads to the problem of its historicity as a question within the systems. Both systems (art and religions) are—analyzing their internal structures— less monolithic as it appears in the discussions.

The term "camouflage," used to understand why and how religious discourses enter the dis-enchanted spheres, can be regarded as a crucial point that leads to the general problem, whether we can interpret religion as concept, idea, or institution.

Art beyond the Western world

Besides mentioning the existence of a non-European art scene by quoting generic Indian arts, the discussion focused also on the main well-known modernist and contemporary artists from Europe or North America. The critics of contemporary art, of the avant-garde, concentrate their interest in the same manner that traditional art history is occupied with the Italian Renaissance of Rome and Florence with problems of Hegelian and Kantian aesthetic discourses and less with practice and agency. Kajri Jain demanded to address the ethnographic gaze on the West itself. Elaborating on her statement, I would like to ask, what could this mean to invert the gaze? In the given context she said further that private religious art exhibited in public is embarrassing; for her, the problem lies in the fact that the sacred is privatized. In the different traditions of Latin America described above I would like to emphasize the "otherness" of modernity and religious concepts, with their inherent differentials in the distinctions between private and public. Therefore feelings like shame and discomfort about expressing and communicating inner states would affect neither artists nor spectators in the way that it was

described in the discussions about European and North American contemporary arts. In the context of Latin America, magical realism—within modernist and contemporary art—constitutes one of the main movements for the continent. Especially the Latin American variety of the movement evinces different qualities of religious art. Another example from the Brazilian context is the painter and sculptor Hector Carybé,[59] who was born in Argentina, but established in Salvador de Bahia his art production, which is especially related to the culture of Candomblé, a syncretistic form of Catholicism and Afro-Brazilian religious cults.[60] His art, which is also shown in the main galleries and museums of Brazil, is rooted deeply in this hybrid variety and the local customs and their representations like Capoeira. One of his works can be found in the John F. Kennedy airport of New York; and the Bank of Bahia commissioned his series of 27 panels representing the African gods/Afro-Brazilian saints, the Orixás.[61]

Beyond dichotomies

David Morgan made an important statement that analysis and reflection have to deepen regarding different kinds of imagery when we talk about religious arts today. But there seems to be, among other participants, an underlying agreement about a dichotomous model between fine art and popular art. This appears highly problematic because it ignores the "blurred" boundaries between these two types; something that is widely accepted in relation to different genres of fine art, but is disregarded in relation to the variety of representations and their respective categories. The power of dichotomies seems to be overwhelming, as for example oppositions between believer and non-believer or religious and secular. Postmodern, post-colonial, and queer theories, quoted variously during the discussion, tried to challenge traditional methods and to establish approaches beyond dichotomies. Especially the post-colonial idea of transgression, and hybridisms, including concepts of discourse analysis based upon Foucault's models, help us to think and write about more complex and multi-interdependent conceptualizations.

As with the observation that art is conceptually dependent on discussions in universities for a century, it also seems clear that many

of the dichotomies are a result of historiographical discourses within the disciplines of aesthetics and art history. The discomfort in dealing with religion and contemporary art together lies within a historiographical "(suppressed) trauma." In this context I would like to return to an argument regarding the term and concept of modernity. Hans Sedlmayr championed anti-modernist thinking in his book, *The Lost Center*. As a conservative supporter of the Austro-fascist class state, Sedlmayr tried to reunite Catholic faith and contemporary art. He used a dichotomous argument to devalue contemporary art by confronting the "Gesamtkunstwerk" of the Gothic cathedral with the "Zerspaltung" (splitting up) of the arts in the modern and contemporary era.[62] Sedlmayr, deeply involved in Nazi politics before and during the war, later used the Nazi rhetoric of degeneracy to discredit modernist and especially abstract art.[63] This discussion was revived only recently when the Archbishop of Cologne, Cardinal Meisner, applied the same arguments and language to condemn Gerhard Richter's sketches for some window glass in Cologne's dome. The critical article of Gustav Seibt, published in the *Süddeutsche Zeitung*, refers to Sedlmayr's publication, emphasizing the brilliance of his analysis, but criticizing the problematic use of his arguments as normative guidelines.[64] It is therefore interesting, as I mentioned before, that Sedlmayr's separation of art and religion seems to be very similar to many statements in the discussion, such as the axiomatic claim that there could be no relation between the two spheres of contemporary art and religion.

Therefore, I would like to close my very associative comments with a proposal that, in my opinion, the main problem for a dialogue between contemporary art and religion consists of methodological and theoretical incoherences. In this context it would be interesting to comprehend the different systems of art and religion not only in a sociological way, but to establish a systematic meta-theoretical approach that could help to discern a methodology to understand better the different frictions, superimpositions, and contrasts between contemporary art and religion in a wider perspective. Aspects of practice and materiality particularly are still completely missing in the methodological approaches.

An approach via a meta-theoretical idea of visual systems could help to overcome dichotomies. Especially in the instance of

non-European Catholic societies with their sacred art, it could help to analyze the construction and efficiency of the formation of varying visual systems to understand the aesthetic and social transformations.[65] Perhaps it really could be challenging to put the question of contemporary art and religion in a wider context: to develop the idea of different systems, which can be artistic but not necessarily, that can comprehend the self-reflection of the modern and postmodern discourses, that includes the doubts and skepticism without reaffirming new universal values or essentialisms.

David Brown
How Real is the Conflict?

The morning session considered approaches to religion as a prolegomena to the afternoon discussion, which explored how religion might impinge on the practice of contemporary art. To someone like me who lives and works in Britain, the morning session appeared to reflect, to an extraordinarily high degree, the difference between American (and French) social structures and British. Both France and the United States insist on the separation of religion and education, whereas in Britain religious education is compulsory in schools and all major universities have theology departments where the conceptual and experiential side of religion is taken seriously and not just its phenomenology (as in departments of religious studies). That, I think, makes a big difference in a number of key ways. With the exception of analytic philosophy, which continues to be pursued without acknowledgment of the historical conditioning of thought, in almost all other arts subjects the Enlightenment model of knowledge is seen as a vain will-o'-the-wisp, with theology placed on a continuum of problematic issues rather than in a league quite of its own. In school, children are also encouraged to experience the worship of faiths other than their own, and so the practice of entering sympathetically into other belief systems without endorsement is a skill that ensures a less dogmatic approach than has characterized so much of American fundamentalist religion. The result has also been greater readiness to connect religion and art. Witness, for example, the hugely successful millennium exhibition in the National Gallery in London, with the accompanying TV series from the Director, Neil

MacGregor, who had no inhibitions about using the programs as a way of exhibiting not only the faith of the artists concerned but also his own beliefs as an Anglican.[66] Equally, cathedrals have become common venues for contemporary art exhibits, as with Yoko Ono at St Paul's, Bill Viola and Paula Rego at Durham, or, most recently, Tracey Emin at Liverpool.

None of these remarks is intended to lay claim to a natural superiority on this side of the Atlantic. The British approach also generates its own set of problems and tensions, but it perhaps helps to explain why I would see the issue rather differently from most of the contributors to the panel discussion. Thierry de Duve supported Marcel Gauchet's position (following Weber) that modern society is witnessing the inevitable disenchantment of the world and so the eventual disappearance of religion. For what it is worth, my own view would be that, although adherence to Christianity is undoubtedly declining in the West, religion simply takes new forms and that this shows itself in the arts generally as also in the visual arts more specifically.[67] Both Van Gogh and Mondrian, for example, continued to express religious convictions through their art even as they dispensed with the Christianity of their youth.[68] In the twentieth century, dance was almost wholly divorced from the practice of religion, yet spiritual issues continued to be seen as central by quite a number of choreographers.[69] Clearly, no one single factor is responsible for this situation. However, a key element surely lies in the low view of the contribution made by the arts to religious belief, a view that is shared, ironically, by both theologians and church leaders on the one side and by art historians on the other. The former tend to see the artist's role as simply illustrative of what is better known by other means, through Scripture, the pronouncements of the Church and so forth. For the latter, in any particular cultural context faith is a monolith and so content is seen as merely incidental to more interesting modern questions such as form, use of color, or whatever. But wide variations can exist even within a general shared framework, and so artists, I suggest, are often themselves to be found attempting to shape or advocate one particular avenue of approach over another. Of course sometimes it is their patron who has made the request. More commonly, we cannot know for certain. But I would hazard a guess that in the period when most artists were practicing Christians, part

of their intention was to engage the viewer in how they themselves appropriated a particular belief, and that meant making choices between one approach over another. Who, for example, should bow to whom in the Annunciation, how is the equality of the persons in the Trinity to be balanced over against their priority in matters of procession, are Resurrection and Ascension fundamentally the same event, and so on?[70]

Such issues have of course long since ceased to be intelligible to the typical artist or viewer. My point is that both art critic and religious believer will underestimate the potential contribution of art to religion or of religion to art for so long as this element is ignored, of open-ended exploration in the attempt to invite the viewer into an imaginative engagement with the Christian story. Thierry de Duve speaks of being made "hostage to someone else's belief system."[71] But the point is surely not that artworks ever force a particular perspective but rather that the artist (or rather the serious one) tries to entice the viewer gradually into the possibility of seeing matters this way rather than that. This helps explain why the great religious artist does not necessarily have to be a believer. Like the British school children I mentioned earlier, what he or she needs is rather the capacity to enter sympathetically into an alternative world, even if this world is not finally endorsed. To take an example mentioned in the panel discussion, the atheist Le Corbusier clearly made much more of an effort with the pilgrimage chapel at Ronchamp than he did with the monastery of La Tourette.[72]

None of this, though, should be taken to imply that, for a connection valuable to religion to be made, it must necessarily be a positive one. Francis Bacon used crucifixion imagery to speak not of salvation but of the meaninglessness of suffering. More recently, John Bellany and Douglas Gordon have both sought to challenge religious dogmatism through their art. The intention of all three was to undermine religion, yet for the believer that need not necessarily be their final impact. All three could be seen as offering important cautions against over-simplistic belief. So, for example, Douglas Gordon's 2006 complex installation that reversed Holbein's *Old and New Testaments* (1535) might actually be endorsed by many a contemporary Christian for exposing too relentlessly negative a view of Judaism in much Christian thought.[73]

It is very easy to set religion and art over against each other, in, for example, the narrow fundamentalism of modern Iran and the wonders of its medieval architecture at Isfahan. But of course it was the same religion that also produced those mosques. Indeed, the patterning of the buildings that gives them such aesthetic power is incomprehensible except in relation to the profound reverence Islam has for the words of the Qur'an, reflected in the quotations that help to make up that patterning. Religions usually have the historical resources to reinvent themselves. Modern Iran, so far from denying the more distant Zoroastrian history of that land, actually claims continuity with it in a monotheism willing to tolerate other religions, and so even the images of Ahura Mazda at Persepolis are endorsed with pride.[74] Again, the favored image of being drunk with God in their most popular poet, Hafiz (d. 1390) continues to provide a standing challenge to an alternative view on alcohol.

Human beings naturally prefer simple accounts of their world. But religion and art are complex phenomena, and it is those complexities that need to be engaged, not implausible absolutes on either side.

Insoo Cho

East Asian Perspectives

I view the Art Seminar *Re-Enchantment* in close relation to the earlier theme of the Art Seminar, *Is Art History Global?* To me, some arguments reveal the limitation of a Eurocentric or Judeo-Christian framework. In order to widen this narrow scope, the definition of art and religion should be expanded or altered. As it is discussed in the Seminar, "religion" as a Western discursive object is not naturally given but historically imagined and constructed. It is often difficult to find an equivalent term or concept for "religion" in the non-Western world. For example, in East Asia, institutionalized belief systems were called "teachings," as we see the term of "Three Teachings" that refers to Confucianism, Buddhism, and Daoism. The discrepancy also remains in the notions of primordial being, heaven, netherworld, ghosts, immortality, etc.

Recent historical experiences in East Asia during the late nineteenth and early twentieth centuries ascribe some of the traditional

teachings to religion and some others to philosophy or superstition. As a result, Buddhism is usually regarded as religion while Confucianism as philosophy in spite of its sophisticated rituals. Daoism is split into philosophical Daoism and religious Daoism based on the binary notion of reason and spirit. Generally, these East Asian thoughts are considered through a kind of academic lens, relying on scriptures and doctrines rather than practice and faith.

The definition of art also needs to be altered. It is well known that the Western concept of fine art excludes certain types of arts in the non-West. As a result, many objects produced and used for East Asian belief systems are not artworks but artifacts according to the Western standard. However, bronze vessels, jade ornaments, musical instruments, and ink rubbings consist of an important portion of artworks according to the East Asian taxonomy of art. Religious sculptural images are rarely categorized as art in pre-modern East Asia. For another example, ancestor portraiture, sacred images for Confucian ancestor worship, had not been a collectable item. As functional portraiture, an aesthetic response was not normally expected or considered appropriate. These images began to enjoy high esteem as paintings in the modern period. By contrast, wooden name tablets, which were much more important than pictorial images in the ancestor rite, are still not considered as artworks but are displayed in ethnographic museums due to their non-representational form. Therefore, as Aby Warburg gained a comparative understanding of paganism in Western civilization by examining the primitive cultures, we need to apply ethnological, and anthropological approaches to understand religious objects of the non-West.

In the modern period, the situation is more complicated. The modern understanding of East Asian "Teachings" has changed the traditional notion of them in order to meet the modern and Western religious view. It results in a distorted relation of contemporary art and East Asian religions. Zen Buddhism is a good example. Exported to the West, it adjusted itself to Western perspectives. Suzuki Taisetsu's popular books are mainly for Westerners who look for alternative thoughts. He introduced the taste of Zen with the admixture of humor, intransigence, and detachment. Interestingly, this Westernized Zen is re-imported to East Asia and has sometimes even replaced the original.

Korea-born video artist Nam June Paik opened his eyes on Zen Buddhism when he first met John Cage, who had already attended Suzuki's classes at Columbia University, in 1958. In 1962, Paik introduced *Zen for Film*, which screened an endless loop of unexposed film through the projector. The resulting image shows a surface illuminated by a bright light, occasionally altered by the trace of scratches and dust particles. As an analogy to John Cage, who included silence in his music, Paik uses the void of the image for his art. Another work, *Zen for Head*, consists of a Buddha statue gazing at his own meditative pose on a TV monitor. Since Paik, who left Korea when he was 17 years old, established most of his artistic career in Europe and America, he relied on Western sources to find Eastern reference for his works. Although he explored a new realm of video art, there is no truly religious moment in his Zen inspired works. He simply followed the stereotyped contrast between a Western superiority in a rational progress of the material world and an Eastern superiority in an intuitive approach to holistic spirituality.

Interestingly, Paik's pioneering use of Buddhist motives and imagery in contemporary art has been inherited by a later generation of Korean artists. Like Paik's case, these young Koreans, often educated in the West, are not so familiar with Buddhism, but visual representations of Buddhist motives permeate their works through various media. In Noh Sang-kyoon's series of sculptures *For the Worshippers*, Buddha wears not a monk's robe but rather an ornate, flashy one made of thousands of shiny sequins. Viewers are puzzled by the holy symbol of religious power with a mannequin-like body of commercial refinement. Atta Kim, in one of his photograph series *The Museum Project*, placed nudes enclosed by plexiglass boxes on an altar in a Buddhist monastery. Contrasted with Buddhist asceticism, the vulnerability of a human body placed in a sacred space seems to echo with emptiness. Choi Jung-Hwa, in his *Ladies and Gentlemen*, adopts kitschy devotional religious imagery to parody industrialized society and barren life.

Even though Buddhism has lost its prestigious status, it is still dynamic and possesses a capacity to move great numbers of people in Korea. I often wonder how Buddhist monks and lay Buddhists observe the use and abuse of Buddhist icons in contemporary art. I haven't heard any claim from Buddhists on those profane images. It

is not because Buddhism is more generous, patient, or inclusive but because it has a different attitude toward religious images. So far as I know, Buddhism never initiated iconoclasm against other religion. I think the more important reason why Buddhist motifs frequently appear in modern Korean art is because they display non-religious characters. These Buddhist motifs are received as cultural symbols associated with traditional and national values. By the way, Christian motifs are seldom used in contemporary Korean art even though the total Christian population is about 30 percent compared to 20 percent of Buddhists. Furthermore, if we pay attention to religious visual and material culture, the most active and popular religious images come from indigenous folk belief often called Shamanism. Some Korean artists insist that they turn the mundane into something essential and spiritual because they automatically share with Shamanistic attitudes consciously and unconsciously. Therefore, the Western perception of religion and art is not entirely relevant to East Asian cases. It is important to keep a global perspective and rethink the relationship between contemporary art and religion.

Cordula Grewe
A Godless World Will Do

The conversation in this volume focuses on the relationship between contemporary art and religion, its possibility or impossibility, impediments and opportunities. A question that was not raised explicitly, although several contributions touched upon it obliquely, is the fundamental: What is the purpose of "serious" contemporary religious art? In an essay on the history of the Western altarpiece, Johann Friedrich Overbeck has defined the purpose of ecclesiastical art as "aiding the devotion of the faithful, averting distraction as much as possible and concentrating thought/the mind exclusively on the subject of contemplation." He no longer sees contemporary art fulfilling this purpose. For him, an immanent conflict exists between religion and modern art because of the latter's self-assertive and self-referential character, which inevitably places the object's aesthetic qualities above its religious function. He defines this moment as the displacement of devotion by artifice and locates it—unlike most of the participants in this conversation—not in the Enlightenment, but

in the High Renaissance. Overbeck emphasizes that this rift between religion (and he talks here exclusively about Christianity, and even more specifically Catholicism) and modernity is aggravated by the advent of capitalism. In a capitalist market economy, value judgment is always driven by market value, by competing systems of taste rather than a unified religious need. His comments raise doubts whether artistic ritual can indeed, as Bryan Markovitz (pp. 138–39) suggests, prevent art from being entirely consumed by commodity culture. Overbeck's own career demonstrates that it is virtually impossible for the serious producer of ambitious high art to abstain from the modern market economy. But Overbeck leaves no doubt that the goal cannot be merely to produce religious art. Rather, the religious artist has to aim at converting the fabric of society itself. In this context, the painter emphasizes the need to resist the mobility of modern art. To develop a concrete meaning, religious art needs a determined place. Without such site-specificity, it loses its ability to be self-explicatory (and purposeful) and becomes incomprehensible.

Overbeck wrote 150 years ago, but his argument has lost none of its validity for our discussion of today's contemporary art.[75] His essay questions the value of art that defines itself as religious but is divorced from a devotional practice. It resists an amorphous complaint about the world's disenchantment; for him, re-enchantment is a concrete project defined by the teachings of the Catholic Church. This position poses a critical challenge to the current desire for serious religious contemporary art: What is its purpose in the refined world of galleries, celebrity culture, and art speculation? Positioning itself radically within an orthodox Catholic milieu, Overbeck's account also draws attention to the *specificity* of religion and therefore of the art that engages with it. The discussion of "religion" or "the religious" as undifferentiated umbrella terms seems problematic, as it covers up the fundamental differences between various religions, religious practices and belief systems. This, in turn, diverts our attention from the inherently political nature of religion.

"The representation of politics," Peter Weibel has reminded us, "is present in the politics of representation,"[76] and it is always so. This insight might help to explain the reaction of Thierry de Duve, when he encounters an artistically successful contemporary artwork that is explicit in its doctrinal Christian claim. De Duve experiences a

conflict between the aesthetic quality and religious content that is, I argue, inevitable. As a self-proclaimed child of the Enlightenment, he inevitably reacts to the implied socio-political consequences of such a work. If "religious" implies concrete doctrine (like transubstantiation or the Immaculate Conception) rather than some vaguely defined spiritual sensibility, the viewer has to take a stance, like Hercules at the crossroads. Tellingly, de Duve—whose brief comment on the distinction between religion and religiosity calls for further explication—relates more easily to religious art that is geographically or historically removed from his own life sphere. In both cases, the religious loses its socio-political immediacy, and can just be enjoyed with the aesthetic disinterest offered by the Kantian autonomy aesthetic and discussed in depth at the beginning of this conversation. From this perspective, I disagree with David Morgan when he judges T. J. Clark's "prescriptive statement" that contemporary art and religion *shouldn't* be linked as "silly." Rather, I would interpret Clark's insistence on such a prohibition as a political statement. Thus, are the "set of rules" that Clark in Morgan's eyes evokes just those of the elite critic who exerts his hegemonic powers? Or do they rather reflect a set of ideological convictions that are—at least to a certain extent—incommensurate with the forms of belief, social organization, and political foundation implied by a religious order? We should not forget that religions in their various forms are also about closure; the tenor of this conversation seems to set up a binary between disenchanting, deadening, repressive secularism and enchanting, life-imbuing, victimized religion. This is an essentialism that needs to be resisted. Fundamentalism, intolerance, and despotism as well as misogyny and social restrictions are also potentials of religion, which are integral parts of the history of religion, and not just in its extreme forms of crusades and jihad. This does not mean that secularism is *per se* a guarantor and promoter of openness either; but its advent cracked open a dominant structure of thinking, dominant for many millennia. Indeed, the evidence suggests that the process of modernity has contributed to an inner transformation of the monotheistic religions themselves, relativizing their claims to exclusive truth and opening them to a greater degree of pluralistic toleration.

Not religion, but secularism is the anomaly in world history. It is

a young phenomenon, a few hundred years old at most, which seems more endangered and in dire need of protection than religion's stronghold. Being still new, it is necessarily also at the beginning of articulating its own expressions of mystery, awe, enchantment, and ritual. Religion does not have a monopoly on deep meaning, emotional richness, and forms of ecstasy. One might even speculate that these feelings and the yearning for transcendence preceded and actually produced religion, and as anthropological constants can find other, non-religious articulations as well. The prison bars that James Elkins' teacher erected (the impossibility of transcendence) are self-imposed rather than genuine to the secular itself. The return to religion is one answer to this view, the rethinking of modernity's capacities and nature another. Yet the rhetoric of refusal, of a structure of refusals organized around camouflage and smuggling (metaphors to describe the importation of religious ideas into allegedly non- or even anti-religious artistic practices and art theory), denies the secular the chance of its own opening toward transcendence. I address here not the intentional camouflage of religious ideas for political purposes (that Wendy Doniger touches on briefly) or for the purpose of manipulating the artwork's consumer. Nor am I concerned with the question of cynical power plays, whose ultimate aim is control over the art market's make-up, a question at stake in several of the participants' statements. Rather, I am concerned with the conceptual and ontological underpinnings of Mircea Eliade's "camouflage of religion," which Frank Piatek summarized as "the idea that various secular practices carry on or project religious or sacred or mythic gestures and meanings in disguised form."

Eliade's position is but one expression of those who defined secularization not—like Tomoko Masuzawa—as an "evacuation of religion from the world," but rather as a transformation of religious into secular concepts, which retain the underlying substance of their religious origins. A famous example for this position is Carl Schmitt, the notorious German political philosopher. In 1922, he proposed in his *Political Theology*: "All significant concepts of the modern theory of the state are secularized theological concepts not only because of their historical development . . . but also because of their systematic structure. . . ."[77] This thinking runs the danger of becoming oppressive in itself, as it denies the secular the possibility of being

self-possessed, of being able to articulate genuine versions of concepts, feelings or practices once occupied by the religious. It represents a strategy to block the secular. In contrast to Schmitt and the secularization argument he stands for, Hans Blumenberg developed his "reoccupation thesis." In his 1966 *The Legitimacy of the Modern Age*, he tackled what he identified as two pernicious propositions: in general, that "the modern world is to be understood as a result of the secularization of Christianity" and, in particular, that "modern historical consciousness is derived from the secularization of the Christian idea of the 'salvation story [*Heilsgeschichte*].'" Blumenberg calls into question the "logic of continuity" embedded in these propositions and argues that secularization theorists (like Carl Schmitt) have mistaken the "alienation" of the Christian content for a "transformation" of it.[78] Acknowledging the persistence of religious metaphor in modern intellectual history, Blumenberg speaks of the "reoccupation of [theological] answer positions that had become vacant and whose corresponding questions could not be eliminated."[79] Rather than seeing metaphor as carrier of an ideal substance, a substratum of religious meaning, Blumenberg maintains that metaphor become detached from its initial referent and thereby free to serve new purpose.[80] I thus propose that we cease thinking about art's potential for social inquiry, ritual structure, and meaning production as substitution processes. If we no longer label meditative and even spiritual engagements with art as crypto-religion, art might be able to become a vehicle for a form of self-realization that does not deny the non-rational and the irrational and yet is secular. The true challenge lies in avoiding the "modern age's readiness to inherit such a mortgage of prescribed questions," and finding ways of setting our own agenda rather than reoccupying "vacant answer positions."[81] This, of course, is a project that transcends the region of art, whether high art or kitsch; but I would like to charge contemporary art with the task of contributing to this project by developing alternative forms of enchantment, transcendence, awe, and ecstasy that can free itself of the prescribed religious framework. Perhaps this project is impossible given the capitalist structure of the art market, in which, as Slavoj Zizek lately remarked, the gesture of resistance is itself a commodity and part of the commercial machine.[82] In this case,

however, the question is not the secular versus the sacred, but art versus capitalism.

Deborah J. Haynes
Where I Stand: Assessing Re-Enchantment

I begin by invoking James Elkins' image of a spectrum or continuum of art practices. On the more conservative end of this spectrum is the corporate and commercial art world, which elevates a small coterie of "stars" to create the highest market value for works of art to be consumed. I appreciate David Morgan's characterization of art and artists within this system as embodying "a sort of secularized charisma" that is commodified "in the relentless cycles of the art-luxury market." The critics and theorists who esteem and glamorize such artists and art belong to this conservative approach to the visual arts.

On the more progressive side of this continuum is ubiquitous art-making that occurs at the margins and outside of the multinational gallery–museum system. Such art may (or may not) involve religious aspiration, faith, and belief. When it does address religion and spirituality, however, this art is often dismissed by scholars, theorists, and critics who "patrol strict boundaries," to use Morgan's phrase, and whose exclusivist ideas about art would deem such work insignificant. For example, Jonathan Z. Smith's claim (footnoted by Thierry de Duve) that the use of the term spirituality since the 1970s comes from Alcoholics Anonymous expresses a secular cynicism that is at odds with the history of human religious and artistic aspiration.

I see two major gaps in the discussion, with only a few attempts to acknowledge their importance or do the bridge-building that would facilitate a more complete discussion. First, in the transcript of the day-long seminar that forms the core of *Re-Enchantment*, the dialogue is predominantly Christian, with slim acknowledgment that there are other voices and traditions. We find only a nod to non-Western religions, philosophies, and arts, and to the broader question of the definitions of religion and spirituality. Descriptions of the histories that have led to the current condition of the relationship of art and religion are consequently narrow.

The second gap concerns feminism, the contributions of women artists, and the use of gender as a lens for interpreting the complex

interplay of religions and the visual arts. Only a member of the audience, Lisa Wainwright, raised this question. Artists of diverse backgrounds—Marina Abramowitz, Mary Beth Edelson, Faith Ringgold, Suzanne Lacy, Margot Lovejoy, Ana Mendieta, and Kiki Smith, to name only a few—have been instrumental in bringing issues of religion and spirituality into the public sphere in recent decades.

There is much to be said about both of these issues, but I want to turn in another direction for the remainder of these brief remarks. I fundamentally agree with Gregg Bordowitz that many artists are not afraid of religion and spirituality. Though I have written a fair amount about modern and postmodern theories of art, from Kant and Hegel to Bakhtin and feminist aesthetics, I am presently more engaged in integrating my scholarly and creative work through writing, drawing, and carving marble. Together, these activities may perhaps best be described as an expression of my contemplative practice.

Like Bordowitz, I am an artist who seeks to give creative form to the relationship of eros, impermanence, and death; who explores the significance of ritual; and who sees the profound interrelationships of religious, moral, and aesthetic acts, as well as the necessary connections of the ethical and aesthetic domains of culture more broadly. Ultimately, these spheres cannot and should not be separated; to do so reflects the prevailing Kantian "wrong turn" about which myself and others have written.

I do not believe there is a dearth of contemporary art that actively engages religion and spirituality, only that there is little comprehension of this art and the nature of religious or spiritual practice. We need to ask new questions. How does artistic practice become an expression of contemplative life? What does it mean to connect aesthetic and ethical values in creative studio practice? How might art become an integral part of daily life instead of a commodity for the luxury market? What role does place and the land play in this? Community-based projects, land art in many of its manifestations, performance and installation, and a variety of both historical and contemporary arts explore such questions. For example, the best installation and land art, from Antonette Rosato (d. 2006) to Agnes Denes, is about the re-sanctification of the environment, particular

spaces, and places. In performance and ritual arts, the body, space, and place are the medium of the work.

When Edward Casey began publishing books about place in the early 1990s, he claimed that the lack of reflection about the significance of place in philosophy needed to be corrected, especially because the categories of space and time had dominated modern philosophy. But since Emerson and Thoreau's nineteenth-century journals, books, and essays, some intrepid writers have written consistently about nature. Among them, theologians, historians of religion, and feminists in several disciplines have consistently turned their attention to the natural world, to ecology, and to challenging local and global issues. With the development and evolution of land art, earthworks, and outdoor site-specific installations in the 1970s, there has been much art that purports to be about place. Yet, as Lucy Lippard correctly observed in *The Lure of the Local*, in the visual arts "place-specific art is still in its infancy. Of all the art that purports to be *about* place, very little can be said to be truly *of* place."[83]

I have nearly completed a new book about creativity, spirituality, and the land—about philosophy, theory, and history, yes, but also about the changing of seasons, clouds and butterflies, water and mountain, snake and fox, children and dying elders, solitude and community. I have come to this place in the foothills of the Rocky Mountains to tend a small parcel of land. I draw the place I envision, with stone steps and wall painting, gardens and paths. I carve texts in massive marble slabs and monoliths. I walk and sit. I lie down on a large stone engraved with *metta*, a lovingkindness prayer, my legs extended up the trunk of one of the willow trees. This late fall morning I taste argula and kale, small plants still alive within the cold frames. Tendrils of ice on the stream are now melting because the days are unusually warm. Such mundane details of daily life are part of both my artistic and contemplative practice.

Some have observed that the most important question is "how should one live?" This question points first of all to the values that guide our daily lives—values that may range from cultivating mindfulness, kindness, and compassion toward others, to acquiring fame and wealth in the art world. In the end, I am drawn to historical and contemporary traditions of art-making that embody what Boris Groys called the "visualization of the invisible." How one conceives

of this invisible is crucial, of course, for is it an entity or void, presence or absence, form or emptiness? Artists, critics, and others engaged in the contemporary art world will spin their own tales and live through various earthquakes and hurricanes. Where I stand, however, is clear. I will continue to investigate life's contingency and impermanence here—in this community, in this place.

Pepe Karmel

Re-enchantment: A Problem of Definition

The relationship between religion and contemporary art is an important topic—perhaps the most important topic confronting art criticism today. The rise of neo-Dada, conceptual art, installation art, performance, and postmodern art signal the collapse of the formalist tradition that regulated the production and criticism of Western art for the previous five hundred years. What we have today is an art whose signifiers are drawn from the familiar range of human experience, but that leads us constantly beyond the borders of the familiar. It is impossible to talk meaningfully about contemporary art without invoking a religious vocabulary of symbol and ritual, degradation and transcendence.

From this perspective, the publication of the present seminar on contemporary art and religion marks a major step forward, building on earlier texts by James Elkins, Eleanor Heartney, and other critics. Unfortunately, much of the discussion in the Art Seminar section of this volume is limited by a conventional focus on Christianity as a paradigm of religion and as a source of symbols. I find myself grateful to Tomoko Masuzawa for her insistence that our understanding of "religion" is a recent product of Western culture, and one that is strikingly inadequate to the variety of "religious" experiences found at other times and places. Bryan Markowitz, a member of the audience, makes an important contribution when he reminds us of the centrality of ritual in religious practice, going on to argue that "secularized contemporary art often functions as a ritual practice detached from religious faith and used to re-examine values and ethics."

Is it meaningful, however, to speak of an activity as "religious" if it is detached from conventional religions? To answer this, we would need to examine more deeply the range of functions and

practices included in the religions of different times and places. From Durkheim's perspective, religion might be considered the imaginary Other that serves to reify social entities such as families, tribes, cities, nations, and states. Some ritual practices are performed to seek good fortune in the vicissitudes of everyday life. In most cultures these are called "religious" practices; in others they are denigrated as "magic." Some rituals mark the passage from childhood to adulthood or life to death; others to lift a sense of shame or guilt; yet others to induce a sense of transcendence. Most religions include extensive mythologies or histories, often with only a marginal relationship to the associated theology. These too play an important social role, fulfilling our need for narratives that dramatize and aggrandize the events of daily life. Any and all of these religious experiences can provide the material and structure for art.

In his introduction to this book, David Morgan recapitulates the Weberian hypothesis that the rise of monotheism led to the disenchantment of the physical world. This in turn implies that the decline of established religions in the West, beginning in the eighteenth century, has led, not to true secularism, but to a re-enchantment of the world: a proliferation of magical beliefs and un-established religions. James Elkins, at the beginning of the seminar, quotes John Updike's remark that: "modern art is a religion assembled from the fragments of our everyday life." What we need now is a detailed examination of the ways that particular works of art—and not necessarily those utilizing recognizable religious symbolism—function as fragmentary religions.

Anna Niedźwiedź
Theory and Practice

As an ethnographer studying religious people and their relationship to and with images, I frequently ask questions about the nature of how they see art and how they treat it as religious. As my research concerns mostly lived religion, visual piety, and religious practices performed within old and contemporary popular Catholicism, my main interests in relation to the Art Seminar are questions about the theory and practice of religion.

I agree that all the terms we try to use in our theories like "art,"

"religion," and "spirituality" are ambiguous and unclear and we should try to define them more precisely by tracing them back to their origins within Western culture, philosophy, and civilization. We absolutely need to be conscious that our contemporary terms are present within different discourses and that dialogue among those different discourses and traditions must be based on mutual understanding of the historically defined usage of the terms. Sometimes, we must accept that dialogue is hardly possible and that different discourses would appear to be describing art–religion relations and phenomenon from different, sometimes contradictory points of view. Maybe, paradoxically, those contradictions do not exclude each other nor limit different interpretations since human beings and culture as well as society are all contradictory and paradoxical phenomena. As so, paradox is one of the most characteristic features of any humanistic discourse. And it is our free choice—as scholars and humanists—to define our theoretical background and attitude as well as to change it. However, it is equally important to realize that a level of theory reveals only one aspect of the complicated relations between art and religion that are still present and practiced in the contemporary world within its still enchanted (or re-enchanted) cultures.

Having in mind my ethnographical experience, I would appreciate it very much if contemporary discourses about art and religion might agree to be a bit more conscious about contemporary art as it relates to religious practices. What people do and the rituals they perform in front of religious imagery, how the relationship between art and religion is actually lived by those who seem to be emotionally, intellectually, or spiritually within this relationship. It is important to emphasize that the ontological status of art is fully established when we consider the position of the viewer and that of beholder. Maybe it is worthwhile to consider an anthropological approach with its inclination toward interests in unofficial practices, cultural contradictions, non-mainstream rituals, and unconscious, spontaneous interpretations. Maybe it would also be a key to opening an understanding and interpretation of "unconscious religion," which on a broader scale re-enchants our contemporary local societies as well as our globalized culture. We will probably still be asking questions about aesthetical value, bad and good art, high and low artistic production. Moreover, while agreeing on a presence of practice and religiosity in discourse

about contemporary art we might develop a new perspective and new questions revealing another level of understanding of at least a few important phenomena present in our societies.

Many of these issues arose during the Chicago discussion, like the problem of kitsch and specificity of contemporary religious art, questions about status of fine art and popular art, influence of digitalization in the context of its medial, transforming characteristic. All these are new fields and new subjects for which we need to develop a "new lens of interpretation." The most interesting issues appear on the borders between anthropology, art history, and visual studies, and as it was said during the discussion those borderlands are still undertheorized and still seen as very problematic among many academics. The burden of separate theories might be transformed into new interdisciplinary approaches to examine contemporary society in which borders between fine art, religious practice, ritual, visualization, and artistic creativity are far from anything clearly defined. To understand these intermingling dimensions and features we need to develop an interdisciplinary approach filling the yawning gap between theory and practice. The power of images and imagery seems not only not to be weakened, but quite the opposite, it reveals more and more embracing and involving features. We, as academics, would not be able to avoid new questions and new interdisciplinary fields unless we wanted to say nothing important about contemporary cultures and societies. Popular art and culture, globalization, the recent appearance of non-European discourses and traditions within the academic world, and conflicts derived from misunderstanding of religious practices and iconography are present in our contemporary experience and shape our modern societies.

The multi-leveled and interdisciplinary discussion in Chicago did not give answers to these new issues and sometimes made me feel concerned about the durability and stability of old traces present in Western philosophy. On the other hand, however, the discussion raised a number of interesting questions and revealed how the field meshing art history and anthropology might be inspiring, rough, and tremendously encouraging. Among Polish anthropologists working on a kitschy and aesthetically shocking example of contemporary bad religious art (in a newly built Marian shrine in Licheń), which has appeared to be extremely popular among huge number of pilgrims, a

joke is shared that it would be a miracle to ever see a group of art historians visiting the place together with ethnographers sharing field research using not only ethnography but also the perspective of art historians. Perhaps seminars like that in Chicago are one of the first steps showing an increasing need for interdisciplinary discourse, without which the story about art and religion(s) practiced in contemporary societies cannot be told or maybe even cannot be seen by traditionally isolated academic disciplines.

Kristin Schwain
Anointing Modernism

The Art's Seminar's conversation about the place of religion in contemporary art demonstrates why the subject generates such befuddlement: a pervasive scholarly resistance to upset aesthetic modernism's genealogy and attend to the history of religion. There are moments when participants address and confront these inclinations. Wendy Doniger, for example, distinguishes between believers from those who study believers. Tomoko Masuzawa stresses that sacralization and secularization emerged in concert with one another and remain intertwined. Kajri Jain challenges listeners to turn an ethnographic gaze on the Western tradition and question its assumptions, particularly its stress on the privatization of belief. And David Morgan inserts the history of Christianity and the practice of belief into the discussion. However, these interventions rarely meet with considered engagement by the other panelists. Nearly everything deemed outside the self-professed world of aesthetic modernism and its contemporary critical discourse is excluded, reifying the very assumptions that require dismantling.

Understanding religion's role in contemporary art production and reception demands a reconsideration of modernism's historical development, and more specifically, the interconnected roles played by art and religion in its formation—particularly within an American context. In the late-nineteenth and early-twentieth centuries, American religious leaders, tastemakers, and commercial magnates promoted a modern conception of faith characterized by an individual relationship with the divine more than a formal set of theological precepts. This stress on the interior and subjective experience

of religion coincided with artists' efforts to engage beholders personally and empathetically with works of art. While these new ways of seeing emphasized the viewer's ability to transcend the material world, they nevertheless contributed to evolving debates over class, ethnicity, sexuality, and gender. Indeed, cultural producers conceptualized fine art as a means to inculcate Anglo-American Protestant values and prompt middle-class codes of conduct at the same time they universalized these norms. Focusing on the individual more than the community, personal experience more than social ritual, and interiority more than shared moral standards, modern American art and religion invited disciplined transcendence.

The importance of religion to the formation of Modernist aesthetic experience emerges, too, in the development of criticism. As art historian Jonathan Crary illustrates, aesthetic philosophers and art critics sought to differentiate between everyday viewing practices and looking at a work of art at the end of the nineteenth century.[84] Philosophers William James and Charles Sanders Peirce underscored the subjective nature of human vision and the myriad ways that cultural context and individual experience influenced individual perception. In contrast, art critic Roger Fry proposed a "modernist" form of aesthetic vision that divorced perception from the body and its location in time and space. He distinguished between "actual" life —the world of responsive action and moral responsibility—and "imaginative" life—a higher realm of human emotion and disinterested contemplation. He located art within the imaginary life, since it "appreciates emotion in and of itself" without requiring "resultant action." Importantly, Fry's definition of religion paralleled that of art, since he believed that a believer "would probably say that the religious experience was one which corresponded to certain spiritual capacities of human nature, the exercise of which is in itself good and desirable apart from their effect upon actual life."[85] In his view, the beholder's engagement with the object was not circumscribed by the individual's material conditions or autobiography; instead, the viewer's absorption rested in a higher realm of emotion unhindered by the prosaic details of everyday life.

Scholarly resistance to a deeply historicized and contextualized approach to modernism results in two spurious assumptions: that secular and sacred, art and culture, are discreet cultural categories

rather than always, already jumbled; and that religion is transcendent rather than historically conditioned, deeply enmeshed in the same intellectual, political, and social forces that shape art production, economic policy, and international relations. Until scholars allow history and culture to inflect their theoretical presumptions, they will be unable to address the role of religion in contemporary art in all its richness and complexity.

Jorgelina Orfila
A Plea for the Re-Enchantment of the Discipline of Art History

In my opinion, the discussion of the place of spirituality or religion in contemporary art is essentially related to the debate about the possibility of a global art history. Therefore, I much appreciated Tomoko Makuzawa's intervention and her efforts to make the discussion turn around the fact that the notion of religion itself is a Western construct and that it has created a prejudiced interpretation of the past and non-Western cultures. The epistemic regime that began with the Enlightenment and that gave currency to the notion of religion as the opposite of secularization, also created the notion of Art "as we know it."[86] From now on, I will use Art to refer to this new way of understanding art.[87]

This essential transformation of the meaning and function of Art, which also entailed its sacralization, coincided with the emergence and institutionalization of art history. Jacques Rancière would say that art history is the specific system of visibility and the discourse that identifies Art as such. Makuzawa's intervention, thus, underlined what is at the foundations of my scholarship: that the notions of religion, as much as those of Art, are historically constructed and reflect the Western epistemological tradition and its history. In this sense, the fact that her voice was buried under those of artist and art historians who do not even take into consideration this line of reasoning, demonstrates that years of critical theory and deconstruction have not modified the modernist foundations on which our approach to art history and Art stands. There is a sense in which modernism was, and still is, as exclusivist and jealous as the monotheistic God. It conceives of itself as universal and dismisses other approaches to knowledge, with the dire consequences that we all know.

The fact that these categories and the discipline belong to and project the same epistemic regime raises the question: how can we know or study the art from other cultures and historical times? Moreover, how would it be possible to find the pockets of difference and opposition within the modern West itself? In the end, we go back to a most Kantian question, which I think has not been definitively answered: How is knowledge possible?

According to Stephen Melville, it was with Erwin Panofsky that art history became the discipline we practice today.[88] Panofsky's work provided a basis to respond to the historical situation of the 1930s, when Humanism became the battle cry used to defend the basic values of Western civilization against totalitarian ideologies. Panofsky not only established an idealized Renaissance Humanism at the center of the discipline but also imbedded its values within art history's epistemological underpinnings and methodologies. This amounted to the inscription of basic Judeo-Christian principles at the foundation of the discipline.[89] Panofsky's Humanism contains many ideas inherited from the Enlightenment. As such, it implies a certain understanding of the definition of a human being and his place in the hierarchy of creation. It also implies a certain regime of knowledge, the differentiation of science from religious belief and thus, the disenchantment of the world and secularism. Thus even Marxism and modern secular and atheist agnosticism derive from and reflect fundamental aspects of this worldview.

This is not to suggest that art historians must believe in astrology in order to understand Sumerian art or that they convert to the religions observed by the cultures they study. Nevertheless, it would be useful to analyze the negative reaction we experience when confronted with such ideas and explore the foundations of our own epistemological beliefs. These are such that we tend to reject the mere notion of adopting other approaches to knowledge—as if this would imply a "conversion"—and have problems considering them of the same cognitive value as our own. But, it should be recognized that art history reflects a belief system that is essentially related to the Judeo-Christian worldview, which in certain ways is equivalent to [religious] proselytism.

How does the conceptual frame we employ relate to the object of study? Who chooses which beliefs become part of the epistemological-

foundations of the discipline and part of the methodologies we apply for the study of world art? Shouldn't art history be, or aspire to be, value neutral with respect to religion? This is why I believe that the problem of the relationship of contemporary art and religion is fundamentally related to the discussion about the globalization of art history.

I found the discussion transcribed here "dogmatic," in that it does not reflect the serious doubts manifested in recent years about the universal validity of art history's methodologies and categories of analysis. I do not doubt the power or value of art/Art. The real challenge is to devise a way of questioning the artistic phenomena that does not predetermine its true significance.

At the end of "The Question Concerning Technology," Martin Heidegger's scathing examination of technology as the epitome of modernity, the philosopher considers Hölderlin's idea that " '. . . where danger is, grows/ The saving power also,' " and asks:

> Could it be that the fine arts are called to poetic revealing? Could it be that revealing lays claim to the arts most primally, so that they for their part may expressly foster the growth of the saving power, may awaken and found anew our look into that which grants and our trust in it?

Heidegger finds that Art is the realm that opens the way for re-considering the foundations of the modern approach to the world. In Art resides the saving power that would enable us to understand what for him is the danger, technology, because Art is both akin but also fundamentally different from it. And he concludes: "Such a realm is art. But certainly *only if reflection on art, for its part, does not shut its eyes to the constellation of truth* after which we are *questioning*"[90] (my emphasis).

Thus, my plea for the re-enchantment of art history.

Christopher Pinney

Artworlds are Cosmologies

Two quite distinct issues are conflated in much of the discussion, namely: (a) the issue of whether "art" is a secular ("camouflaged," or "smuggled") religion; (b) whether artists and their audiences—of

the kind valorised by the international art world—are made anxious by forms of cultural production which occur under the sign of religion, embarrassed by the possibility of public affect threatening the subversion of sophisticated "absorption" by vulgar "theatricality," as Fried would have it.

The second question is, I think, largely un-interesting (and Bordowitz is undoubtedly correct that it is also largely illusory); the first is surely crucial to any critical understanding of art as a social practice.

The unwillingness to embrace the proposition that art is secular religion has two central causes. Firstly, the issue of religion gets mistranslated as a question about "God" (vide de Duve's initial contribution), when the operative category should be transcendence. Secondly, the analogy is usually made as an accusation in ways that erase any recognition of the productivity of religion *as cosmology*. If religion can *only* be an opium (which I agree it frequently is) or a mere question of "belief," then of course T. J. Clark et al. are likely to decline the comparison.

So part of the problem stems from the negative parameters within which the parallel is proposed. This negativity entails one or all of the following propositions: as a general practice it sedates an otherwise insurgent population; its institutional spaces of display manifest the icy solemnity of temples (Bourdieu, Gell); or it participates in the fundamental illusion of the western tradition, namely transcendent signification (Derrida).

Greenberg's *Partisan Review* paranoiac stigmatisation of the "illegitimate content" of "religion or mysticism" in "our period style" recalls the narcissism of petty difference akin to the nomenclature of the Judean People's Liberation Army in Monty Python's *Life of Brian*, or Richard Dawkins' attack on religious belief through the mobilization of a structure of thought (neo-Darwinism), which itself manifests most of the formal features of religious dogma ("the religion of the exit from religion," as Gauchet might say).

A more productive approach might involve a detour through Nelson Goodman (*Ways of Worldmaking*) and come to think of art as (like religion) concerned with *world making*. This seemed to be implicit in the argument made by Masuzawa concerning religion as "cultural technology," despite her baulking at "exotic cosmology."

The same issue is raised (by Bordowitz) via Winnicott. The subsequent discussion—perhaps inflected by Bordowitz's insistence on a psychoanalytic trajectory to this issue—is derailed by the question of whether the worlds that art makes are "reparative" as opposed to "critical or deconstructive." The assumption in the discussion is that these worlds are necessarily referenced to an *ur*-ready-made world. Nelson Goodman can really help us here for he points out that the operative term is "rightness" not "truth." For Goodman, there would be no transcendent ego that would fair better in some worlds rather than other worlds. Rather, he stresses the internal systematicity of worlds in which all that matters is "rightness of fit." Worlds as cosmologies are obliquely incarnated by Doniger in her references to the "world of Narnia," "world of Tolkien," etc. We might parallel these with the "world of Greenberg," the "world of Vedanta," etc.

Both religions and art worlds are incipient cosmological machines that create their own worlds structured by rightness of fit, structured around the centrality of aesthetics and ethics. Sarat Maharaj's account in the *Documenta XI* catalogue of art-ethical processing plants concerned with knowledge generation describes very well this sense of art as cosmology. Bordowitz is also close to it, when he comments on art and religion's engagement with the "ethical part of creation."

However, Goodman's "rightness of fit" entails an ethics/aesthetics that has no intrinsic proximity to moral "goodness." De Duve is therefore surely correct in his insistence concerning the "great advantage of radically severing the artistic or the beautiful from the morally or religiously good": of course terrorists can also be artists.

Notes

1. Sigmund Freud, "The Uncanny," in *Psychological Writings and Letters*, ed. Sander L. Gilman (New York: Continuum, 1995), pp. 127, 126. One might suggest that the disavowed relations between art and religion, the topic of this response, is an underlying source of the prominence of the "uncanny" in recent art criticism. See, for instance, Rosalind E. Krauss, *The Optical Unconscious*, (Cambridge, MA: MIT Press, 1998) and Hal Foster, *Compulsive Beauty* (Cambridge, MA: MIT Press, 2000).

2. Jacques Derrida discusses "hauntology" and religion in *Specters of Marx: The State of the Debt, the Work of Mourning, and the New International*, trans. Peggy Kamuf (New York: Routledge, 1994).

3. Freud, of course, would find my proposition preposterous. For him, religion was wish fulfillment at the level of civilization itself. See *The Future*

of an Illusion, trans. James Strachey (New York: W. W. Norton & Company, 1961).
4. Art Seminar, p. 114.
5. Perhaps this is the true origin of the pain, embarrassment, and anxiety that keeps some critics from being able to acknowledge, much less discuss, the place of religion in contemporary art?
6. For an excellent discussion of the repression of the sacred in modern life, see Michèle H. Richman's study of the *Collège de Sociologie* in *Sacred Revolutions: Durkheim and the Collège de Sociologie* (Minneapolis: University of Minnesota Press, 2002).
7. A few artists who come to mind are Kiki Smith, Robert Gober, Bill Viola, and, in different registers, Joel-Peter Witkin and Andres Serrano.
8. In a much-quoted remark, Stanley Fish said: "When Jacques Derrida died I was called by a reporter who wanted to know what would succeed high theory and the triumvirate of race, gender, and class as the center of intellectual energy in the academy. I answered like a shot: religion."
9. Thinkers such as David Tracy, Mark C. Taylor, Jean-Luc Marion, Jacques Derrida, and Slavoj Zizek exemplify this sophisticated theological mode. Each of them also writes on art.
10. Art Seminar, p. 167.
11. James Elkins, *On the Strange Place of Religion in Contemporary Art* (New York: Routledge, 2004), p. 31.
12. The equation of religion with fundamentalisms is a similarly vulgar characterization.
13. Mircea Eliade, *Images and Symbols*, trans. Philip Mairet (Princeton: Princeton University Press, 1991), p. 16.
14. Elkins speculates in a similar vein in his discussion of "unconscious religion" in *On the Strange Place of Religion in Contemporary Art.*
15. Art Seminar, p. 141.
16. Rosalind Krauss develops Walter Benjamin's concept of the "optical unconscious" in her book of that title.
17. Though Eliade's scholarship has come under massive criticism in the decades since his death, his concept of sacred space still finds much currency outside of strictly academic circles.
18. Michel de Certeau, *The Practice of Everyday Life*, trans. Steven Rendall (Berkeley: University of California Press, 1984), p. 41, 37.
19. Bruce Lincoln coins the term "profanophany" in his book *Discourse and the Construction of Society: Comparative Studies of Myth, Ritual, and Classification* (New York: Oxford University Press, 1989).
20. Michèle Richman's book *Sacred Revolutions* provides a provocative and insightful discussion of effervescence and the sacred in modern life.
21. I don't think that these are mutually exclusive binaries. Faith and skepticism coexist in many serious religious thinkers, a point that gets lost in caricatures of "religion" as schmaltz, on the one hand, or as unthinking fundamentalism, on the other.
22. Jonathan Z. Smith, *Imagining Religion: From Babylon to Jonestown* (Chicago: University of Chicago Press, 1982), p. xi.

23. James Elkins speaks to the strangeness of religion in contemporary art in *On the Strange Place of Religion in Contemporary Art*.

24. Art Seminar, p. 159. He raises three questions that "unfold from a psychoanalytic perspective." To adopt this suggested perspective has been my approach here.

25. Jonathan Z. Smith, *Imagining Religion*, p. xiii. Emphasis in original.

26. James Elkins suggests that the "numinous" is "an interesting candidate" for "coax[ing] conversations about spirituality from reticent artists and teachers" in *On the Strange Place of Religion in Contemporary Art*, p. 105.

27. Rudolf Otto, *The Idea of the Holy: An Inquiry into the non-rational factor in the idea of the divine and its relation to the rational*, trans. John W. Harvey (London: Oxford University Press, 1958), pp. 28, 29.

28. Janet R. Jakobsen and Ann Pellegrini, "Introduction: Times Like These," in *Secularisms*, eds. Janet R. Jakobsen and Ann Pellegrini (Durham, NC: Duke University Press, 2008).

29. Janet R. Jakobsen, "Is Secularism Less Violent than Religion?," in *Interventions: Activists and Academics Respond to Violence*, eds. Elizabeth A. Castelli and Janet R. Jakobsen (New York: Palgrave, 2004): 53–67.

30. R. T. McCutcheon, *Critics not Caretakers: Redescribing the Public Study of Religion* (Albany: SUNY Press, 2001).

31. See Joseph M. Kitagawa, "The History of Religions (Religionswissenschaft) Then and Now," in *The History of Religions: Retrospect and Prospect*, ed. Joseph M. Kitagawa (New York: Macmillan, 1985), 123f; and M. Scott Peck, *The Road Less Traveled* (New York: Simon and Schuster, 1978), Part III "Growth and Religion." Neither Peck nor Kitagawa do much with this instructive image, however. I refracted it somewhat in my dissertation, "The Poetics of Attention as an Emerging Religious Stance in Recent American Poetry," and have extended it further in two book projects currently underway, *The Double-edged Sword of Religion in Political Conflicts*, and *Maps of Reality: Making Sense of Religions in a World Full of Them*.

32. Summarizing religions as maps of reality in one sentence: religions present people with a description of how the world and the cosmos are put together (cosmology); they tell us where we are in that world (the human condition); they describe to us a goal or destiny we can expect life to be taking us to (teleology); and they map out two paths to get to that goal: a path of ethical conduct, both personal and social (morality), and a path of transformation, usually associated with personal spiritual practice (spirituality).

33. See Wijdan Ali, *Modern Islamic Art: Development and Continuity* (Gainesville: University Press of Florida, 1997).

34. For practical theology see, e.g., James Woodward and Stephen Pattison, eds., *The Blackwell Reader in Pastoral and Practical Theology* (Oxford: Blackwell, 2000).

35. From the theological, religious side of the discussion, see further, e.g., William Dyrness, *Visual Faith: Art, Theology and Worship in Dialogue* (Grand Rapids MI: Baker Academic, 2001); George Pattison, *Art, Modernity and Faith: Restoring the Image* (London: SCM Press, 1998).

36. See, e.g., Daniel Pals, *Seven Theories of Religion* (Oxford: Oxford University Press, 1996).

37. See further, e.g., David Morgan, *Visual Piety: A History and Theory of Popular Religious Images* (Berkeley: University of California Press, 1998).

38. Mary Nooter Roberts and Allen Roberts, *A Sense of Wonder* (Phoenix AZ: Phoenix Art Museum, 1997).

39. See further, Ivan Gaskell, "Sacred to Profane and Back Again," in Andrew McClellan, ed., *Art and Its Publics: Museum Studies at the Millennium* (Oxford: Blackwell, 2003).

40. Jessica Shaughnessy, "Sparks fly from Jesus artwork," *Liverpool Daily Post*, February 13, 2007.

41. See Stephen Pattison, *Seeing Things: Deepening Relations with Visual Artefacts* (London: SCM Press, 2007).

42. See further, e.g., James Elkins, *Pictures and Tears* (London: Routledge, 2001).

43. See, e.g., Tom Beaudoin, *Virtual Faith* (San Francisco CA: Jossey-Bass, 1998).

44. See, e.g., Colin Campbell, *The Romantic Ethic and the Spirit of Capitalism* (Oxford: Blackwell, 1987).

45. Plato, *Theaetetus* (London: Penguin Books, 1987), 155d.

46. Mary Midgley, *Wisdom, Information and Wonder: What is Knowledge For?* (London: Routledge, 1989).

47. Bruno Latour, *We Have Never Been Modern* (Cambridge, MA: Harvard University Press, 1993).

48. Larry Shiner, *The Invention of Art: A Cultural History* (Chicago: University of Chicago Press, 2003).

49. W. H. Auden, *For the Time Being*.

50. Tobi Kahn, telephone conversation with the author, July 5, 2006.

51. Archie Rand, telephone conversation with the author, July 7, 2006.

52. Gertrude Stein, *Everybody's Autobiography* (New York: Random House, 1937), p. 289.

53. I also refer to two other books of the Art Seminar series already published: *Art History versus Aesthetics* and *Is Art History Global?* for my starting point.

54. This also included the idea that religion and art were born together.

55. Mari Carmen Ramirez, *Inverted Utopias: Avant-Garde Art in Latin America* (New Haven, CT: Yale University Press, 2004).

56. For example, Walter D. Mignolo, *Local Histories/Global Design: Coloniality, Subaltern Knowledges, and Border Thinking* (Princeton: University of Princeton Press, 2000); *The Darker Side of the Renaissance: Literacy, Territoriality, and Colonization* (Ann Arbor: University of Michigan Press, 1995).

57. Juan Ortega y Gasset, "The Dehumanization of Art", in *The Deshumanization of Art and Other Essays on Art, Culture, and Literature* (Princeton: University of Princeton Press, 1948), pp. 3–54 (originally published in 1924).

58. Hans Sedlmayr, *Verlust der Mitte: Die bildende Kunst des 19. und 20. Jahrhunderts als Symbol der Zeit* (Salzburg: Otto Müller, 1948); trans. *Art in Crisis: The Lost Center*, trans. Brian Battershaw (Chicago: H. Regnery Co., 1958).

59. Ana Lucia Lopes, *O universo mítico de Hector Julio Paride Bernabó, o baiano Carybé* (São Paulo: Petrobrás, 2006).

60. Another artist in this context is the photographer Mario Cravo Neto, who

also participated in the exhibition about the "Age of Modernism," eds. Christos M. Joachimides, Norman Rosenthal, *Die Epoche der Moderne: Kunst im 20. Jahrhundert* (Ostfildern-Ruit: Hatje, 1997). It is illustrative that the catalogue also included an article which declared the self-critical modernism of the twentieth century as the European century that has ended; Wolf Lepenies, "Selbstkritische Moderne oder das zwanzigste, das europäische Jahrhundert—am Ende," in: ibid., pp. 29–38.

61. A more profound analysis regarding concepts of "memory" and "agency" of Afro-Brazilian culture is provided by Henry John Drewal, "Memory and Agency: Bantu and Yoruba arts in Brazilian Culture," in Nicholas Mirzoeff (ed.), *Diaspora and Visual Culture: Representing Africans and Jews* (London, Routledge, 2000).

62. Thomas Zaunschirm, *Kunstwissenschaft. Eine Art Lehrbuch* (Essen: Klartextverlag, 2002), pp. 123–33.

63. Frederic J. Schwartz, *Blind Spots: Critical Theory and the History of Art in Twentieth-century Germany* (New Haven, CT and London: Yale University Press, 2005), p. 246.

64. Gustav Seibt, "Meisner und die 'entartete Kunst.' Vor dem Verlust der Mitte," *Süddeutsche Zeitung*, September 16, 2007, http://www.sueddeutsche.de/kultur/artikel/341/133094/?page=5.

65. In the same direction with other implications tends also Jean-Marie Rabot, with his concept of "remythologization," Jean-Martin Rabot, "L'image, vecteur de socialité," *Sociétés*, no. 95 (2007): 19–31.

66. G. Finaldi et al., *The Image of Christ: The Catalogue of the Exhibition Seeing Salvation* (London: National Gallery, 2000); N. MacGregor with E. Langmuir, *Seeing Salvation: Images of Christ in Art* (London: BBC, 2000).

67. Hence the rather different title for one of my recent books: *God and Enchantment of Place: Reclaiming Human Experience* (Oxford: Oxford University Press, 2004).

68. In Mondrian's case, there was the new influence from Theosophy. Recent studies of the position of Van Gogh include N. M. Maurer, *The Pursuit of Spiritual Wisdom* (London: Associated University Presses, 1998); Deborah Silverman, *Van Gogh and Gauguin: The Search for Sacred Art* (New York: Farrar, Strauss and Giroux, 2000).

69. Discussed in my *God and Grace of Body* (Oxford: Oxford University Press, 2007), pp. 61–119.

70. Just some examples of the issues I myself have found interesting: see my "The Annunciation as True Fiction," in *Theology* CIV (2001): 121–28; "The Trinity in Art," *The Trinity*, eds. S. T. Davis, D. Kendall and G. O'Collins (Oxford: Oxford University Press, 1999), pp. 329–56; "The Ascension and Transfigured Bodies," *Faithful Performances*, eds. T. A. Hart and S. R. Guthrie, (Aldershot: Ashgate, 2007), pp. 257–72.

71. Art Seminar, p. 156.

72. The latter does not attempt to get beyond one basic assertion, the simplicity of monastic life.

73. For some illustrations and Gordon's own views, *Douglas Gordon: Superhumanatural* (Edinburgh: National Galleries of Scotland, 2006).

74. Contrary to many press reports, the present regime wishes to distinguish carefully between Judaism and Zionism.

75. Johann Friedrich Overbeck, "Altarbilder," manuscript in the Stadtbibliothek Lübeck, in Michael Thimann. "Hieroglyphen der Trauer: Johann Friedrich Overbecks 'Beweinung Christi'," *Marburger Jahrbuch für Kunstwissenschaft* 28 (2001): 191–234, text: 231–33.

76. Peter Weibel. "An End to the 'End of Art'? On the Iconoclasm of Modern Art," in *Iconoclash: Beyond the Image Wars in Science, Religion, and Art*, eds. Bruno Latour and Peter Weibel (Karlsruhe / London: ZKM/MIT Press, 2002), pp. 570–670, quote 588.

77. Carl Schmitt. *Political Theology: Four Chapters on the Concept of Sovereignty* (Cambridge, MA: MIT Press, 1985), p. 36.

78. Hans Blumenberg, *The Legitimacy of the Modern Age* (Cambridge, MA: MIT Press, 1983), pp. 25, 27, as well as 16–18, 28–29. For a succinct discussion of the book, see Laurence Dickey, "Blumenberg and Secularization: 'Self-Assertion' and the Problem of Self-Realizing Teleology in History," *New German Critique*, no. 41 (1987): 151–65, in particular pp. 153–58.

79. Blumenberg, *Legitimacy*, 65.

80. See Warren Breckman, "Creatio ex nihilo: Zur postmodernen Wiederbelebung einer theologischen Trope," *Zeitschrift für Ideengeschichte* 1, no. 2 (2007): 13–28.

81. Blumenberg, *Legitimacy*, 69.

82. Slavoj Zizek, *The Fragile Absolute, or, Why is the Christian Legacy Worth Fighting For?* (London: Verso, 2000).

83. Lucy Lippard, *The Lure of the Local: Senses of Place in a Multicentered Society* (New York: New Press, 1997), p. 20.

84. Jonathan Crary, *Suspensions of Perception: Attention, Spectacle, and Modern Culture* (Cambridge, MA: MIT Press, 1999; reprint, 2000), p. 46.

85. Roger Fry, "An Essay in Aesthetics" (1909), in *Art in Theory 1900–1990: An Anthology of Changing Ideas*, eds. Charles Harrison and Paul Wood (Oxford, UK and Cambridge, MA: Blackwell, 1992), pp. 81, 80.

86. I am taking the expression from Makuzawa.

87. For the notion of "Art," see Larry Shiner, *The Invention of Art: A Cultural History* (Chicago: University of Chicago Press, 2001).

88. Stephen Melville, "The Temptation of New Perspectives" in *The Art of Art History: A Critical Anthology*, ed. Preziosi, Donald (Oxford: Oxford University Press, 1998), pp. 408–09.

89. The bibliography on this subject matter is enormous. See, for example, Christopher Wood, "Art History's Normative Renaissance" in *The Italian Renaissance in the Twentieth Century: Acts of an International Conference, Florence, Villa I Tatti, June 9–11 1999*, eds. Grieco, Allen, Michael Rocke, Fiorella Gioffredi Superbi (Florence: L. S. Olschki, 2002). Panofsky had been deeply influenced by Ernst Cassirer's Neo-Kantian approach to philosophy. In reference to the strong association between Western epistemological tradition and Judeo-Christian values, it seems to me that Thierry de Duve forgets that Kant himself was influenced by his Pietist upbringing.

90. Martin Heidegger, "The Question Concerning Technology," in *The Question Concerning Technology and Other Essays* (New York: Torchbooks, 1969), pp. 34–35.

5
AFTERWORDS

MISSING RELIGION, OVERLOOKING THE BODY

Jojada Verrips

Sometimes it is good to be confronted with a confusion of tongues, for it can force one to seriously try to disentangle and understand what the (categories of) persons involved in such a babel are trying to get across. That, at least, is what I felt about the project on art and religion by Elkins and Morgan after having read and pondered the series of extremely variegated contributions by a wide range of scholars. However, my first impression was not positive, for I was—I have to admit—rather irritated by certain pieces included in this volume. I found especially difficult the way in which the participants of the Art Seminar frequently talked over each other, did not listen to their colleagues, were sometimes very vague and imprecise with regard to the sources and issues to which they referred, and, last but not least, launched bold and often unfounded statements. One such example, for instance, was the *ex cathedra* statement by Thierry de Duve that the best religious art nowadays is made by non-religious artists. However, my uncomfortable feelings about such remarks and ideas were gradually replaced by a strong desire to look for a system in the apparent chaos, so as to try to make sense of it. I think that this change in attitude had everything to do with the fact that I—as an anthropologist by training—am very much interested in such phenomena as religion, enchantment and disenchantment, aesthetics (or more precisely *aisthesis*), and art, especially in what is called the

Western world. One of the things, for instance, that interests me very much right now is the question of how anthropologists can profit from cooperating at least with certain artists in their quest to find more adequate ways, means, and methods to come to grips with their highly complex field of study, i.e., societies and cultures or—in my own jargon—the intricate interconnections between landscapes, manscapes, mindscapes, and sensescapes all over the world. In general, it is the differences or discontinuities between anthropologists and artists and their work that are emphasized, rather than the continuities or similarities.

Elkins and Morgan's project has generated a host of interesting problems and puzzles that deserve a more prominent place on the agenda of all scholars with an interest in the study of the relation between religion and art. In what follows I will present a few reflections that might be relevant for the development of an approach that seeks to bring the main protagonists somewhat closer to each other than they appear to be now. Between some of them the gap seems to be insurmountable: between, for example, certain art historians and scholars studying religious imagery.

Let me start with the following observation. Bringing together representatives of different disciplines with a request to present viewpoints on the relationship between art and religion *tout court* is in a sense asking for trouble, for it will lead to exactly what clearly happened in this particular case: a salient confusion of tongues and a retreat onto one's own turf. Instead of a rapprochement, one witnesses an alienating hammering out of the necessity of defining the phenomena under discussion in one way or another, preferably the way embraced by the community of discourse to which the protagonist belongs. One of the first things one discovers is the fact that sharing terms and concepts, even among close colleagues, does not mean agreement upon their content. On the contrary, the strategy that is generally chosen to escape this predicament implies the summing up of what one considers (on the basis of the language game or discourse with which one is familiar) to be essential features of the phenomenon under review and then to sell this package of features to one's audience. In itself this is an acceptable procedure, but often it becomes unacceptable and even counter-productive because the person who presents it proclaims it to be the one and only way to define,

for example, art or religion. In other words, definitions are vested with truth claims. What happens at this point is often exactly what one wants to avoid: the retreat into the safety of one's own domain, or the raising of the bridge. In cases like this I think that it might be more fruitful to look in a much more relativistic way at one's own definition, as one amongst a host of possible others, for that would open up vistas of a promising cooperation. In a sense this is a plea for accepting a more ethnographically oriented attitude towards the language use of colleagues with different disciplinary backgrounds; for this will push into the background the presentation of specific definitions of crucial concepts as *the* definitions and the accompanying inclusion and exclusion and hierarchization of scholars who do or do not accept them. This will also stimulate a more grounded comparison of both the family resemblances and differences between the definitions or meanings circulating among the members of different scholarly communities. In short: working with sensitizing concepts instead of nominalistic and/or essentialistic definitions designed by a particular discipline, as observable in the Art Seminar, which do not fit in with the conceptions of others inside and outside academia, is in my view the only way that can yield more and deeper insights into the connection between what is called art and religion. Looking at the nature of the scholarly field interested in exploring this connection, one sees a figuration of tribes, each of which is coming in on the production of imagery and objects directly or indirectly related to what is called religion from a different angle. I see at least three of these tribes.

First, there is the tribe of the art historians and philosophers of art working at universities, in museums, and art galleries. Many members of this tribe have rather strict opinions about what they consider to be art and artists. Only the work of people that stay in the modern tradition of the Enlightenment and avoid expressing religiosity in their imagery, objects, and performances—which is not to say that they are not allowed to use elements of the iconography of certain religions, for they are, but under certain conditions—is considered to be real art and therefore a legitimate object of study, collection, and exhibition. All the rest, produced after the process of disenchantment of the world that began in the second half of the eighteenth century, is considered to be dubious art or no art at all,

whatever its producers and consumers might think or say about it. This is a rather exclusivist attitude.

The second tribe consists of scholars engaged in visual studies. They do not exclusively devote their time and energy to studying the type of imagery considered to be real art by the members of the first tribe, but they also deal with all kinds of other imagery, whether religiously inspired or not. They are interested in tracing the meaning of the products of both artists in the strict sense of the word and others, some of whom might perceive themselves as artists and be perceived as such by a particular public or category of consumers. The focus here is rather different, although there are overlaps. Religion, or more specifically religiosity, does not seem to figure as a criterion for the inclusion or exclusion of certain imagery as a legitimate object of study: rather, the opposite. In this case the chain "enchantment–disenchantment–re-enchantment" does not function as a filter or a basis for the demarcation of the field of study, but more as a sensitizing tool that can be helpful for reaching adequate interpretations.

The same seems to hold true for the representatives of the third tribe, who are interested in charting, describing, and analysing the production and consumption of a broad range of objects and imagery related to particular religions as well as of the variegated practices connected with them. For the members of the first tribe many, not to say most of these might not be qualified as art, but should be seen as outright kitsch or, at most, popular art, even if their makers consider themselves to be artists and are considered as such by a broad public. Take, for example, the stained-glass windows made by Manessier. The religiosity that forms one of the sources that, alongside others such as a specific color theory, led to the production of these windows, is seen by a lot of art historians as an insurmountable obstacle to classifying and evaluating it as real art. They therefore exclude it as a serious object of study. Apart from the fact that this is strange against the background of their attitude towards the work of such religiously inspired persons as Bellini and Bach, which they consider not kitsch but high art, it leads to a rather arbitrary drawing of boundaries between their field of study and that of the other two tribes, especially the third one. Reading the statements of some participants in the Art Seminar, I got the impression that the members of

the first tribe fear that their turf might be undeservedly intruded and even contaminated by the members of the third, because the latter try to smuggle (cleverly camouflaged) things onto it that according to their introvert definitions should not be called art at all. From a sociological point of view this smacks of an effort by an established group to keep academic newcomers exploring a vast and important but neglected field in an outsider position.

The point I want to make on the basis of this—admittedly—rough sketch is as follows. Presenting and defending outspoken essentialistic and/or nominalistic positions with strong moral overtones regarding art and religion is problematic, because it will obstruct the road to a fruitful study from different angles of the ways in which all kinds of people, both religious and non-religious, have tried and are still trying to make visible the invisible using a wide variety of images and objects. To start from the idea that it became possible with the onset of the Enlightenment to make a distinction between non-religious modern art and non-art, which is all images, objects, and even performances based on "smuggled in," "camouflaged," or even outright religiosity, is not only disputable because it leads to an unrealistic way of classifying. It is also problematic because it rests on the dubious assumption that the Enlightenment led to the decline of religion, or at least a retreat into the private sphere and a clear-cut separation of art from religion. This secularization has been more a specific form of wishful thinking by a certain part of the intellectual elite in the Western world than a hard and proven fact. This is not to say that the role and significance of (institutionalized) religion, belief, and faith has not changed over the last few centuries, but they have never disappeared from the stage. On the contrary, in the last few decades religion and spirituality have flourished and prospered all over the world as never before. However, defenders of the idea of a widespread secularization often like to point out that the development of the sciences triggered a rapid process of disenchantment and that this process is still going strong. Instead of using this misleading perspective, one would do better to recognize that magic and modernity, enchantment and disenchantment do not exclude each other, but are inextricably intertwined twin processes that more or less color our ways of experiencing, approaching, and (re)presenting the world and the wider universe of which it

is part.[1] If one is prepared to acknowledge this, it is possible to escape suffocating classifications and evaluations that blind us to the fact that art and religion are not mutually exclusive categories or phenomena, but rather frequently presuppose each other in one way or another. We would then no longer need such lopsided and biased terms as "smuggling in" and "camouflage." A less sharp demarcation on the grounds mentioned would not only do more justice to what seems to be a widespread reality, but also to what people themselves claim with regard to the religious and/or artistic nature of the imagery and objects they produce, as well as to what the consumers other than scholars researching them think and feel in facing them. In this respect one cannot but conclude that the members of the first tribe take a rather exclusivist and non-sociological stand, which is far removed from the viewpoints and experiences of both producers and consumers. That the aesthetic criteria as formulated by the former more often than not differ considerably from the criteria used by the latter does not need to be a problem as long as they are considered in relation to each other. However, it really becomes a problem, at least in my view, when this does not happen and the criteria of producers and consumers are discarded as invalid. This would imply the neglect of particular dimensions of imagery and objects because they are perceived as irrelevant on scholastic grounds.

A possible way out of this trap might be the use of the (sensitizing) concept "theo-aesthetics" coined by Van Schepen and launched in his contribution to this volume, for it refers to a particular state of "grace" or "the conjunction of theology and aesthetics" in the experience of a specific type of imagery, in this case modernist art. Although the concept is meant to cover both the aesthetic appreciation and in its wake experiences of the sublime and transcendence of its consumers, I do not see why it could not be used to catch the implicit or explicit intentions of the producers to create something in which both phenomena (the religious or spiritual and the aesthetic) are contained or expressed. If the members of the three tribes, and especially art historians, art critics, and art theorists, were to decide to embrace the term of Van Schepen in a sensitizing sense in their research and studies, this could signal the disappearance of many of the communication problems (originating from rigid definitions of art and religion on debatable grounds) between them and open up

vistas for a constructive cross-fertilization and cooperation. Moreover, it would place center stage the rich and highly variegated empirical reality of all kinds of imagery, objects, and performances, their production and consumption by a wide range of people with varying goals (religious and/or aesthetic), instead of a rather sterile and stubborn (academic) struggle regarding the demarcation of fields and phenomena. History has taught us that such demarcations are an easy prey for the tooth of time and, more importantly, artists are the first to make them obsolete and even ridiculous. Take, for example, the elevation of so-called kitsch or ordinary appliances and garbage to the status of high or fine art, which not only shows the evanescent nature of classifications and criteria, but also the relevance of framing. Pondering the texts brought together in this volume, I cannot help but conclude that in spite of the fact that both tendencies—a centrifugal and a centripetal one—can be signalled in the whole corpus, though differently emphasized, the one I deem the most promising for future research, the second, seems to be dominant. It may be, however, that this is a case of the wish fathering the thought.

I now want to briefly sketch and reflect on another point that occurred to me with regard to the main issue of this book: the relation between art and religion. This point refers to the crucial importance of the contested field of imagery and objects made by people who explicitly call themselves artists and who express in an aesthetically appealing and explicit or implicit way their religiously or spiritually inspired thoughts and feelings. Sometimes they express these thoughts and feelings by using religious iconography in an orthodox or unorthodox manner. This is not always the case, however, as many of them, for example Manessier, work with rather abstract—not to say, "camouflaged"—forms and patterns. I deem this field to be of great importance because it confronts us with puzzles regarding the agency of imagery and objects. In other words, these objects raise the question of what they do with us in a positive or negative sense: how they touch us in a healing, disturbing, or even sick-making way. My former teacher, the anthropologist Jan Van Baal, who had a great interest in religion and art, emphasized long ago how both illusions, as he called them, functioned as a means to help human beings overcome feelings of alienation, and to restore their bond with the world or the wider universe. Just like having a

religion, "[t]he enjoyment of art leads the subject back to its universe to be incorporated in it," he once remarked.[2]

However, like so many people studying artistic imagery and objects, whether inspired by religion or not, Van Baal forgot to pay attention to the fact that the aesthetic and/or religious experiences generated by these "things" in the consumers is not only a highly spiritual affair, but also and maybe even more a somatic or bodily phenomenon. It is remarkable that this dimension does not figure in this book. The fact that it is left out or overlooked as relevant is no small wonder, for both religion and art have long been associated with spirituality and aesthetics: with matters of the mind, and not so much with the body and how it functions in relation to such concrete things as paintings and sculptures. The neglect of the body as the basis of our experience of these artistic creations in particular and the world in general is all the more striking given that the crucial notion of aesthetics goes back to Aristotle's concept of *aisthesis*, which explicitly includes the body and all our sensorial sensations, not only the visual one so much emphasized in the appreciation of art and everything to which it bears a family resemblance.[3] Although Baumgarten introduced the "aesthetica" in the middle of the eighteenth century as the science of sensory cognition in the classical sense, it developed into a science of the beautiful and the philosophy of art: further and further away from the Aristotelian conception or, more important here, the body in its relation to such things as statues, sculptures, and paintings, as well as to such events as performances. How important the body is becomes very clear when people are confronted with imagery and objects presented as art that do not represent what they have learned to literally incorporate as representations of the sacred and holy and that, on the contrary, seem to mock such notions. I am talking here about what is known as blasphemous art. The often rather aggressive reactions this type of art triggers in specific categories of consumers cannot be understood unless one realizes that references to being hurt or wounded by it are not just metaphorical, but indicate that they are physically hurt, that their corporeally internalized format of the sacred and the holy is fundamentally disturbed. This format functions as a kind of corporeal yardstick each and every religious subject uses to measure everything by which he or she is touched through the senses. What I am

talking about here is not an aesthetics in the narrow "enlightened" sense of the word, emphasizing the role of the mind's eye in spotting beauty on the basis of perfection and harmony, but in the broader Aristotelian sense, accentuating the role of the whole sensitive body in engaging the world, which I deem more promising in studying the relationship between art and religion.[4] More promising, because the latter sensitizing conception of aesthetics does not lead to a rather dubious banning of, for example, a work like *Piss Christ* from the realm of modern art, as Thierry de Duve suggested in the Art Seminar, because its maker Serrano used "blasphemy as camouflage" in order to convert, which is "despicable on the aesthetic . . . level," but instead to constructive and grounded empirical research of the interaction between this controversial picture and its consumers. This is interesting, at least in my view, for it might help us to better understand what is going on when people are confronted with the imagery exhibited both in museums and galleries and in other contexts, for instance in religious arenas such as churches and chapels. In order to reach the kind of deeper insights at which I am hinting, I think that it is vital to take into consideration recent work by cognitive scientists trying to develop more insights into the embodiment in obtaining and using (religious) knowledge.

The initiative taken by Elkins and Morgan to put the relation between art and religion under the spotlight may signal an aesthetic turn, leading us away from unproductive border disputes over definitions, classifications, and evaluations of these ever-changing phenomena towards a really broad, interdisciplinary approach to the relations between people and imagery and how such imagery can not only physically disturb but has also the potency to physically and socially re-integrate.

Notes

1. See Meyer and Pels, for the claim that religion (or magic) and modernity do not exclude each other or represent two mutually exclusive ways of dealing with the world, or that the former is disappearing rapidly because of the expansion of the latter, as some supporters of the *Entzauberung-der-Welt* hypothesis state. Birgit Meyer and Peter Pels, eds., *Magic and Modernity: Interfaces of Revelation and Concealment* (Stanford: Stanford University Press, 2003).
2. "Aisthesis comprises more than just visual perception; it stands for general

perception with all the senses, as well as the impression that the perceived leaves on the body. In the original meaning of the concept, tactile and visual perception constitutes a whole, and it was not until later (e.g. in the Kantian tradition) that this meaning was reduced to merely an eye that observes without a body," eds., Maaike Bleeker et al., "Bodycheck: Relocating the Body in Contemporary Performing Art," *Critical Studies* 17 (Amsterdam and New York: Rodopi, 2002); see also, Jojada Verrips, "Aisthesis and An-Aesthesia," in eds., O. Löfgren and R. Wilk, *Off the Edge: Experiments in Cultural Analysis* (Copenhagen: Museum Tusculanum Press, 2006), pp. 29–37.

3. Jan Van Baal, *Man's Quest For Partnership: The Anthropological Foundations of Ethics and Religion* (Assen: Van Gorcum, 1981), p. 308.

4. In The Art Seminar, David Morgan spoke about the possibility of producing a taxonomy of different ways of seeing or different gazes by looking at how an object "is engaged by viewers, values, by histories." One of the types distinguished by him is "close seeing . . . where vision turns into touch, where one sees with one's viscera" or where work and reality "blur in a way that offends, embarrasses, revolts, horrifies, even nauseates the viewer," David Morgan, "The Critical View: Visuality and the Question of God in Contemporary Art," *Material Religion* 3, no. 1 (March 2007): 135–43.

THE NEXT STEP?

Erika Doss

Where do we go from here? What else remains in theorizing the subject of religion in the consideration of modern and contemporary art? As the editors of this volume argue, the "problem" of art and religion remains unsolved, and perhaps irresolvable. James Elkins remarks that theorizing the place of religion in contemporary art, which he posits as "among the most challenging subjects in the current writing on art," may well be impossible because of the ways in which the subjects themselves have been forced into separate disciplines, and considered on different terms. David Morgan similarly notes that the intellectual trajectory of scholars and historians who are interested in art and in the felt-life of religious imagery, in what he defines as art and visual enchantment, is exceptionally fraught because it does not "fit" within the "professional discourse on art." Likewise, while few of the participants in the Art Seminar held in April 2007 shared the same understandings of either art or religion, or seemed especially interested in testing (and/or expanding) their own assumptions about either subject, most agreed that theorizing religion in the consideration of modern and contemporary art was "problematic."

Yet as several members of the Seminar audience pointed out, and many of those who were invited to write assessments of the Seminar concurred, the "problem" itself has been too narrowly defined, and

too tightly confined, within limiting interpretations of religion, art, and modernism. In particular, anxieties about meaning—about the nuances of interpretation, the contexts of significance—overwhelm more efficacious approaches to the cultural work of religion, and the broader relationships between art and faith. Theorizing the subjects of modern art and religion begins with discarding limiting assumptions about both—especially those that insist on their binary opposition—in favor of more relevant, and critically ambitious, considerations of the felt life of faith, the material and visual dimensions of piety, and the affective dynamics of art. As Gregg Bordowitz remarked during the Art Seminar, "I am rethinking an inherited opposition between thinking and feeling. I am asking myself, how does sensation play a mediating role between thinking and feeling; how are affects produced? To think about these questions, I have to stretch my limits. I must open myself up to different lines of thought, different intellectual histories."

The "problem" of modern art and religion, in other words, and any promising (rather than merely contentious) level of discourse regarding their shared relationships and practices, requires both critical reconsideration of their (supposed) separation, and critical recognition of their affective realms and conditions. "Religion permeates the modern," Brent Plate asserts; indeed, modern art and religion are no more separate than art and affect. Those who insist otherwise, those who cannot even participate in this conversation because talking about art and religion at the same time is too "painful," are caught up in smug intellectual fictions of their own devising—if they also betray their deep discomfort with the admittedly affective dimensions of these subjects. As Sally Promey puts it: "For some involved in this conversation, and for some who decline to be involved, it would appear that devotees at the altar of art can tolerate no competing gods." Where do we go from here? Toward reconceptualization—itself a kind of re-enchantment—of the "problem" on more generous, less self-righteous terms.

Rethinking religion in modern and contemporary art includes opening up the field of inquiry. *Sublime Spaces & Visionary Worlds*, an exhibit organized in 2007 by the John Michael Kohler Arts Center (Sheboygan, Wisconsin), detailed how twentieth-century vernacular artists in America reworked gardens, houses, barns, abandoned lots,

and other built environments into transcendent spaces marked by the tenets of personal, private beliefs and prophecies. *Coming Home! Self-Taught Artists, the Bible, and the American South* (2004) similarly considered the religious impulses of various American folk artists including Howard Finster, Lonnie Holley, J. B. Murray, and Nellie Mae Rowe. *Elvis + Marilyn: 2x Immortal* (1994) centered on the global veneration of two leading popular culture icons, and featured hundreds of works of art by modern and contemporary artists, including Andy Warhol, Ray Johnson, Keith Haring, Alexis Smith, and Peter Halley. All three of these exhibits challenged paradigmatic assumptions of the separation of art, religion, and modernism.

Rethinking religion in modern art includes addressing the place of faith in the lives of modern artists: recognizing that Andy Warhol was Catholic, that Joseph Cornell was Christian Science, that Mark Tobey was Bahai. It includes retelling the story of modern art by remembering that New York's Guggenheim Museum originated as a temple of non-objective art that its first director, German-born baroness Hilla Rebay, envisioned as the "gospel of modernism." Writing in 1937, shortly after she exhibited the Guggenheim's core collection of abstract paintings by Kandinsky, Mondrian, and Moholy-Nagy in a Charleston, South Carolina art gallery that was especially patronized by a clientele that, like herself, followed the tenets of Theosophy, Rebay exclaimed how modern art "elevate[s] into the cosmic beyond where there is no meaning, no intellect, no explanation, but something infinitely greater—the wealth of spiritual intelligence and beauty."[1]

Of course, as Elkins argues, "adding" religion to the canon of modern art discourse is hardly enough: critics and historians need to further consider how—if—religion shapes and directs modern and contemporary art. What are the relationships between religious beliefs and rituals and the practice and production of art? How do images and objects embody, reveal, perform, and negotiate religious faith? What are the ways that religion visually "happens" in modern and contemporary art?

Re-imagining religion's contemporary visual presence includes expanded understandings of religion and art: recognizing how both often connect through what Plate wonderfully terms "iconomash," or the morphing of pluralistic, synchronistic, and multi-cultural

spiritual perspectives and art-making processes. Modern and contemporary artists draw on religious inspirations, practices, and rituals from all over the world; assumptions of a pervasive Christian, and particularly Protestant, influence are grossly uninformed.

At the same time, however, recognizing the real-time, real-life connections of contemporary art and religion requires further critical attention to how modern nations, and notions of nationalism, are deeply invested in both in order to sacralize their own operations and ensure public loyalty. Public art and architecture, like public rituals and ceremonies, are all forms of civil religion that help to mobilize particular forms of national consciousness, civic and social identification, and shared purpose. At a moment when American public culture and political rhetoric is increasingly dominated by divisive strains of Christian religious fundamentalism, the anxiety of some of the participants in the Art Seminar about the ideological terms of art and religion is completely understandable.

Developing a critical theory of art and religion further depends on recognizing where both happen, and how they are felt. Religion is not simply a matter of faith, or conviction, but of lived encounter and experience; likewise, art cannot be reduced to image or object but includes multiple structures of feeling and various levels of emotional and even physical response. Until relatively recently, anxieties about these emotional states, and deep worries about their anti-rational and manipulative dimensions, helped to perpetuate a kind of criticism that disavowed their significance and privileged seemingly more objective and conceptual approaches. Contemporary theorists including Lauren Berlant and Brian Massumi, however, propose affectivity as crucial to an understanding of the inseparability of thought and feeling, and further refuse the bracketing of creative, cultural, and social exeriences.[2] The implications of such refusals are crucial for the theorization of art and religion: put simply, both subjects are visual, material, intellectual, and emotional bodies whose social, cultural, and political significance cannot be adequately considered without a simultaneous appreciation of their affective nuances. Critical discourse that pursues these approaches may well generate the sort of creative and compelling analysis that the "problematic" subjects of art and religion sorely deserve.

Notes

1. Hilla Rebay quoted in Eleanor Heartney, "Hilla Rebay: Visionary Baroness," *Art in America* (September 2003): 112.
2. See, for example, Laurent Berlant, "Critical Inquiry, Affirmative Culture," *Critical Inquiry* 30 (Winter 2004): 445–51, and Brian Massumi, *Parables for the Virtual: Movement, Affect, Sensation* (Durham: Duke University Press, 2002).

6
ENVOI TO THE *Art Seminar* SERIES

ENVOI

James Elkins

It isn't customary for series editors to write something at the end of the series, but in this case the temptation is overwhelming. This series has been a fascinating experience. The idea was to invite a wider range of contributors on each subject than had been assembled in the past, in order to reveal the new diversity of art discourse. I was impelled in the first instance by a growing sense that certain models of poststructuralist criticism were no longer making headway with some of the crucial concepts of art. In particular I wanted to move away from the kind of art theory that has been practiced since the 1960s, in which the contributors to conferences and edited volumes are all roughly agreed on the protocols of interpretation, so that despite appearances of dialectic and disagreement, all that actually remains is to investigate agreed-upon problems in an increasingly formulaic manner. I wanted to open the way to a more divergent and flexible discourse.

The structure of the series was intended to maximize open-endedness: my role in these volumes has been to help pick the panelists in the roundtables, and to try to moderate in such a way that the panelists' concepts, methodologies, and purposes are as clear as possible. Preparing the transcribed Art Seminars was an excruciating process. I did all the transcriptions myself, and then each panelist was invited to edit his or her own contributions and add new comments,

resulting in multiple drafts and revisions. But when the Art Seminar transcripts were complete, my involvement effectively ended. I chose some of the people who wrote Assessments and Afterwords, but my co-editors and the panelists themselves came up with most of the names. No one edited what the Assessors wrote, so there was no way to control the form or direction of the books. Each book was meant to reflect the disarray of its subject as accurately and thoroughly as possible.

When the series was planned, I imagined that the books would be full of concerted critical encounters in the manner of, say, *Critical Inquiry*, but more wide-ranging. I expected contributors to argue with the panelists' positions, developing and extending the conversation. I thought the panelists' questions would be sharpened, their assumptions undermined, their frames broken, their ideologies revealed—all the usual elements of intellectual discourse.

What happened was of a different order. Instead of disagreements, these volumes are full of contributions that choose to ignore not only specific claims and influential scholars, but also entire disciplines and schools of interpretation. The Assessors talk past one another, and past the panelists, carrying on different conversations and creating divergent discourses that cannot be compared or adjudicated.

Here are examples from each volume. (The descriptions of Volumes 1 through 4 are paraphrased from an exchange published at the end of Volume 4; these comments do not reflect the opinions of my co-editors in these books.)

Volume 1, *Art History versus Aesthetics*, has a particularly wild roundtable conversation. Afterward, Arthur Danto said it was like herding cats. Yet the sources of that wildness, and the kinds of misunderstandings between art history and aesthetics, were clearly articulated. In that respect the book is very arguable; it is largely possible to compare the different positions its contributors take. Danto, Jay Bernstein, Thierry de Duve, and many others in that book argue very sharply and it is not hard to discover productive points of disagreement. Of the books, it is the least like the model I am proposing.

Volume 2, *Photography Theory*, has deep disagreements about what a theory of photography might be, and some pitched arguments

between Joel Snyder and Rosalind Krauss about Peirce's concept of the indexical sign. Some people who wrote Assessments for that book seemed completely to miss the point of trying to articulate a theory of photography at all. They talk about other things instead, and there's the argument—which Walter Benn Michaels dismisses in an endnote—that you shouldn't try for a theory of something like photography that isn't a single subject. (Michaels says, of course you should.) Other contributors misunderstand the claims about indexicality, in often definable ways. But most contributors choose not to join the debate except in passing, and a number do not say why they do not have a position on indexicality, and also do not say why they think it is unimportant that they do not have a position.

Volume 3, *Is Art History Global?*, raises some very serious questions to do with whether art history is Western, and how one might think outside the boundaries of Western historical thinking. As in Volume 1, the species of disagreements in Volume 3 are themselves well defined. For instance, there is David Summers' position that Western concepts can be made capacious enough to address experiences of art across many cultures. Against that there are doubts about how universal art experiences are, how limiting Western languages and metaphysics might be, and how blinding Western institutions might be. As in the first volume, the problematic is not about to be resolved, but the species of disagreement are themselves agreed upon. A deeper disagreement, however, is scarcely broached: it would be between those who think that local ways of writing art history are helpfully diverse but potentially legible as art history, so that local practices will appear as contrasts within a larger discursive field; and those who feel, or hope, that no such legibility exists. That divergence of opinion is implicit in contrasts between people's arguments, but the book does not directly provide material that would allow the question to be developed.

Volume 4, *The State of Art Criticism*, is incoherent in a different way. For example, there is an enormous range of ideas here about whether art criticism has a history. For some people, like Dave Hickey, art criticism's history is comprised of whatever creative writers the critic likes. (Hickey names Hazlitt, DeQuincey, Dickens, Wilde, and others.) For others, like Steve Melville, by its very nature art criticism doesn't have a history, because it depends on the

individual act of judging. The range of ideas about whether art criticism has a history is itself much broader than the range of opinion about, say, the index in photography, or aesthetic terms in art history. It is a deeper incoherence. And *The State of Art Criticism* harbors an even more difficult difference, which most every contributor notices but hardly any think is worth pursuing: the difference between critics who see their purpose as rendering judgment, and those who take art criticism as a place to meditate on the conditions under which critical judgments might be made. To me that is an astonishing gulf, and it is not bridged by anyone in the book.

Volume 5, *Renaissance Theory*, had a compact seminar conversation, which elicited Assessments that have a wide range of elisions. In the panel discussion, a principal theme was the lack of engagement of modernist art historians with possible Renaissance precedents, and the complementary lack of interest, on the part of Renaissance scholars, in modern artists' responses to Renaissance art. That issue was hardly addressed in the Assessments, leaving the impression that a conceptual and institutional gulf might separate modernist from Renaissance art history. On a smaller scale, Georges Didi-Huberman was brought up in the Art Seminar, but scarcely mentioned in the Assessments. (Excepting one Assessment, which was intended as an embodiment of Didi-Huberman's approach.) A number of the Assessments keep closely to the contributors' own specialties, so that their responses to the Art Seminar are often only implicit. There is relatively little direct engagement with the Art Seminar in the book. My feeling, overall, is that Renaissance studies is somewhat isolated from other branches of art history, and that its isolation is not comparable to the relations between other specialties: the Renaissance has an inbuilt reason for its disconnections.

Volume 6, *Landscape Theory*, sports a mass of disagreements and indecisions on fundamental issues. At the beginning of our panel discussion, we quickly agreed that landscape is not *only* ideological. But that led us immediately into a wonderful confusion. What is landscape, aside from ideology? There were as many answers as there were panelists in the Art Seminar. The same thing happened when we talked about the role of aesthetics, and again when the subject was space and time in landscape, the connection of landscape and representation, landscape and subjectivity, and landscape and place. I

counted seventeen terms, any of which could be regarded as funda-
mental, on which there was little agreement. Of the volumes in the
series, *Landscape Theory* is the most like a contestation of phil-
osophies built on incompatible premises.

Volume 7, *Re-Enchantment*, is potentially the widest ranging of
the series, and that is why it is last. As you will have discovered
reading this book, the fundamental issues at stake, such as the pres-
ence or absence of religious meaning and the very definitions of fine
art, are contested among an unusual range of writers, scholars, and
artists inside and outside academia. Despite David Morgan's and my
best efforts, several scholars refused to participate in the book under
any terms: the sign of a field where dialectic exchange seems so
remote a possibility that only refusal remains.

What conclusions might be drawn from this? If the *Art Seminar*
series is an indication, pluralism is not an adequate way to character-
ize the way art is currently conceptualized. What happens in these
books is more like a mixture of several kinds of encounters: dialectic
exchanges, *Critical Inquiry*-style, in which the operative terms are
shared and there is broad agreement about what constitutes the
terms' problematic or undefined elements; persistent misunderstand-
ings that are not corrected or meliorated by professional exchanges
such as conferences or reviews; and many individual refusals to come
to terms with other people's positions. Let me call those three possi-
bilities critical discussions, misunderstandings, and refusals. The
Art Seminar series suggests that critical discussions are not the bread
and butter of professional academic exchanges, as I think they are
assumed to be: instead they are the exception, and in some instances
they are rare. The series also shows, I think, that misunderstandings
(the second kind of encounter) are more persistent than they might
be thought to be. A number of writers in the series show evidence
of misreadings that have not been effectively challenged, and are not
likely to be adequately addressed in the future—either because
scholars lack the time for the kind of extended engagements which
could disabuse others of long-held interpretations, or because it
can come to seem that entire interpretive projects and careers are
founded on formative misreadings, which then become unrewarding
topics of discussion. And the series shows, I think unarguably,
that what I am calling refusals (the third kind of encounter) are

very common, and in some cases the most prevalent sort of academic exchange.

I am not criticizing these phenomena. For some contributors to this series, a state of affairs like the one I have sketched would call for concerted critical work. The idea would be to try to disentangle critical discussions, meliorate misreadings, and challenge refusals. But I think the art world is more or less immune to that kind of effort. That also means that art theory can no longer hope to produce the kind of loose critical consensus that surrounds the reaction to modernism epitomized by poststructuralism and *October*. It is a truism of poststructural criticism that the search for overarching theories should be abandoned, and at any rate consensus wasn't one of the purposes of the *Art Seminar*. But the disarray I am describing here is different from the pluralism and anti-hegemonic interests associated with poststructuralism: this disarray is caused by *lack of interest* in sustained critical discussions. For me, one of the discoveries of this series is an agnosticism in relation to argument, enabled by the conviction that critical discussion is always available, prevalent, potentially effective for anyone who might want it.

As I write this, I am beginning a five-book series based on events called the Stone Summer Theory Institutes at the Art Institute of Chicago. I hope to refine the *Art Seminar* model so that it can handle even more complex species of critical discussions, misunderstandings, and refusals. What matters is to continue trying to understand what art theory might mean today, and what kinds of work we want our leading theories to accomplish.

NOTES ON CONTRIBUTORS

Gregg Bordowitz is a writer and filmmaker. His films include *Fast Trip Long Drop* (1993), *A Cloud In Trousers* (1995), *The Suicide* (1996), and *Habit* (2001). He is the author of *The AIDS Crisis Is Ridiculous and Other Writings 1986–2003* (2004). Bordowitz is an Associate Professor in the Film/Video/New Media Department at the School of the Art Institute of Chicago and he is currently a guest professor at Die Akademie der Bildenden Künste Wein.

Wendy Doniger [O'Flaherty] graduated from Radcliffe College and received her Ph. D. from Harvard University and her D. Phil. from Oxford University. She is the Mircea Eliade Distinguished Service Professor of the History of Religions at the University of Chicago and the author of many books, most recently *The Bedtrick: Tales of Sex and Masquerade, The Woman Who Pretended to Be Who She Was*, and a new translation of the Kamasutra. (don8@midway.uchicago.edu)

Erika Doss is Professor and Chair of the Department of American Studies at the University of Notre Dame. She is the author of numerous publications, including *Benton, Pollock, and the Politics of Modernism: From Regionalism to Abstract Expressionism* (1991), *Elvis Culture: Fans, Faith, and Image* (1999), and *Twentieth-Century American Art* (2002). She is currently writing two books, *Memorial*

Mania: Self, Nation, and the Culture of Commemoration in Contemporary America and *Picturing Faith: Twentieth Century American Artists and Religion.* (doss.2@nd.edu)

Thierry de Duve is professor at the University of Lille 3. His books include *Pictorial Nominalism: On Marcel Duchamp's Passage from Painting to the Readymade* (1991) and *Kant After Duchamp* (1996). He curated "Voici—100 ans d'art contemporain" at the Brussels Palais des Beaux-Arts in 2000 (English: *Look! One Hundred Years of Contemporary Art* [2001]), and the Belgian Pavilion at the 2003 Venice Biennale (shared by Sylvie Eyberg and Valérie Mannaerts). (thierry.de.duve@skynet.be)

James Elkins is E. C. Chadbourne Chair of Art History, Theory, and Criticism at the School of the Art Institute of Chicago. His books include *On the Strange Place of Religion in Contemporary Art* (Routledge, 2004), *Visual Literacy* (ed.) (Routledge, 2007), and *Visual Practices across the University* (ed.) (2007). (jameselkins@fastmail.fm)

Boris Groys is Professor of Aesthetics, Art History, and Media Theory at the Academy of Design/Center for Art and Media Technology in Karlsruhe, Germany, and Global Distinguished Professor at the Faculty of Arts and Sciences, New York University. He has authored numerous books, including *Logik der Sammlung* (1997), *Unter Verdacht. Eine Phänomenologie der Medien* (2000), *Topologie der Kunst* (2003), and *Ilya Kabakov: The Man Who Flew into Space from His Apartment* (2006).

Kajri Jain teaches South Asian visual culture and contemporary art at the Centre for Visual and Media Culture and the Graduate Department of Art at the University of Toronto. Her publications include *Gods in the Bazaar: The Economies of Indian Calendar Art* (2007) and articles on popular prints, film, television, art, and modern Hinduism. Her current research is on monumental religious statues in contemporary India.

Tomoko Masuzawa is Professor of History and Comparative Literature at the University of Michigan. She is the author of *The Invention of World Religions: Or, How European Universalism was Preserved in the Language of Pluralism* (2005) and *In Search of Dreamtime: the*

Quest for the Origin of Religion (1993). Her current publication projects include a monograph entitled *The Promise of the Secular* and an edited volume, *Genealogies of the Study of Religion.* (masuzawa@umich.edu)

David Morgan is Professor of Religion at Duke University. Author of *Visual Piety* (1998), *Protestants and Pictures* (1999), *The Sacred Gaze* (2005), and *The Lure of Images* (Routledge, 2007), Morgan is also co-founder and co-editor of *Material Religion,* and has recently edited and contributed to a volume entitled *Key Words in Religion, Media, and Culture* (Routledge, 2008). (David.Morgan@duke.edu)

Randall K. Van Schepen is an art and architectural historian at Roger Williams University in Bristol, Rhode Island. His publications include essays on Marcel Duchamp (*Art Criticism,* 1992), Leo Steinberg (*Art Criticism,* 1993), Clement Greenberg (*Art Criticism,* 2007), Walter Benjamin, Gerhard Richter, and Sherrie Levine (*InterCulture,* 2007), and Eric Fischl (*Aurora: The Journal of the History of Art,* 2008). (rvanschepen@rwu.edu)

Jojada Verrips is emeritus professor of European Anthropology at the University of Amsterdam. He has written and edited a number of books in Dutch and is currently working on a book entitled *The Wild (in the) West.* His main interests are anthropology and religion, anthropology and (abject) art, aisthesis or aesthetics as an embodied and embedded phenomenon, anthropology of the senses, blasphemy, cannibalism in the Western world, maritime anthropology, vandalism, and violence.

Taylor Worley serves at Union University as Instructor of Christian Studies and Special Assistant to the Dean of the School of Christian Studies and is completing a PhD thesis at the Institute of Theology, Imagination and the Arts at the University of St. Andrews on the topic of potential areas of dialogue between twentieth-century theology and modern and contemporary art. (tworley@uu.edu)

INDEX

Addison, Joseph 59–60
Adorno, Theodor 60–61
aesthetic contemplation 33
agnosticism 166
aisthesis 287–88, 294
ambivalence 162–63
American Academy of Religion 197, 203
Anderson, Benedict 27
anthropology 141, 144–45, 270–72
Apostolos-Cappadona, Diane 237–39
art: definitions of 87–88, 147–48; moral theory of 29; redemptive power of 35; religious 69–71, 113, 161–62, 172–73, 219, 261–62; sacralization of 16, 32, 34, 164–65; *see also* kitsch; Romantic theory of 34; and market 14, 152; *and* psychology 122–23; *and* ritual 138–39; *and* therapy 18, 39, 159; *see also* spiritualization of art
art worlds 140–41, 147, 172, 176, 195
artist as prophet 39
Ater, Renée 224
aura 165–66
avant-gardism17 39, 145, 160

Bach, Johann Sebastian 154
Bachelard, Gaston 204
Bacon, Francis 257
Bakhtin, Mikail 155
Barr, Alfred 228
Barthes, Roland 110
Baskind, Samantha 244–49
Bataille, Georges 137, 149, 155
Baumgarten, Alexander 32, 294
Baumgarten, Jens 249–55
beauty 29, 33, 52–54
Beckett, Sister Wendy 69
belief: *and* faith 131–32, 157, 168–69, 195, 204–05, 233–34, 238, 242; reduction of religion to 132; as false consciousness 131; *see also* agnosticism; doubt
Bell, Clive 35
Bellini, Giovanni 154, 199–200, 290
Belting, Hans 72, 116
Benjamin, Walter 165, 226
Berensen, Bernard 34
Berger, John 145
Berlant, Lauren 300
Bersani, Leo 174

Besançon, Alain 73, 121
Bidlo, Mike 95–96
Biles, Jeremy 187–92
blasphemy 148, 155–57, 232, 294
Blocher, Sylvie 102, 104, 106n15
Blumenberg, Hans 265
Böhme, Jakob 120
Bordowitz, Gregg 19, 117–18, 122–23,
134–36, 142, 146–47, 151–53,
159–60, 162–64, 178, 192, 200, 203,
218, 227, 232, 236, 241, 244, 267, 279,
298, 311
Borofsky, Jonathan 209
Bourriaud, Nicolas 158
Brown, Dan 195
Brown, David 255–58
Bourdieu, Pierre 221, 278
Buddhism 258–61
Burgess, Brian 215
Bush, George W. 155

Calvinism 3, 5
camouflage 141, 143, 149, 151, 171,
189–90, 219, 264
Caputo, Jack 158
Caro, Anthony 58
Casey, Edward 268
Castenada, Carlos 16
Chan, Paul 151–52
Chesterton, G.K. 228
Cho, Insoo 258–61
Christianity 40, 97–99, 103, 125, 153,
157, 212, 252; Council of Trent 125,
156; Orthodox 89; Spanish
Inquisition 200, 202; Western
251–52
Clark, T.J. 50, 72, 77n8, 110–12, 118,
141, 175, 196–97, 263, 278
Clifford, James 139
Cole, Thomas 38
Confucianism 258–59
Cooper, James 39
Cornell, Joseph 299
Courbet, Gustave 39, 118

Count of Stolberg, Friedrich Leopold
6–7
Crary, Jonathan 274

Danto, Arthur 87–88, 93, 110, 167
Daoism 204, 258–59
Darwin, Charles 80, 114
David, Jacques-Louis 28, 175
Dawkins, Richard 190
death of God 177
death of painting 177–78
DeBoer, Lisa 217–19
De Certeau, Michel 158, 190
De Duve, Thierry 19, 51, 73, 75–76,
87–106, 113–15, 126–27, 130–35,
148, 153–57, 160–62, 188, 198–99,
226–27, 233–34, 239, 242, 244, 247,
256–57, 262–63, 266, 278–79
democracy 27–28
Derrida, Jacques vii, 174, 190
Desmond, William 234
Diderot, Denis 54
Didion, Joan 11, 12
digitalization 119–20, 170
disenchantment 3–9, 12–13, 17, 203,
250–51, 289–92; see also secularism;
secularization; Enlightenment
disinterestedness 9, 32, 50–53,
65n19
Dissanayake, Ellen 205
Doniger, Wendy 19, 116, 137–38, 141,
189–90, 193, 196, 206–07, 239, 273,
279, 311
Doss, Erika 208, 297–301, 311–12
doubt 167–68, 242
Dreier, Katherine 35, 237
Drucker, Johanna 48–49
Dubuffet, Jean 207
Duchamp, Marcel 35, 93–96, 101–05,
237
Durkheim, Emile 135, 191, 270
Dyrness, William 228–29

Edwards, Jonathan 51, 54, 60–62

Eliade, Mircea 138, 140–41, 189–91, 204, 206
Elkins, James vii–x 18, 19, 69–78, 110–12, 143–44, 148–50, 152, 158–59, 173–76, 189, 192, 195, 198, 202, 207–8, 212, 217, 225, 231, 237, 240, 244–45, 269, 289, 297, 312
Elliot, T.S. 49, 50
El-Said, Issam 211
Emerson, Ralph Waldo 36–37, 268
empathy 37
enchantment 11, 37, 215–17; and art 13–14; as magical thinking 11; in the social sciences 11–12
Enlightenment, the 4, 13, 16, 39, 49, 79, 114–16, 118–19, 124–25, 129, 188, 193–94, 215, 233–34, 239–41, 250–51
essentialism 87, 124, 263
exhibitions: Fourth Berlin Biennial for Contemporary Art 155; Heaven 209; High Times, Hard Times 178; Iconoclash 209; Negotiating Rapture 209; 100 Artists See God 166, 209; Société Anonyme 35, 237; Whitney Museum Biennial 151–52
existentialism 172, 206

Fabre, Jan 175–76
feminism 142, 144, 267
fetishism 150–51
Finster, Howard 207, 299
Fluxus 167
Foucault, Michel 79, 117, 118, 253
French Revolution 29, 163
Freud, Sigmund 100, 116, 130, 187–88, 191, 240; the uncanny 187; see also psychoanalysis
Fried, Michael 47–52, 57–58, 61–63, 110–12, 278; "Art and Objecthood" 47–49, 61; theatricality 53–54; Three American Painters 67n43
Friedrich, Caspar David 37, 38
Fry, Roger 274

fundamentalism: see Protestantism; religion

Gablik, Suzi 15–17, 71, 111, 202
gaze vii–viii 296n4; ethnographic 145; ways of seeing 173
Gauchet, Marcel 5, 96–97, 103, 126–27, 256
Geertz, Clifford 139
Gellner, Ernest 5
gender 142
genealogies, historical 130, 170
German Idealism 29, 33–34
ghosts 9–10, 11, 187
Gibson, Mel 84
Giraradot, Norman 200–08
Gober, Robert 102
Godard, Jean-Luc 96
Gombrich, Ernest vii, ix
González-Torres, Félix 156
Goodman, Nelson 278–79
Gordon, Douglas 155, 257
Greenberg, Clement 48, 55, 114–15, 120, 153, 174, 234, 278
Greenfeld, Liah 28
Grewe, Cordula 261–66
Groys, Boris 18, 79–85, 88, 90, 92, 119–20, 129, 137, 155, 164–65, 203, 244, 268–69, 312

Habermas, Jürgen 146
Hamilton, Kevin 219–22
Harries, Karsten 77–78n8
haunting 5, 187–88, 235
Hauser, Arnold ix
Hawthorne, Nathaniel 10
Haynes, Deborah 266–69
Heartney, Eleanor 269
Hegel, G.F.W. 27, 33, 36, 40, 55–56, 112–13, 117, 249–50; Aesthetics 36
Heidegger, Martin 117, 120–22, 238, 277
Heller, Ena Giurescu 229–32
Heltzel, Peter 136–37

Herder, Johann Gottfried 27, 66n31
Hickey, Dave 110
Hinduism 112, 145, 157, 161, 279
Holbein, Hans 257
Howes, Graham 243–44
Hume, David 135–36

iconoclasm 14, 148, 150, 175, 210
icons 74, 91, 119–20
iconomash 210, 299
idols 3–4, 171
imagination 9, 34, 37, 67n48, 191–92
installation art 151–52, 164–66, 176,
 267–68
interestedness 50
iPod 146
Iran 258
Islam 202, 211, 258

Jain, Kajri 19, 112, 128, 145–46, 157,
 170, 198, 252, 312
Jakobsen, Janet R. 193–94
Jarves, James Jackson 36
Jefferson, Thomas 28
Jeanneret, Charles-Édouard (Le
 Corbusier) 93–94, 96, 161, 257
Jensen, Robin 235–37
John Paul II, Pope 228
Johns, Jasper 101
Jones, Amelia 95–96, 97
Joseph, Saint 102–03, 131–32, 143
Judaism 3–4, 98–99, 152–53, 173, 212;
 and art 245–49
Jung-Hwa, Choi 260

Kahn, Toby 246–48
Kandinsky, Wassily 15, 17, 35, 72, 73,
 121, 227
Kant, Immanuel 27, 33, 51, 53–54, 59,
 67n48, 73, 103, 134–35, 249–50;
 Observations on the Feeling of the
 Sublime and Beautiful 27
Kaplan, Mordechai 245
Kapoor, Anish 191

Karmel, Pepe 269–70
Kelly, Mary 142
kenosis 166–67, 174
Khakhar, Bhupen 161
Kiefer, Anselm 37, 158, 209, 243
Kierkegaard, Soren 88, 137, 157, 238
Kitagawa, Joseph 198
kitsch 113, 152, 175–76, 188, 218, 237,
 272, 293
Knox, Israel 55, 68n48, 68n53
Koerner, Leo 175
Kolakowski, Lesek 12–13
Koons, Jeff 171, 173
Krauss, Rosalind 63n4, 63n8, 110,
 165–66
Kuspit, Donald 71, 77n6

Lacan, Jacques vii, 95, 100
Laocoon 14, 31
Latour, Bruno 210
L'Enfant, Pierre 28
Le Corbusier, see Jeanneret, Charles-
 Édouard
Levine, Sherrie 101–02
Lévi-Strauss, Claude 133, 169
Lewis, C.S. 137
Lippard, Lucy 268
Locke, John 51–52, 54
Lublin, Lea 101–02
Lüdeking, Karl 87
Luther, Martin 32
Lyotard, François 174

McCutcheon, Russell 197
MacGregor, Neil 255–56
McKenzie, Janet 69–71
McLuhan, Marshall 120
Madonna: see Virgin Mary
magic 4, 11, 165
magical thinking 11
Maharaj, Sarat 279
Malevich, Kasimir 72, 74, 81–82, 101
Malraux, Andre 49
Manet, Edouard 73–76

Marcus, Greil 202
Marion, Jean-Luc 158
Markovitz, Bryan 138–39, 234, 262, 269
Marty, Martin 243
Marx, Karl 116, 240
Masheck, Joseph 71, 77n7
Masuzawa, Tomoko 19, 118–19, 124–26, 131–32, 150, 167–69, 194, 210, 218, 226, 240, 269, 273, 275, 278, 312–13
materiality 149–50, 170
Matisse, Henri 161, 227
The Matrix 119
Melville, Stephen 246
Menzel, Adolph 111
Miller, Melissa 209
Miller, Perry 61–2
Millet, Jean-François 70
Minimalism 47, 53, 57
modernity 13, 146, 220, 232, 264
Modernism 40–1, 71, 101, 111, 115, 142, 171–72, 193, 226, 234, 252
monotheism 3–4, 103, 114, 126, 245, 263, 275
Monty Python 200, 208, 278
Morgan, David 3–22, 25–45, 73, 128, 141, 144–45, 157, 165–69, 189, 196, 198–200, 205–06, 208, 214, 218, 227, 230–31, 233, 240–42, 248, 253, 263, 270, 273, 277, 296n4, 313
Mortiz, Karl Philipp 32–33, 52–53, 59–61, 64n19; *Anton Reiser* 52, 65n20
Mulder, Susan 171
museums: Art Institute of Chicago 152; Jewish Museum 152–53; John Michael Kohler Arts Center 298; Metropolitan Museum of Art 246; Modern Art Museum, Forth Worth 209–10; Museum of Modern Art 246; Museum of Biblical Art, New York 230–31; Museum of Contemporary Art, Chicago 209; National Gallery of Art, London 255;

Solomon R. Guggenheim Museum 247, 299; Victoria and Albert Museum 246; Whitney Museum 151
mysticism 117, 120–21, 122, 158
myth 13, 140

nationhood 25–30
Nazarenes 36, 38, 218; *see also* Overbeck, Johann Friedrich
Negri, Antonio 120
New Age 16
Newman, Barnett 37, 159, 173–74; *Stations of the Cross* 173–74
Nietzsche, Friedrich Wilhelm 79, 90–92, 137, 196
Noguchi, Isamu 211, 239
Noonan, Kimmy 178–79, 236–37

Ofili, Chris 209
Olitski, Jules 67n43
Orfila, Jorgelina 275–77
Orsi, Robert 208
Ortega y Gasset, José 250–51
Otto, Rudolf 37, 192
Overbeck, Johann Friedrich 261–63

Paik, Nam June 260
Panero, James 225–28
Panofsky, Erwin viii, ix, 276
Parr, Chris 195–200
Pascal, Blaise 131
Pattison, Stephen 211–17
Paul, Saint 153
Peck, M. Scott 198
Peirce, Charles Sanders 110, 274
Pellegrini, Ann 192–94
performance art 159
Piatek, Frank 140–41, 143, 176–78, 195, 218
Picasso, Pablo 139, 148
Pietism 32, 42n19, 52, 61, 65n22
Pinder, Kimberley 73
Pinney, Christopher 277–79

Plate, Brent 202, 208, 209–11, 298, 299

Plato 121, 148, 216, 243

Podro, Michael 54

Post-Enlightenment 81, 170

Pre-Raphaelites 36, 38

Prescott, Theodore 239–41

Primitivism 40, 150

Profanophany 191

progress 36, 80

Promey, Sally M. 73, 205, 208, 222–25, 298

Protestantism 6–7, 32, 36, 89–90, 218–19, 228; Fundamentalist 230, 300; see also Calvinism; Pietism; Puritanism

Psychoanalysis vii-viii 68n48, 100, 105n14, 122–23, 130, 160; and belief 128

Puritanism 5, 10, 62, 94

Queer theory 142

Rancière, Jacques 275

Rand, Archie 246–48

Rapetti, Rodolphe 226

Raphael 31, 70

Raynaud, Jean-Pierre 161

re-enchantment 15, 17, 111, 119, 191–92, 196, 215–17

Reinhardt, Ad 177–78

religion: civil 29; definitions of 119, 124–25, 213–14; discursive construction of 125–26; privatization of 25; Fundamentalist 116–17, 127, 234, 243, 258, 263; lived 141; and philosophy 82; and ritual 138–39; as maps of reality 198, 281n32; as belief system 126–29; as Western discourse 124; see also: Buddhism; Calvinism; Christianity; Confucianism; Daoism; Hinduism; Islam; Judaism; monotheism; mysticism; New Age; Pietism; Protestantism; Puritanism;

Roman Catholicism; shamanism; theosophy; Zorastrianism

Rennie, Bryan 206

republicanism 27–28

revelation 4, 33

Richter, Gerhard 153, 166–67, 171, 254

Riegel, Alois vii, ix

Rilke, Rainer Maria 238

Ringgold, Faith 267

ritual 138–40, 141

Rodriguez, Roberto 84

Roman Catholicism 36, 71, 89, 96, 228, 252, 262; see also Christianity

Romanticism 15, 27, 32–35, 39; and folk culture 29

Rosenblum, Robert 37, 71

Rothko, Mark 159, 174, 209

Rouault, Georges 155

Ruel, Malcolm 168–69

Ruff, Thomas 148–49

Ruskin, John 38, 64n13

Saint-Simon, Henri de 39

Sang-kyoon, Noh 260

Schapiro, Meyer ix

Schelling, Friedrich 33

Schiller, Friedrich 4, 6–9, 15, 29–30, 55, 59–60; 205; Letters on the Aesthetic Education of Humanity 9; "The Gods of Greece" 4, 6–9; Philosophical Letters 7; as infidel 6

Schlegel, August Wilhelm 33

Schlegel, Friedrich 27

Schleiermacher, Friedrich 37

Schmitt, Carl 264–65

Schnabel, Julian 178

Schneider, Mark 11

Schönberg, Arnold 147

Schwärmerei 163

Schopenhauer, Arthur 34–35, 54, 56, 73

Schwain, Kristin 273–75

secularism 193, 224, 265, 291; see also secularization; Enlightenment

secularization 3–4, 223, 233

Sedlmayr, Hans 251, 254
Seel, Martin 87
sensus communis 136
Serrano, Andres 155–57, 161, 191, 207, 209, 248, 295; *Piss Christ* 156–57, 295
Shaffer, Fern 16
shamanism 40, 261
Shiner, Larry 205
Siedell, Daniel A. 232–35
Smith, Jonathan Z. 138, 187, 190, 192, 266
Smith, Kiki 267
smuggling 150, 190–91, 217, 264, 291
Snyder, Joel 110
Sontag, Susan 71
Spiritual in art, the 17, 30, 159
spiritualization of art 16, 25–26, 30–41
Stein, Gertrude 249
Stella, Frank 101
Sturtevant, Elaine 103
sublime 15, 37–38
Sundaram, Vivan 161
Swedenborg, Emanuel 226

Tarkovsky, Andrei 82
taste 27, 160
Taylor, Mark C. 158, 168
terrorism 148, 226
theosophy 35, 299
Tillich, Paul 37, 73, 172, 206
Titian 71, 153
Tobey, Mark 299
totemism 133
transcendence 33–34, 37, 47, 49, 53–57, 149, 159, 196
Turner, Victor 139
Tuveson, Ernest Lee 51, 59, 66n29
Tweed, Thomas 208

Updike, John 72, 111, 118, 270

Van Baal, Jan 293–94
Van Schepen, Randall 47–68, 292, 313
Vasari, Giorgio 25
Verrips, Jojada 287–96, 313
Viola, Bill 37, 161, 191, 203, 207, 209, 256
Virgin Mary 91–92, 99–100, 102, 130–32, 143
visual culture 18, 19, 145, 204, 231, 271–73
visual piety 141, 249, 270
visual studies 144–45, 249, 272, 290
"Visual Studies Questionnaire" 144

Wainwright, Lisa 142, 267
Warburg, Aby vii, 259
Warhol, Andy 88, 90, 93, 299
Weber, Max 3–6, 15, 96
Webster, Noah 28
Weibel, Peter 262
Wellbery, David 54, 66n31
Werckmeister, Karl 72, 77n8, 111
West, The 121, 125, 145, 157, 212, 251–53, 258–59
Winnicott, D.W. 122
Winckelmann, Johann Joachim 7, 31–32; *Reflections on the Imitation of Greek Works* 31
Wittgenstein, Ludwig 128, 133
Woodmansee, Martha 52, 64n19
Worley, Taylor 19, 146, 155–57, 172–73, 313
Wuthnow, Robert 202, 243

Zizek, Slavoj 265–66
Zoroastrianism 258

Related Titles from Routledge

Is Art History Global?
Volume 3
Edited by James Elkins

This is the third volume in *The Art Seminar* series. The topics discussed are political, economic, philosophic, linguistic, and personal. Contributions from the worlds' most prominent and widely-traveled art history scholars stage an international conversation on the subject of the practice and responsibility of global thinking within the discipline.

PB ISBN13: 978-0-415-97785-2
HB ISBN13: 978-0-415-97784-5

The State of Art Criticism
Volume 4
Edited by James Elkins and Michael Newman

Art criticism is spurned by universities, but widely produced and read. It is seldom theorized and its history has hardly been investigated. *The State of Art Criticism* presents an international conversation among art historians and critics that considers the relation between criticism and art history and poses the question of whether criticism may become a university subject.

PB ISBN13: 978-0-415-97787-6
HB ISBN13: 978-0-415-97786-9

Available at all good bookshops
For ordering and further information please visit:
www.routledge.com

Related Titles from Routledge

Renaissance Theory
Volume 5
Edited by James Elkins and Robert Williams

Renaissance Theory presents an animated conversation among art historians about the optimal ways of conceptualizing Renaissance art, and the links between Renaissance art and contemporary art and theory. This is the first discussion of its kind, involving not only questions within Renaissance scholarship, but issues of concern to art historians and critics in all fields. Organized as a virtual roundtable discussion, the contributors discuss rifts and disagreements about how to understand the Renaissance and debate the principal texts and authors of the last thirty years who have sought to reconceptualize the period. The volume includes an introduction by Rebecca Zorach and two final, synoptic essays, as well as contributions from some of the most prominent thinkers on Renaissance art including Stephen Campbell, Michael Cole, Frederika Jakobs, Claire Farago, and Matt Kavaler.

PB ISBN13: 978-0-415-96046-5
HB ISBN13: 978-0-415-96045-8

Landscape Theory
Volume 6
Edited by Rachel Ziady DeLue and James Elkins

Artistic representations of landscape are studied widely in areas ranging from art history to geography to sociology, yet there has been little consensus about how to understand the relationship between landscape and art. *Landscape Theory* brings together more than fifty scholars from these multiple disciplines to establish new ways of thinking about landscape in art.

PB ISBN13: 978-0-415-96054-0
HB ISBN13: 978-0-415-96053-3

Available at all good bookshops
For ordering and further information please visit:
www.routledge.com